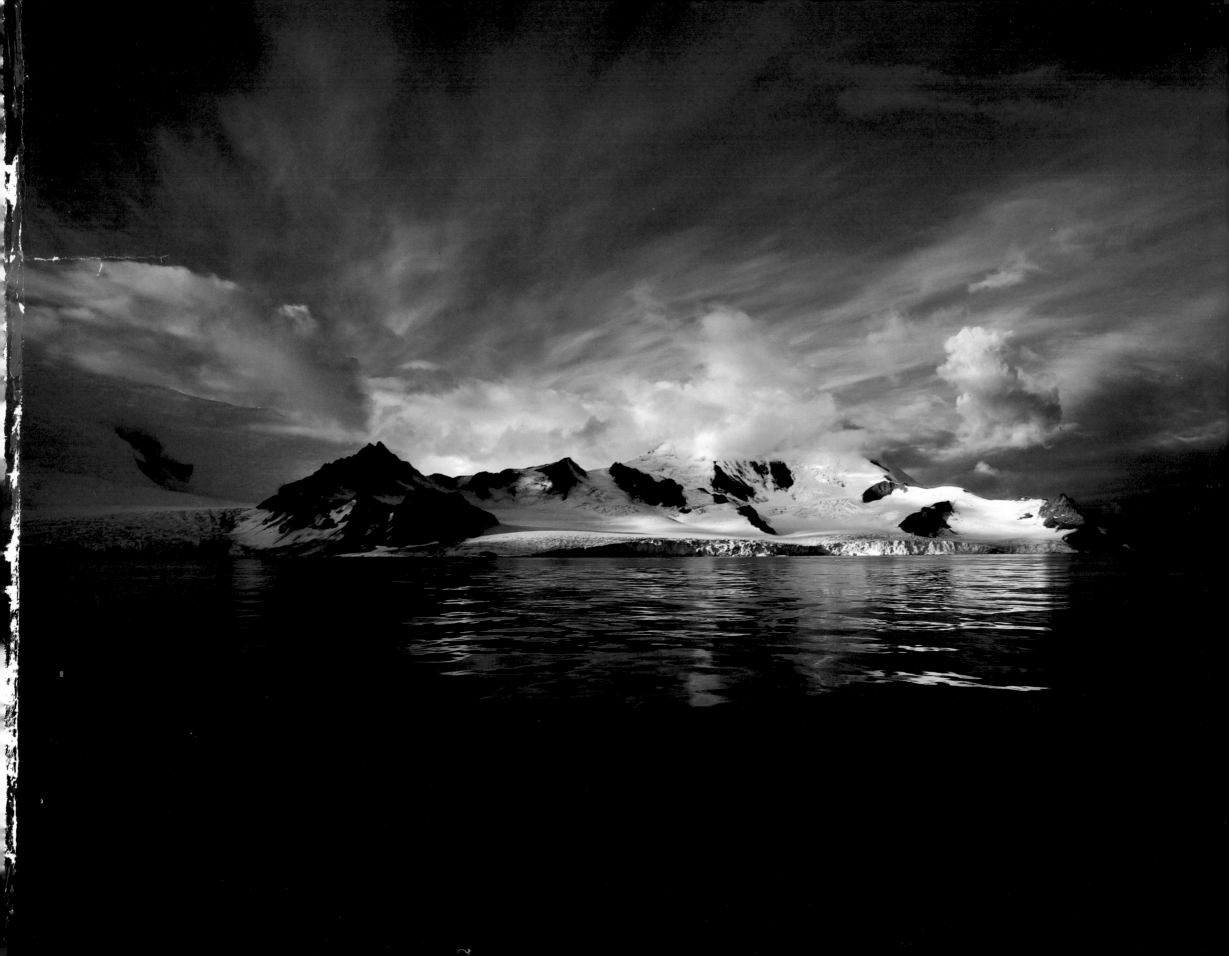

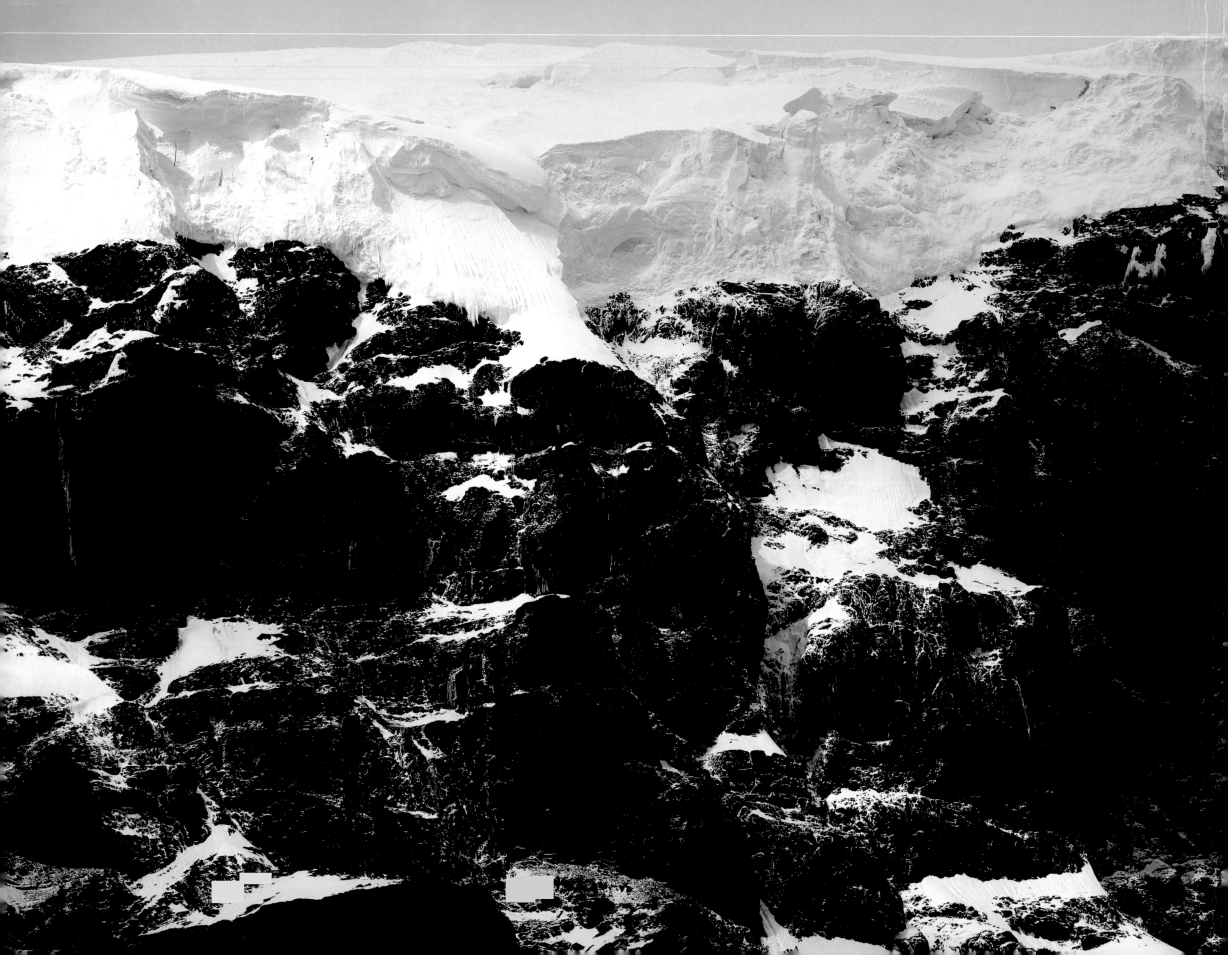

Antarctica

THE GLOBAL WARNING

"In our way of life with every decision we make, we always keep in mind the seventh generation of children to come. When we walk upon Mother earth, we always plant our feet carefully, because we know that the faces of future generations are looking up at us from beneath the ground. We never forget them."

— *Oren Lyons, Native American*

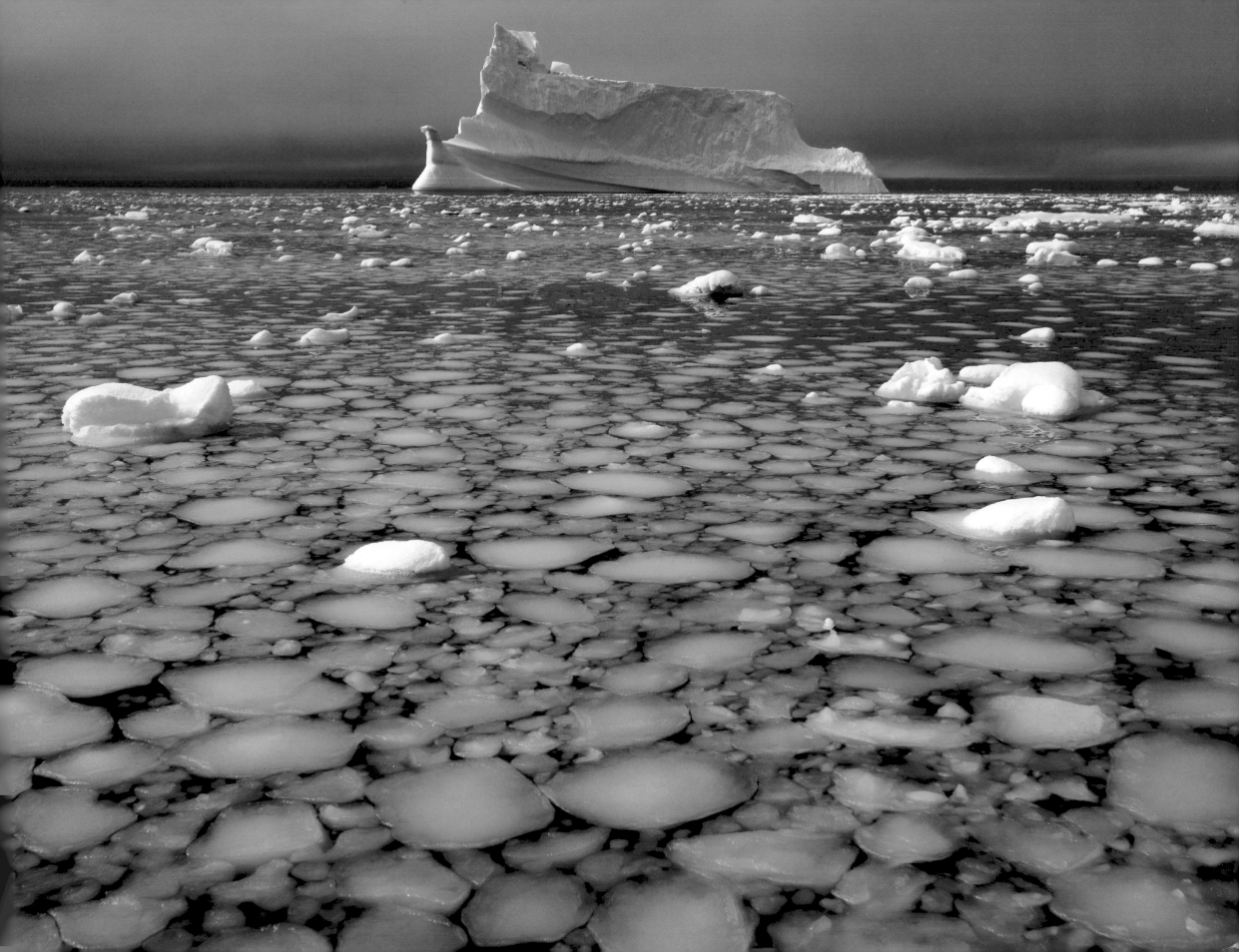

This book is dedicated to future generations.

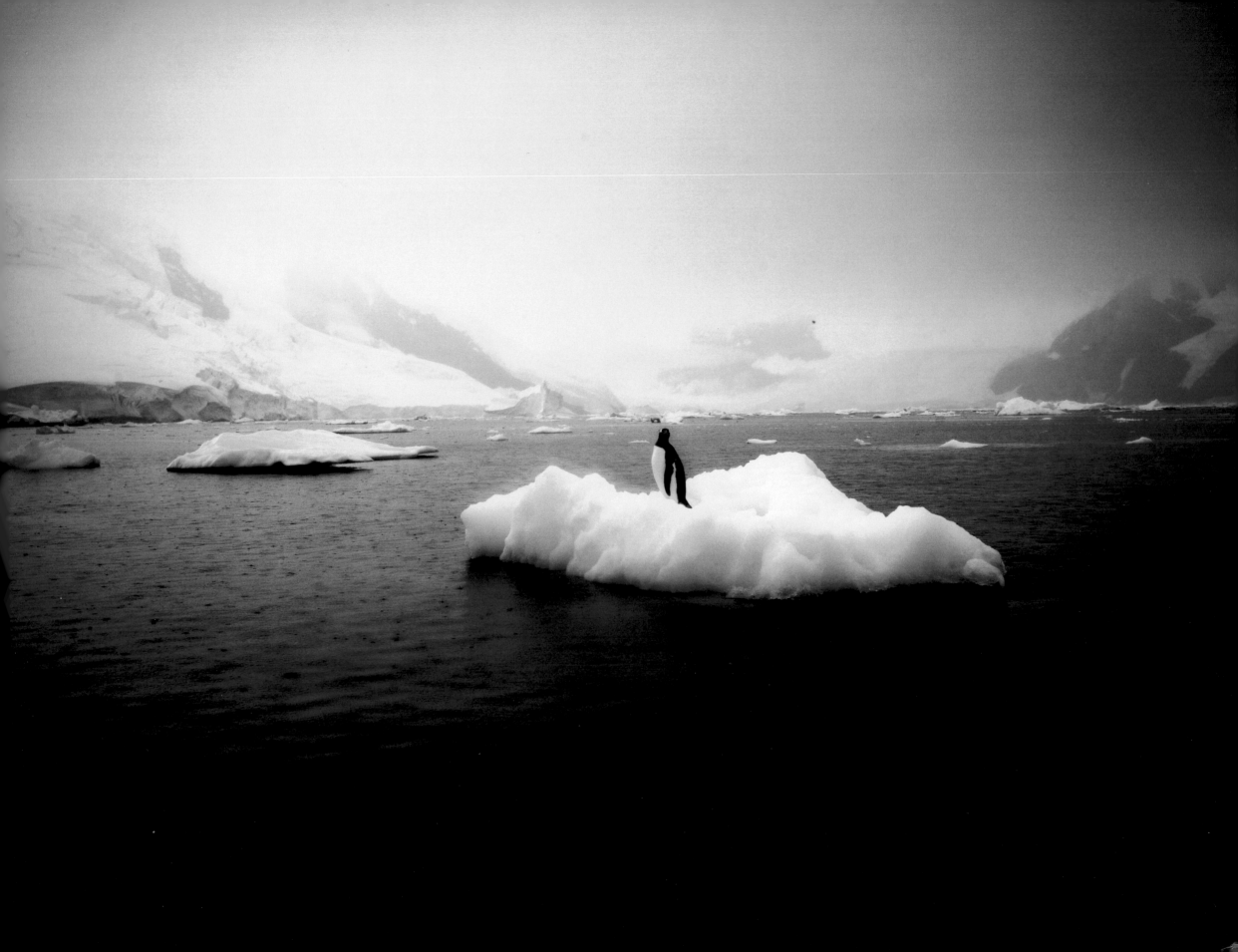

ANTARCTICA

THE GLOBAL WARNING

Photography and text by

Sebastian Copeland

MOUNT VERNON CITY LIBRARY
315 Snoqualmie
Mount Vernon, WA 98273-4298
(360) 336-6209

Foreword by **Mikhail Gorbachev**

Preface by **Leonardo DiCaprio**

EARTH AWARE

San Rafael, California

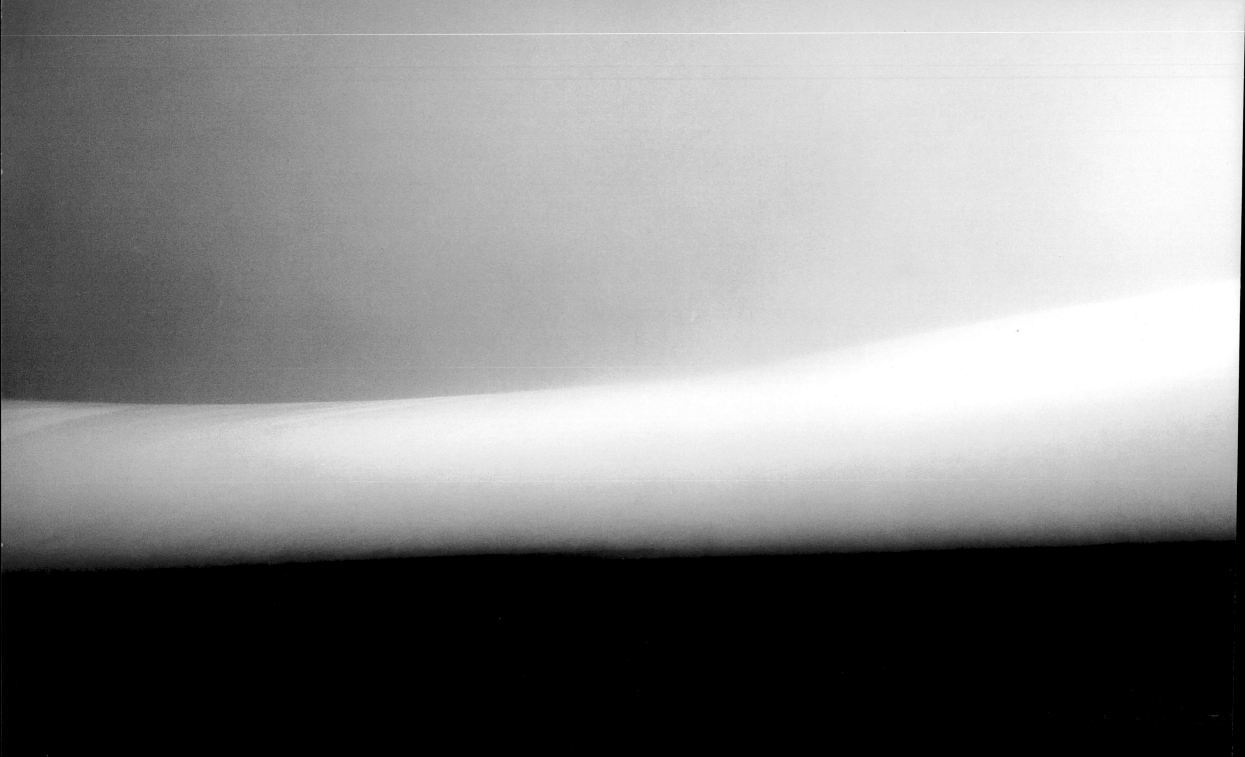

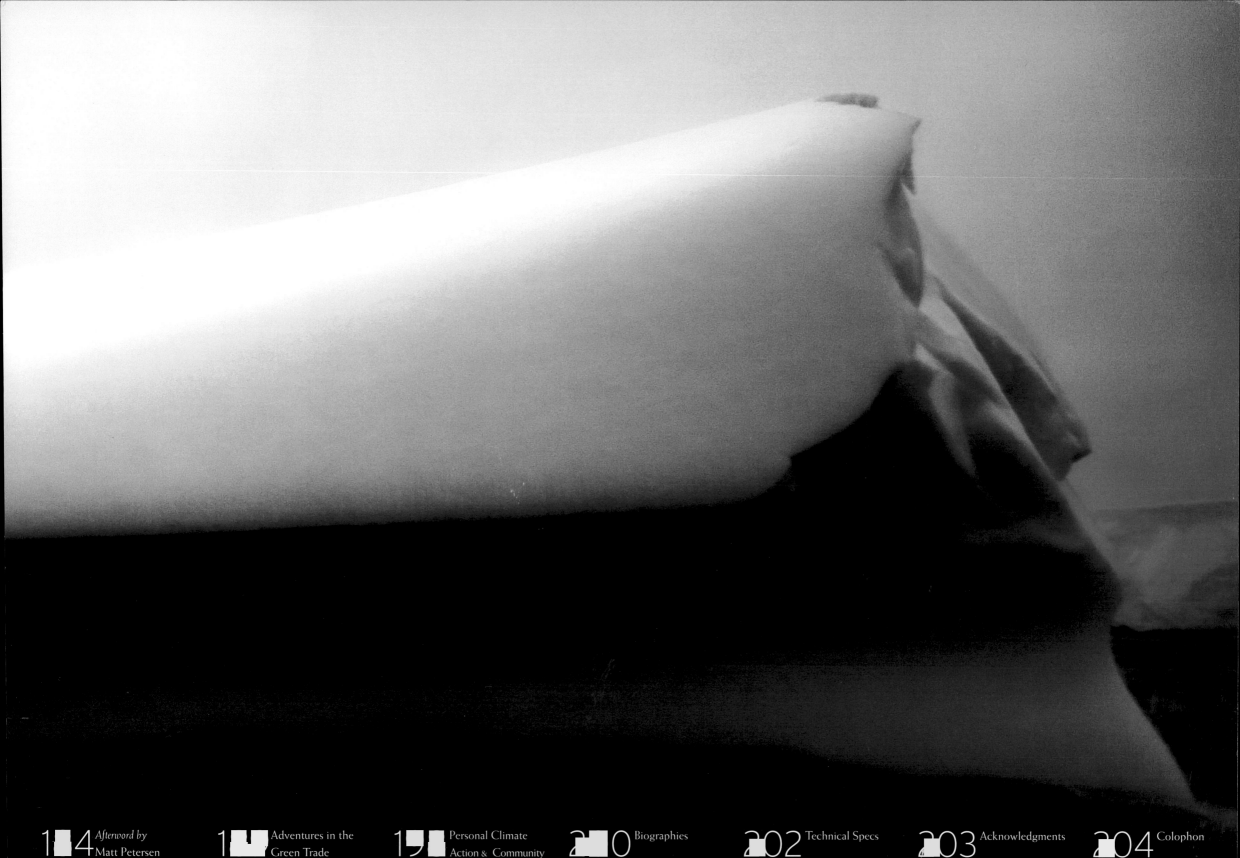

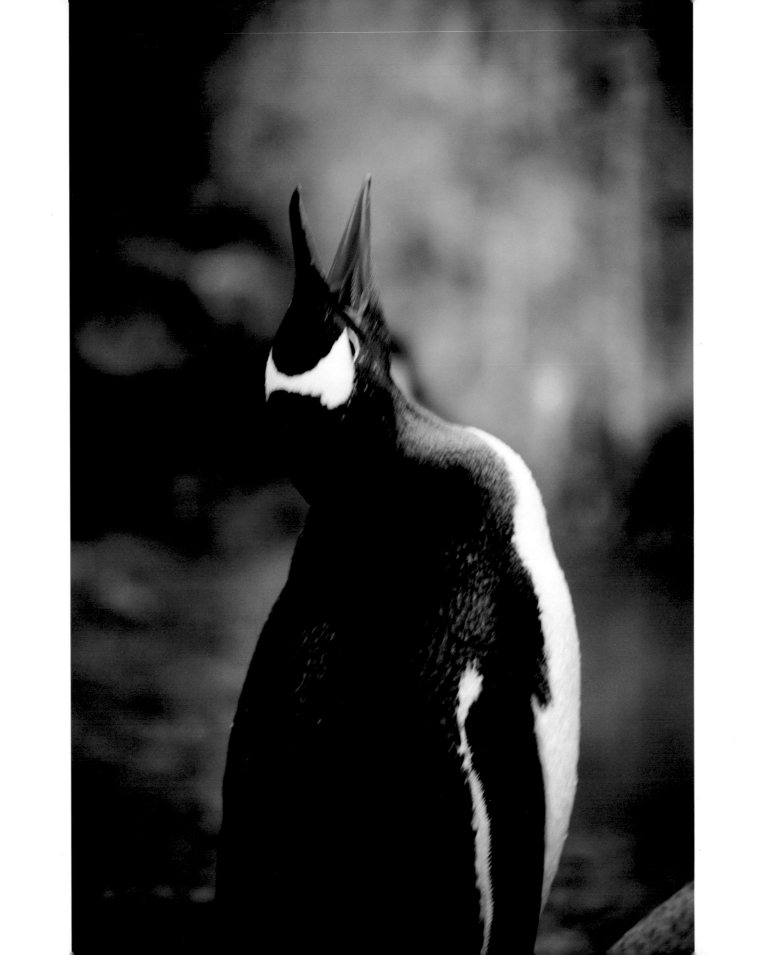

Foreword by Mikhail Gorbachev

In January 1991 I received a message from Jacques-Yves Cousteau, who was sailing to Antarctica for a scientific mission and public awareness campaign designed to protect the white continent for future generations and to create a World Peace Park in Antarctica. At the time, certain groups wanted to exploit the hypothetical underground mineral resources of the Antarctic. A convention had been negotiated between parties of the Antarctic Treaty that would guarantee a fair and clean exploitation. Captain Cousteau, who along with many NGOs was aware of the risk of accidents and their potentially drastic consequences for such a fragile and unique environment, proposed to replace the unenforceable convention with a protocol aimed at truly protecting the environment. In 1992, this protocol was adopted in Madrid, and Antarctica was declared "Land of Science, Land of Peace" and protected for fifty years. It was a wise decision taken by politicians, heeding the call of millions of citizens around the world.

Nevertheless, today, Antarctica is once again threatened: this time not by oil or coal exploitation, but by global warming. The impact of climate change is most apparent in the Antarctic, where global warming has driven significant changes in the physical and living environment, causing ice to melt faster than anywhere else in the world. Antarctic surveys have clarified several key issues in the field of the science of climate change and unveiled the clearest link between levels of greenhouse gases in the atmosphere and surface temperatures. If all the ice captured in Antarctica were to melt, sea levels would rise by a terrifying sixty meters.

Climate change is happening now and will remain with us for a long time to come. As a result, in the past decade, the number of floods, hurricanes, tropical storms and other natural disasters has quadrupled in comparison with the 1960s. Scientists have already calculated that – if the carbon gas concentration continues to grow at current rates – during the course of the present century the average temperature of the earth will rise by 1.1 to 6.4 degrees Celsius. It is time to act to avoid the clearly forecast global climatic catastrophe: now is the time to develop efficient solutions on a local, national and global level.

More than an indicator of the effects of human activity on global warming, I truly believe that Antarctica should become a powerful symbol to raise awareness of the urgent need to save our planet while there is still time.

It is in this essence of hopefulness that *Antarctica: The Global Warning* came to life. It depicts the ephemeral and austere beauty of Antarctica through stunning photographs of the largest remaining wilderness on earth. But while Antarctica appears to be the last unspoiled place on earth, its balance is being systematically endangered by rising temperatures caused by greenhouse gases emitted thousands of miles away.

I hope from the heart that this book will inspire you to further explore the issues surrounding climate change and its impact at the farthest reaches of our planet.

Mikhail Gorbachev
Chairman of the Board,
Green Cross International

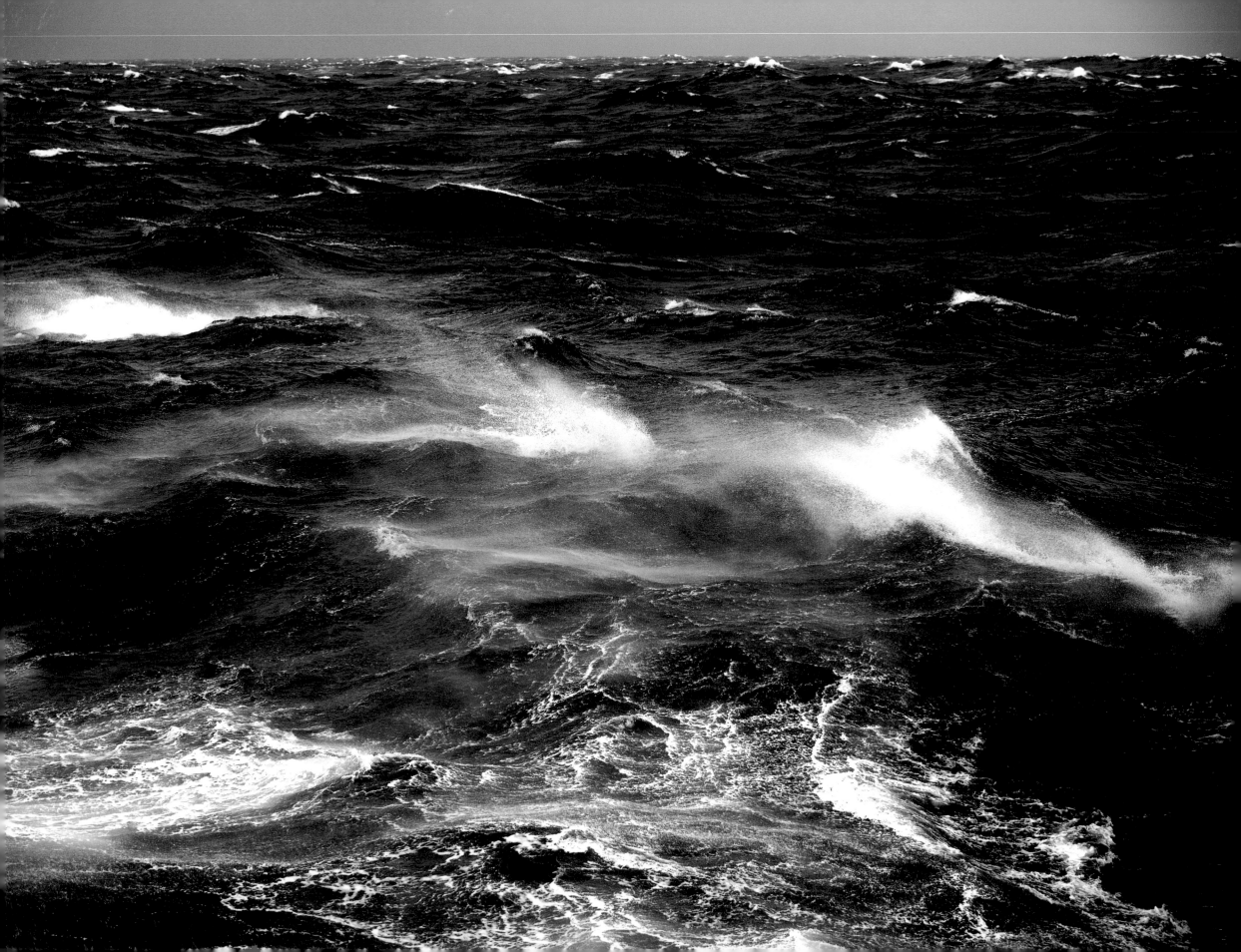

Preface by Leonardo DiCaprio

Antarctica is a world of extremes. It is the coldest, windiest place on earth; it hasn't rained in its Dry Valleys for over two million years, yet it has the most freshwater on the planet frozen in its glaciers and ice shelves. For centuries, mankind imagined what Antarctica was like, but it was only when Captain John Davis landed in 1821 that the continent became accessible.

The journey to Antarctica can still be challenging, even in our age of modern technology. Explorers used to make the voyage in wooden ships propelled by wind in their sails and it was not uncommon for them to get stuck in the frozen seas. Today, icebreakers and steel-hulled tankers carrying scientists to the many research stations on the continent make the trip.

Antarctica has no native population but some of its research stations are staffed throughout the year. It is from these stations that studies on global warming are conducted. The Antarctic Peninsula is particularly sensitive to climate change. In the past fifty years, temperatures there have risen up to five times faster than the rest of the world. Ice shelves have been breaking off faster than scientists have predicted and the freshwater once locked on the continent is flowing into the sea. Moreover, increased instances of rain are falling on the continent and further accelerating the melt.

It is because of the phenomenon of climate change that Sebastian Copeland set out on the difficult trip on an icebreaker named The Ice Lady Patagonia for Global Green USA and Green Cross International. It took three days to cross the Drake channel in winds of up to sixty knots to reach Antarctica in January 2006. Sebastian made the journey again in 2007 to witness for himself and for all of us a place that will be forever changed. The stunning photos in this book show a frozen landscape with a scale and light that tell the tale of an otherworldly place that is fast slipping away.

Leonardo DiCaprio

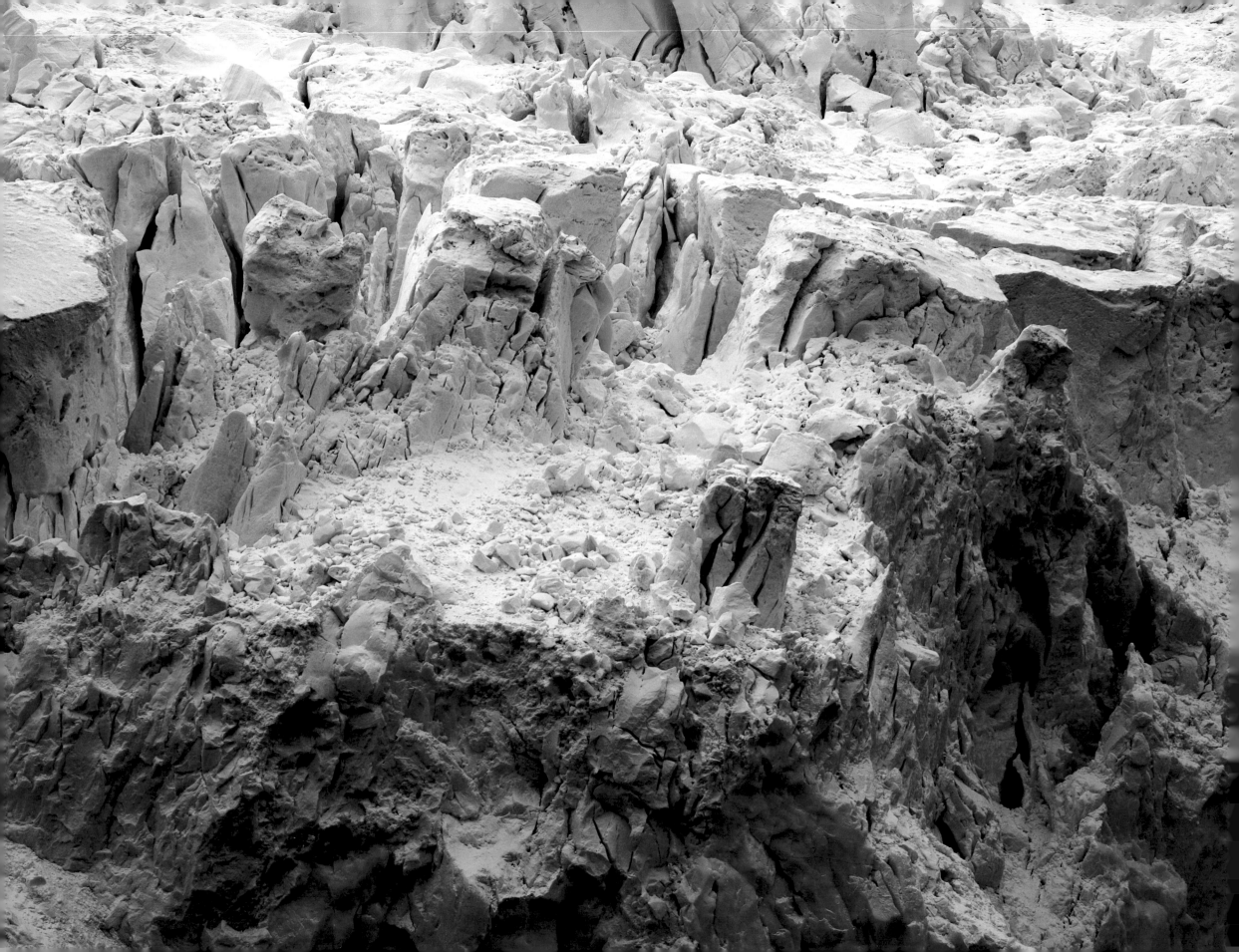

Introduction by Sebastian Copeland

Scale and light. That is how I will remember Antarctica. As I review six cumulative weeks' worth of intense shooting, I am awed by the raw power of nature in this surreal environment, where mankind, yet again, is dwarfed by such gigantic proportions. Towering volcanic peaks plunging precipitously into the sea; glaciers nonchalantly and inexorably pouring into the ocean, where chunks of ice the size of city blocks carry their last hurrah as they float away to their inescapable fate. Trapped in frozen air bubbles are hundreds of thousands of years' worth of environmental data.

Despite the broad areas ominously uncovered by ice and the suspiciously eroding rain, one definitely gets the sense that Antarctica holds untold amounts of geological and climatic secrets – a dynamic environment, rich in mammal and sea life, never conquered by humans.

Yet, remotely and systematically, greed and ignorance are spoiling this extraordinary place, as global temperatures threaten the ice so crucial to the climate balance of our planet. In the last sixty years, the poles have warmed up at more than twice the rate of the rest of the world, while the Antarctic Peninsula, the area photographed in this book, has warmed by up to five times the global average. I wonder if, in the future, people will even have the privilege of witnessing what I have seen; and what will they think, then, of those generations who waited so long before taking action.

The poles hold 30 percent of the world's water, and Antarctica, 90 percent of its freshwater. Melting ice is projected to raise ocean levels by as much as twenty feet within the next couple of centuries, uprooting 80 percent of the world's population. Within as little as eighty years from today, 35 percent of the world's species will disappear. Polar bears will be extinct in the North, and many penguin species will disappear in the South... and one question remains: What arrogance is borne out of Man which does not see the significance of this profound and irrevocable loss?

What better way to experience great music but to share it? The same is true of images. I am grateful for the chance to share these, and I thank you for the privilege of inviting you into your world. To celebrate this magnificent landscape is also a way for me to remember how fragile and precarious it is. This is your home.

Welcome to Antarctica.

Sebastian Copeland

MESSAGE IN A BOTTLE

For as long as I remember, I have had a deep reverence for nature. It is in my genes; instilled in me through my maternal grandfather, who, as early as the 1920s was conducting expeditions in West Bengal, India, and southern Africa. Irish-born and a tireless storyteller, his spirit framed my formative years with tales of elephant rides, tiger hunts and camping safaris in the wilds of Botswana. He was a surgeon, but his passion was photography. And the reality he captured through the eyepiece of his Leicas would ignite the wide-eyed curiosity of a young boy whose destiny was quietly and inexorably sealed with each click of the slide projector. Unbeknownst to me then, as I sat on his lap in the living room of this suburban house in Littlehampton, Sussex, with the shutters drawn, listening to tales of the earth, his profound kinship with nature was simply passed on to me.

That seed has been my most precious gift.

Later in life, and for many years, I directed commercials. I won awards, and thrived at mounting large productions. It fed into my appetite for adventure, which eventually lead me to all four corners of the globe. My love of nature, and connection with the wild, was an organic, kinetic force that strengthened my belief in our shared responsibility to protect it. At the time and simplistically perhaps, support, for me, was limited to sending money to help campaign against clear-cutting or saving the whales. I felt pretty good about that. And assumed that I had done my part. My life was largely unchanged, but for a nagging feeling that working on behalf of consumer products felt uncomfortably at odds with the personal standard I was trying to uphold. Concurrently, my celebrity portrait photography business was growing. I began taking nature stills of the remarkable places I traveled: Bali; the magical forests of Ireland; Brazil; France; Sahara, the majestic; the glorious American landscape... I became interested in the juxtaposition of art and man against the profound backdrop of the Nevada desert, at Burning Man.

Around that time, I had the good fortune and privilege to meet my friend Matt Petersen, president and CEO of Global Green USA. His commitment and patient guidance educated me on the global concern for climate change. As I became more informed of the long-term implications of our carbon imprint, I came to realize that engagement, for me, was not a choice, but a moral imperative. I began working on advocacy and media initiatives with Global Green, and eventually joined the board. My growing interest in the issue forced me to face the dichotomy of my existence: though it was a financial risk at first, I left commercial directing. Photography would become an extension not just of my work as an artist, but as an activist.

The Evidence

All the while, I was confounded by the contradicting science on global warming. I found myself periodically debating with skeptics who, armed with compelling arguments, advocated a business-as-usual attitude towards energy. It was bad enough trying to convince people that global warming was real, and that it was a bad thing. For a long time the interest in climate change lost to other, seemingly more pressing topics. For most of the world, the earth's warming conjured notions of long, lazy summers and milder winters. It didn't sound so bad. The studies were esoteric; the projections based on hypothetical models; the changes nonlinear; and its newsworthy appeal a far cry from the O.J. trial, or the Clinton saga. Humankind and nature were on a collision course, but the implications would not be felt for decades. To be an environmentalist had a resonance of idealism and tree hugging. Climate change, it turned out, was a nightmare from a communication standpoint! I thought then, as I do now, that the vernacular was the first obstacle. To begin with, whoever coined the term "global warming" probably did not live in London or Boston. "Global heating" might have conveyed, more effectively, the ominous and cumulative effect of such warming! Meanwhile, scientists from around the world conducted independent studies confirming alarming warming trends associated with human activities. Eventually, 90 percent of scientists were in agreement on global warming. But the remaining 10 percent amounted to reasonable doubt: for anyone vested in energy interests, that 10 percent was a godsend. It didn't matter that the environmental community suspected a disinformation campaign waged by the energy lobbies. And that some news media exposed those so-called "greenhouse skeptics" as being, at one time or another, on the energy companies' payrolls. That suspicion conveniently sounded like a conspiracy theory. A few years ago, a friend of mine handed me a copy of *State of Fear*, the opportunistically

sensational novel by Michael Crichton, in an attempt to provide a balanced opinion. The book concocts the story of an environmental terrorist group, with the technology to create natural disasters in order to vindicate global warming... My friend is a bright and successful Stanford University graduate. And Crichton, the best-selling writer of *Jurassic Park*, was somehow heralded by big business as an authority on the subject. He questioned the motivation of the global science community by making the following statement: "Auschwitz exists because of politicized science!"[1]

> "The few skeptics who continue to try and sow doubt should be seen for what they are: out of step, out of arguments and just about out of time."[2]
>
> — *Kofi Annan, Secretary General of the United Nations, on global warming*

As it turns out, ExxonMobil Corp. was eventually exposed for utilizing tobacco company tactics by giving $16 million to forty-three ideological groups between 1998 and 2005 in a coordinated effort to discredit the science behind global warming, and deliberately mislead the public.[3] With record profit years and no intention of changing course, ExxonMobil masqueraded behind its publicly proclaimed support of legitimate climate science, while surreptitiously financing communication entities to discredit that very same science. Clearly, ExxonMobil is not alone. In spite of the resounding evidence resulting from international and independent research, they succeeded in creating the impression that there really was a debate. Consequently, the bulk of the media expressed ambivalence in what was perceived as divergent and inconclusive matters of opinion.

As can be expected, climate change was immediately polarized along party lines. Big business and energy interests — the ones most susceptible to environmental policy adjustments — resoundingly support a conservative agenda, which, not surprisingly, has traditionally downplayed the scientific evidence on global warming. Oddly, many corporate leaders whose business practices involve the deployment of powerful lobbies to influence lawmakers in fighting regulatory amendments have privately supported land conservation, and often own vast properties whose premium, ironically, is nature. This is especially dichotomous, as nature is not owned: only the land is. And the threat, real and universal, affects all regions of the world indiscriminately; and to varying degrees, all pedigrees. President Clinton, to be fair, refused to ratify the one international attempt at regulating carbon emissions. Along with only three other industrial countries (Australia, Monaco and Liechtenstein) the US, whose 5 percent of the global population emits 25 percent of the world's greenhouse

gases, worried that addressing climate change through Kyoto's mandatory targets would place excessive pressure on the economy. He pledged to self regulate. But the Bush administration, notorious for its support of energy interests, has systematically rejected the science on global warming. Tragically, each passing year exponentially raises the global stakes and their ominous consequences, as we race towards a cryptic tipping point. In the last ten years, scientists have dramatically re-evaluated their assessments of the accelerated rate of change. Today, ice shelves are collapsing and glaciers receding in manners so sudden as to confound experts.[4]

That race is our gravest challenge.

After September 11th, the world was taken on a diversion course, the motivation of which, ironically, drew from the energy crisis. Is it possible that the terrorists we should prosecute, and the ones that we can identify, are the big polluters who have placed profits, effectively, in front of human lives?

> "The impacts of global warming are such that I have no hesitation in describing it as a 'weapon of mass destruction.'"[5]
>
> — *Sir John Houghton, former Chief Executive of UK's Meteorological Office*

In truth, the attitude reflected by this general disconnection towards the environment is mostly a century old. Entitlement, which we inherited from the Age of Enlightenment, conditioned us to a superior approach towards nature. Reason, science and empiricism placed man, or so he thought, at the top of the pecking order; the earth a subordinate to his needs. With the industrial revolution and the explosion of hydrocarbon energy, modern societies were further conditioned to believe that more is always better; that natural resources are infinite; and that breakthroughs in technology now meant that humanity could operate independently from the natural cycle. If we fail to see our synergic relationship with nature, then science has taught us nothing. What we need today is an Age of the Environment. In his book *The Revenge of Gaia*[6] the scientist James Lovelock suggests that the rising of global temperatures in the 21st century is equivalent to the population-regulating plagues of the past. His Gaia theory, which has been widely accepted by scholars since its introduction in the seventies, sees the Earth as a self-regulating system: each organism has a causative relationship to the next. To undermine one is to challenge the very balance of a cohesive whole, and the Earth acts accordingly to protect itself. It is relevant to consider that by the end of the century, 35 percent of the world's species are predicted to disappear.

Meanwhile, Einstein forewarned that if bees disappeared, man would have four years to live.

First Victims

Applying my photography skills to complement the work that I do as an environmental advocate was a natural fit: finding the right platform to do it with finally became obvious to me after my first trip to the ice. I traveled to the Arctic in 2005 for Global Green, and understood firsthand that the poles are ground zero in terms of climate change. They are the canary in the coal mine of global warming: changes there have fundamental consequences for the rest of the planet. The first thing I understood in the Great North, which obviously was just a confirmation, is that it is really, really cold! Not much of a discovery, I know. But it frames the challenge of a climate dialogue that involves the word "warming" when talking about the poles. On the one hand I would address the minus 60 degree C temperatures I'd experienced as the coldest I'd ever felt in my life; and on the other hand, I would basically say that it was not cold enough! The vernacular, again, got in the way.

My second lesson had profound resonance: I learned that the poles are like great receptacles of what happens remotely: they are like the garbage destinations of the world. Sheila Watt-Cloutier, the international chair of the Inuit Circumpolar Conference, shared with me that in recent years, Inuit babies had strangely been diagnosed with health issues traced to Persistent Organic Pollutants (POP), a phenomenon highly uncharacteristic for an indigenous population whose diet relies primarily on local hunts. We know that POPs and heavy metal pollutants have contaminated US soil. Studies show that agricultural fertilizer and industrial wastewater disposal release heavy metals directly into the soil, which eventually contaminate our rivers. POPs are insoluble carcinogens — they are very difficult to break down. Once in the rivers, they get absorbed by small fish that make their way to the ocean and are eaten by larger fish. These travel north through the Gulf Stream and are eventually eaten by seals, themselves common to the Inuit diet. The babies are then unwittingly poisoned through their mothers' nursing milk or blood cord.

Why is that relevant to a climate debate? Because of the relationship of cause and effect. Because something happening so distantly can have such dire consequences at the macro level, and communities in one of the most remote places in the world can be victimized by a careless lack of accountability and inadequate regulations thousands of miles away. Ironically, that very theme had prompted my trip to the North. Its purpose was to raise awareness on the following: due to activities conducted primarily by industrialized nations and for their sole benefit, the Inuit were losing their way of life. They put a face on global warming. The Arctic is, for the most part, a frozen sea. The CO_2

generated greenhouse effect prevents excessive heat from releasing in the atmosphere, melting the sea ice, and jeopardizing the habitat of its indigenous life. As we know, the polar bear population has precipitously declined, their numbers dropping 21 percent between 1997 and 2004.[7] This we know happens from drowning and hunger, a direct result of melting ice. In a recent surprising twist, while systematically rolling back environmental policies, the Bush administration has suggested placing polar bears on the Endangered Species list.[8] The administration recognizes melting ice as the likely cause, but not human-caused global warming…. Meanwhile, the Inuit have relied on hunting and fishing as a way of life. Fifty years ago, they mainly lived in igloos in the manner they had for a thousand years. In remote areas, that is still common. Today, their culture threatens to disappear as the hunt is migrating north from the receding ice. We may tolerate the loss of what we perceive as a quaint, holistic and sustainable culture as the price of doing business. But what may seem like a sentimental tale is in fact a cautionary one: if the Inuit are the first to go, it is critical to understand that they will not be the last.

Their loss underscores the fundamental relationship between climate and the geopolitical balance of the planet.

With its enormous appetite for energy, the US is, by far, the worst polluter. Presently, it burns through 20.7 million barrels of oil a day. In contrast, China, the second largest consumer, uses 6.9 MB/day.[9] The world's energy needs, following the developing world's explosive demographic growth, are set to increase by 70 percent in the next thirty years.[10] With that rate of consumption, fossil fuels presently factor as the main source of energy for the same reason that they were introduced to begin with: they are convenient and available. They are also the dirtiest pollutants. This sets the stage for the worst possible conundrum to challenge human nature: profit versus survival. Greenhouse gases are projected to grow at a rate of 1.2 percent per year in the industrial world and 2.8 percent per year in the developing world. Countries like China and India, signatories to – but not bound by – the Kyoto Protocol, present a menacing front by following the example set forth by the US's historically inadequate regulations. If their per capita emissions today were those of Japan, global emissions would be 50 percent higher![11] Let's consider that in 1954, world carbon emissions were on the order of 1.6 gigaton a year; by 2000, they had reached 7 GtC/yr. At present rate, the projection for 2054 would exceed 25 GtC/yr.[12]

"It's important not to be alarmist but it is very important to be alarmed."[13]

— *David Miliband, UK Secretary of State for the Environment, Food and Rural Affairs*

Each year, five million people perish globally from insufficient and diminishing access to water; the number of category 4 and 5 hurricanes has virtually doubled in the last thirty years;[14] deadly heat waves; mud slides; killer floods. Nature, it seems, has played an increasing role in displaying its destructive power. But two things have happened in the span of one year that have blown open the doors for popular awareness of the environmental crisis. The first had far-reaching consequences in that it bridged the gap in the universal consciousness between natural disasters and climate change and made global warming a household name. In the late summer of 2005, the world was shaken to attention by the deadliest and costliest natural disaster to hit American shores. Katrina, unlike the recent Asian tsunami, woke the world from its convenient slumber. And it illustrated with brutal and deadly clarity that climate-related natural disasters were not the domain of distant countries. It warned international governments by exposing ours for what it was: ill equipped and unprepared to prevent or effectively deal with a natural trauma of such proportions. As I write this, eighteen months after the tragedy, 50 percent of New Orleans is still uninhabitable. After experiencing a fierce display of nature's power, half of the city - one of the most vibrant cultural centers in the wealthiest country in the world - is dead.

It is tempting to get distracted by the levee debate, and ask why the federal government, in spite of extensive warnings, was so uncommitted to protecting its own people, though it did not hesitate to commit enormous resources to invade a foreign nation to allegedly protect its people. The answer could be summed up in that there is no glory in prevention. And to engage in the scope of natural disaster prevention is so overwhelming that it is easier to just ignore it, hoping that it will go away or that someone else will inherit its burden. Politicians, like business leaders, recoil at facing their constituents - or shareholders - announcing that sacrifices made today will vest fifteen or twenty years from now. In this world, they don't get elected, or they get fired. But the earth is speaking. And what it is saying makes abstraction of short-term and localized measures. These events do not point the finger at one convenient foe. They point to us. And what they demand is a change of course.

"Today's problems cannot be solved if we still think the way we thought when we created them."

— *Albert Einstein*

It can be argued that, once again and this time with Iraq as distraction, the media's attention span, and the popular opinion it ultimately reflects, stopped short of demanding real change by abdicating responsibility to the government. For most people, change would still be dictated by the price index, and not a conventional wisdom view of the future. But the vernacular had infiltrated common parlance, and begun eroding at the notion that climate disasters were a confined inconvenience. US cities began to break away from the federal government's rejection of Kyoto, by implementing the Climate Protection Agreement: local programs targeting a reduction of carbon emissions to pre-1990 levels, as set forth by the protocol. But Katrina also paved the way for what turned out to be the second most dramatic event to help shape popular awareness in recent times. The effectiveness of environmental communication, for me, can virtually be measured in terms of pre- and post- *An Inconvenient Truth*. With his movie it is fair to say that Al Gore has had an impact on the environment that the presidency would not likely have afforded him. Freed from the political jockeying of Washington, the man "who used to be the next President of the United States" delivered the home run that the environmental community, and the world, had desperately needed.[15] What he accomplished with his presentation was to clearly and concisely outline the glaring patterns that scientists have been studying in increasing numbers over the last fifty years. The strength of his delivery, coming from a man who many had thought lacked charisma, won the popular vote, and, like a tidal wave, galvanized the media. The gravitas of a two-term vice president and presidential runner-up would lend this urgent platform the representation it had lacked, and make the issue unavoidable on the ballot for a 2008 US presidential bid. Gore joined the advisory board of Tony Blair's climate change panel, an irony that cannot have gone unnoticed by the Bush administration. Revenge, in this case, was a dish that would be eaten warm.

"Climate change is probably the greatest long-term challenge facing the human race."

— *Tony Blair, Prime Minister's foreword to the 2006 UK Climate Change Programme*

A common misconception is that the Earth needs our help. In fact, Earth is a constantly evolving system, and humans only one of an estimated 30 million species inhabiting it. Whether or not one agrees with Lovelock's theories, science tells us that over 99 percent of all species that ever existed on Earth are now extinct.[16] Man is around 150,000 years old, to the Earth's 4.5 billion years. On the Earth geological clock, we have appeared within one minute before midnight! What is at stake today is not the Earth: it is our ability to survive on it.

With the relentless output of greenhouse gases in the atmosphere, the projections for global temperatures are alarming. The United Nation's

Intergovernmental Panel on Climate Change's last report predicts that temperature rises could reach 5.8C by 2100, with high latitude countries such as the UK reaching 8C.[17] That is especially troubling as a 5C rise amounts to the difference in temperature between the last ice age and today.[18] Additionally, around half of the CO_2 dissolves into the oceans, increasing its acid content. This fact is based on basic chemistry, and does not rely on abstract projections from computer models. The ocean is 0.1PH units more acid today than its pre-industrial levels, a rate of change which has not been seen in over 10,000 years. By mid-century, its acidity could increase five fold.[19] Marine plankton and invertebrates are particularly susceptible to acid content. As are organisms whose calcium carbonate skeleton or shells are dissolved by acid solutions. This includes most shellfish and corals. In other words, the base of the food chain, which as we know evolved from the oceans, is at risk. With global demographic growth and our dependence on commercial fishing, this carries grave consequences. As it is, the biological productivity of the oceans has fallen by 6 percent since the 1980s.[20]

Each year sees new temperature records, while global temperatures continue to set the longest warming trend in instrumental history: the ten hottest years have all happened in the last twelve years.[21] Since the spectacular collapse of the Larsen B Ice Shelf in 2002 - with a surface size comparable to Delaware - several ice shelves have either broken or become unstable in both the Arctic and Antarctica. Among them the Ayles Ice Shelf, 40 square miles in size, one of six remaining in Canada's Arctic, collapsed entirely in August of 2005. In the last year alone, the Arctic sea has lost an area the size of Turkey.[22] Exposed to a temperature rise twice that of the rest of the world, the Arctic's summer sea ice is predicted to be gone entirely by 2040.[23] Meanwhile, the majority of the world's glaciers are set to disappear by 2100.[24]

Melting ice also impacts weather patterns. Freshwater flowing into the oceans from the Greenland shelves, for instance, does not mix with salt water. Salt has more mass than freshwater, making it sink, while freshwater "floats." The result is that currents, particularly in the North Atlantic, get affected. The Gulf Stream, which regulates climate temperatures by distributing cold water from the pole southward, and warm water from the equator northward, is slowing down. Its action prevents the oceans around the equator from overheating and moderates the northern latitude countries from the cold influence of the Arctic. It also regulates the marine ecosystem. Winds build in intensity with higher ocean temperatures, thereby increasing hurricane instances in the South. In the northern countries, it is likely to make winters more brutal, as well as disrupt seasonal and agricultural cycles in place since the last ice age, 10,000 years ago. Were the Gulf Stream to stop entirely, Northern Europe could be thrown into an ice age. The last time this happened, it took place inside of 15 years.

The Melting Ice

After my trip to the Arctic, I traveled to Antarctica the following year to realize an environmental advocacy image, and was profoundly moved by that environment. Antarctica evokes a true sense of adventure. Upon leaving the coastal waters of South America, one soon starts to feel very small. The crossing of the Drake Passage alone - "the Drake Shake"- conjures mythical notions of a Lost World. An old sailor's maxim has it that below 40 degrees latitude, there is no law; below 50 degrees, there is no God. Antarctica begins at 65 degrees latitude. Our ship was quickly reduced to the equivalent of a cork in a fountain. So remote and inhospitable to humans, Antarctica has never seen indigenous human population; no eyes were even set on it until 1821. With a landmass twice as large as Australia, it doubles its size in the winter. It is the most magnificent landscape I have encountered, bursting with animal life and otherworldly dimensions. Yet the irony of the word "untouched," often used to describe the white continent, was not lost on me. In reality, if Antarctica sees very little human contact, it is everything but untouched. Human activities generated thousands of miles away perpetuate – remotely - what could be described as environmental genocide. Warming up by a rate five times the global average, the Antarctic Peninsula has seen a temperature rise on the order of 4.5 degrees Fahrenheit since 1945, increasing its melt season by two to three weeks in the last twenty years.[25] Since 1980, its ice shelves have disappeared by an average of 185 square miles every year, releasing 250 cubic kilometers of new ice and water into the oceans, or around 125 billion tons of water. The Larsen B Ice Shelf, over seven hundred feet thick and probably 12,000 years old, lost two thousand square miles in 2002, over the course of thirty-five days, making for a total of 60 percent ice loss since 1995.[26] These statistics are relevant for three reasons: first, as an indicator of melting trends; second, to give a reference of the enormous proportions we are dealing with; but most importantly, as a forecast of what is likely to come: ice shelves are the protection barriers for interior glaciers. With no obstacle before them, those are susceptible to accelerate their forward motion and water discharge. As it is, Peninsula glaciers have dramatically increased their speed since 2002, pouring into the ocean at rates two to six times faster than previously observed. Where most glaciers move anywhere from a few centimeters to a few hundred meters a year, Peninsula glaciers have accelerated by as much as 1.5 kilometers per year.[27]

That shift in melt patterns sets up what is likely one of the gravest disruptions to international economies, and catalysts for world chaos. We know that global sea levels have risen by ten to twenty centimeters over the course of the last century. Old science has predicted a potential rise to three feet by the end of the century, which in itself is alarming enough since fifty to one hundred feet of beach are lost, on average, to each foot of sea rise.[28] But updated models point to an exponential effect: as ocean

levels rise from melting glaciers, it destabilizes packed ice, making it more susceptible to collapse into the ocean - further accelerating the rise. This is true in Antarctica as it is with Greenland. New models point to an end of century global sea rise on the order of twenty feet!ise[29] The damage this would incur to global communities is hard to even quantify, considering that 80 percent of the world's population lives in coastal areas, and many of the world's port cities were built around the low elevation of their river mouths. To factor the loss, social chaos and economic impact that resulted from the displacement of 100,000 people - within one country - with Katrina, is to begin to understand the order of international magnitude of such an environmental catastrophe.

> ### "Climate change is not an environmental problem. It is a civilizational problem."
>
> — *Ross Gelbspan, author of The Heat is on: The Climate Crisis, the Cover-Up, the Prescription*

If this were a war, these signs would figure as setting the stage for the greatest retaliatory frontal attack on humanity. Because while "global heating" speaks more convincingly of the climate changes taking place, "climate chaos" is a far more accurate description of the consequences of those changes. The poles act like cooling agents for the rest of the planet—not unlike air conditioners to the globe. Their relationship to humanity, once again, is one of cause and effect. Try and visualize, if you will, our connection to - and economic reliance on - the natural order as a chain: global warming figures as the weakening of not one, but a multitude of those links. Sir Nicholas Stern, the head of Britain's Government Economic Services and former World Bank chief economist, likens the global disruption to social and economic activities in this century to the World Wars and Great Depression of the 20th century, threatening such basic needs as water, health, food production and peace. In the shorter term, the countries first in line to suffer are, not unpredictably, the most disenfranchised; countries whose industrial activities have also contributed the least to this condition. The average American generates fifteen tons of greenhouse gases a year from transportation, home energy and consumer products and services. In France, that average is about five tons/year.[30] In most of Africa the numbers drop precipitously to below half a ton a year.[31] Yet the Horn of Africa, for instance, with its already limited resources and unstable social environment, is likely to see an increasingly vast population exodus as the land becomes even more inhospitable. With growing tensions with much of the Muslim world, the West will become

the target of further hostility, vulnerable to residual strategic alignments if provisions are not enacted to relieve their burden.

This is true for many hotspots around the world. The Himalayan glaciers, for instance, which are receding alarmingly fast, provide half the freshwater for 40 percent of the world. Their increased summer flows, as with the Andes glaciers, already impact flooding, mud slides and lake overflows, threatening the communities below them.[32] If the glaciers disappear altogether as predicted, the impact on agriculture, disease and population relocation would be devastating. We know that with human toll comes social unrest. It is not unconceivable that the territorial birthright that we have historically taken for granted would, in the future, be challenged by nations claiming their right of survival on other people's land. The preexisting international tensions and escalation of nuclear programs in this context make an explosive recipe for human disaster. It is perhaps important to be reminded, in this context, that during the Cuban Missile Crisis, three rational and intelligent leaders came within alarming proximity of blowing the world up with nuclear weapons. That level of threat is what we face today from our slow response to global warming, potentially setting the stage for a real "clash of civilizations."

"When people do not pay for the consequences of their actions, we have market failure. This is the greatest and widest-ranging market failure the world has ever seen."[33]

— *Sir Nicholas Stern , former World Bank Chief Economist on Global Warming*

Is it reasonable to expect the Industrial World to shoulder the burden of impoverished nations as they struggle with mounting climate-related challenges? Probably no more than it has been for it to prosper, effectively – whether knowingly or not – at their expense. Either way, the time for debate is over. According to Stern it is a time for "urgent global response," short of which there will be no winners. Today's geopolitical arena is unquestionably growing in complexity; to find ways to address conflicts has never been more difficult. Our actions, whether economic or military, have ever-increasingly polarized, unifying divergent factions in their shared antagonistic views of the West. In this volatile environment, it would seem of conventional wisdom to carefully invest in a) diplomacy b) independence from that which makes us all vulnerable and c) leadership - through example. To understand the symbiotic relationship between the long-term implications of our consumption habits and our ability to

survive on the Earth, is to begin a reflection on the nature of sustainability. That awareness is a responsibility that must be shared by governance and individuals alike. Demanding real change falls on the constituency; implementing it cannot effectively be done without government.

If industrialization has led to entitlement, the path to a sustainable future requires vision, courage and sacrifice. And the same resolve which has seen the country mobilized in times of war. When FDR entered the world conflict in 1941, the country was turned around within weeks to serve the war effort. In 1961, with Sputnik breathing down our neck, President Kennedy committed to putting a man on the moon in spite of inconclusive technology. This, he said, was essential "not because it is easy, but because it is hard." That goal was accomplished within two years. It broke scientific grounds and established decades of US dominance in that field. Today, we have the technology. We have achievable objectives. What we need is the vision and political will to reclaim our energy independence by developing a secure, sustainable economy that can lead the world into a new consciousness.

"Sustainable development
is the peace policy of the future."

— *Dr. Klaus Topfer, UNEP Executive Director (2004)*

The *New Oxford Dictionary* selected "carbon neutral" as the 2006 "Word of the Year." In reality, carbon neutrality will figure prominently in the future. The objective is to reduce our carbon footprint by working towards a market transformation centered around renewable energy. Today, atmospheric greenhouse gases measure around 430 parts per million, rising by 2ppm each year (to pre-industrial levels of 280ppm). While we can no longer avoid changes that will affect us in the coming decades, by current projections, if levels were stabilized around 500ppm the worst could be avoided.[34] Factoring demographic growth, this means that global emissions should figure at 80 percent below current levels by 2050. This may seem like an insurmountable challenge. It isn't. What it requires is an international effort to carefully implement three mutually dependent principles: education, economics and political engagement. Educating the public is mandatory to steepen the awareness curve and adjust our behavioral conditioning towards energy (sources and consumption). This in turn will facilitate the inclusion of the issue on the ballot for public representation - in democratic countries, at least. With economics, there is no argument other than one that makes fiscal sense, convincing business leaders that a sustainable economy means profits,

while serving the community. This can only happen with engagement from elected officials who must be held accountable to stimulate economic growth by subsidizing businesses whose models speed up the process towards a sustainable economy. We need to examine the nature of our current subsidy and tax structures to provide funding for those budgets. Is it logical, for instance, that a luxury SUV should benefit from the same "utilitarian vehicle" tax break as a forklift? Or that fossil fuels get subsidized at almost twice the rate of renewable industries? Programs such as prorated tax scales based on energy use and carbon cap penalties should fund these budgets while initiating the impetus to the new energy consciousness. Stern estimates that 1 percent of global GNP–in perpetuity–is the price we must pay to mitigate climate change, provided we act immediately. Conversely, waiting will damage economic growth, stifling it with the ever-mounting costs associated with climate-related issues; as much as 5 percent of global GNP, and steadily growing to exceed 20 percent, with progressively marginalized results.[35] By then, avoiding what could amount to virtual annihilation would be like trying to swim upstream of accelerating rapids.

A Global Effort

In a culture conditioned by life on credit, it isn't difficult to see why embracing an investment designed to prevent dramatic economic and social downturn for the second half of the century would be met with resistance. With our dependence on and vulnerability to the high costs of hydrocarbon energy, our astronomical trade deficit and foreign debt, our troubled social security, increased gap between classes, failed medical system and aggressive foreign policy, it isn't unreasonable to shriek at the thought of committing to such a high cost in prevention. But to see this dilemma as a "bad or worse" proposition would be to miss the silver lining. Such investments represent the catalyst for significant business opportunities. To create a more efficient, sustainable society will eventually save money, while improving lives. Maintenance costs alone – energy is the second highest monthly bill for low-income families[36] – can be substantially reduced by the adoption of wind, solar or other alternative energy programs, while reducing carbon emissions: one third of greenhouse gases come from the construction and maintenance of buildings. Emerging technologies such as Carbon Capture & Storage will produce growing financial prospects, as well as create employment and a chance to mitigate our trade deficit through their export.

In principle, technology should have reduced our consumption habits by optimizing output and increasing our quality of life. Instead we work more, consume more, owe more. We are increasingly isolated from our community, spend less time with our families and are growing insecure about what is to come. To quote Arthur C. Clarke, "the future isn't what it used to be!" Our voracious appetite and extraordinary ability to absorb an ever-expanding consumer market require a reevaluation of the faith we have placed on modern day economics – and our approach

to population demographics. Today's model relies on a perpetually expanding market that is unsustainable. Outside of space colonization (which some scientists believe is fast becoming our only option), we cannot grow in this fashion, on this planet, forever. The World Wildlife Fund predicts that at the rate we are going, in fifty years time resources will be consumed at twice the rate at which the world can renew them.[37] Today, incredibly, it takes ten calories of hydrocarbon energy to produce each calorie that is eaten![38]

In 1931, shortly before he died, Edison said in conversation with Henry Ford and tire magnate Harvey Firestone: "I'd put my money on the sun and solar energy. What a source of power! I hope we don't have to wait until oil and coal run out before we tackle that."[39] The climate crisis is a platform for us to rethink everything from top to bottom. What is exciting is that there is a lot of common sense in the new economy. How we design houses; develop urban communities; increase energy efficiency; reduce waste; optimize consumption; and, perhaps, even simplify our lives. To demand clean power from heat and transportation companies is a way to exercise our right of representation. To do it now is to invest in the lives of our children. There are approximately 500 million cars in the world today. That number will likely grow to two billion by 2050.[40] With an average lifespan of twenty years, to insist on low emission and high gas mileage vehicles is virtually becoming a moral issue. It puts pressure on car manufacturers to release the technology that doubles gas mileage before the present technology reaches its

sales apex. Energy-saving bulbs are one hundred times more efficient than incandescent – they save money! Switching three bulbs in every household in the US would amount to taking eight million cars off the road.[41] According to General Electric, there are an estimated fifty billion light fixtures in the world; think of what it would mean if the world followed suit.

Spending on energy research and development has diminished in the US by 50 percent since 1979, while military research has increased by 260 percent in the same period.[42] Recent engagements in modern warfare have demonstrated that we are no more militarily efficient for it, and it has done little to our world standing. Conversely, green schools are proven to raise test scores by up to 25 percent, while cutting utility costs by almost 40 percent.[43] Perhaps it is time we start committing to alternatives known to improve lives, with the off chance that it might also improve our leadership role in the world.

At the core of this political and environmental dilemma lies a philosophical examination: Will humanity band together to fulfill its potential for greatness, living up to its promise of intellectual vision and creativity? Or are we overextending our welcome, reduced by our lowest common denominator to an acrimonious breakup with our host planet; fought off like a virus by Earth's natural antibodies? A funny thing happened to me while working on this book: when I learned that I was headed to Antarctica to advocate awareness of climate change, I

began to receive encouragements and friendly taps on the back. In a sad twist of irony, I experienced what I suspect soldiers sometime do when headed to the front, getting offers of support, free drinks, etc. In England, Scandinavia, Canada and the US crowds have marched to express their concern about climate change; thousands of protesters, demanding cleaner environmental policies, have been documented by the Chinese government; the world over, people are waking up to the environmental crisis; and India and China are participating in the G8+5 meetings whose focus is the environment.

Perhaps an idealist, I believe in our capacity to learn. But change is hard. In the story of the melting ice figures humanity's greatest lesson: how to reposition ourselves and work in harmony with our environment. Comfortable in conflict, today we are forced to accept that survival means we cannot fight nature but have to work with nature. Heeding that call will be our finest hour – ignoring it, our darkest. But no great achievement comes without sacrifice. And like the journey of a thousand miles, this one begins with one step: yours.

Welcome to the Age of the Environment.

Sebastian Copeland
Deception Island, Antarctica
February 2006

1. Mooney, Chris, "Some Like It Hot," The Foundation for National Progress, www.motherjones.com, May/June 2005
2. Annan, Kofi, "As Climate Changes, Can We?" Washington Post, November 8, 2006
3. Zabarenko, Deborah, "ExxonMobil Cultivates Global Warming Doubt: Report," Washington Post, January 3, 2007
4. "Ancient Ice Shelf Breaks Free From Canadian Arctic," Associated Press, January 4, 2007
5. Houghton, Sir John, "Global warming is now a weapon of mass destruction," The Guardian, July 28, 2003
6. Lovelock, James, The Revenge of Gaia: Earth's Climate Crisis and the Fate of Humanity, New York: Basic Books, 2006
7. National Resource Defense Council, www.nrdc.org
8. Roach, John, "Polar Bears Proposed for U.S. Endangered Species List," National Geographic News, December 27, 2006
9. "A Crude Awakening," Stanford Magazine, www.stanfordalumni.org, December 2006
10. U.S. Department of Energy, www.energy.gov
11. Socolow, Robert, "Slices and Wedges: Useful Words to Describe Daunting Challenges Managing Global Carbon," presented at BP Sunbury, United Kingdom, March 12, 2004
12. Koonin, Steve, "A Physicist's View of the World's Energy Situation," presented at the Colloquium on World Energy Series, Fermilab, Batavia, Ill., April 13 2005
13. Radio 4, "Today Programme" interview, September 27, 2006
14. Emanuel, Kerry, "Increasing Destructiveness of Tropical Cyclones Over the past 30 Years," Nature, July 31, 2005
15. An Inconvenient Truth, Paramount Pictures 2006

16. Collins, James P, "Where Have All the Frogs Gone?" Natural History Magazine, June 2004
17. McCarthy, Michael, "Environment in crisis: 'We are past the point of no return,'" Environment Editor, January 16, 2006
18. Stern, Sir Nicholas, "Review Report on the Economics of Climate Change," presented to the Prime Minister and the Chancellor of the Exchequer on the Economics of Climate Change, October 30, 2006
19. www.co2capture.org.uk
20. Hecht, Jeff, "Alarm Over Acidifying Oceans," New Scientist Print ed. 25, September 2003
21. Lovell, Jeremy, "2007 Set to be World's Warmest Year: UK Met Office," The Mirror, January 3, 2007
22. McCarthy, Michael, "Vast Ice Shelf Collapses in the Arctic," The Independent, December 30, 2006
23. Eiperin, Juliet, "U.S. Wants Polar Bears Listed as Threatened," Washington Post, December 27, 2006
24. www.climatehotmap.org
25. Watson, R., M. Zinyowera, and R. Moss, eds., The Regional Impacts of Climate Change: An Assessment of Vulnerability. Cambridge: Cambridge University Press, 1998
26. www.coolantarctica.com
27. Murray, Danielle, "Ice Melting Everywhere," Earth Policy Institute, www.earth-policy.org, February 24, 2005
28. www.climatehotmap.org
29. Henderson, Mark, "London 'under water by 2100' as Antarctica crumbles into the sea," The Times (London), March 24, 2006

30. www.co2capture.org.uk
31. National Energy Foundation, The New Scientist, 2002
32. www.coolantarctica.com
33. Stern, Sir Nicholas, "Review Report on the Economics of Climate Change," presented to the Prime Minister and the Chancellor of the Exchequer on the Economics of Climate Change, October 30, 2006
34. Socolow, Robert, "Slices and Wedges: Useful Words to Describe Daunting Challenges Managing Global Carbon," presented at BP Sunbury, United Kingdom, March 12, 2004
35. Stern, Sir Nicholas, "Review Report on the Economics of Climate Change," presented to the Prime Minister and the Chancellor of the Exchequer on the Economics of Climate Change, October 30, 2006
36. Global Green USA. www.globalgreen.org
37. World Wildlife Fund, www.worldwildlife.org
38. Ruppert, Michael, "Crossing the Rubicon: The End of the American Empire and the Age of Oil," New Society Publishers, 2004
39. Revkin, Andrew C., "Budgets Falling in Race to Fight Global Warming," The New York Times, October 30, 2006
40. Socolow, Robert, "Slices and Wedges: Useful Words to Describe Daunting Challenges Managing Global Carbon," presented at BP Sunbury, United Kingdom, March 12, 2004
41. Valley, Paul, "First step: Changing Light Bulbs," The Independent, October 30, 2006
42. Revkin, Andrew C., "Budgets Falling in Race to Fight Global Warming," The New York Times, October 30, 2006
43. Global Green USA, www.globalgreen.org

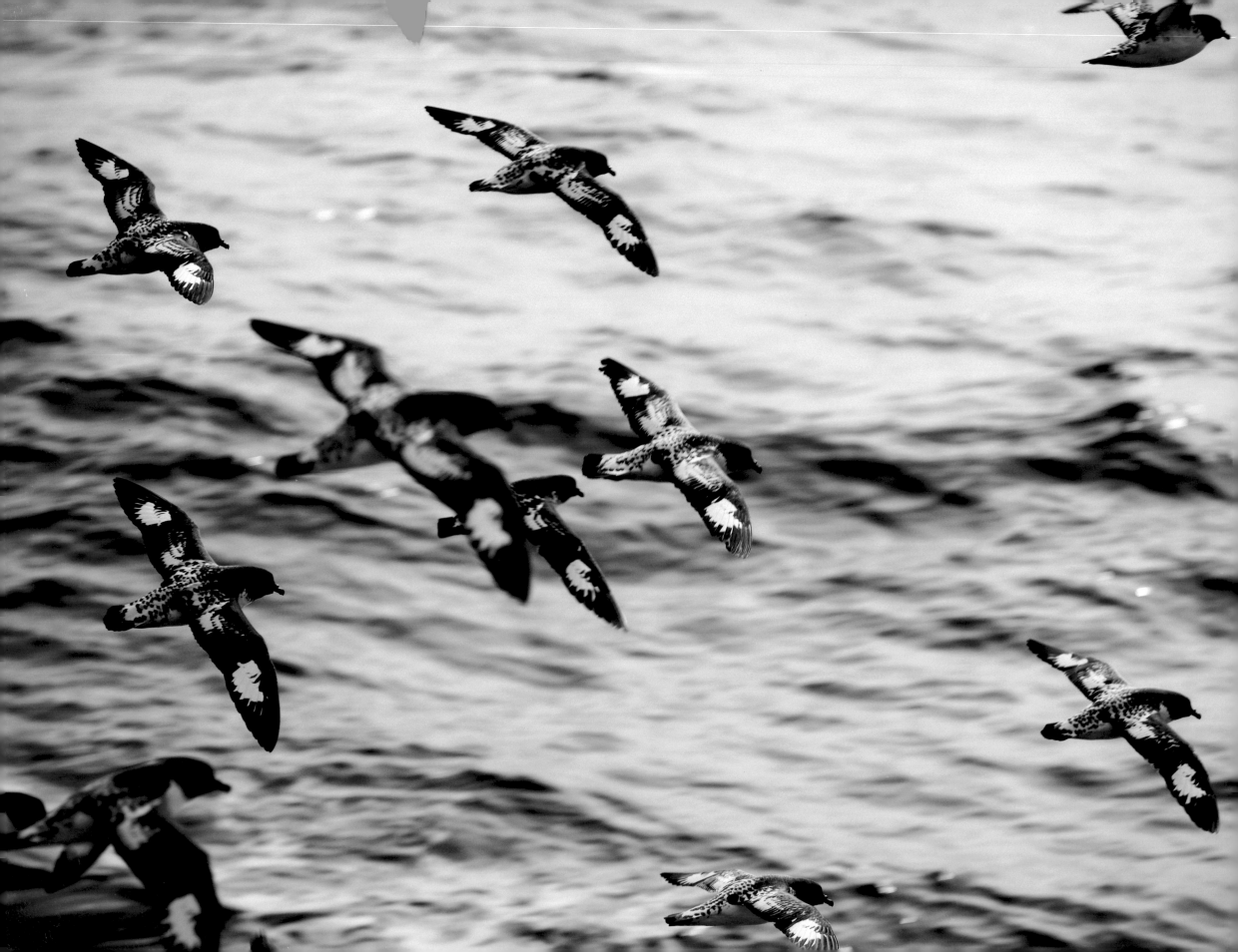

WELCOME TO
ANTARCTICA

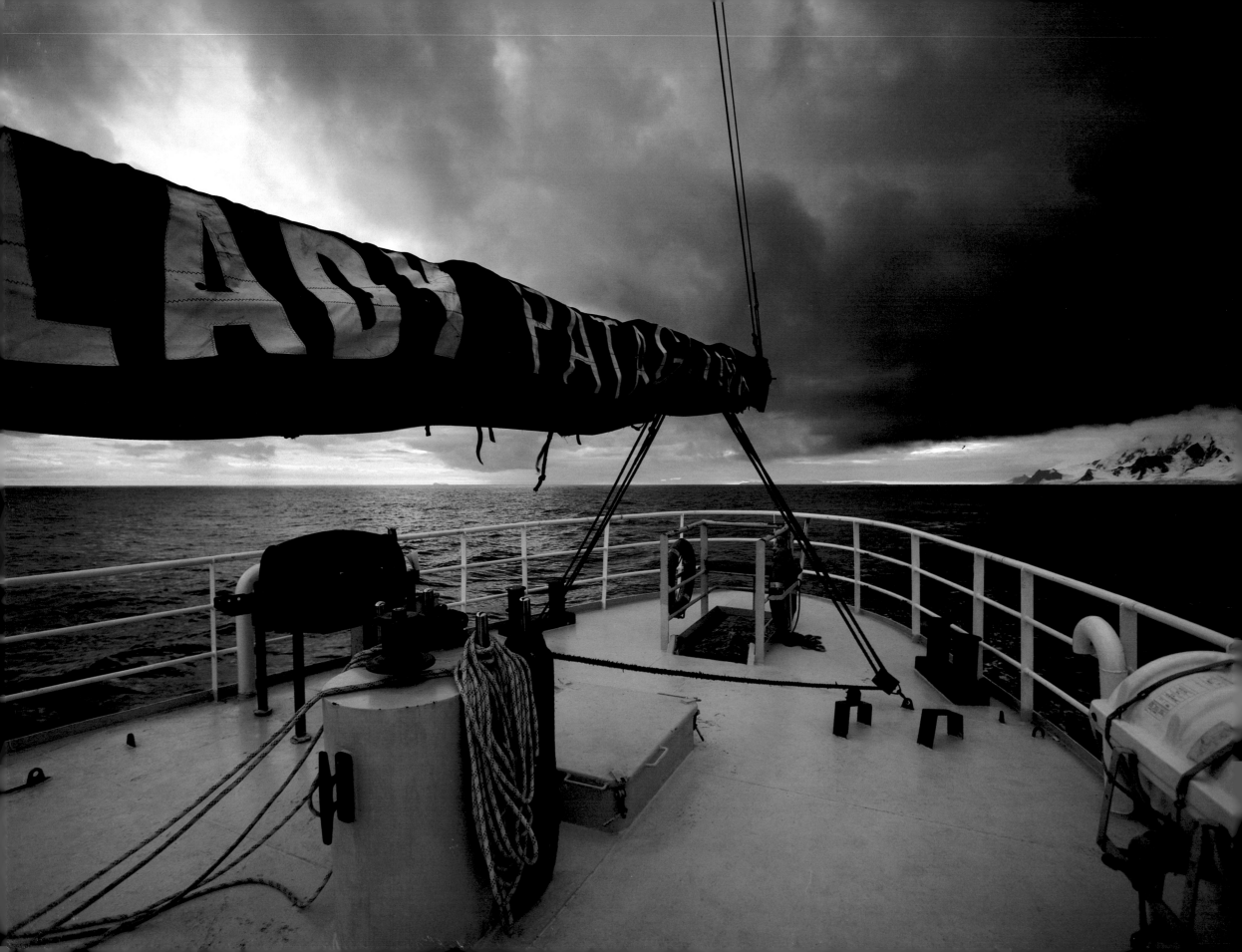

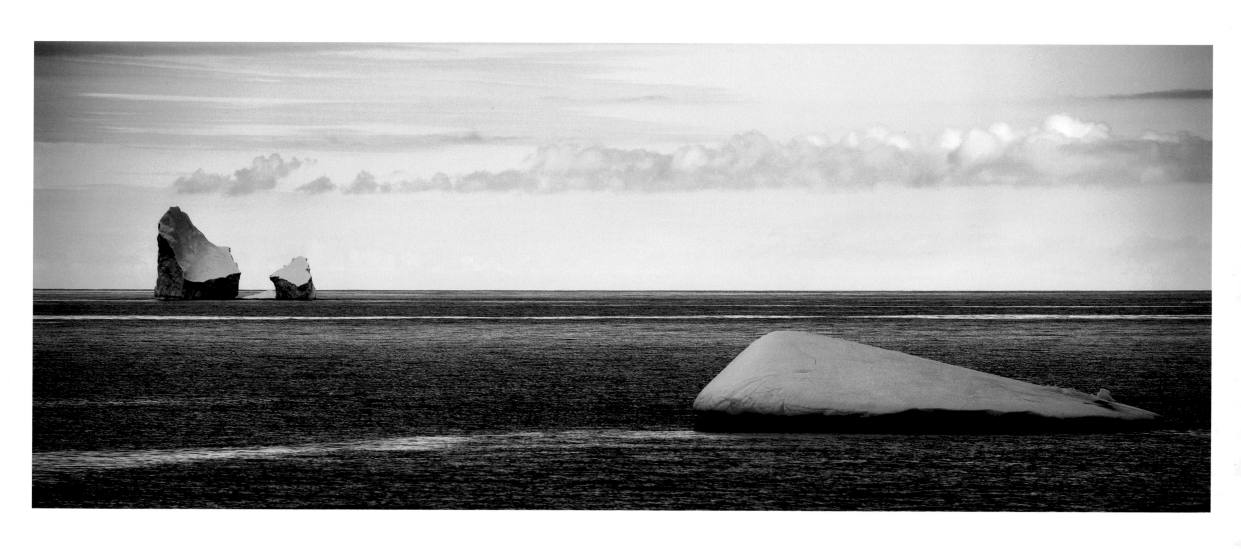

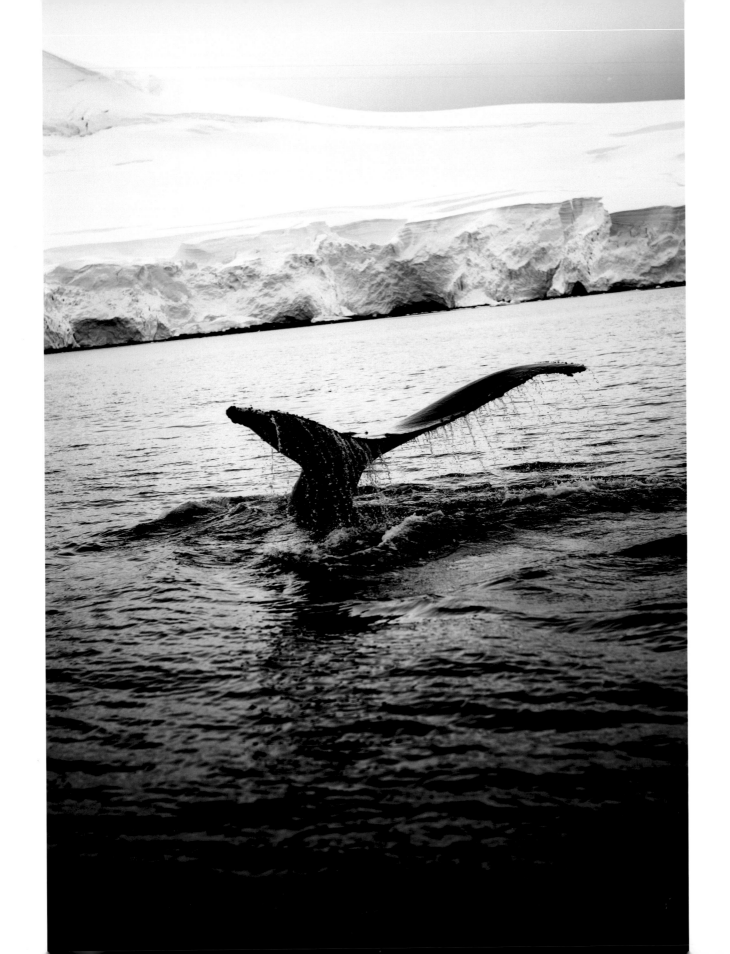

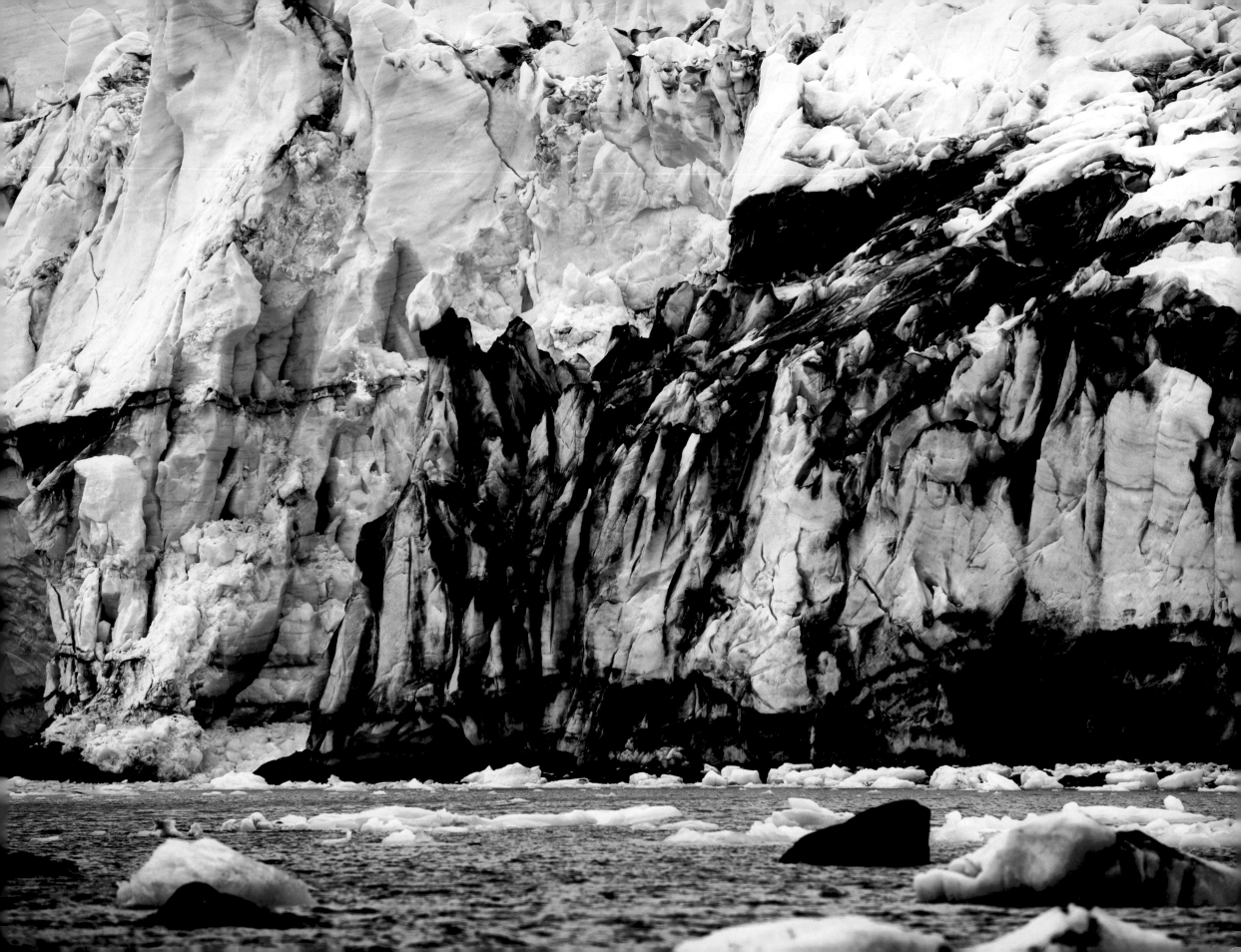

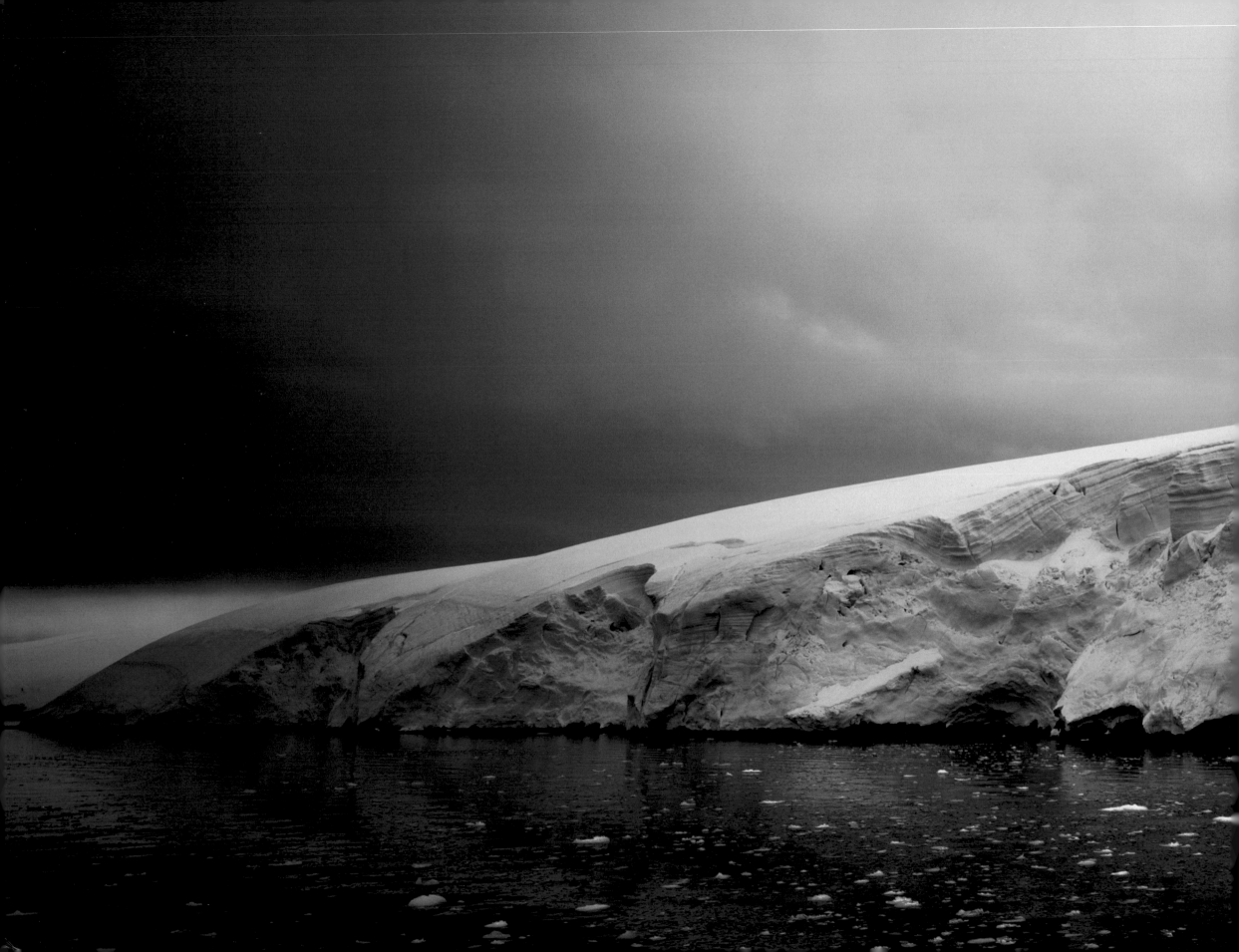

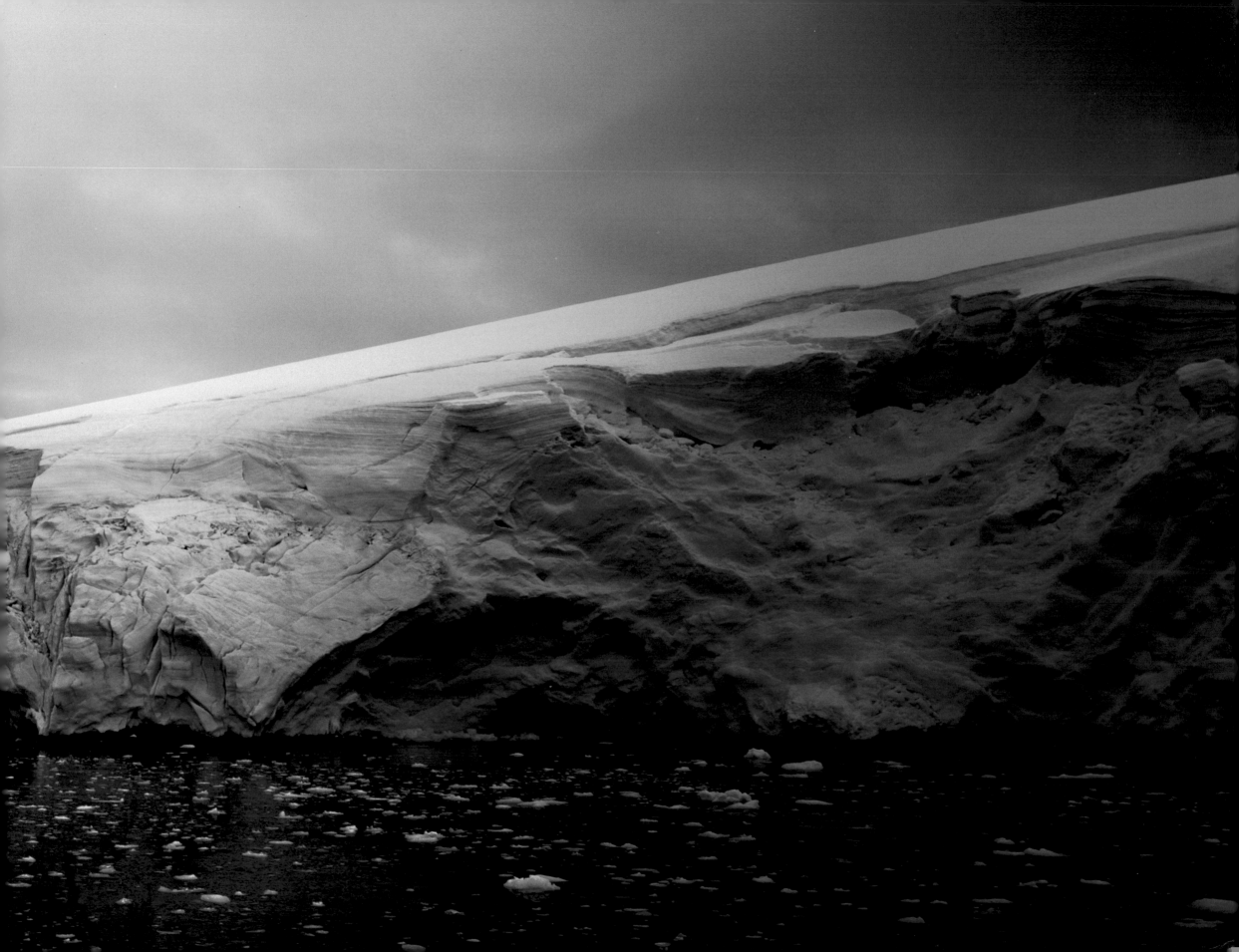

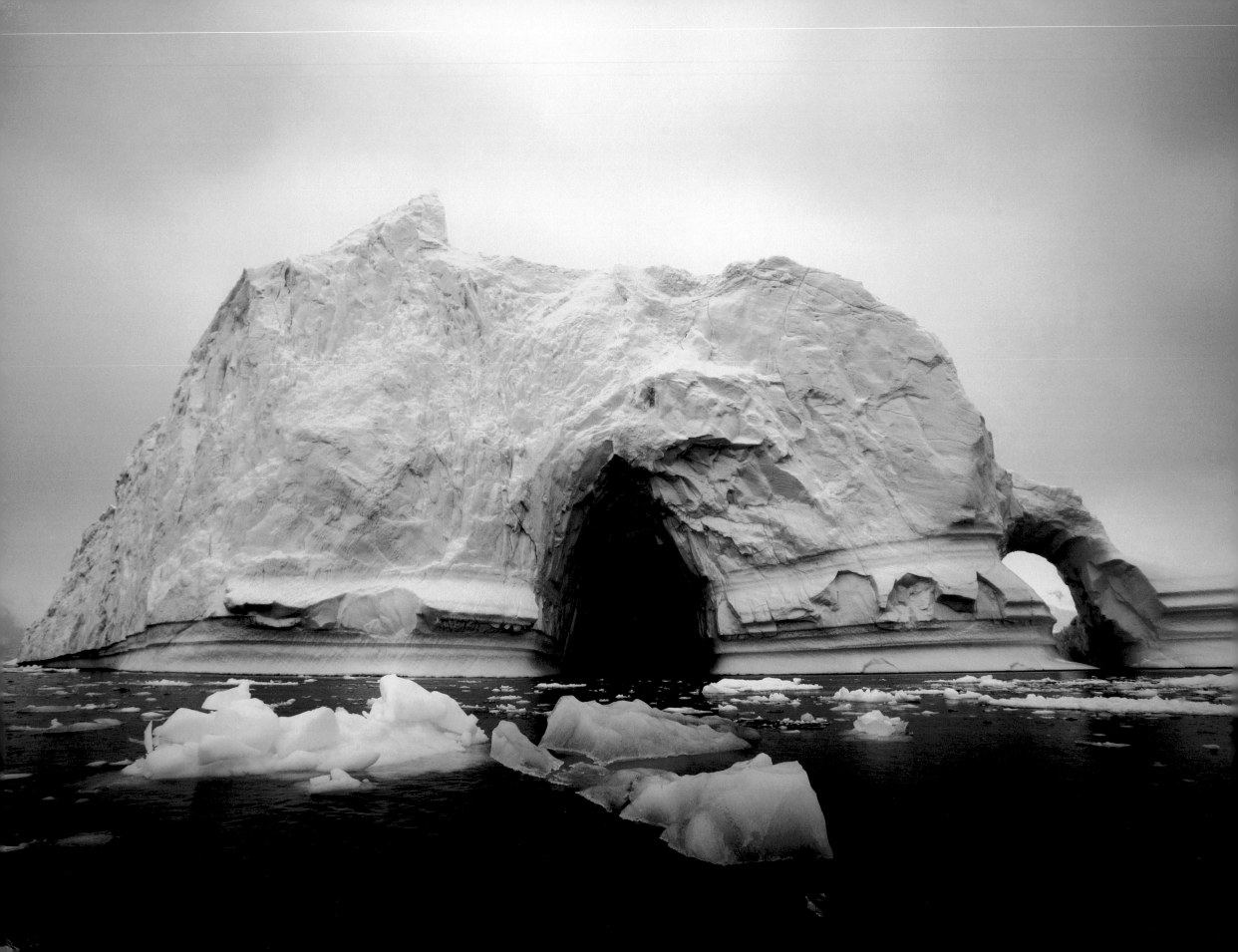

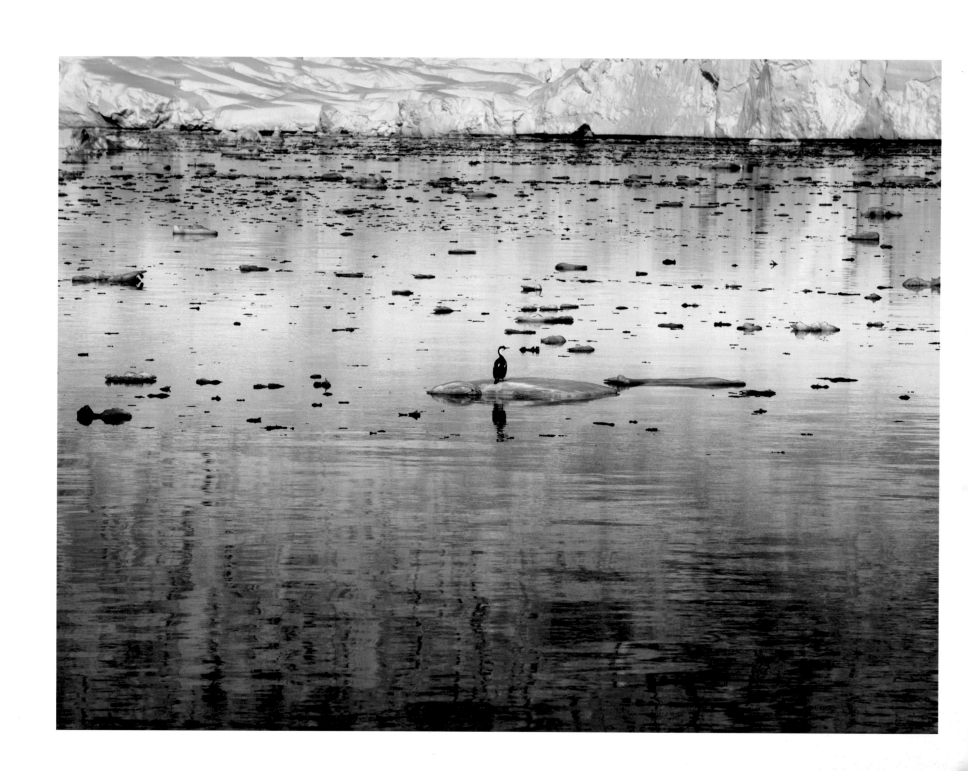

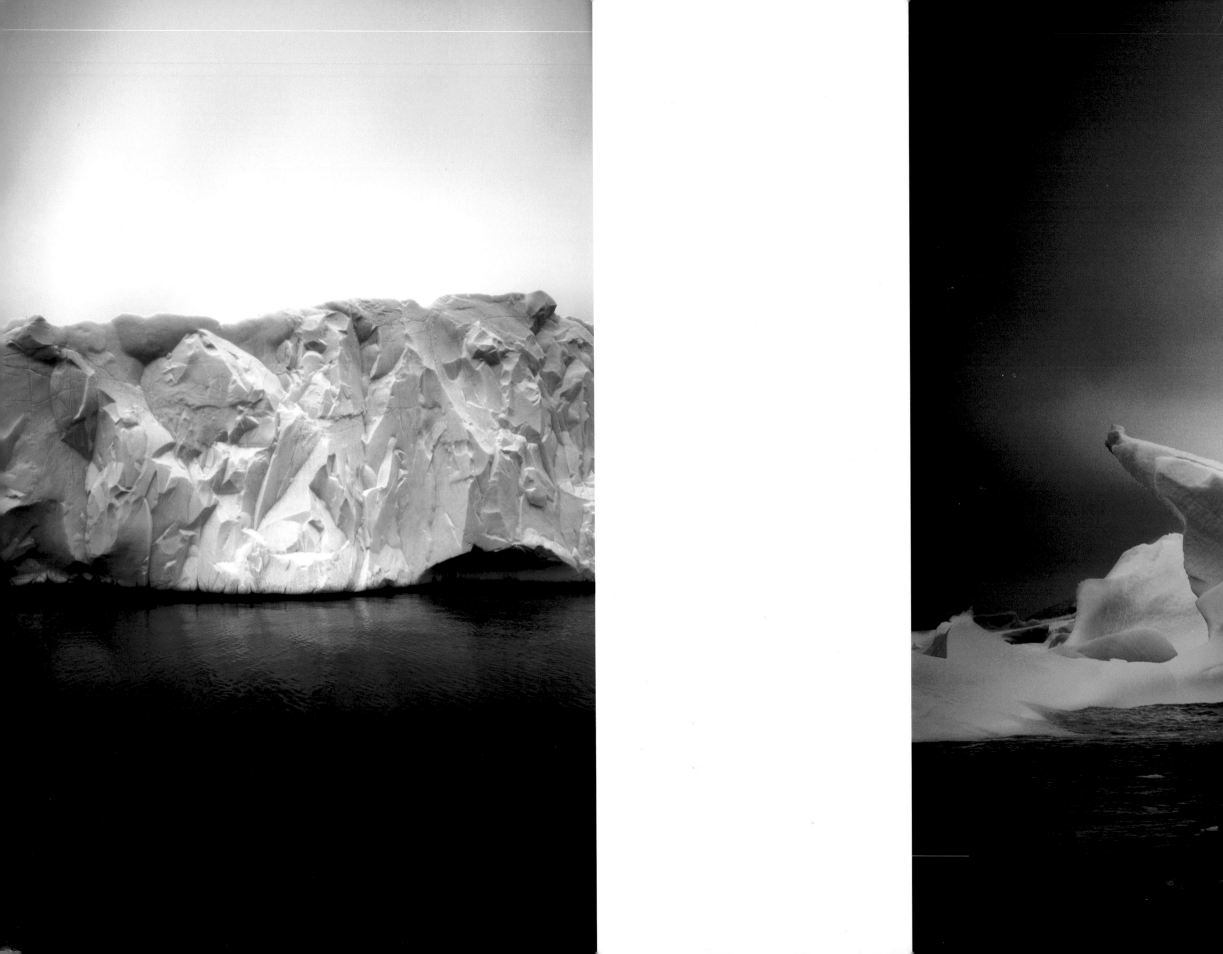

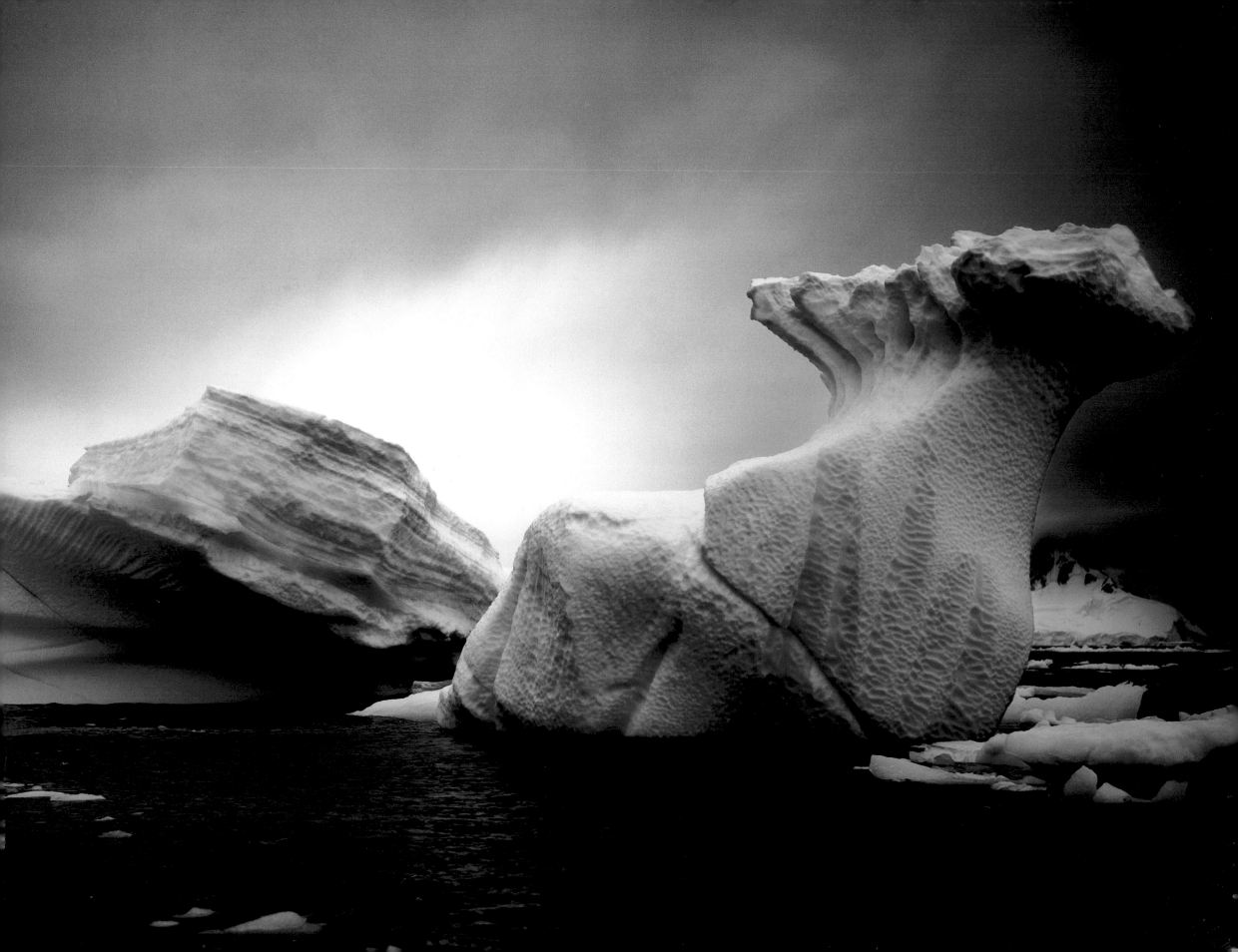

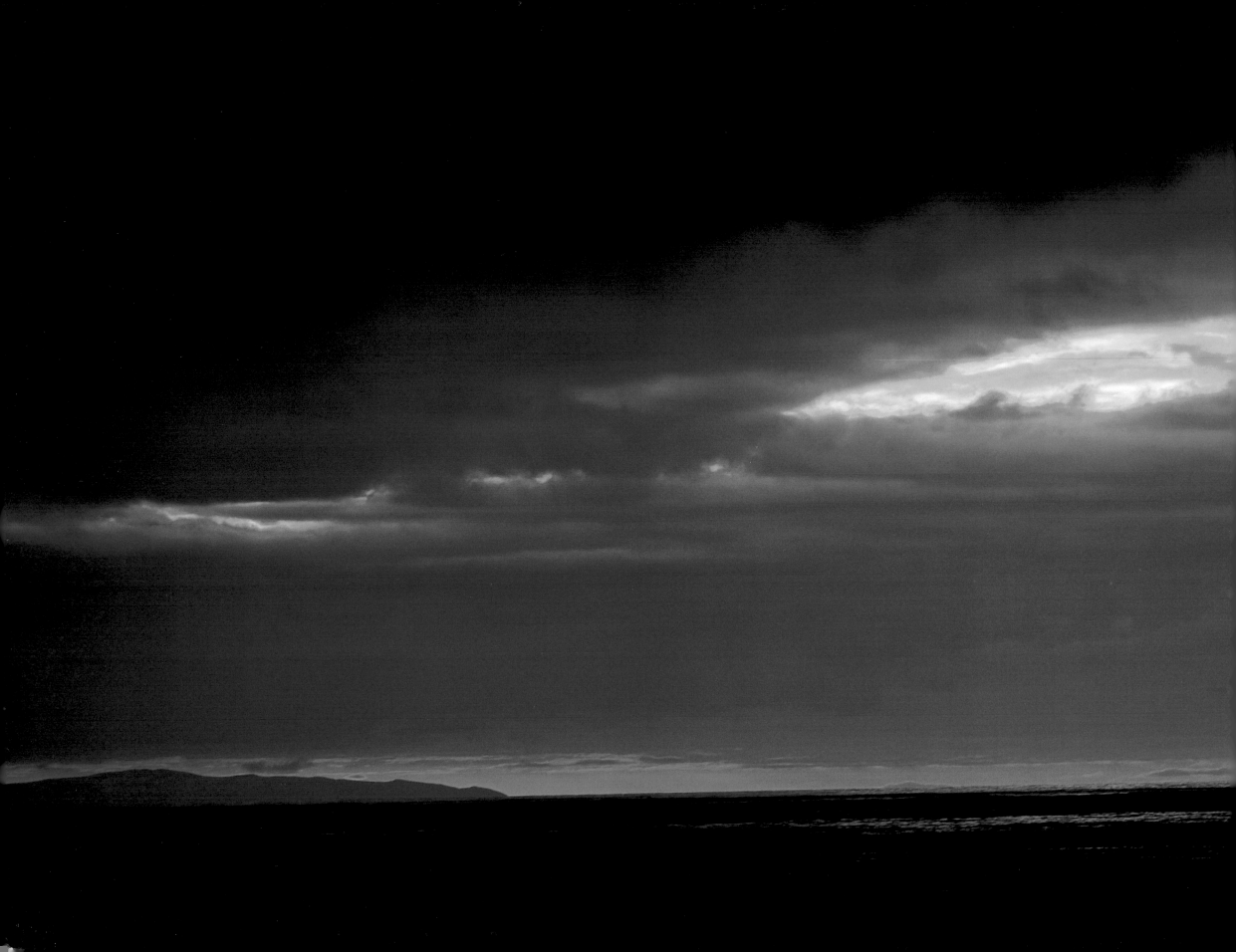

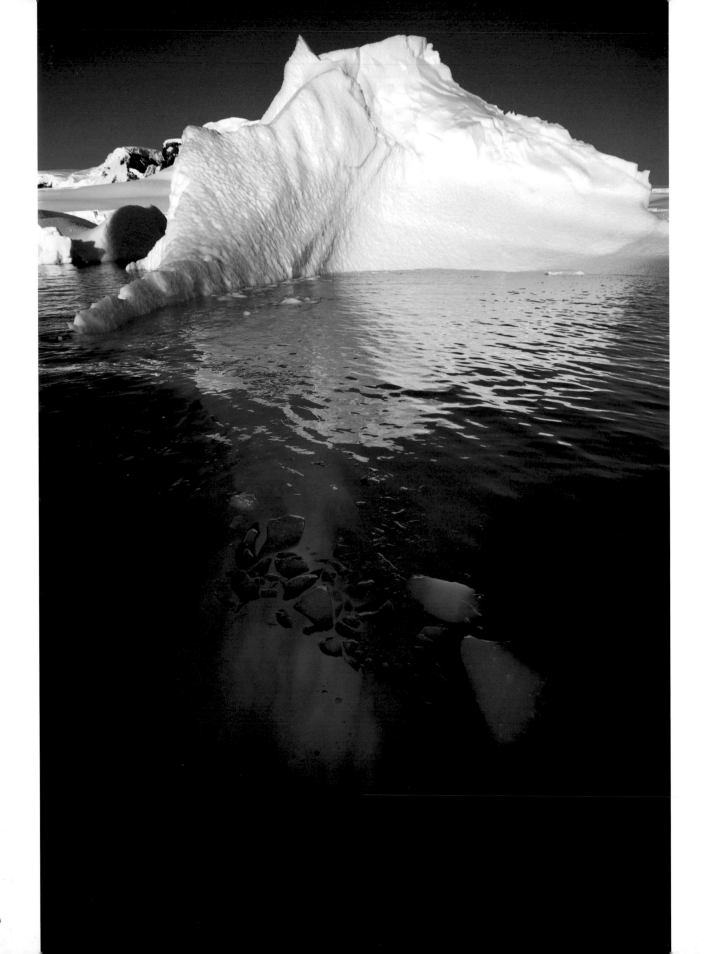

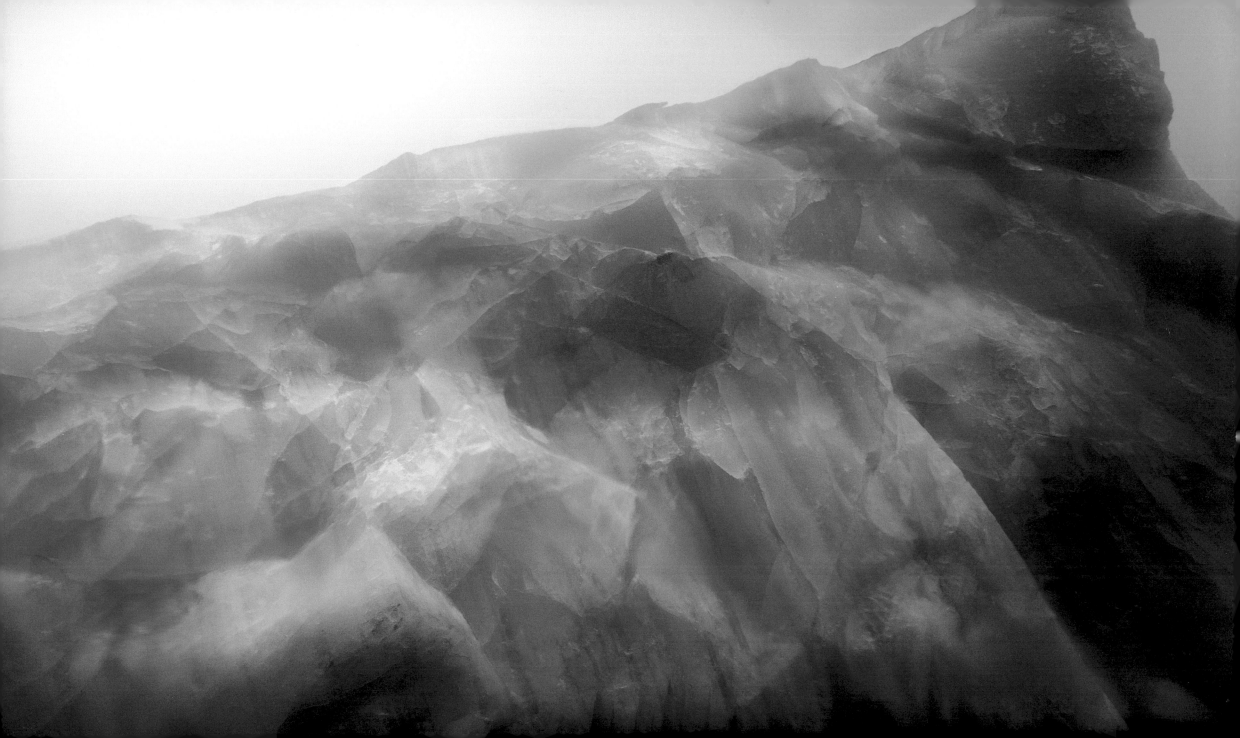

WILL STEGER
Polar Adventurer

In 1990 I led an international team of six people on the longest-ever traverse of Antarctica. Traveling on skis, along with three dog teams, we spent 221 days on the 3,731-mile journey.

My greatest memory was the crossing of the Larsen Ice Shelf on the Antarctic Peninsula. Here we were introduced to the paradox of Antarctica, to its pristine beauty and to its brutal storms that humbled us with their awesome power. We traveled for a month across the shelf's vast surface. At times we were lulled by the silence and calm of the peninsula's panoramic, glaciated mountains; then a sudden storm would engulf us, threatening our lives.

This platform from which we first experienced Antarctica is now gone forever. Victims of global warming, two of the three sections of the Larsen Ice Shelf – an area larger than the state of Rhode Island – have recently collapsed into the ocean. The loss of more than half the Larsen in little more than a decade heralds the seriousness of humankind's complacency in the face of the environmental challenges that lie before us. What is now happening in our planet's remote polar regions will soon affect us all.

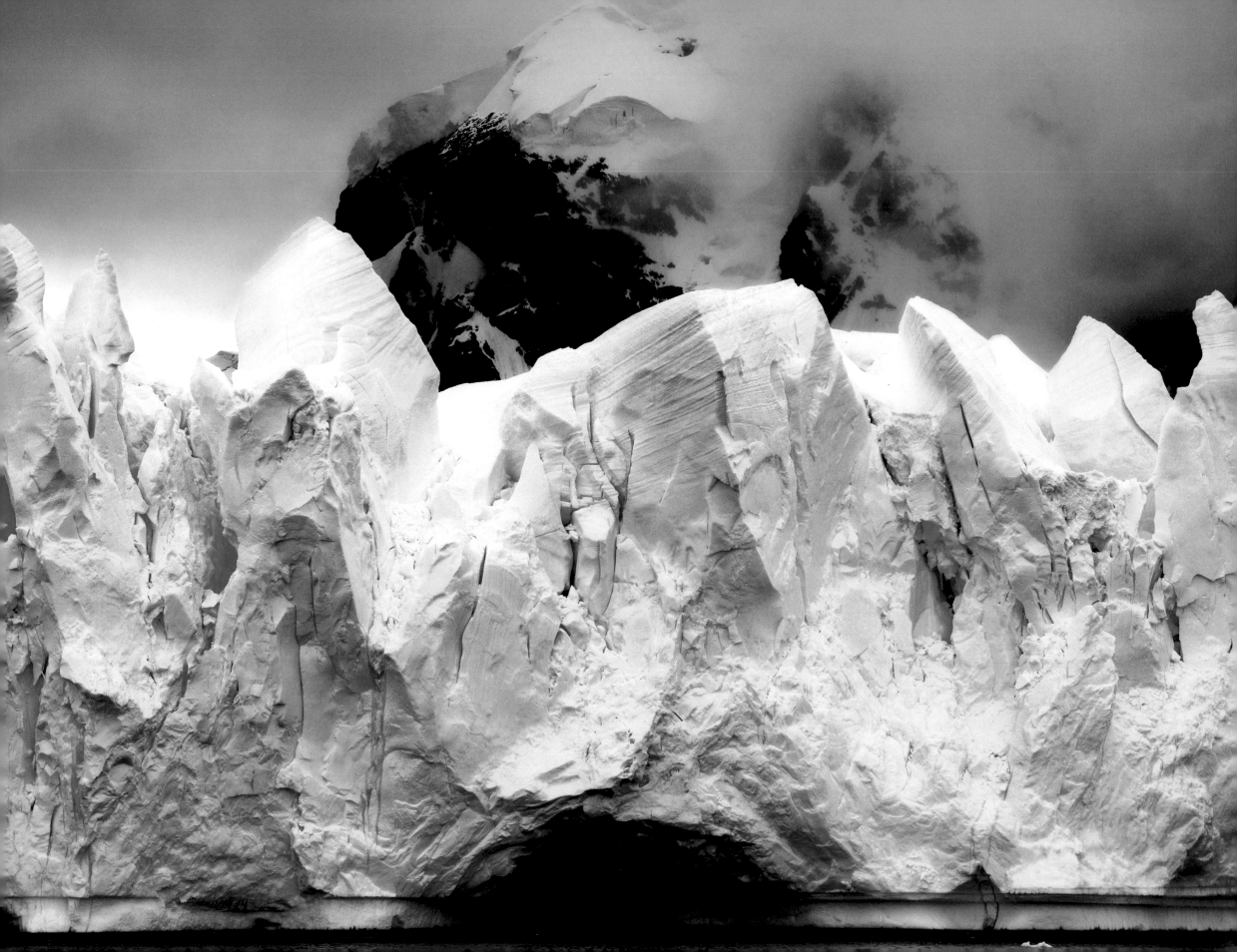

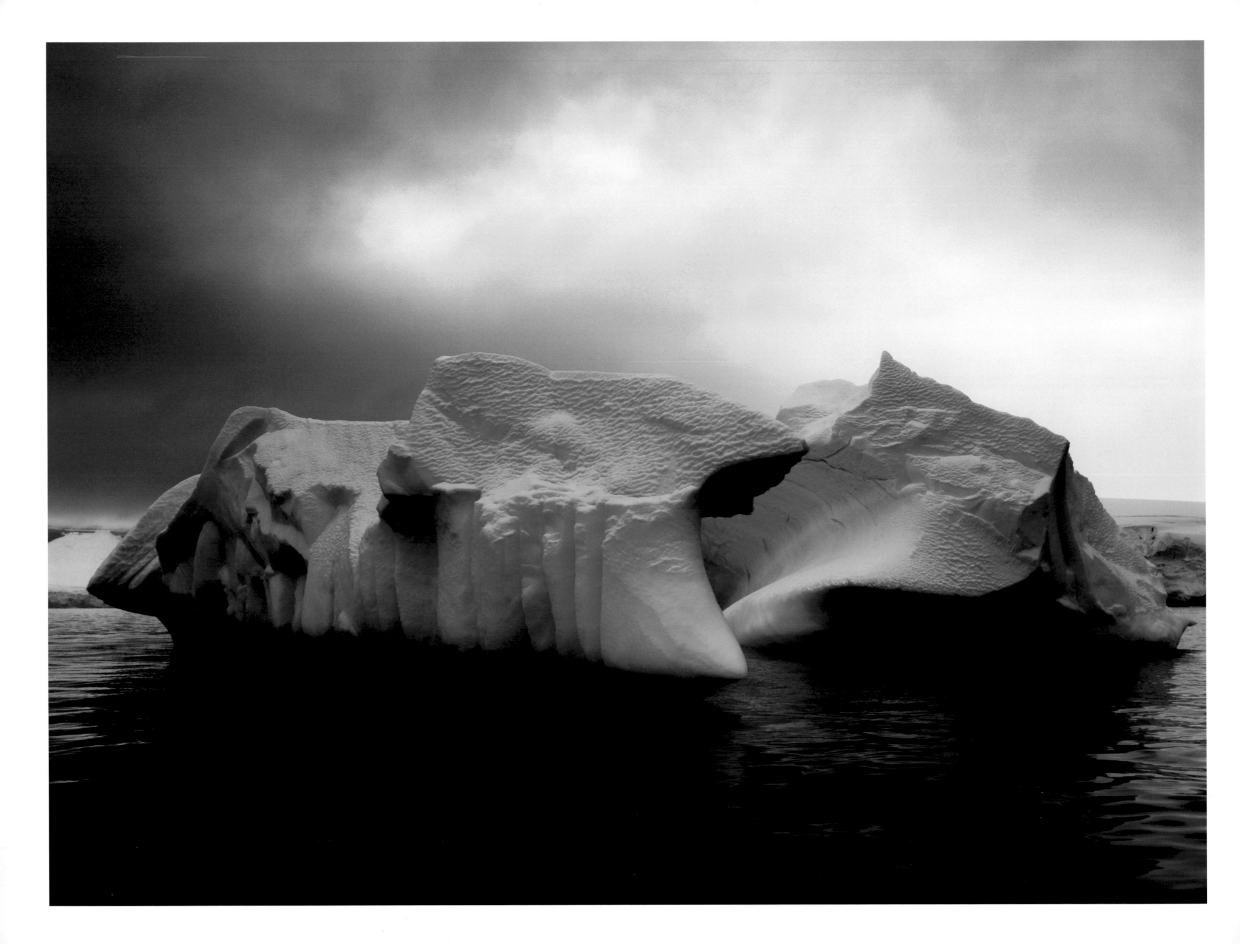

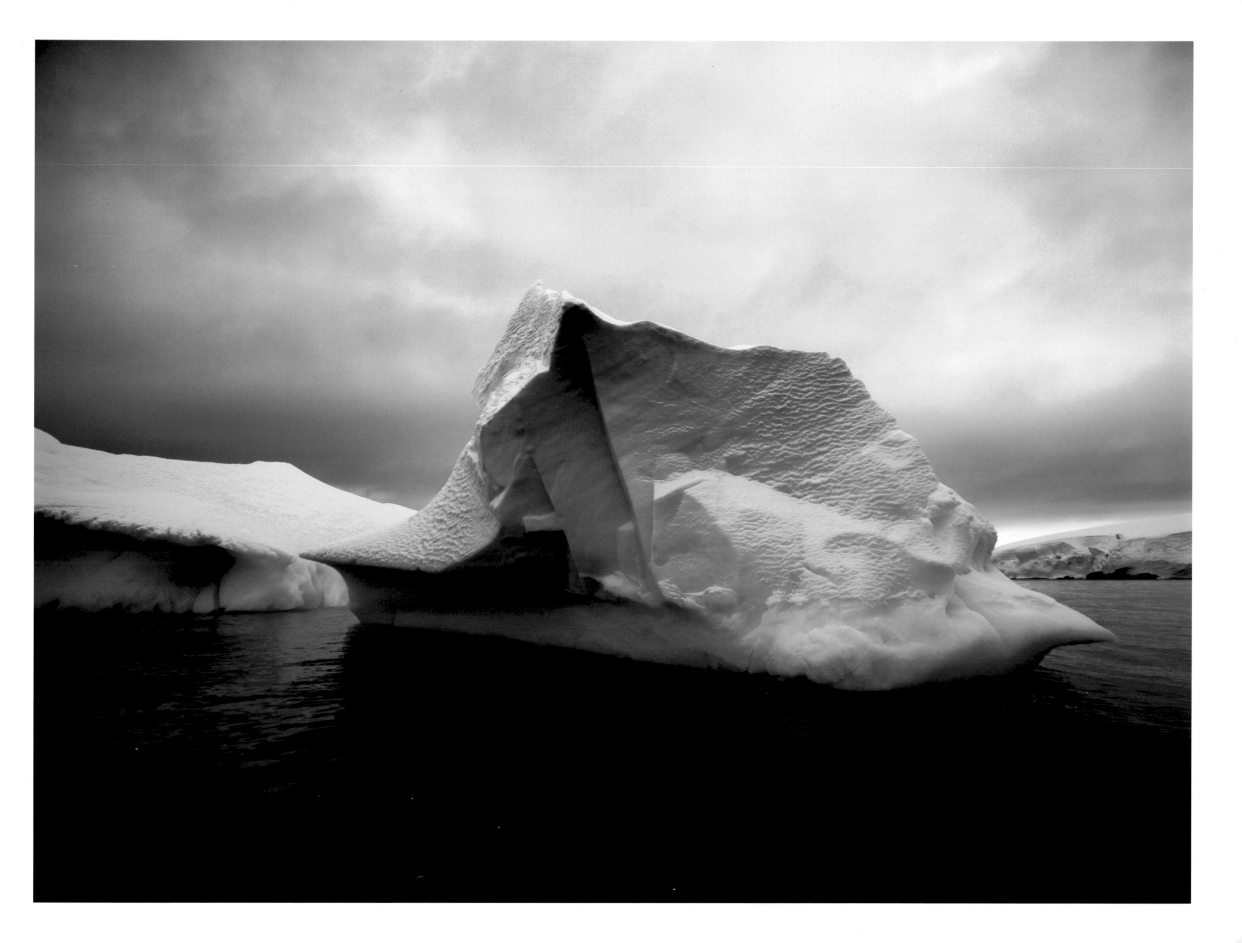

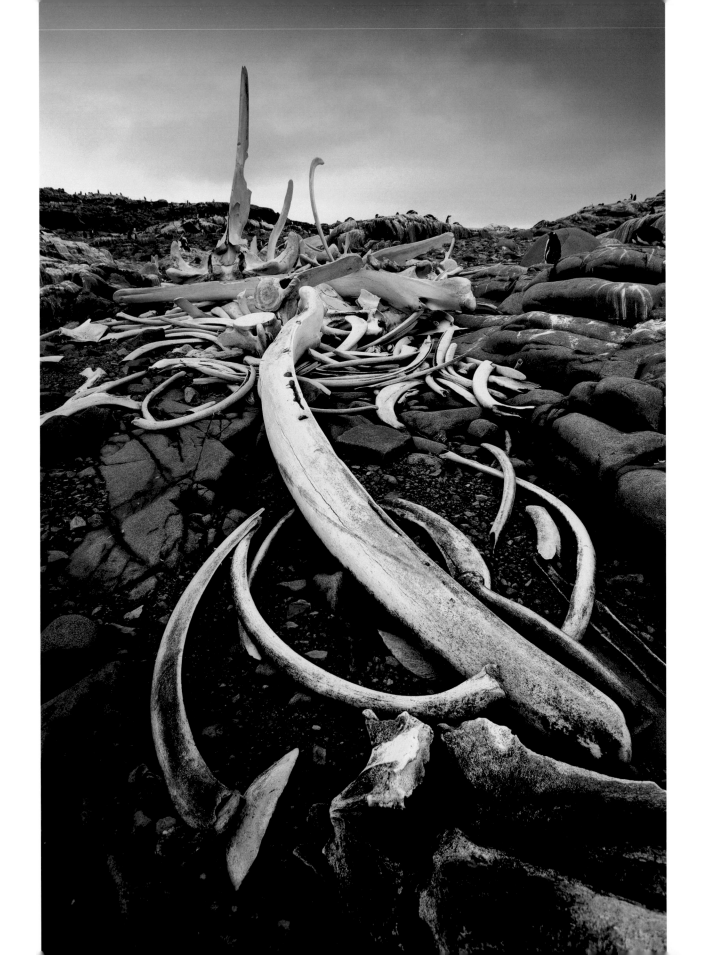

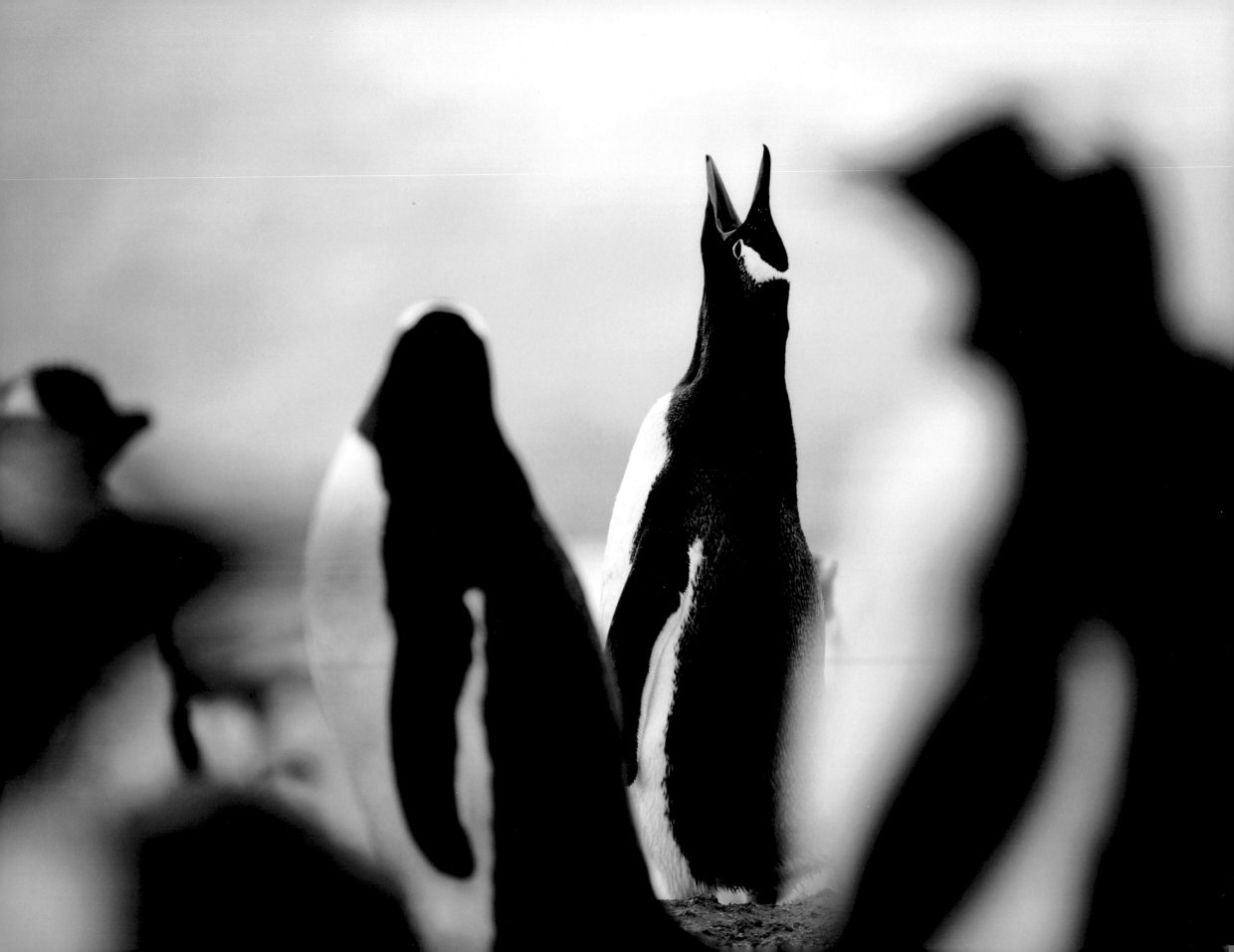

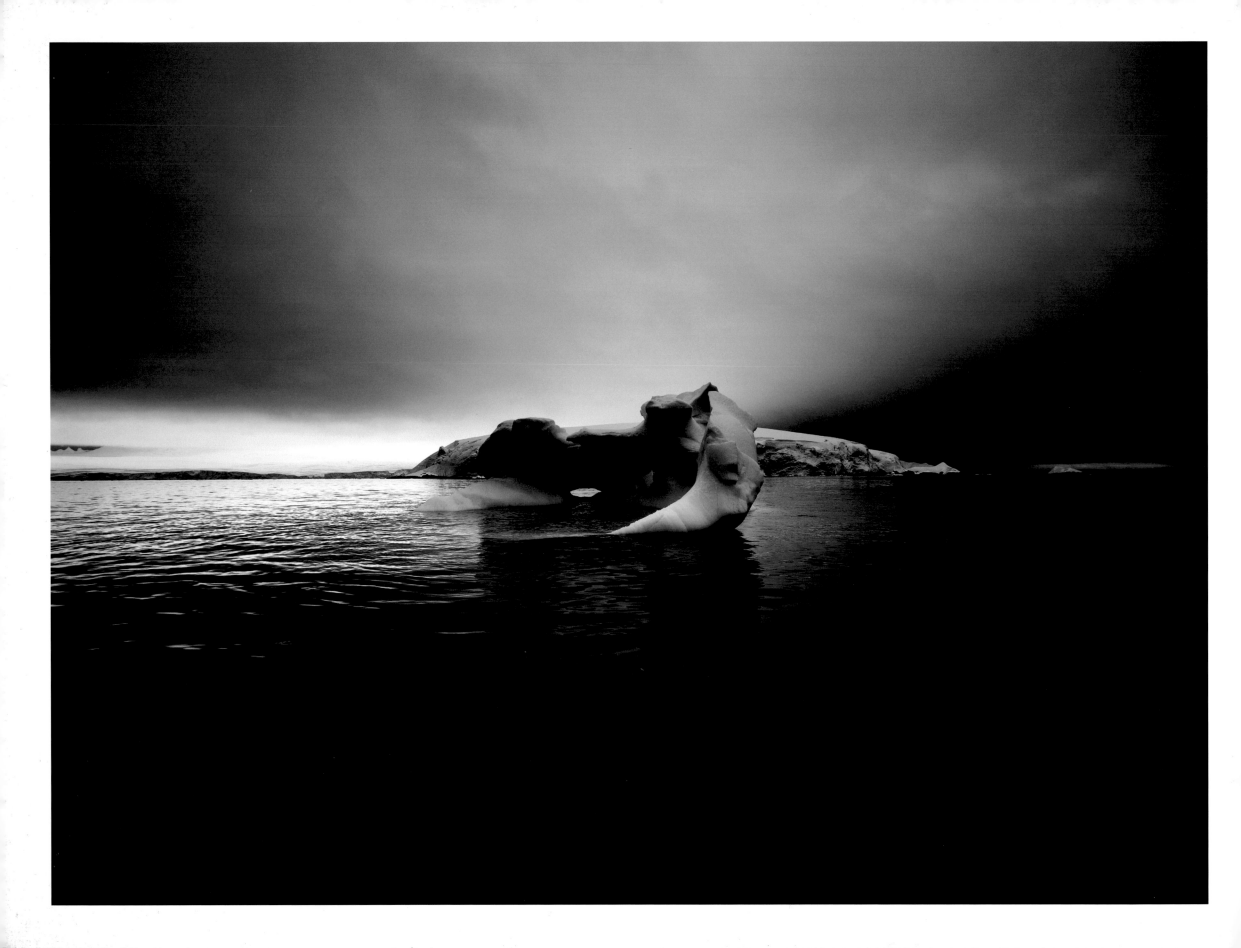

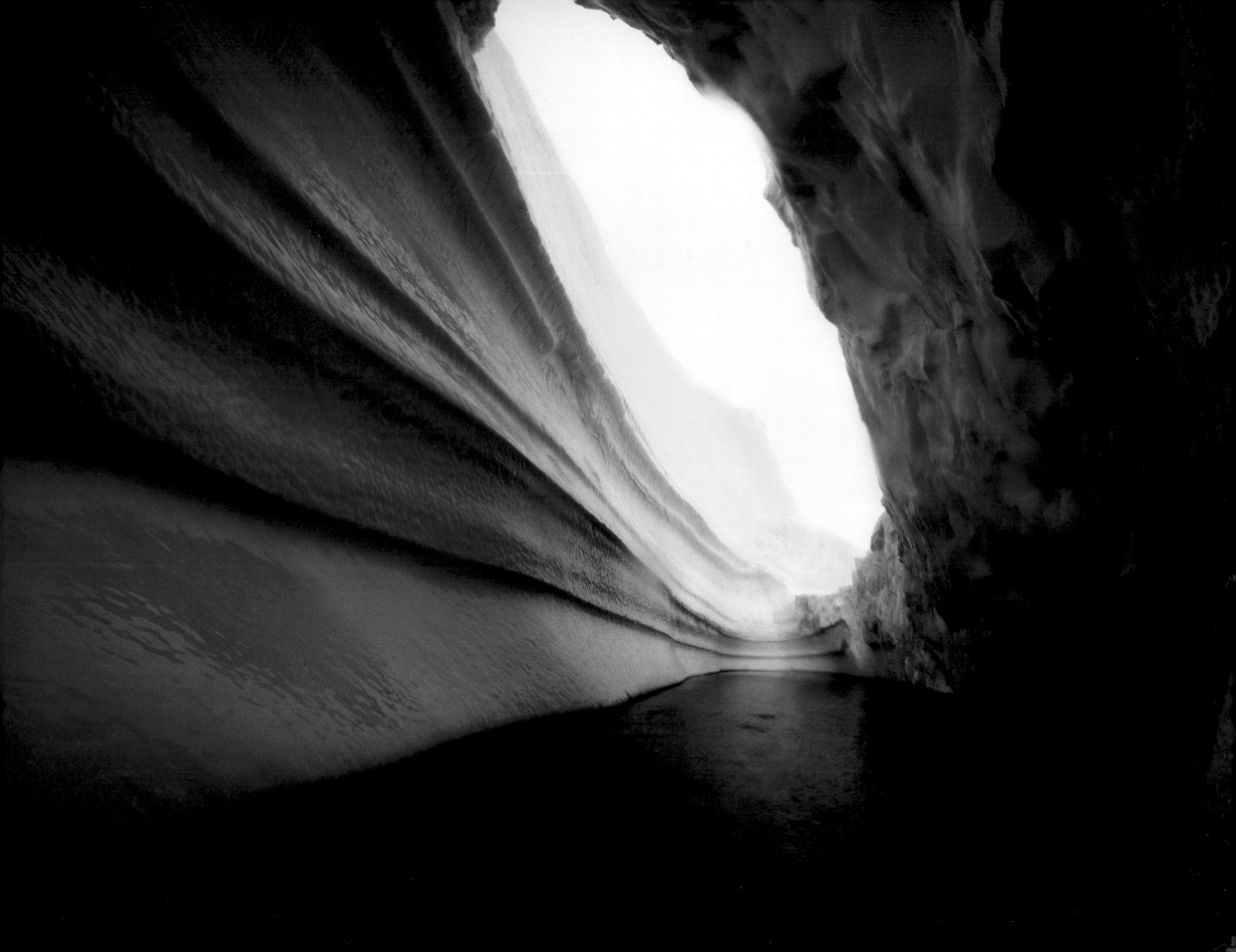

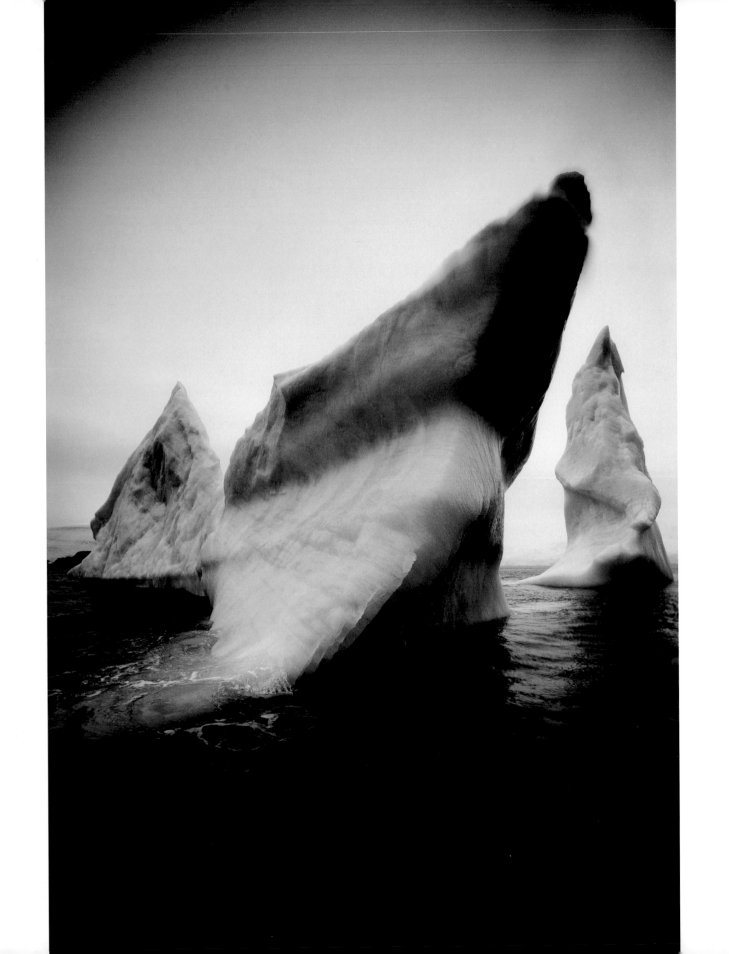

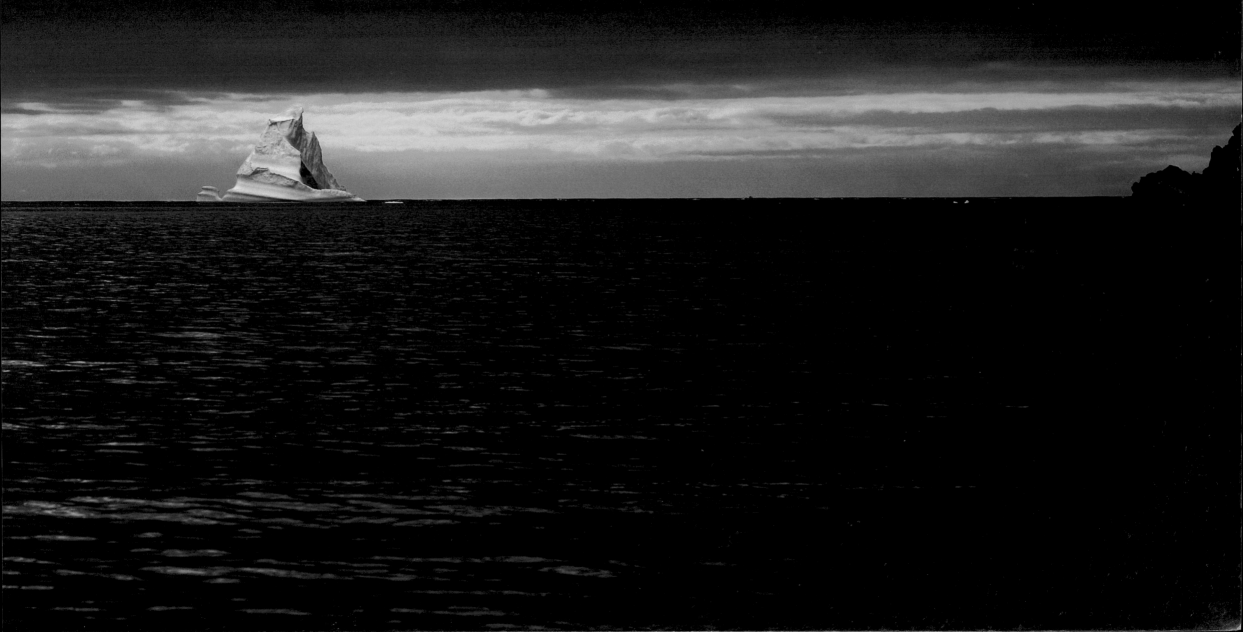

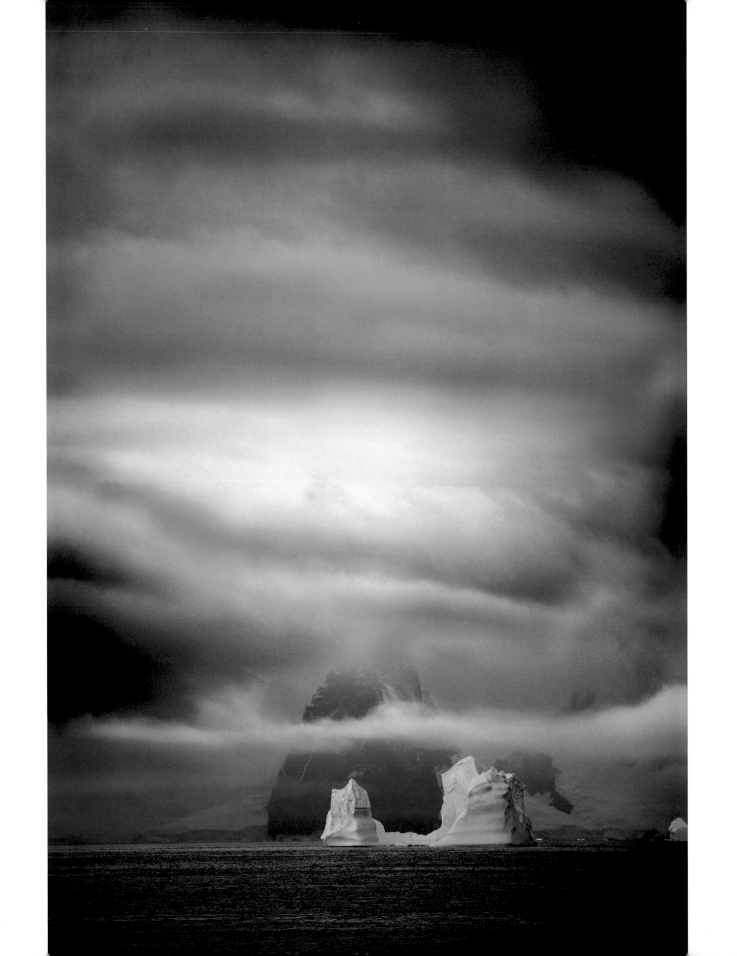

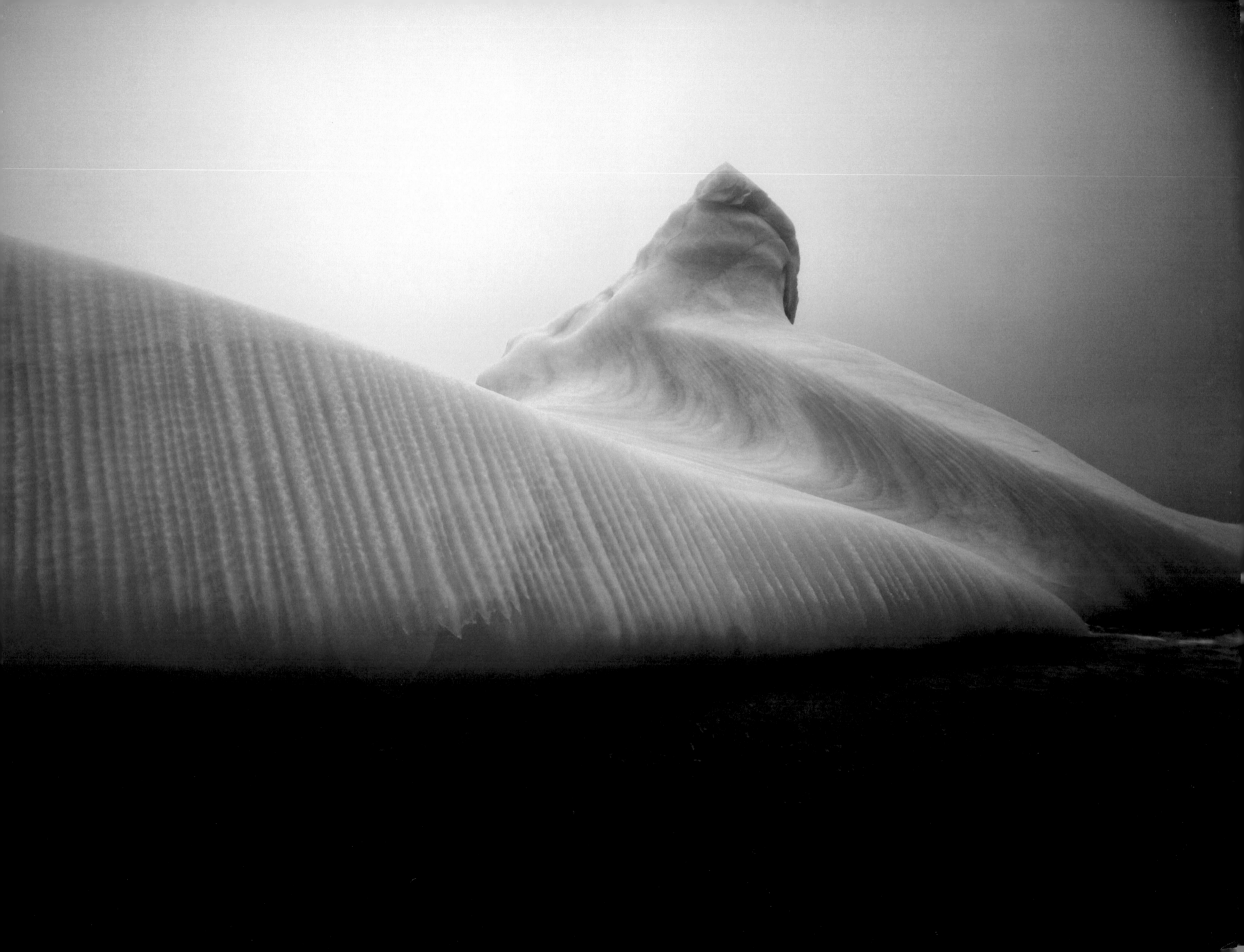

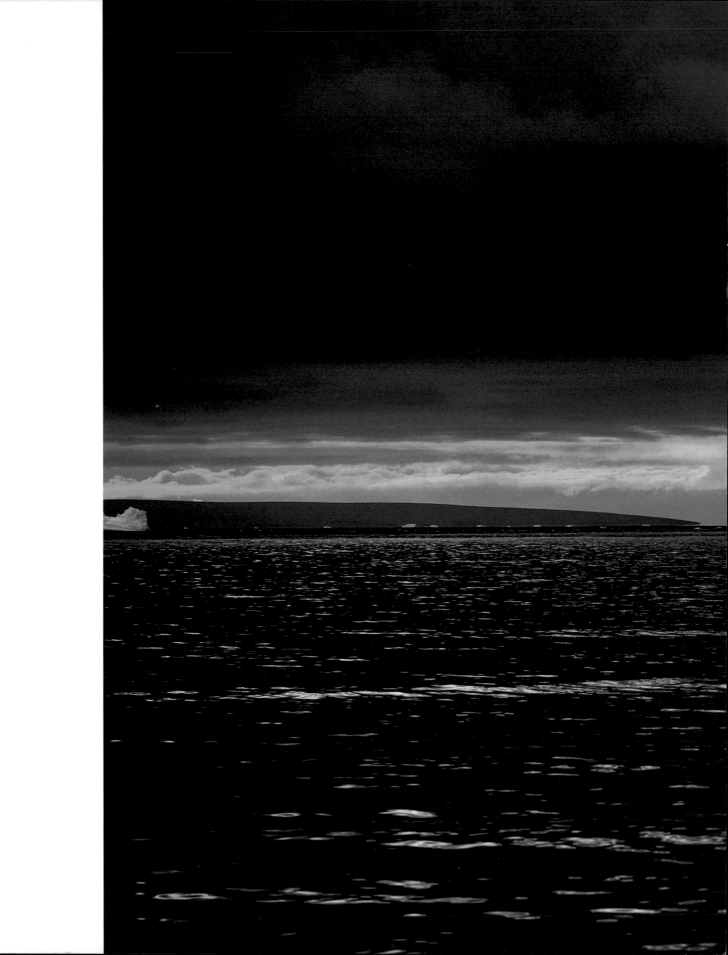

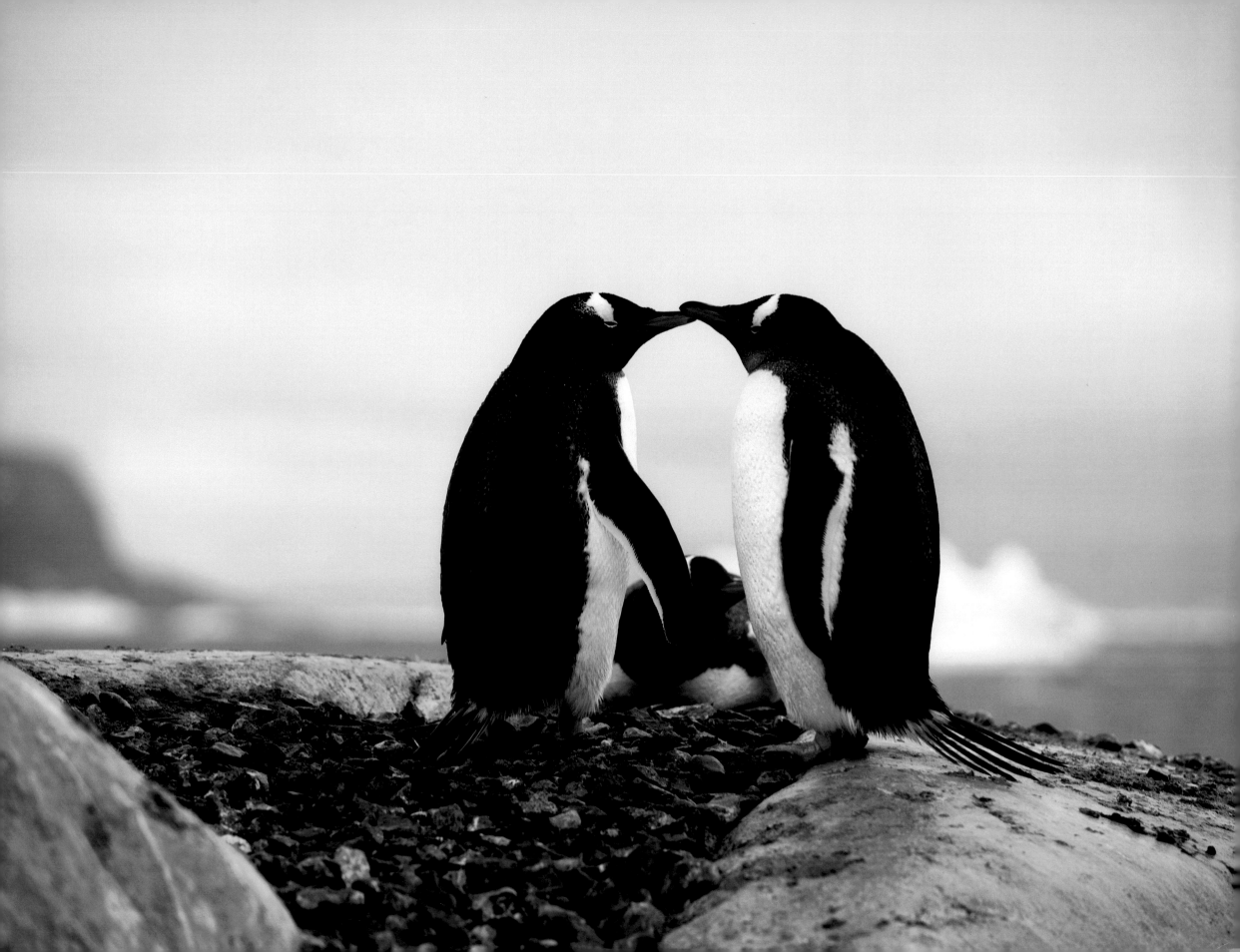

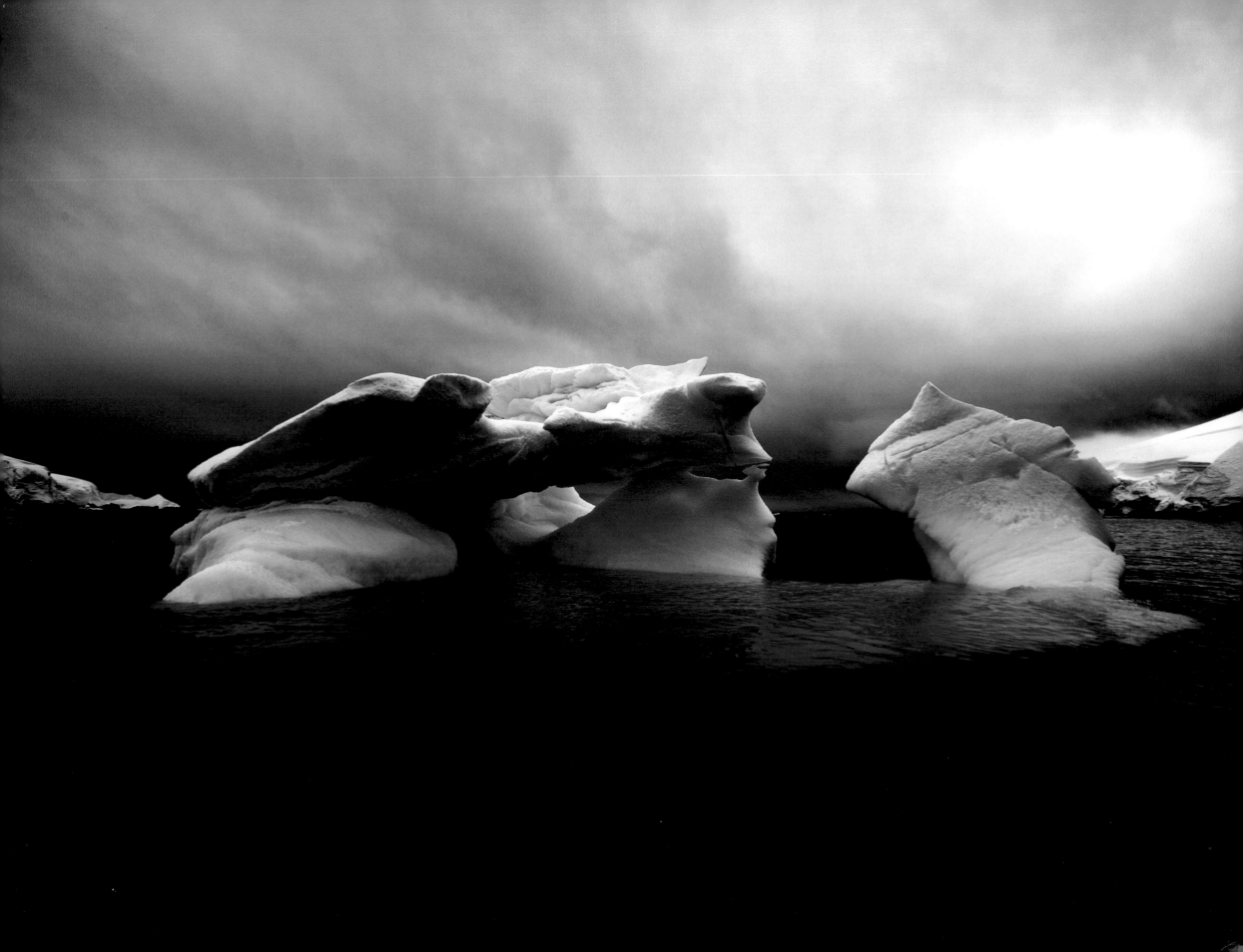

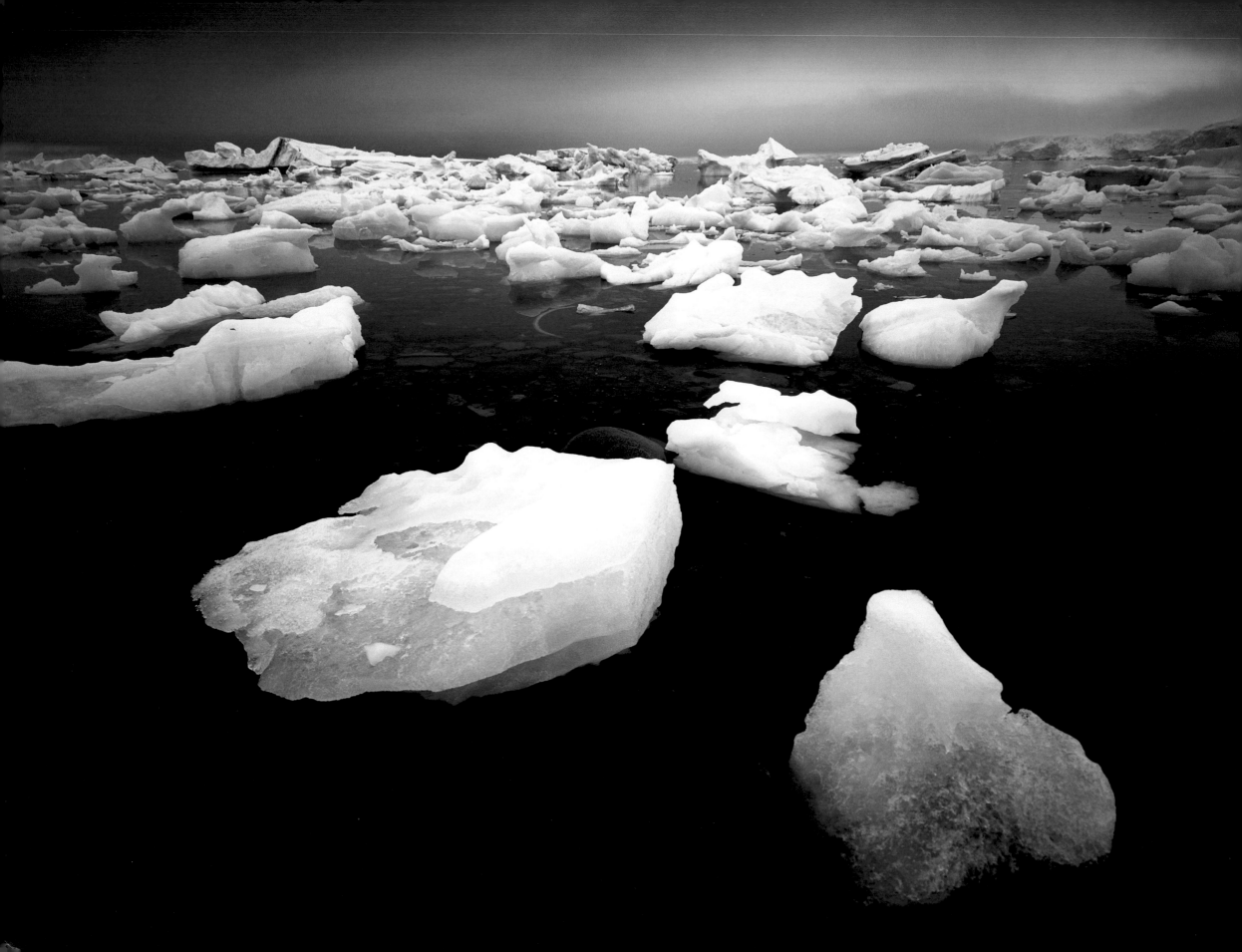

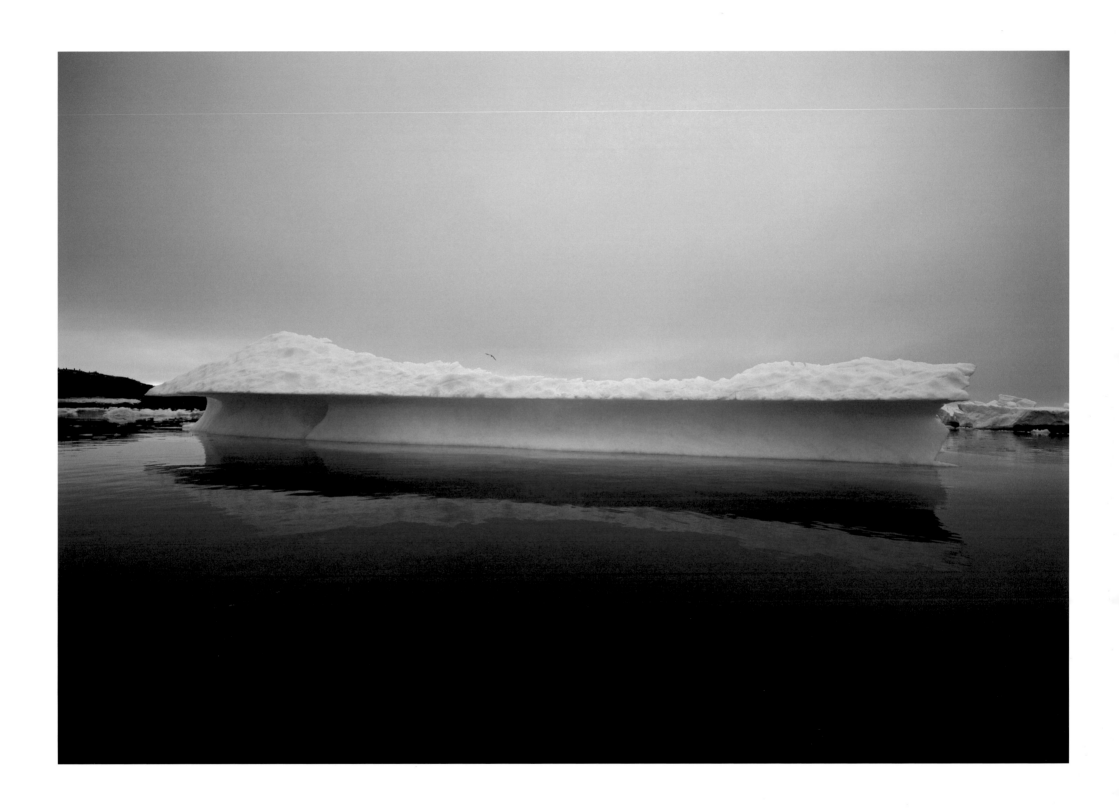

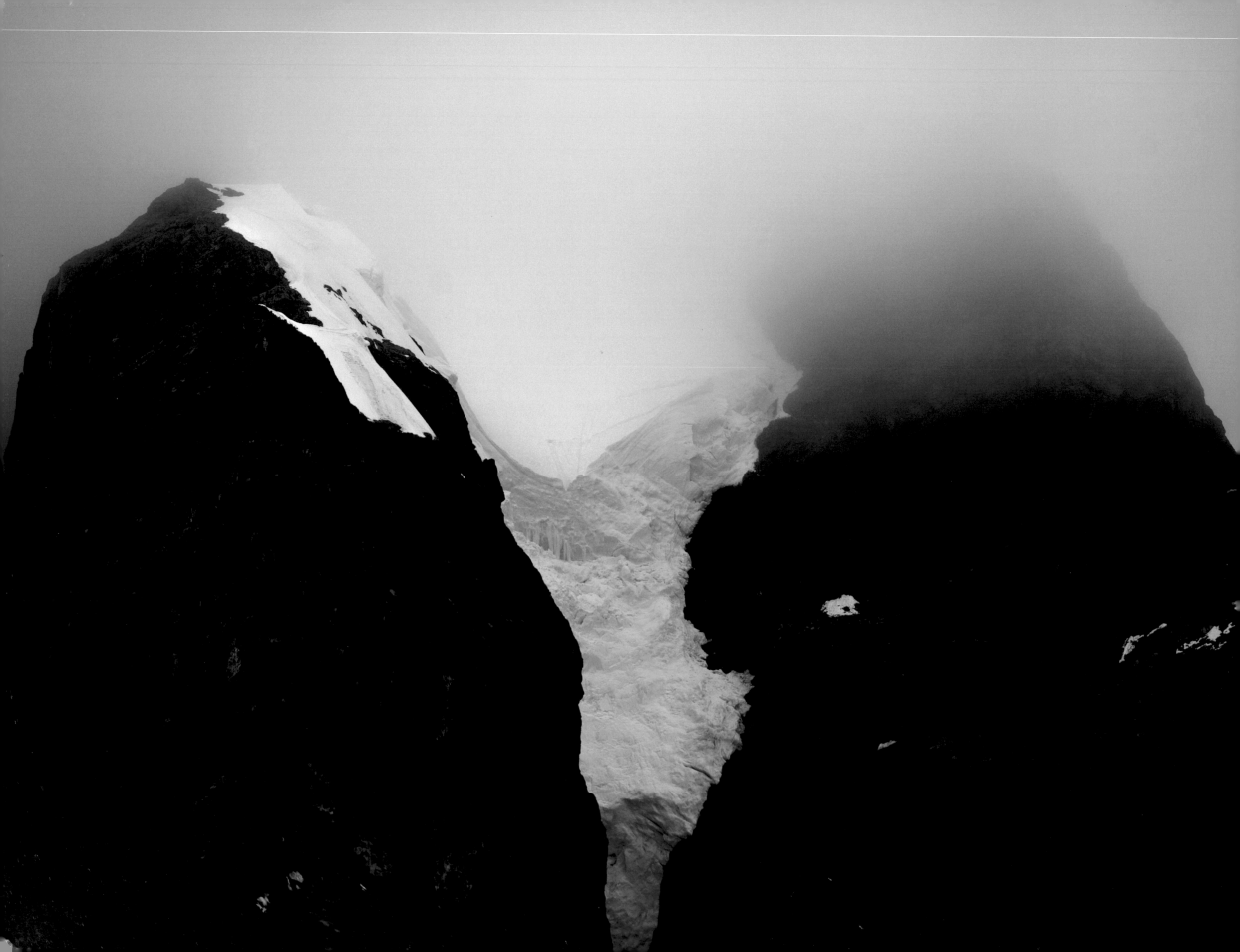

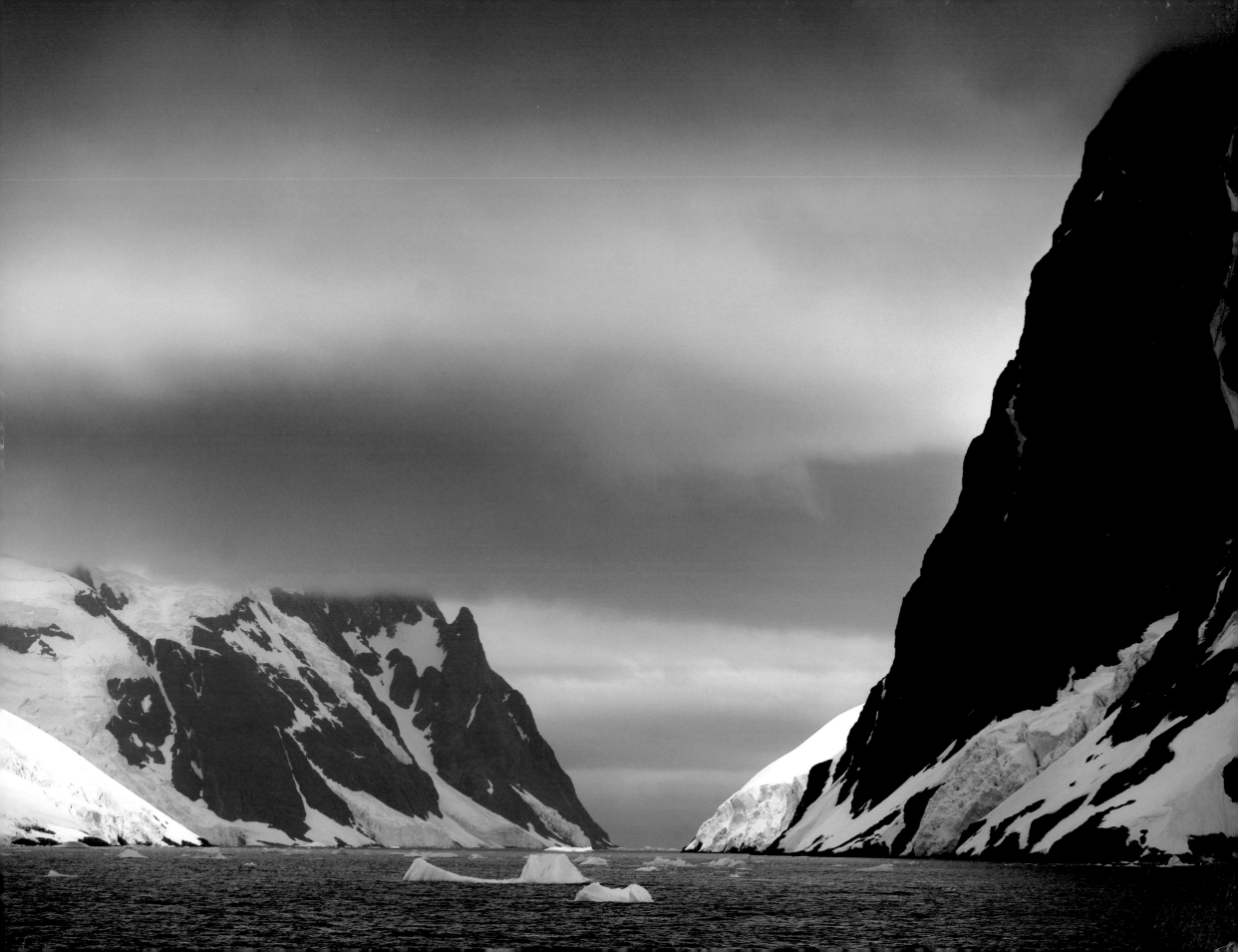

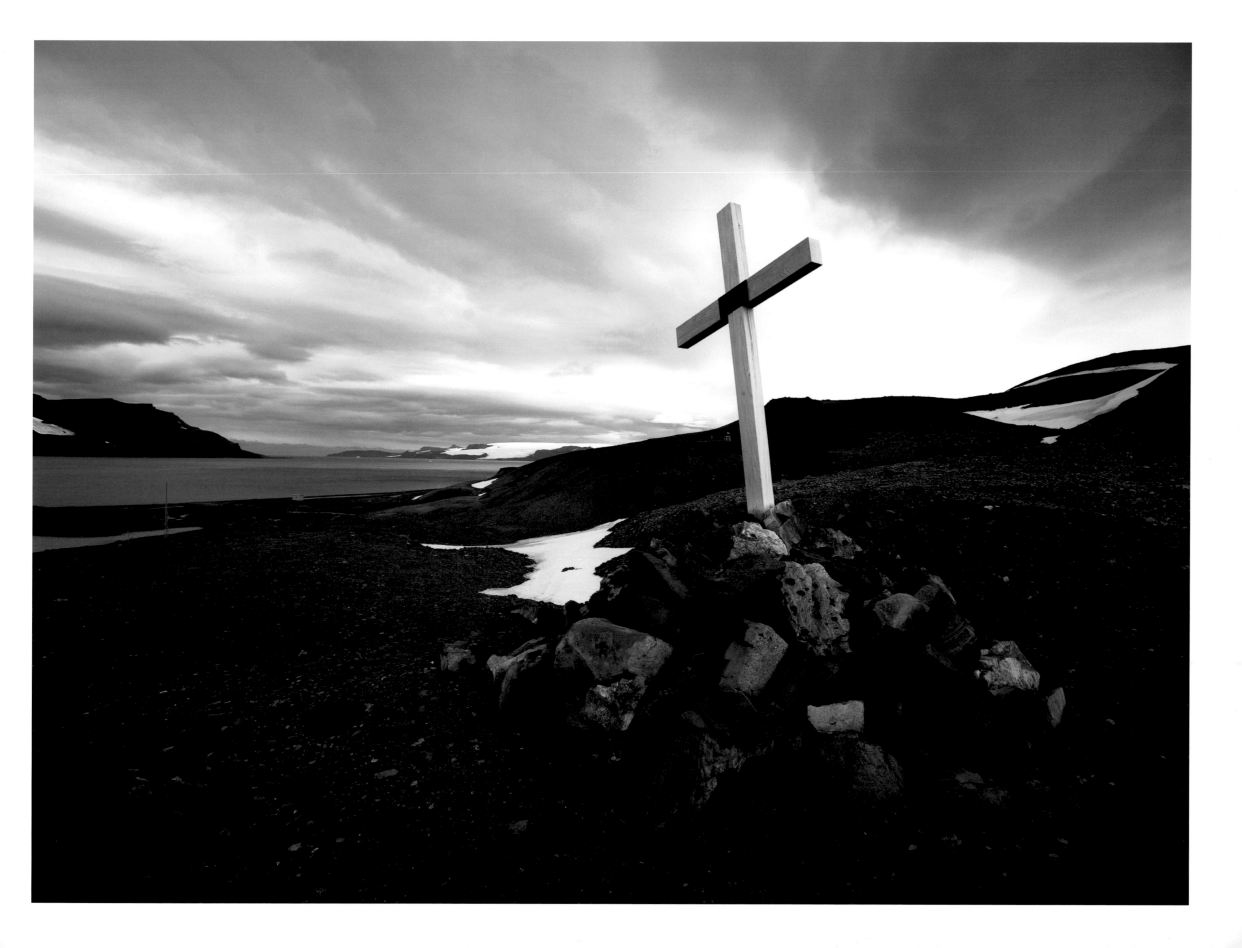

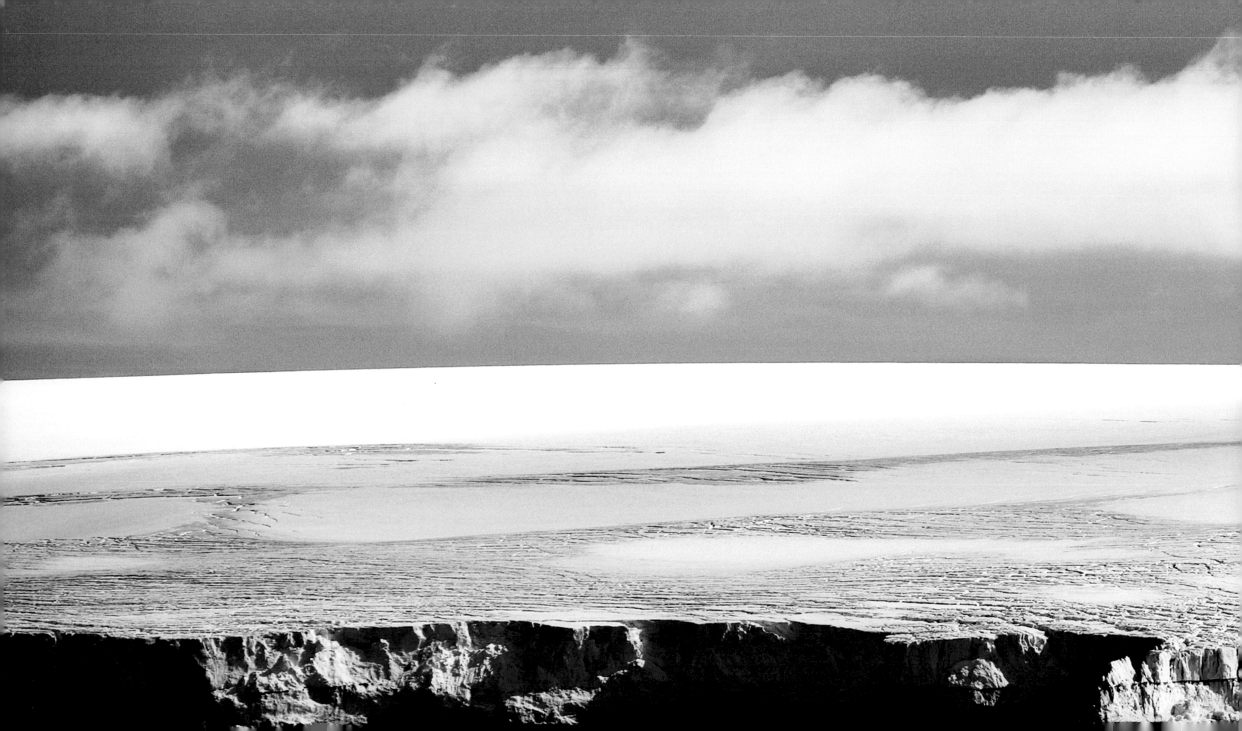

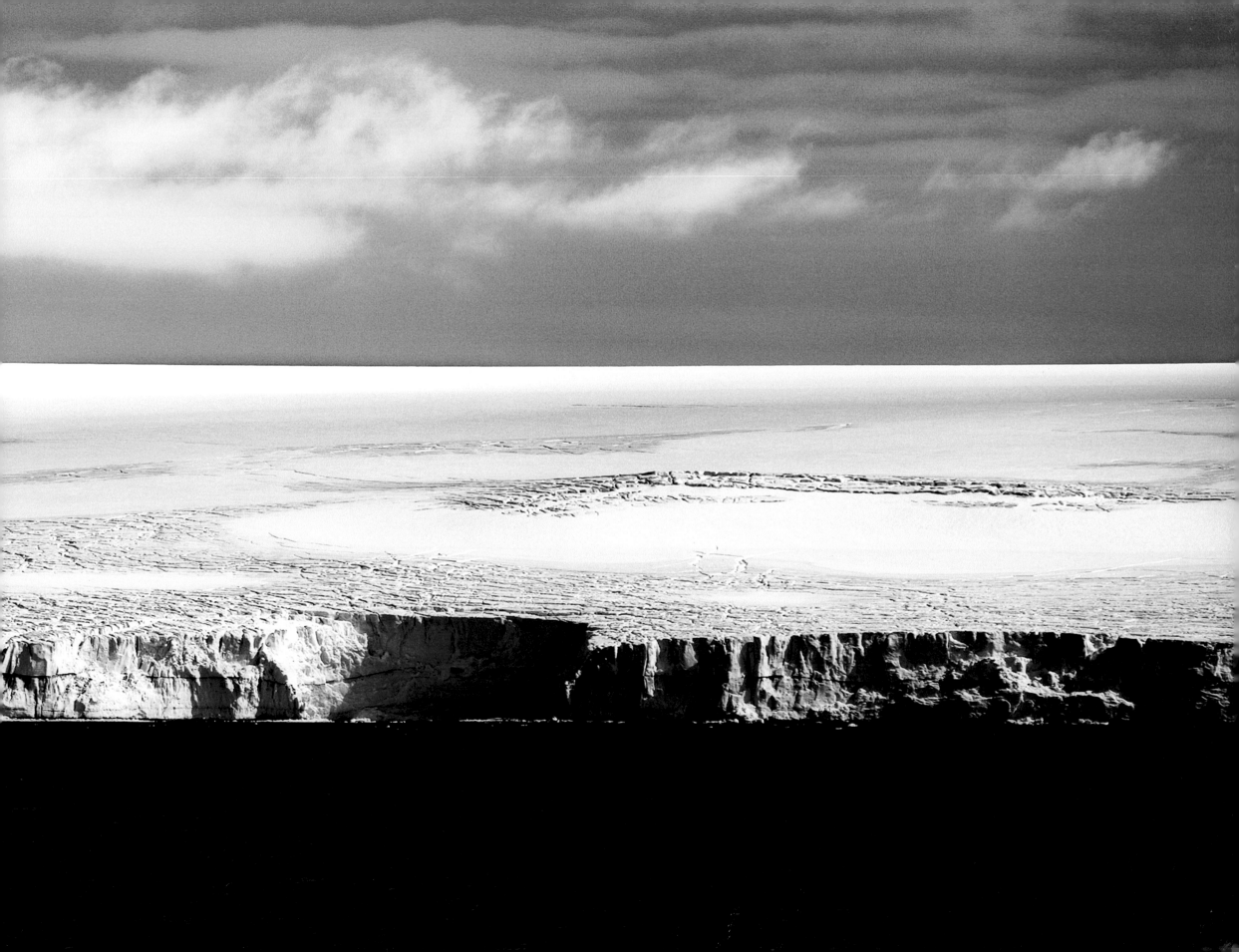

STEPHEN SCHNEIDER

Professor of Environmental Studies

My first polar experience took place in New York City in the mid-fifties. Watching the penguins at the Bronx Zoo, or standing in front of the dioramas of the poles at the American Museum of Natural History, I was transported to a vast, beautiful and pristine place that was home to some terrific creatures. Forty years later I actually made it to the North Pole, via a Russian icebreaker. Being in the land of the polar bear was as profound and mysterious as I had dreamed it would be. I was lucky to have made that trip when I did, for major reductions in sea ice now threaten the entire ecosystem.

As in the Arctic, the disruptions that global warming is causing in Antarctica have implications for all of us. The very existence of a high, large continent at the South Pole determines weather patterns throughout the Southern Hemisphere. And, via interactions with global oceanic currents, the continent affects weather even outside the hemisphere. A changing Antarctic climate means not only the potential loss of unique polar ecosystems, but alterations in climates far away.

This is not the first time we are being called upon to repair damage we have inflicted on Antarctica. Twenty-five years ago the ozone layer over the continent was seriously depleted, a result of humans dumping halogenated chemicals like CFCs into the atmosphere. The ozone hole is slowly healing now, but only after an international agreement to control ozone-depleting substances was put in place and enforced.

Solving the current climate crisis is an achievable prospect, too, if we can desist from our endless consumerism and instead demand sustainable energy and transportation systems. I can only hope that we care enough to do what needs to be done, but in our "me-first" world, too few of us concern ourselves with remote events that will affect the planet in another time and place.

It is painful for me to watch a natural system, one that has traveled such a long evolutionary road, unravel in a century – a mere blink in geological time. Antarctica's unique geology, geography and ecology took millions of years to evolve. The speed with which it is disintegrating raises fundamental concerns about our collective values. I guess I'm one of those romantics who sees the preservation of wild and remote places as a moral necessity.

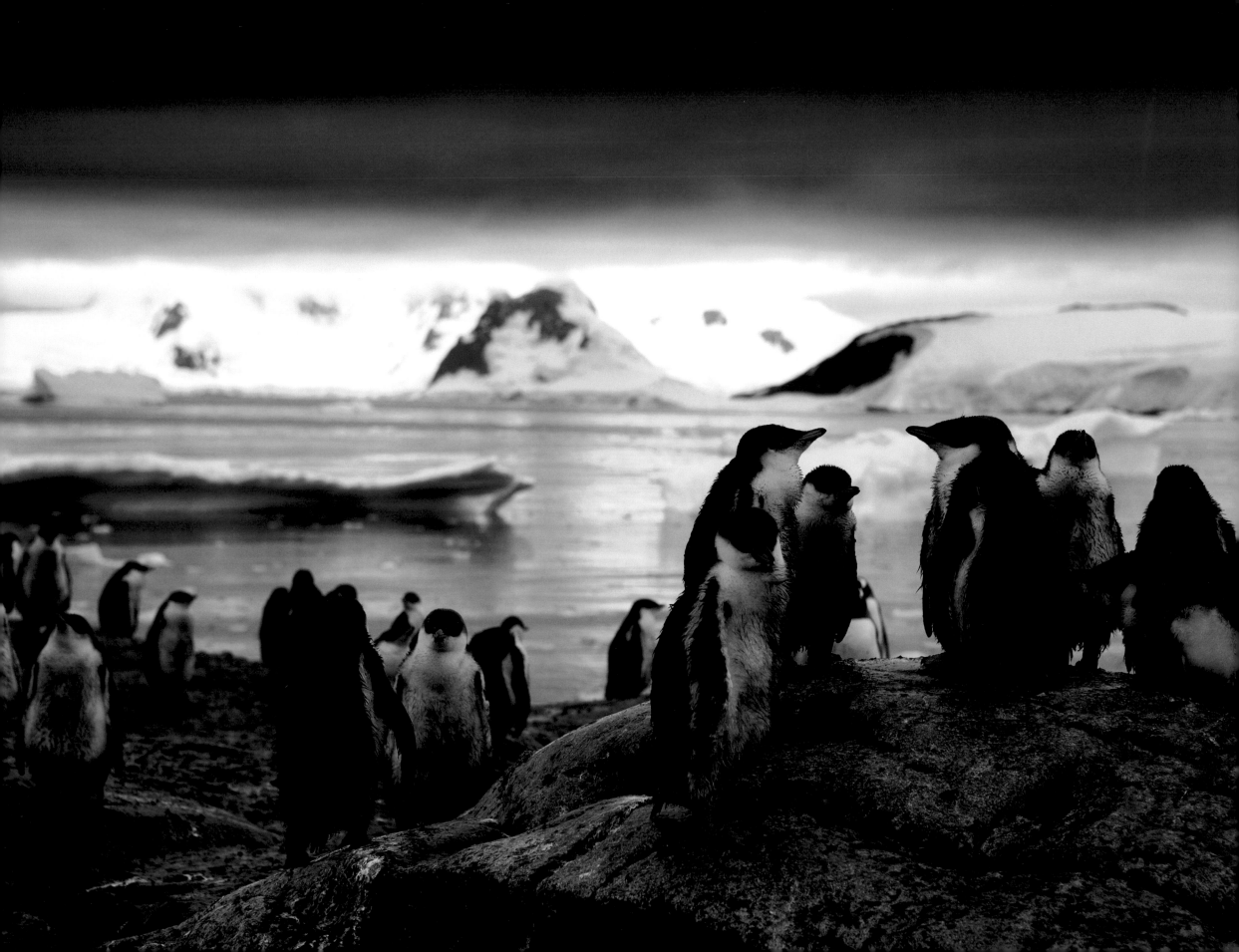

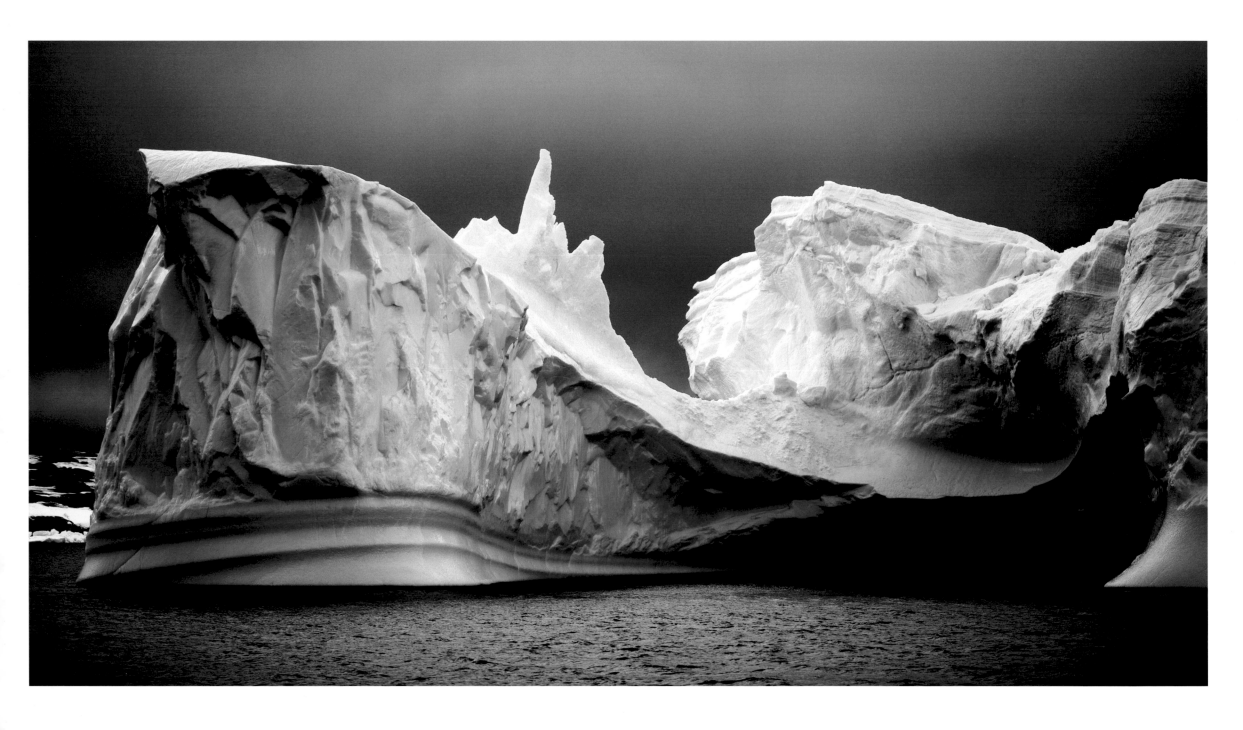

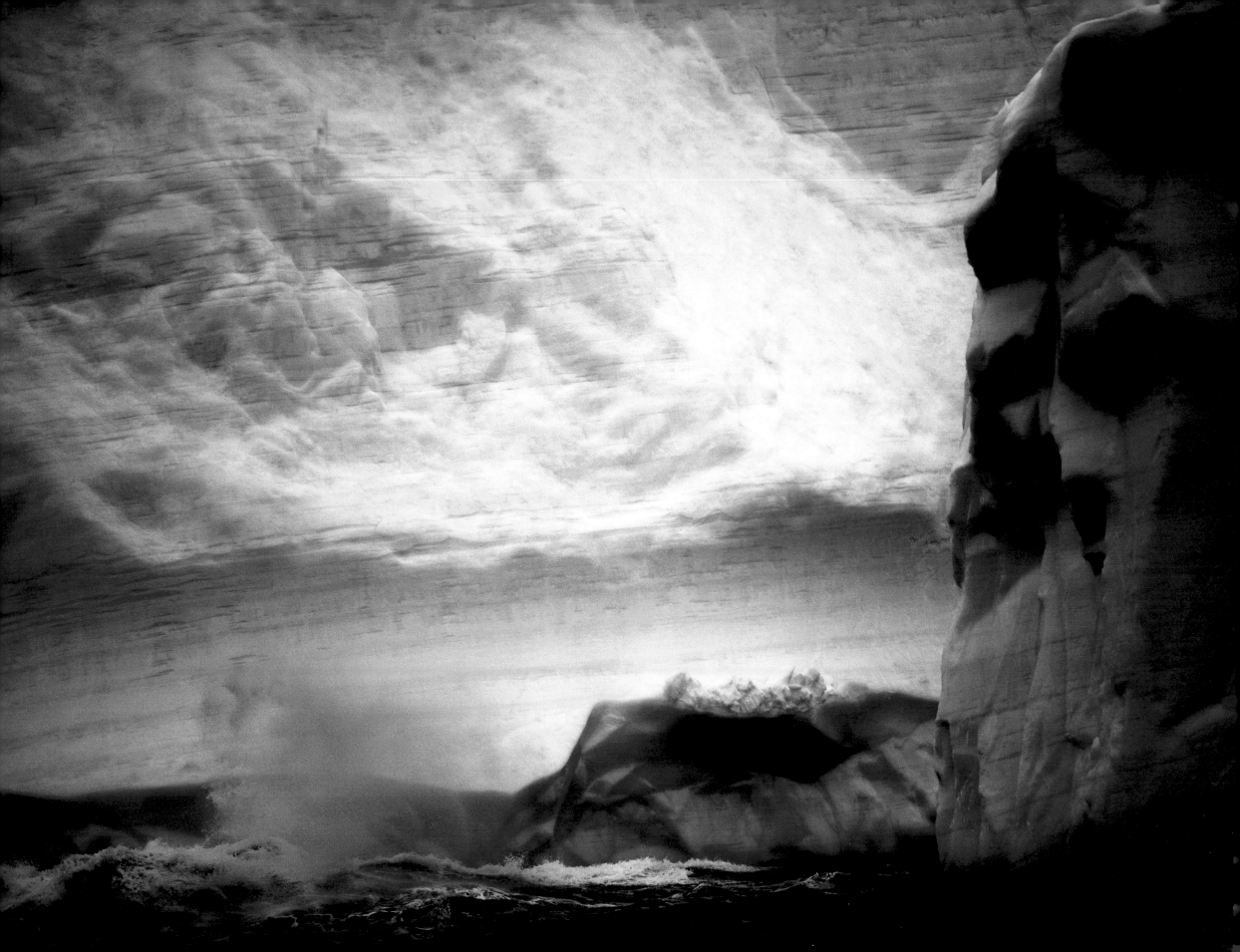

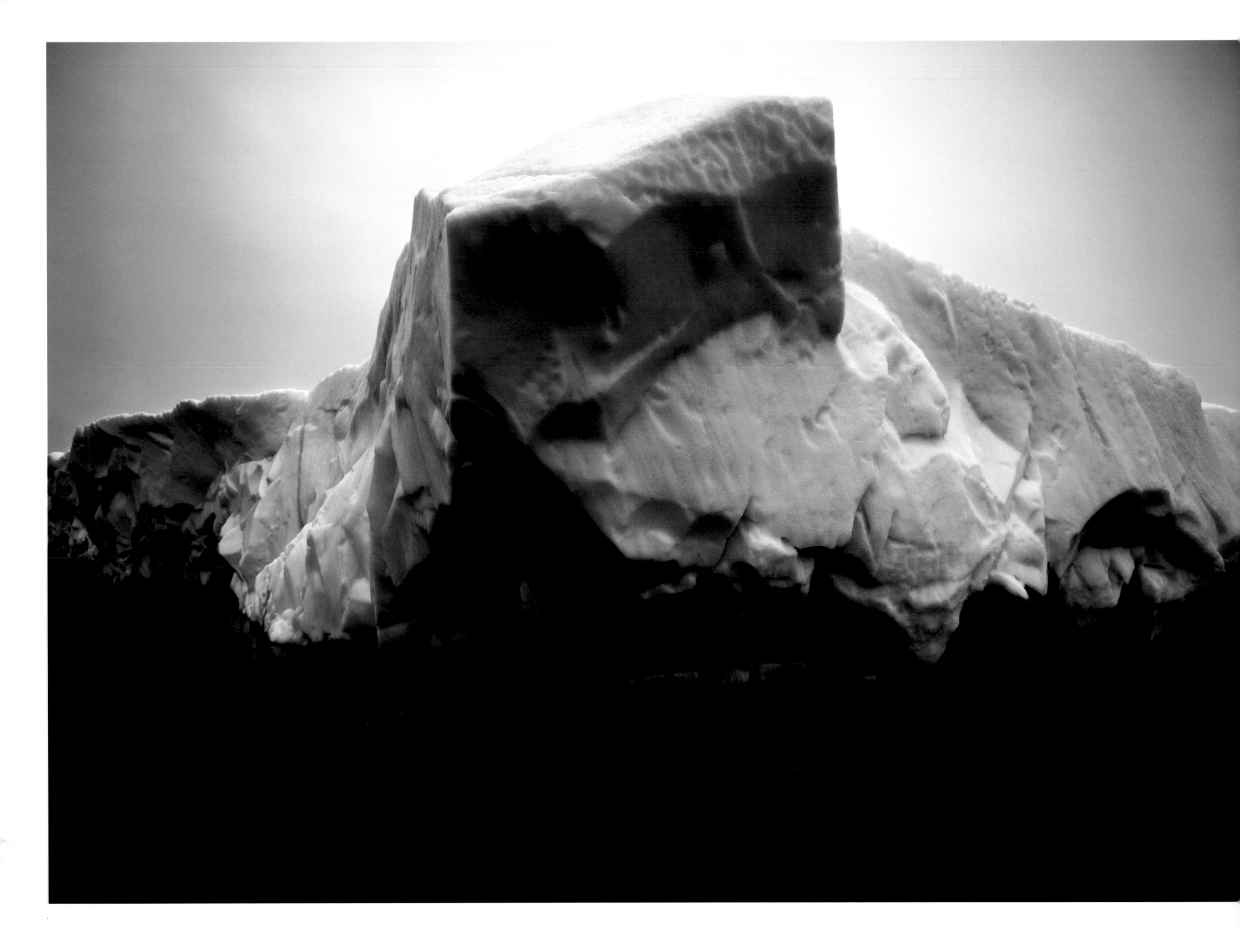

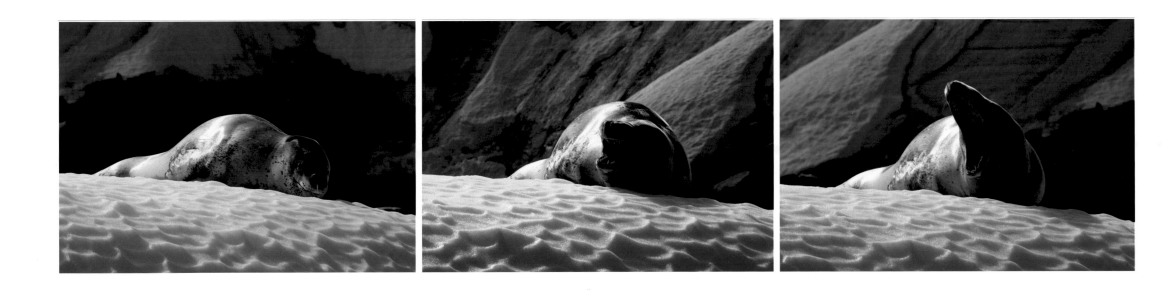

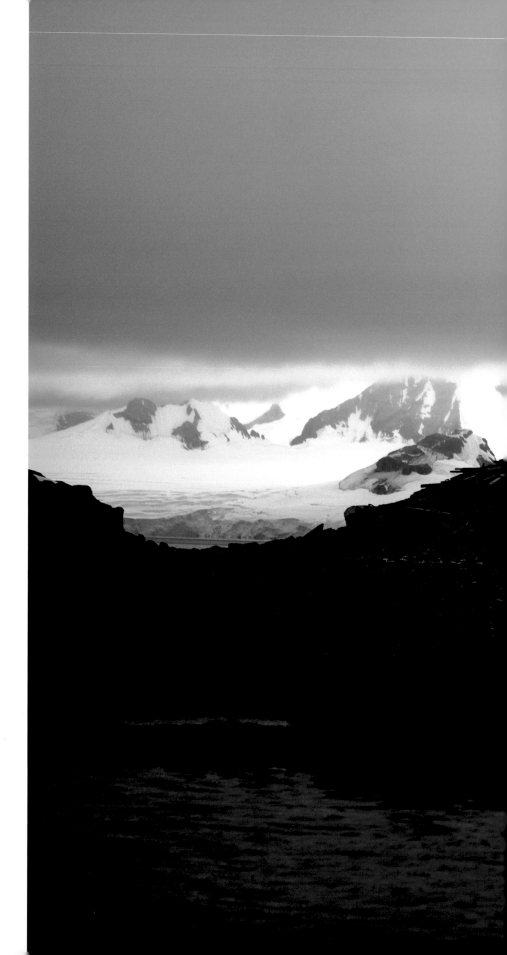

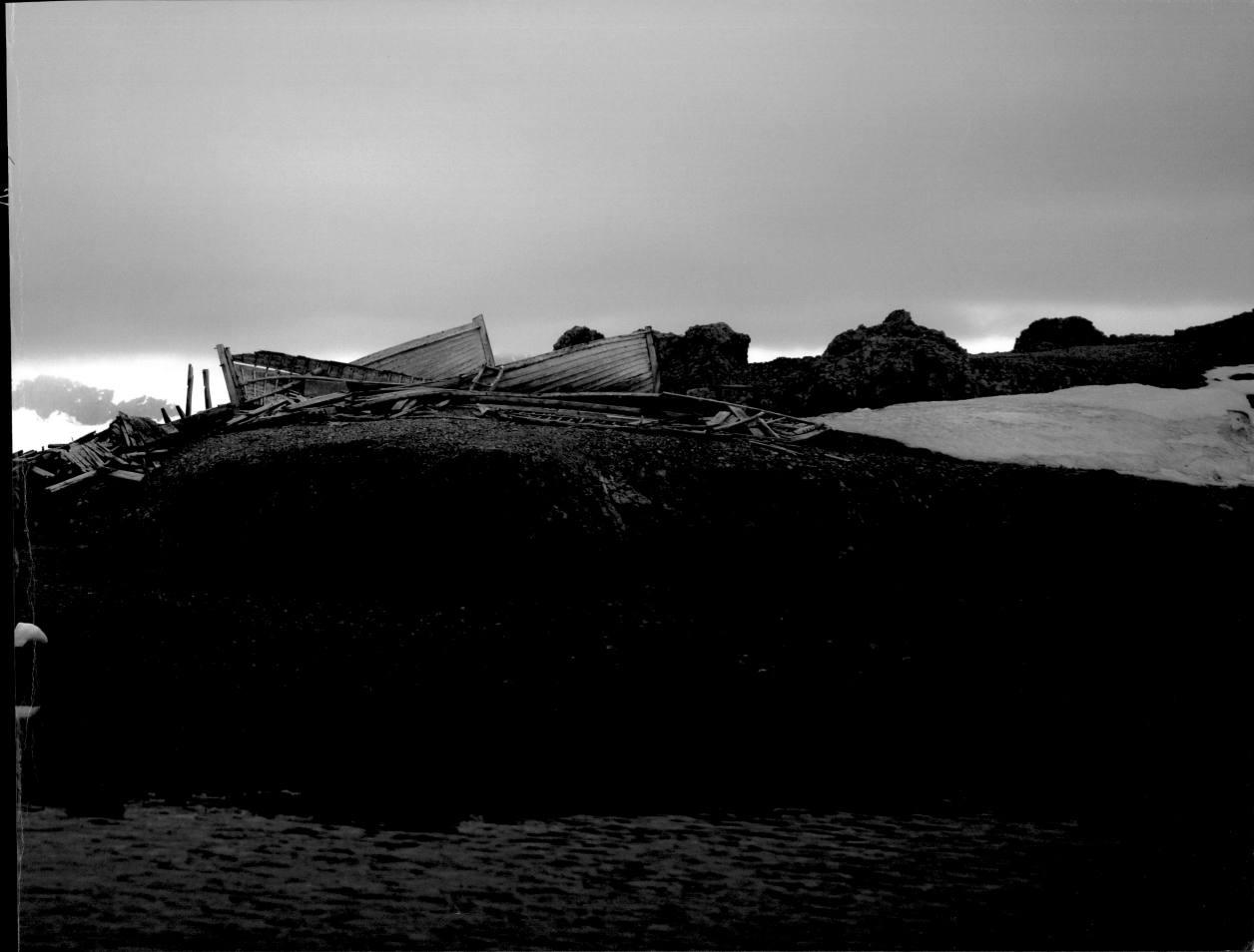

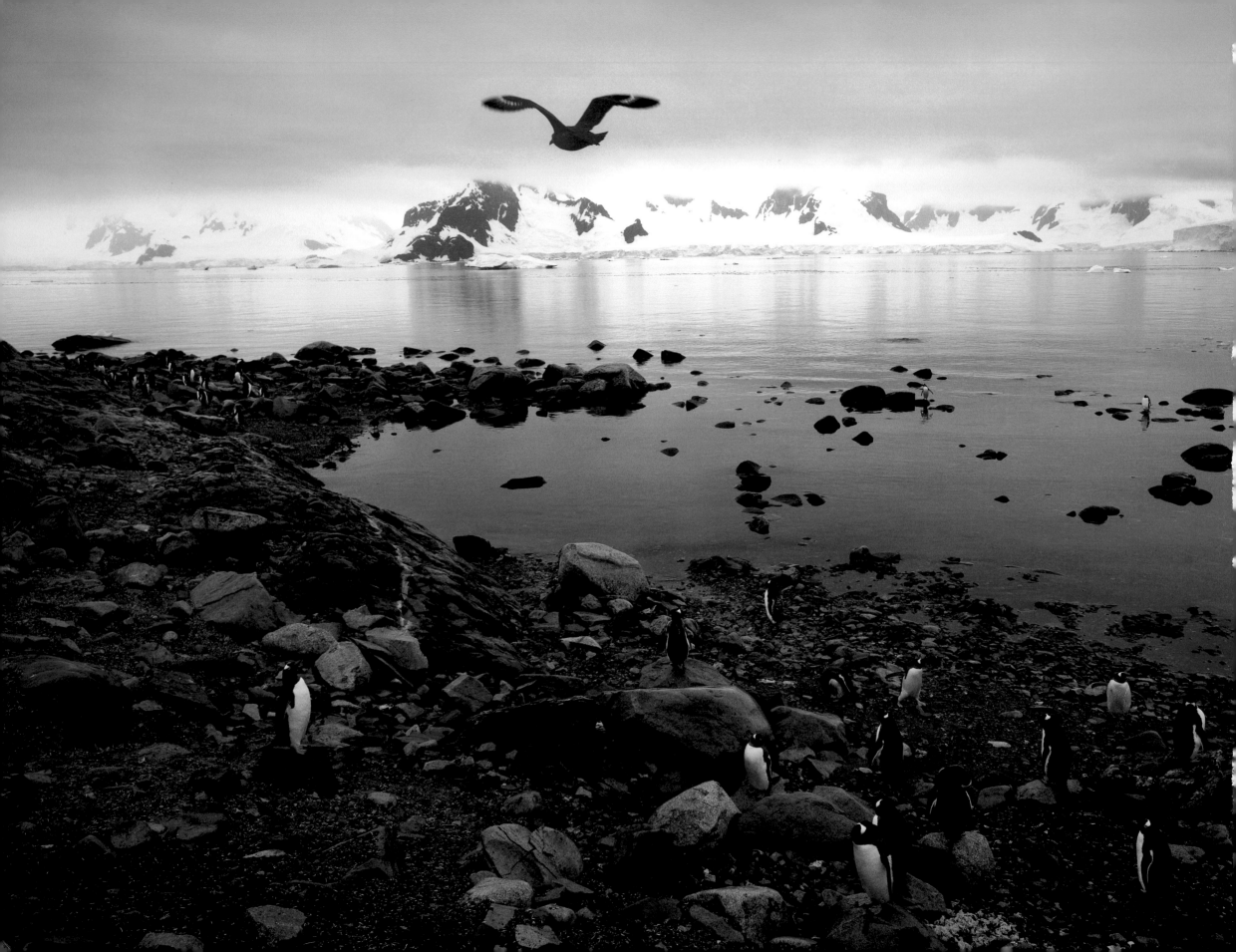

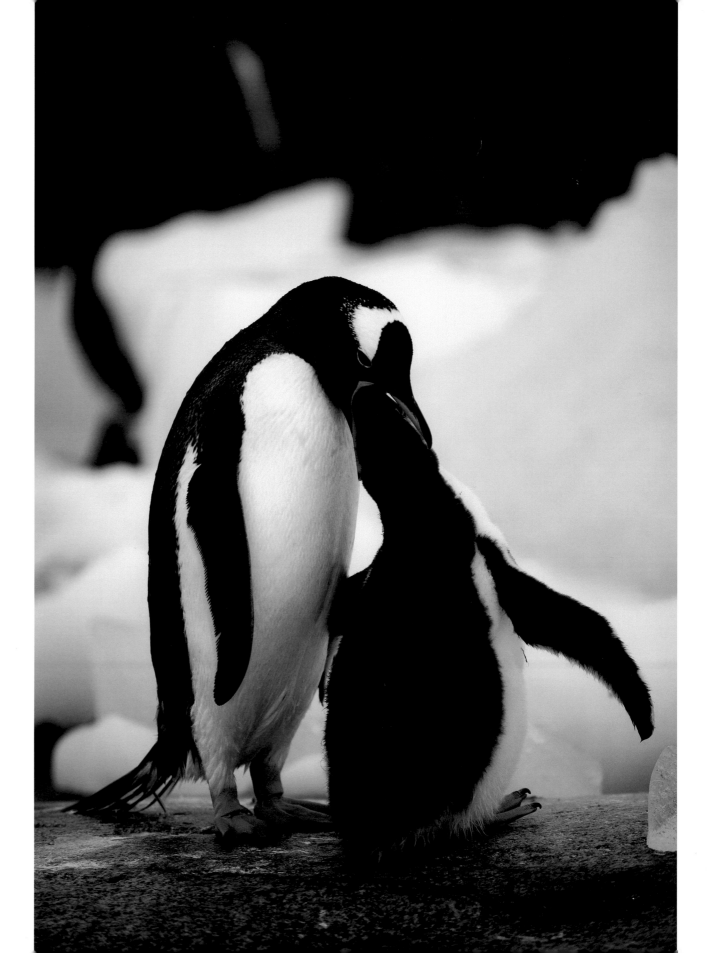

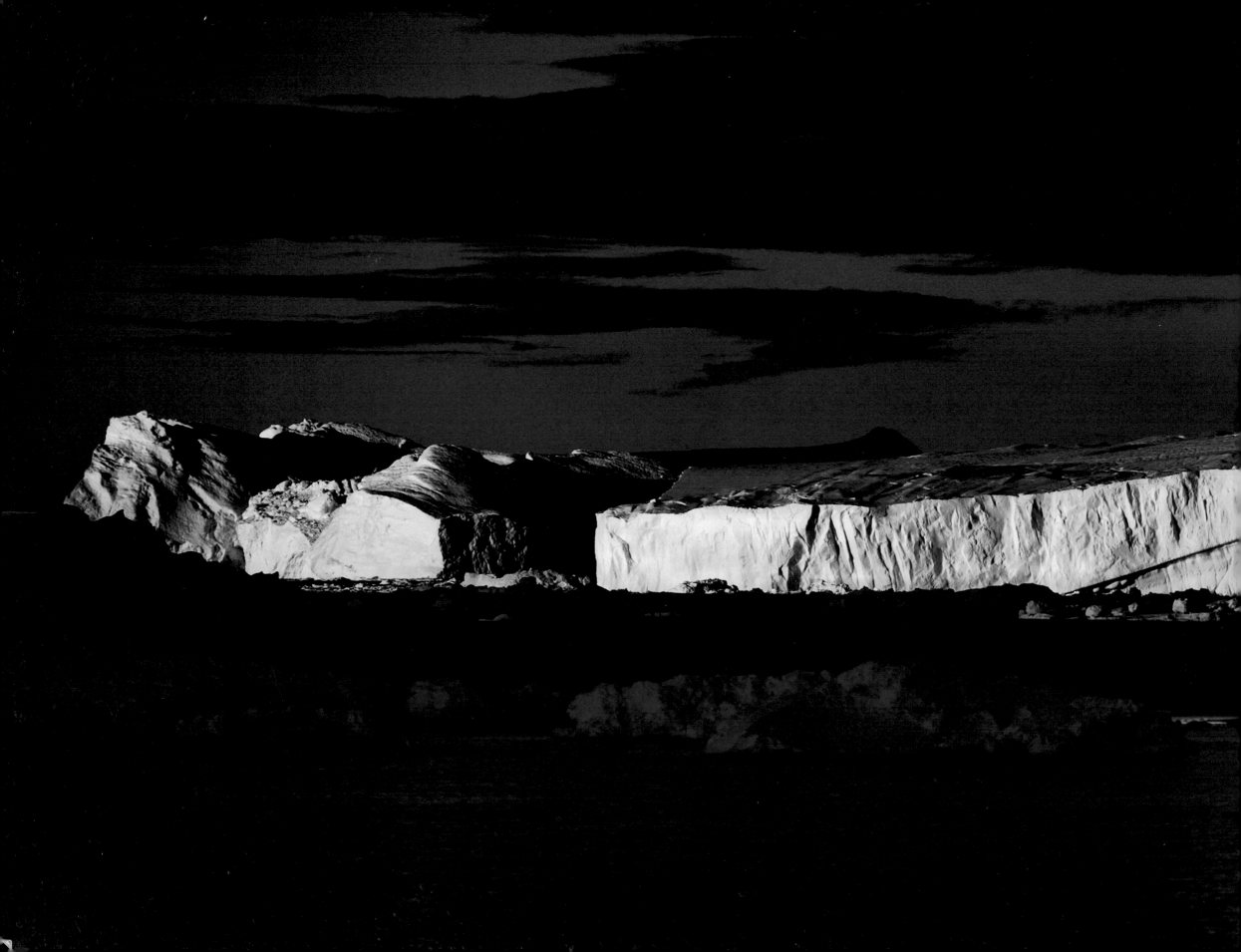

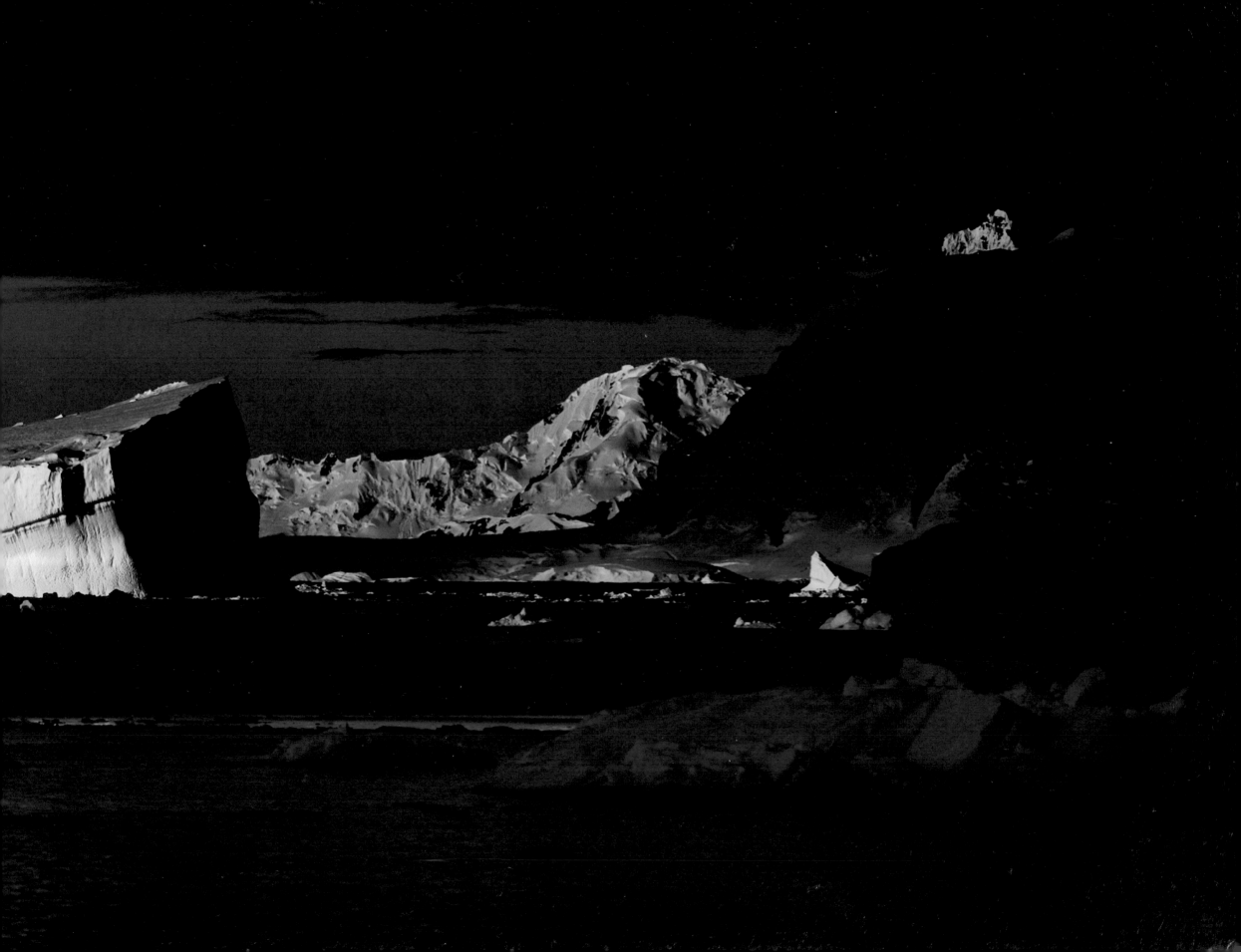

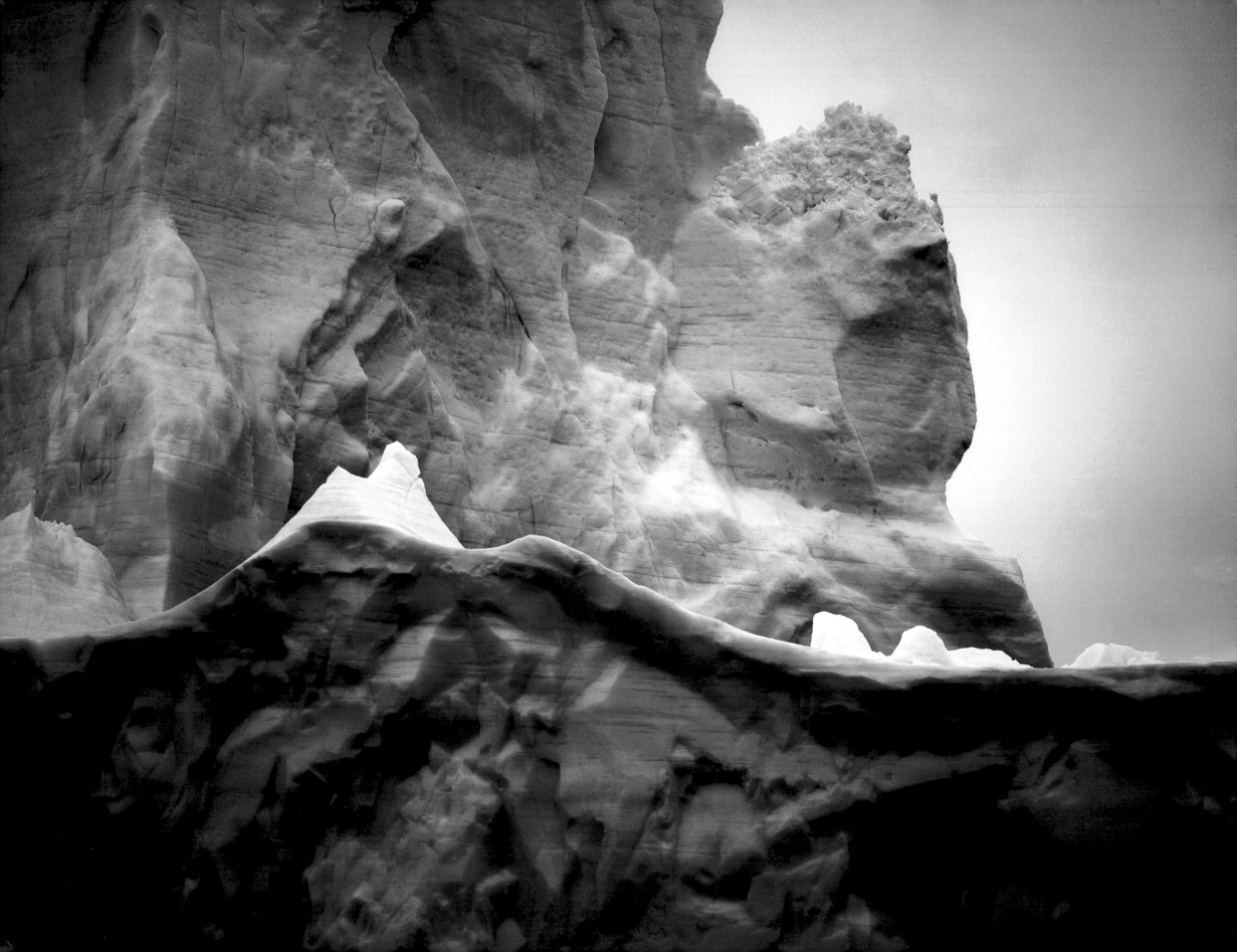

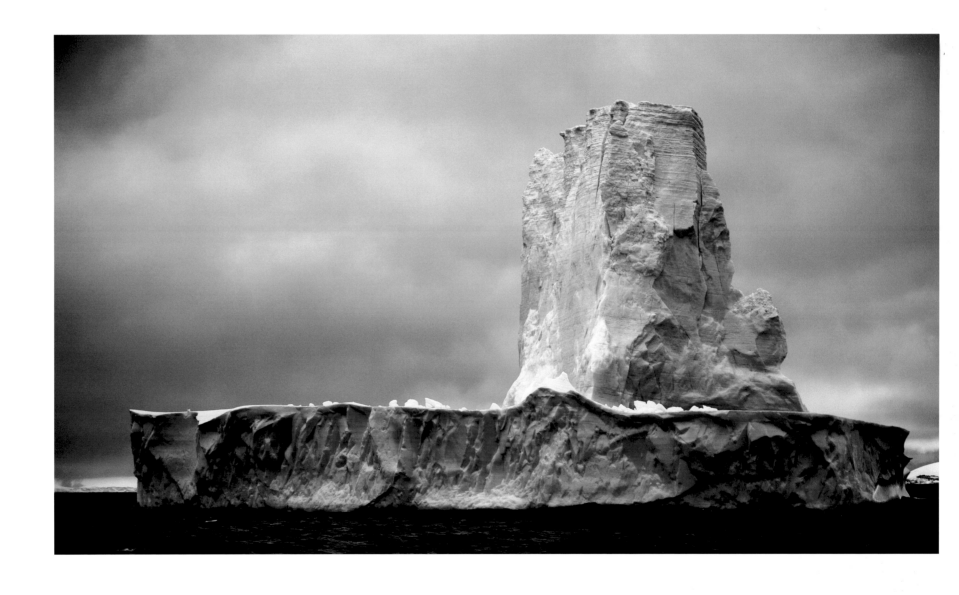

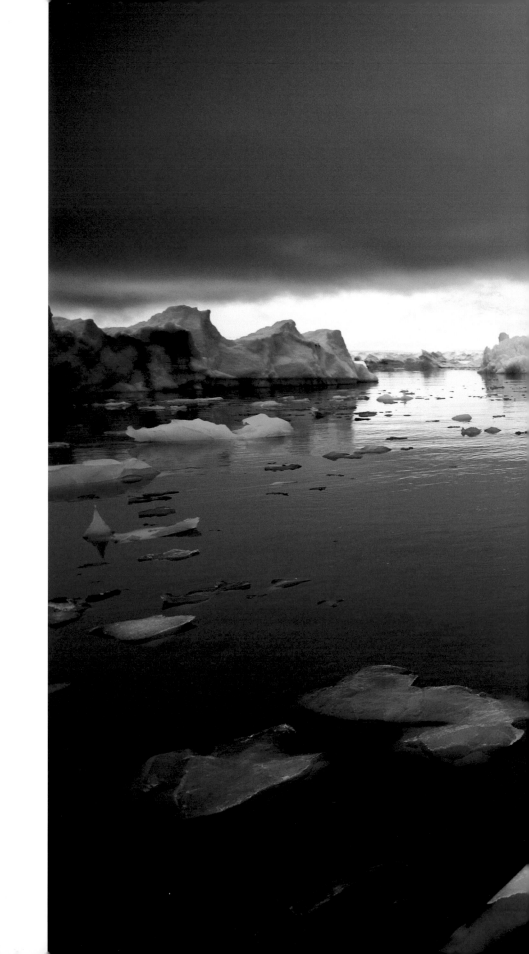

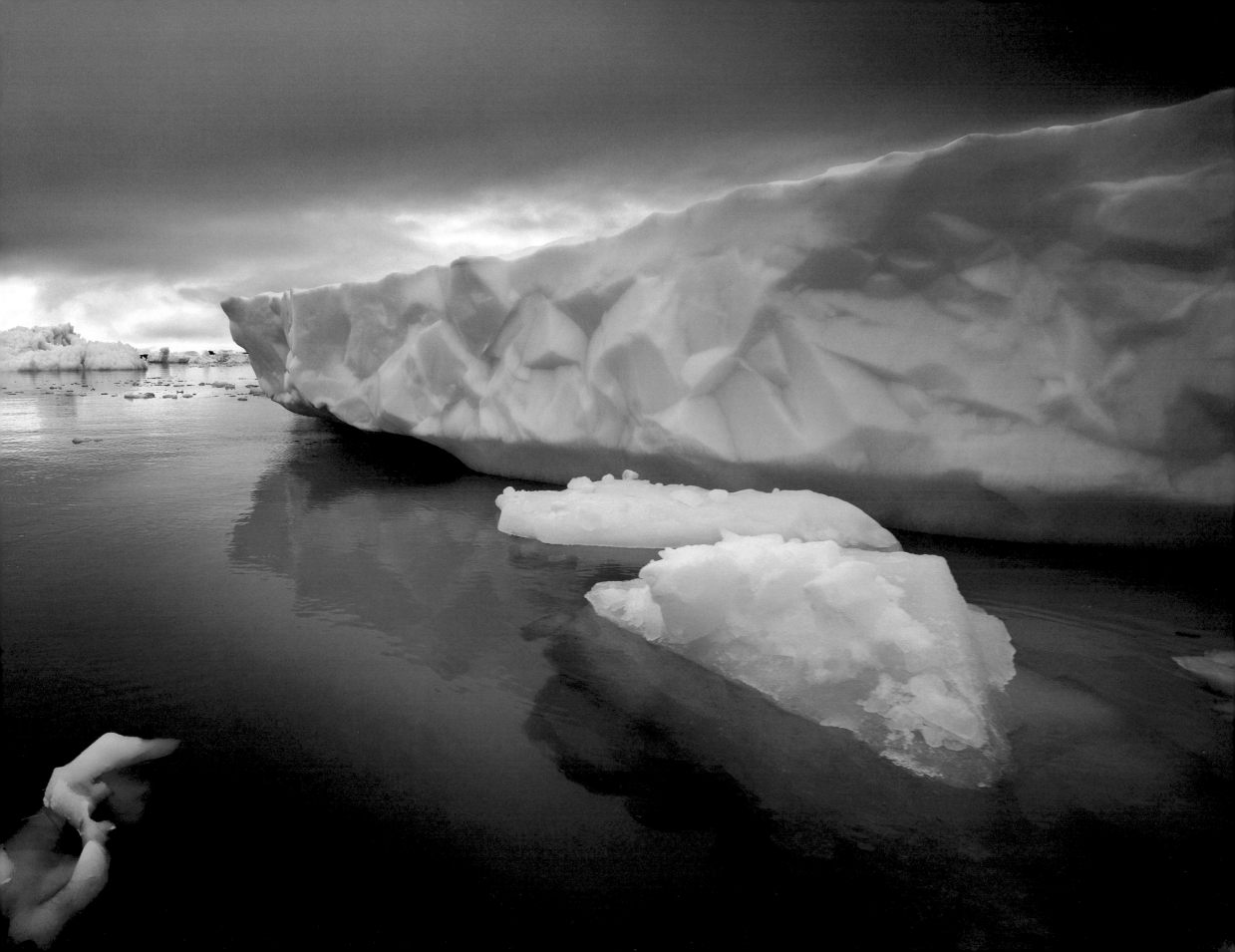

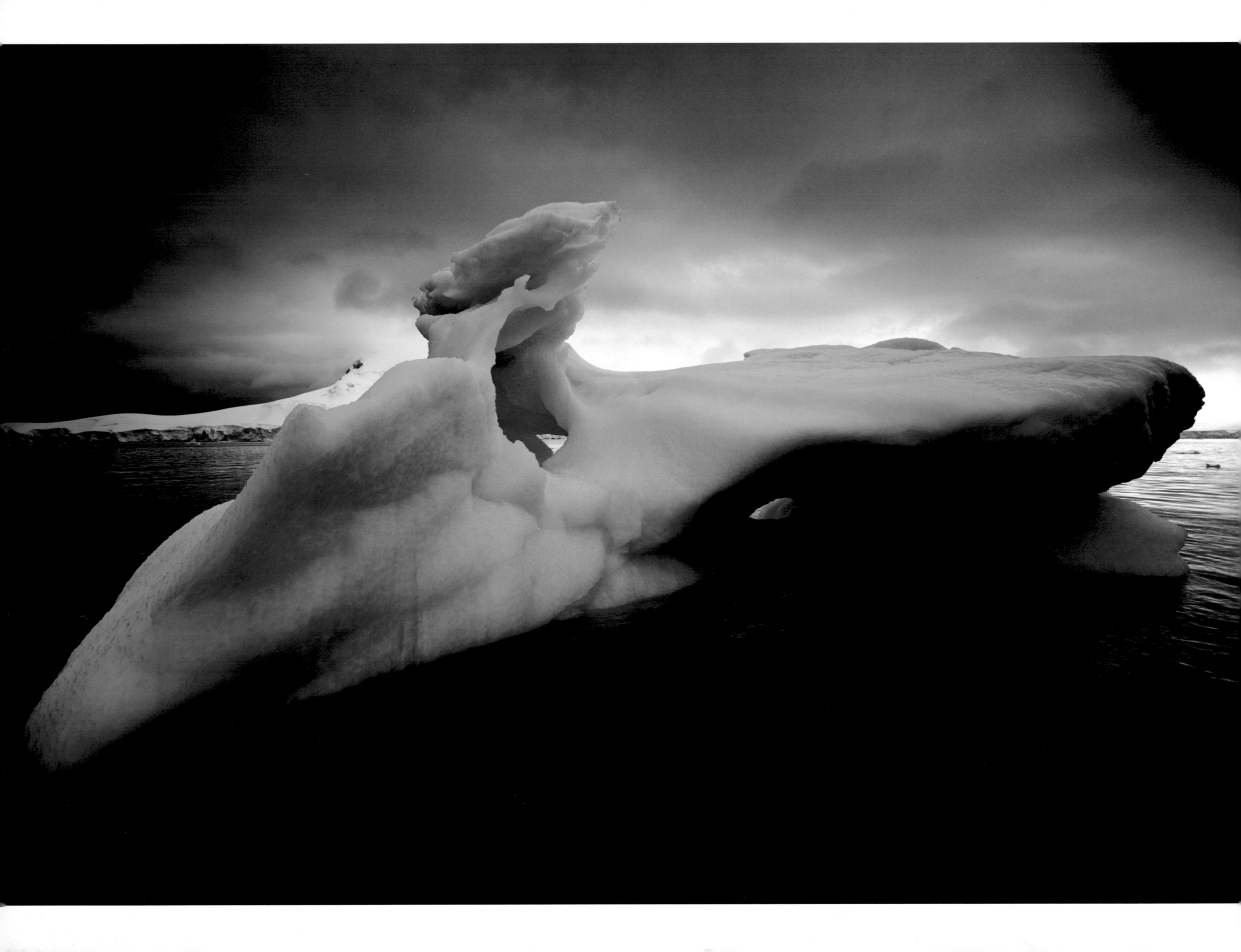

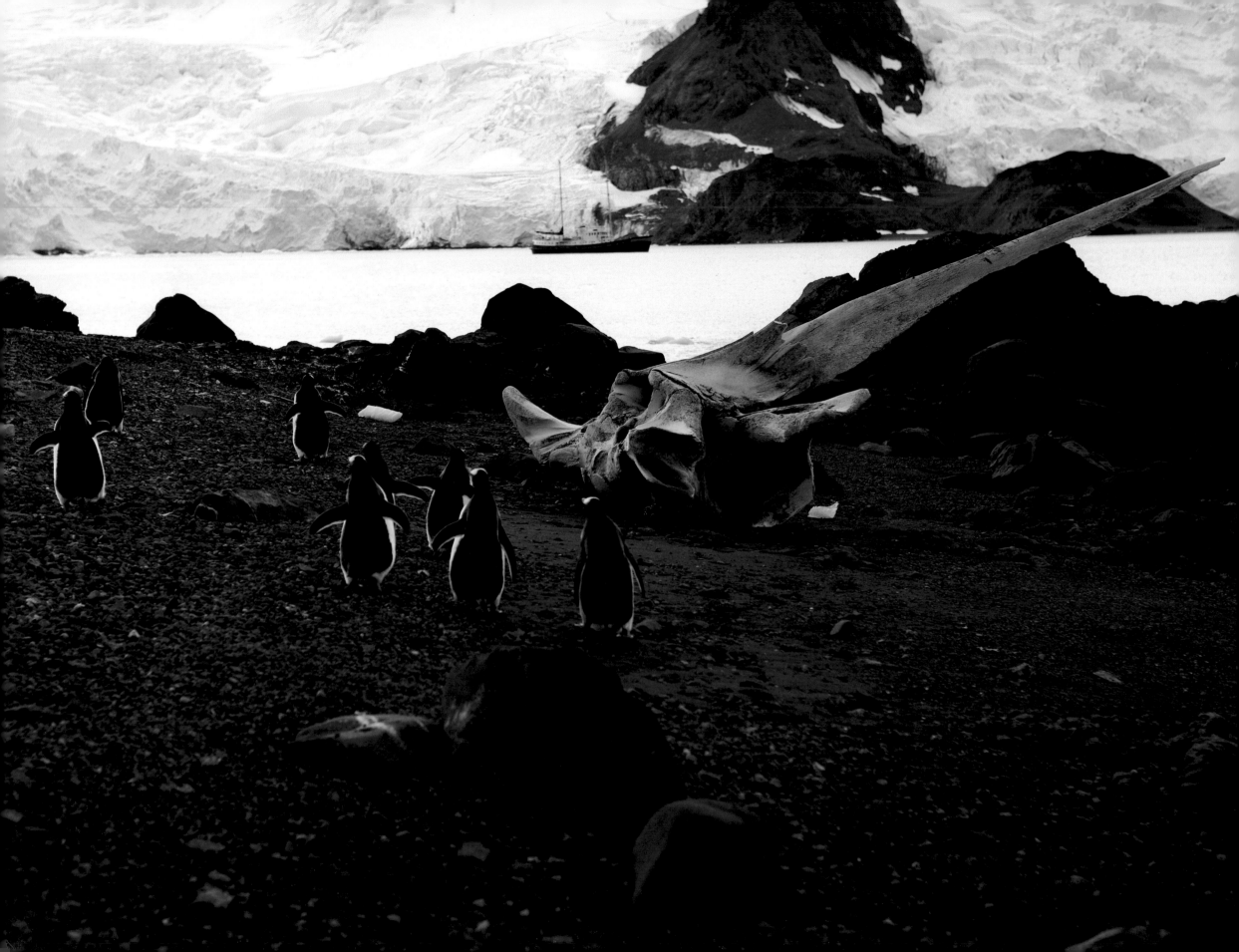

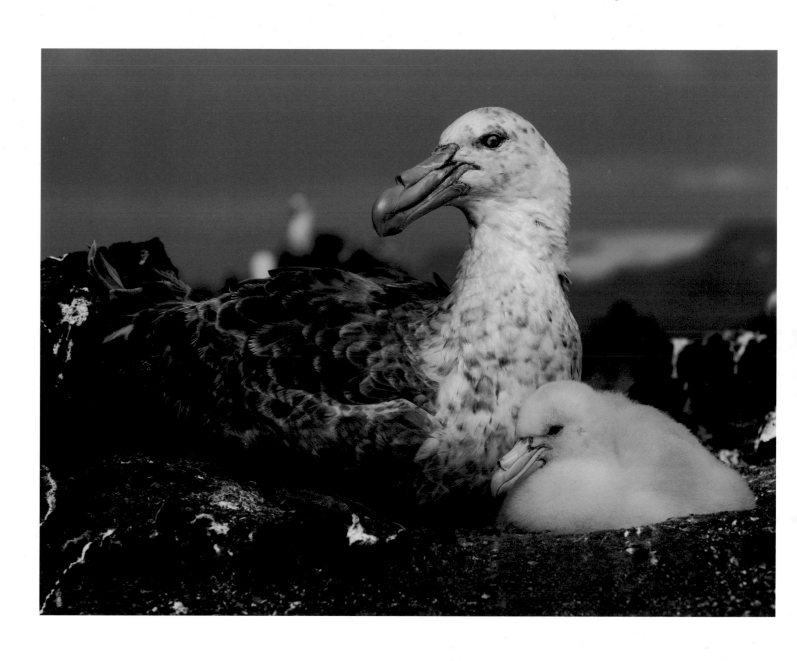

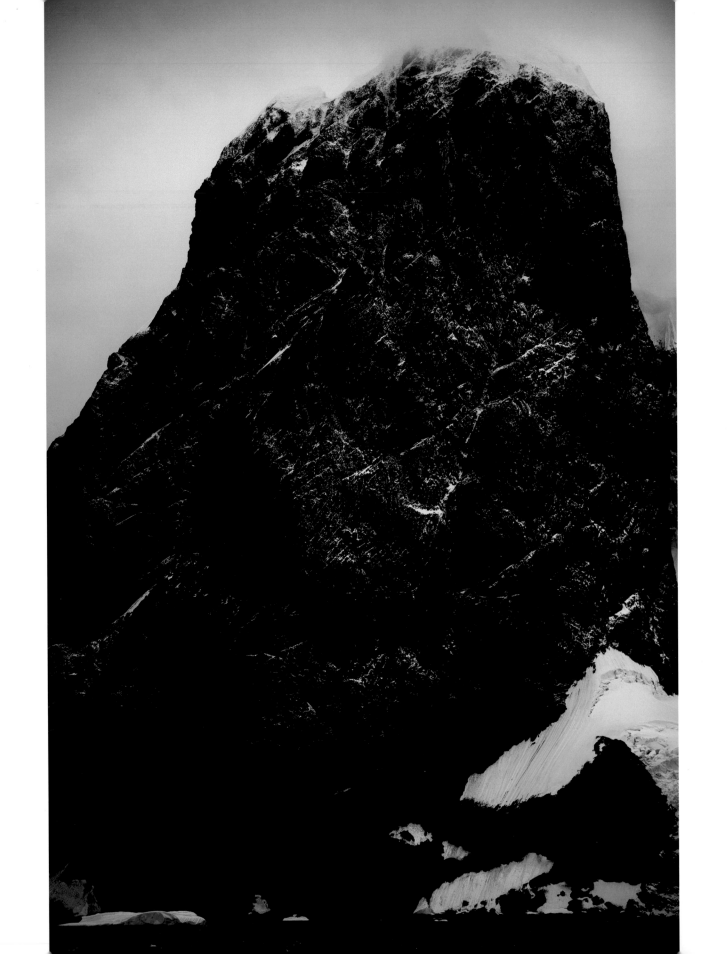

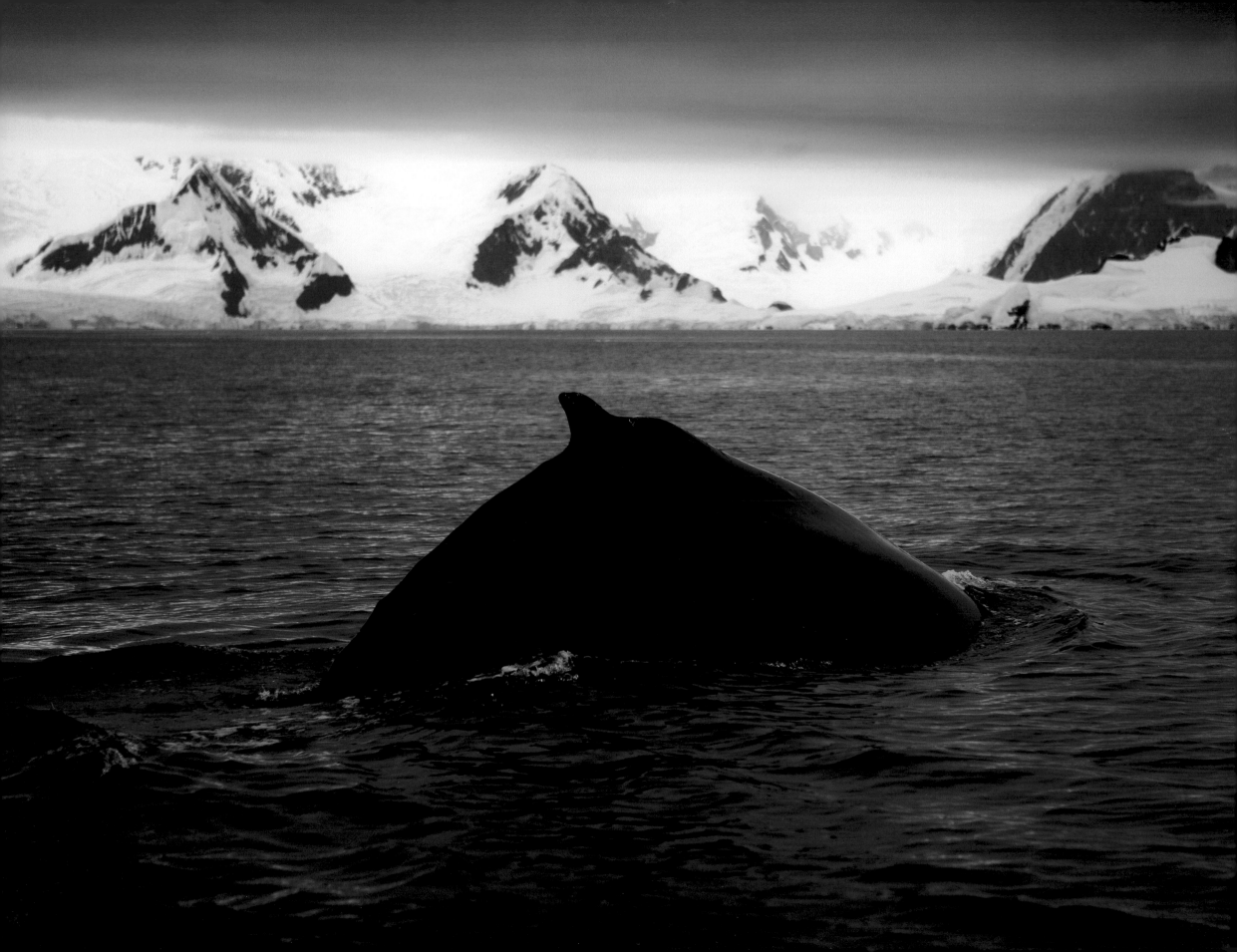

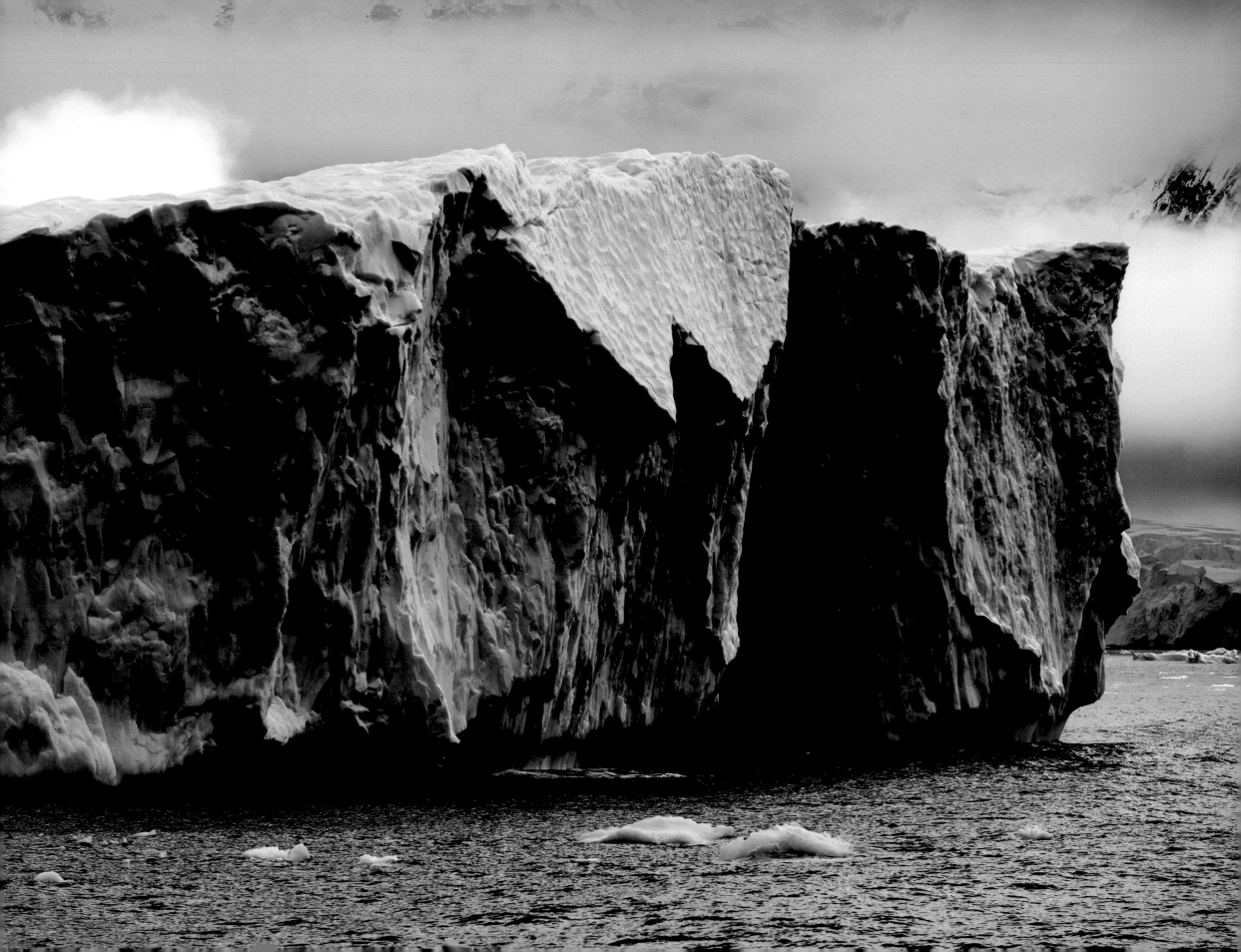

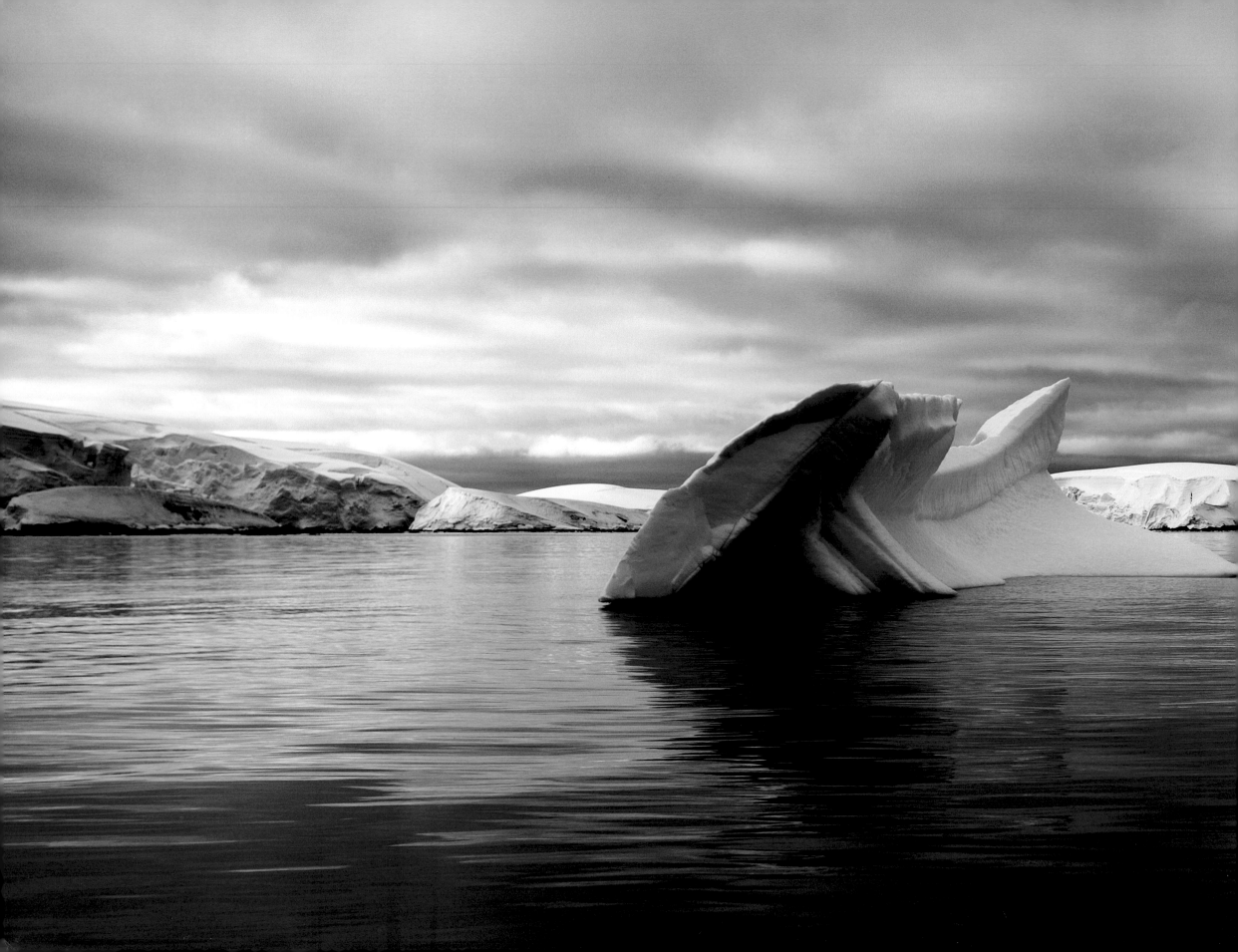

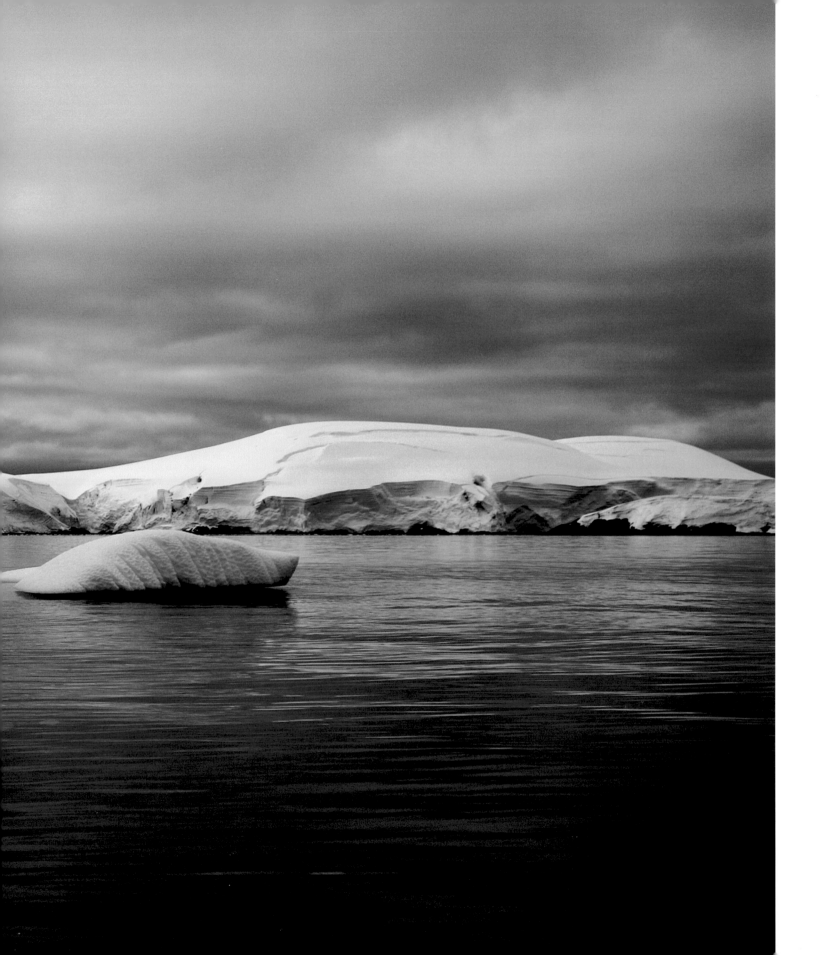

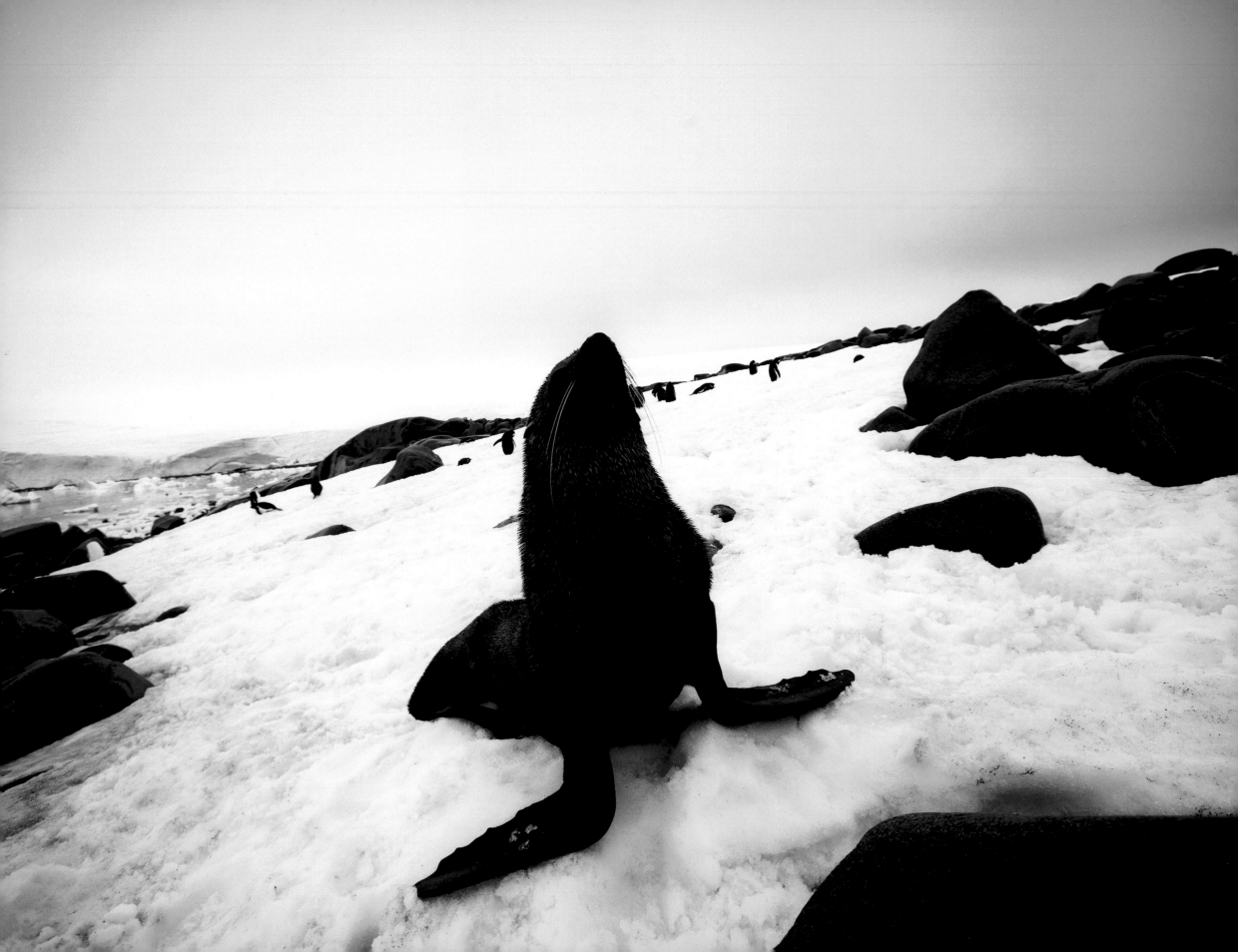

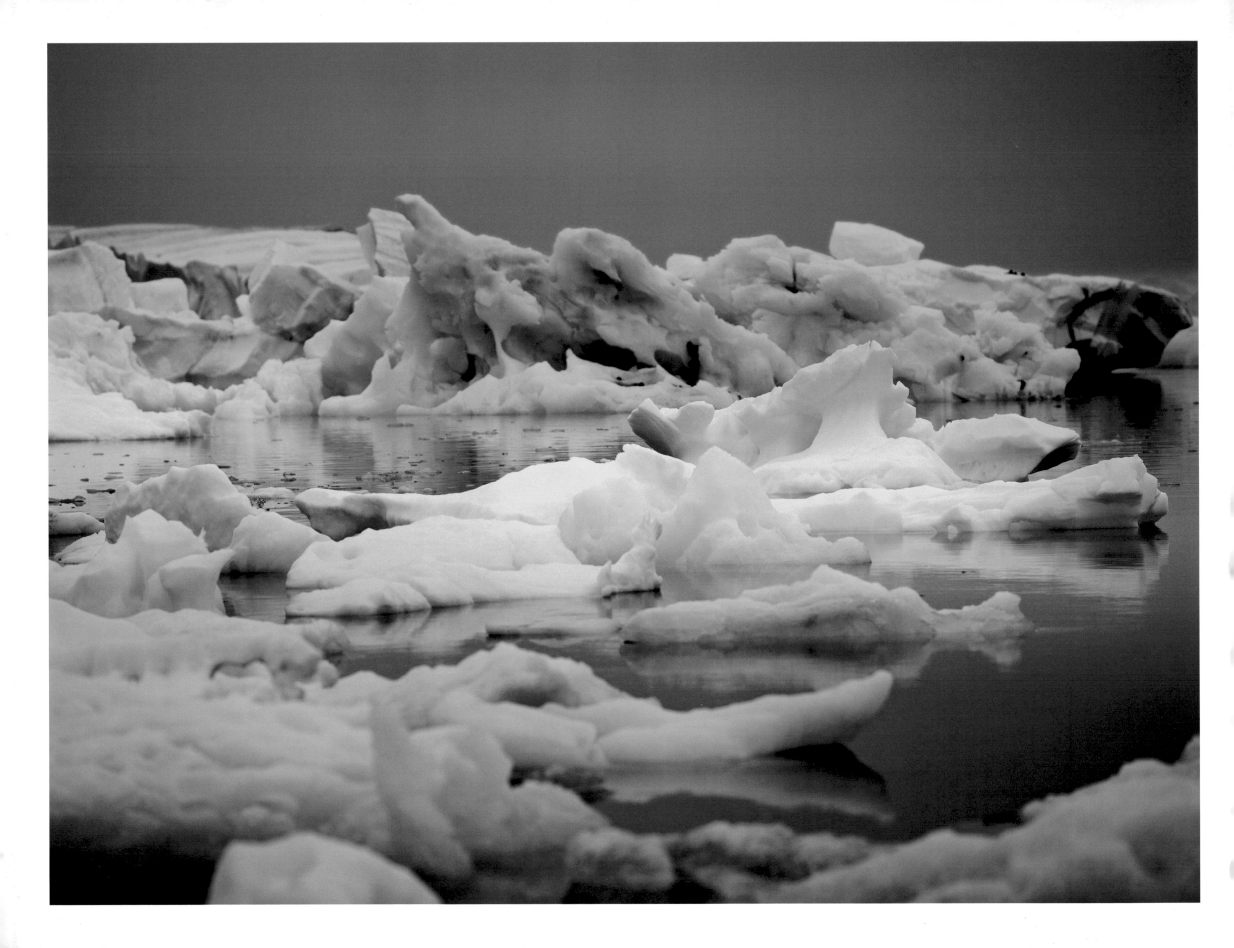

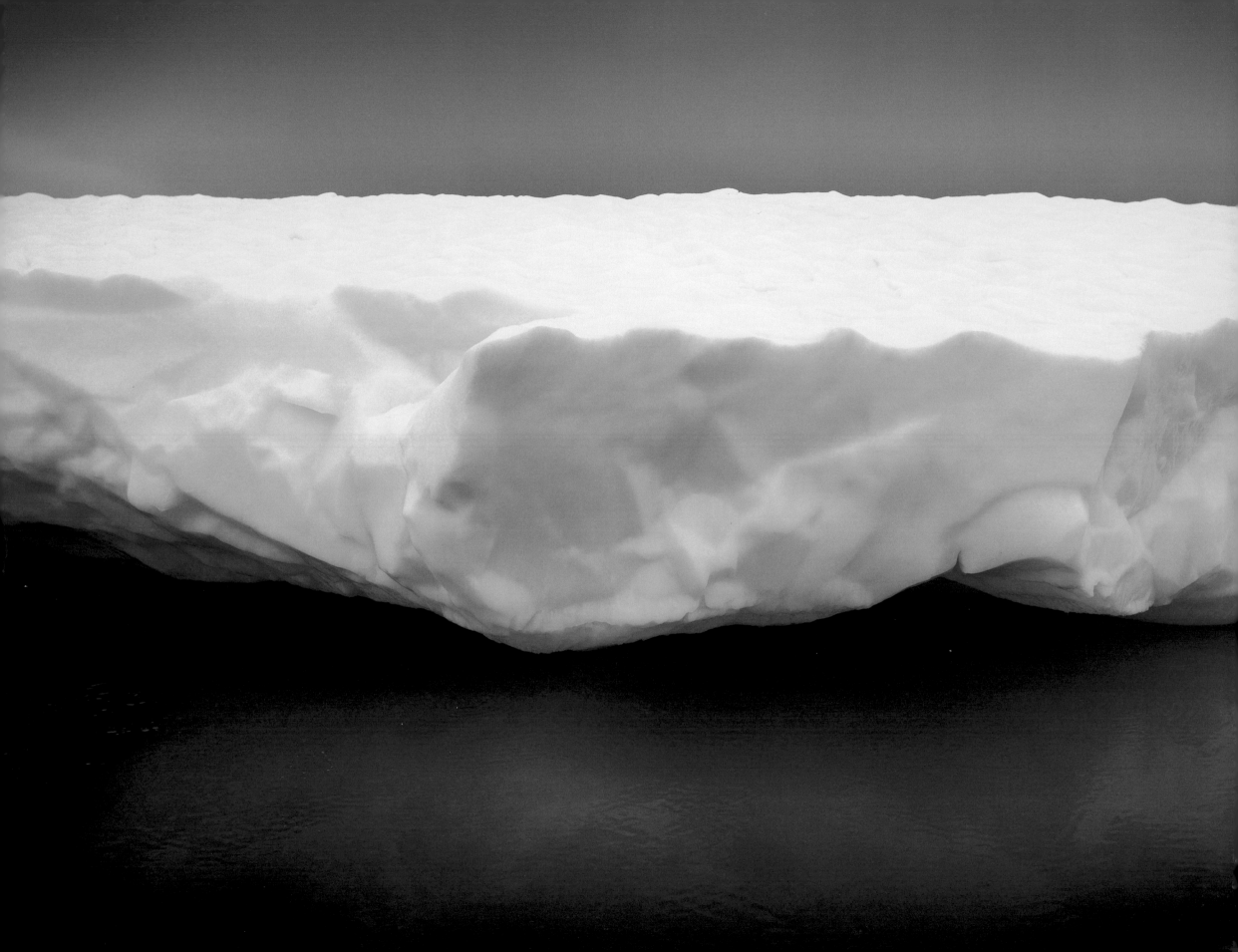

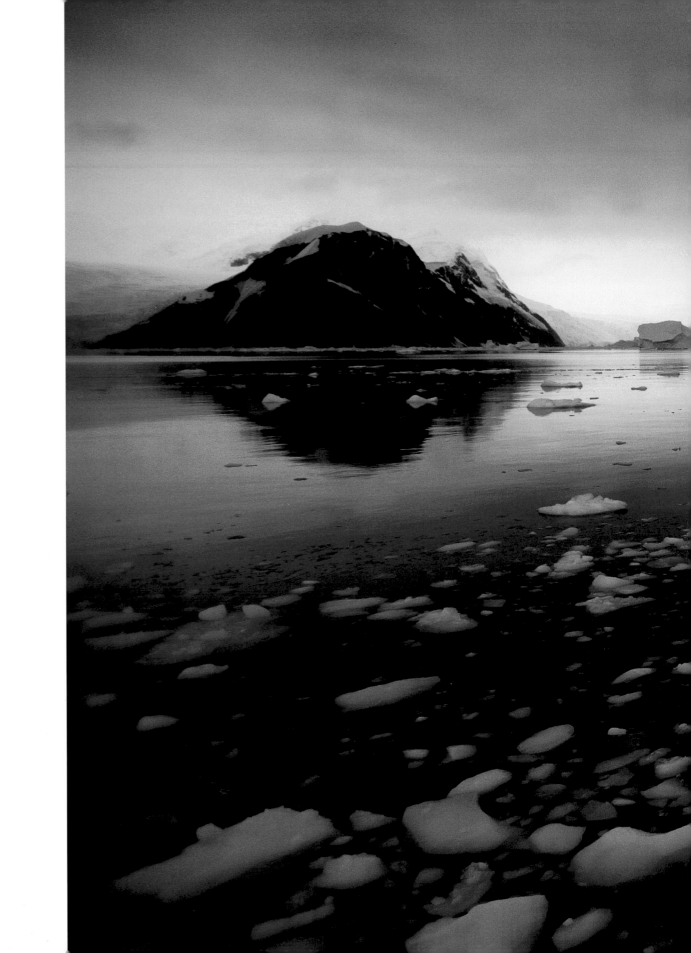

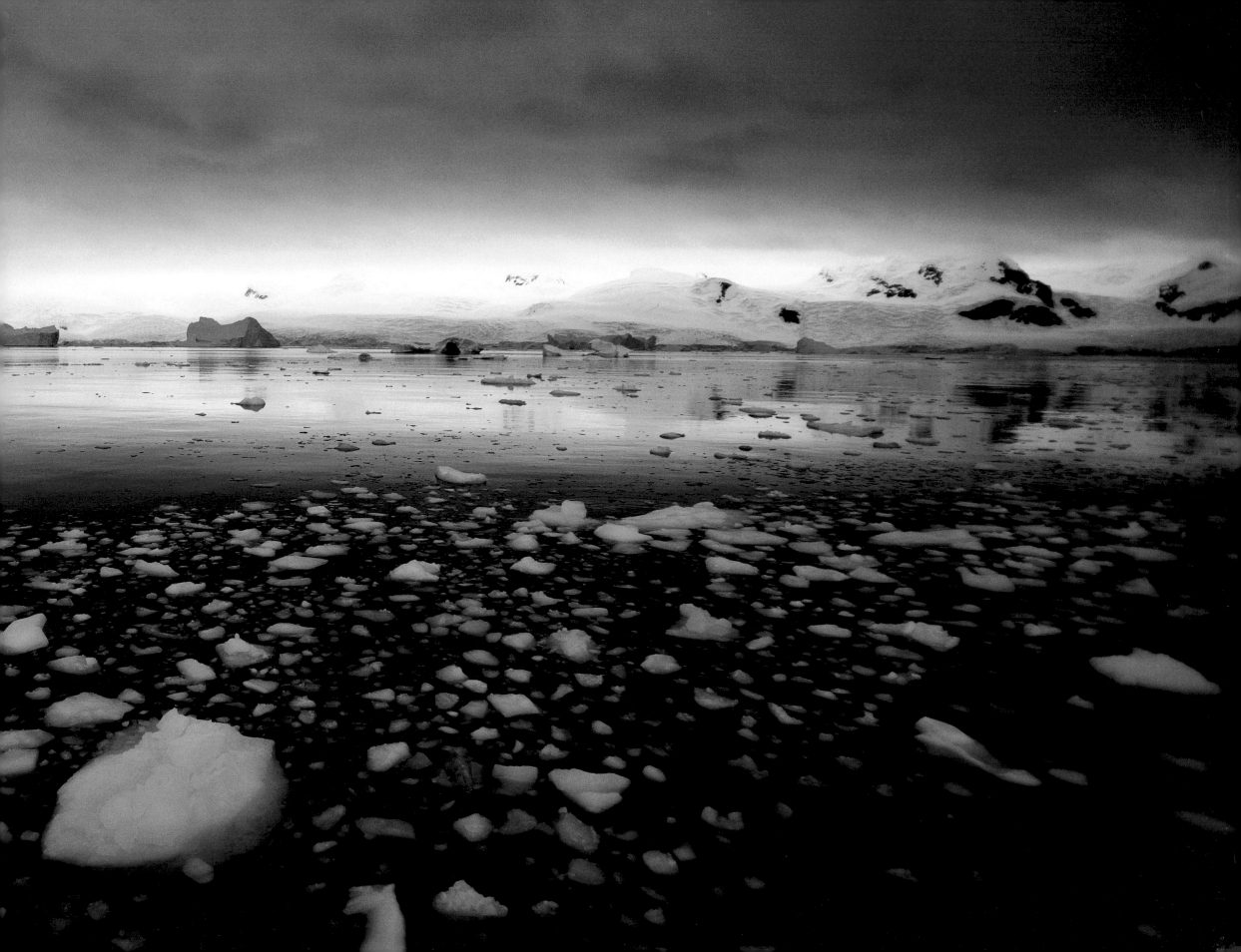

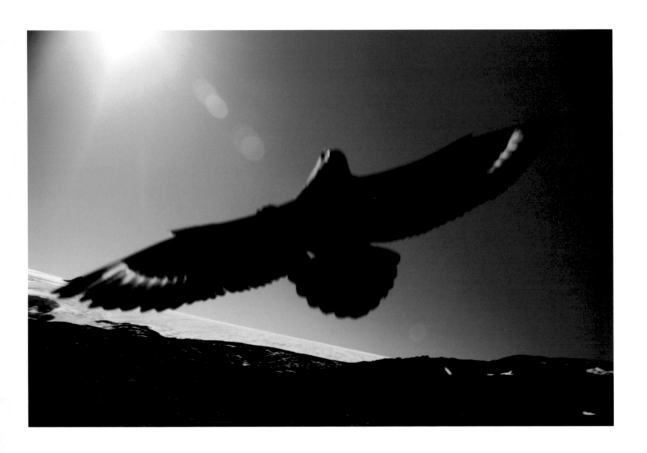

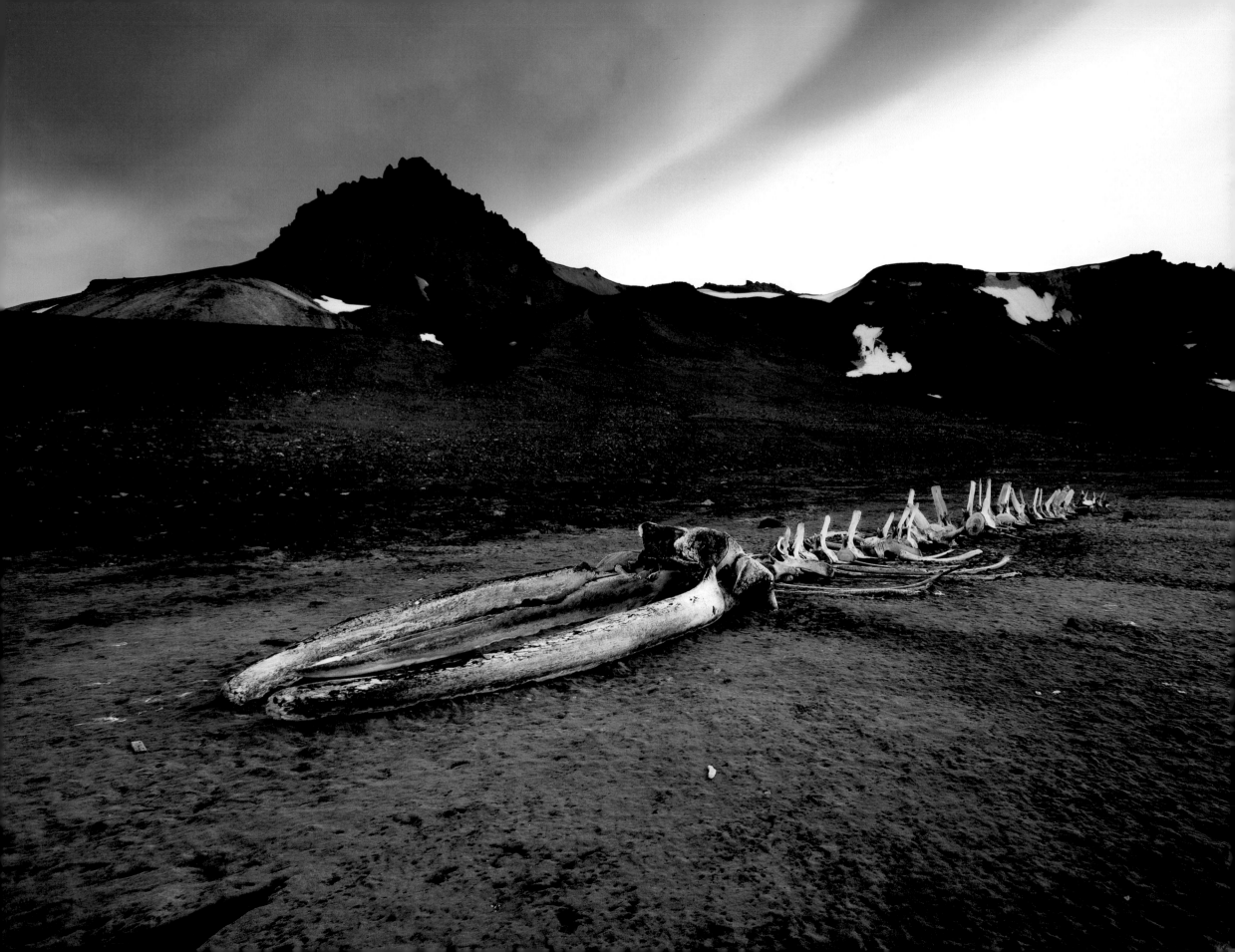

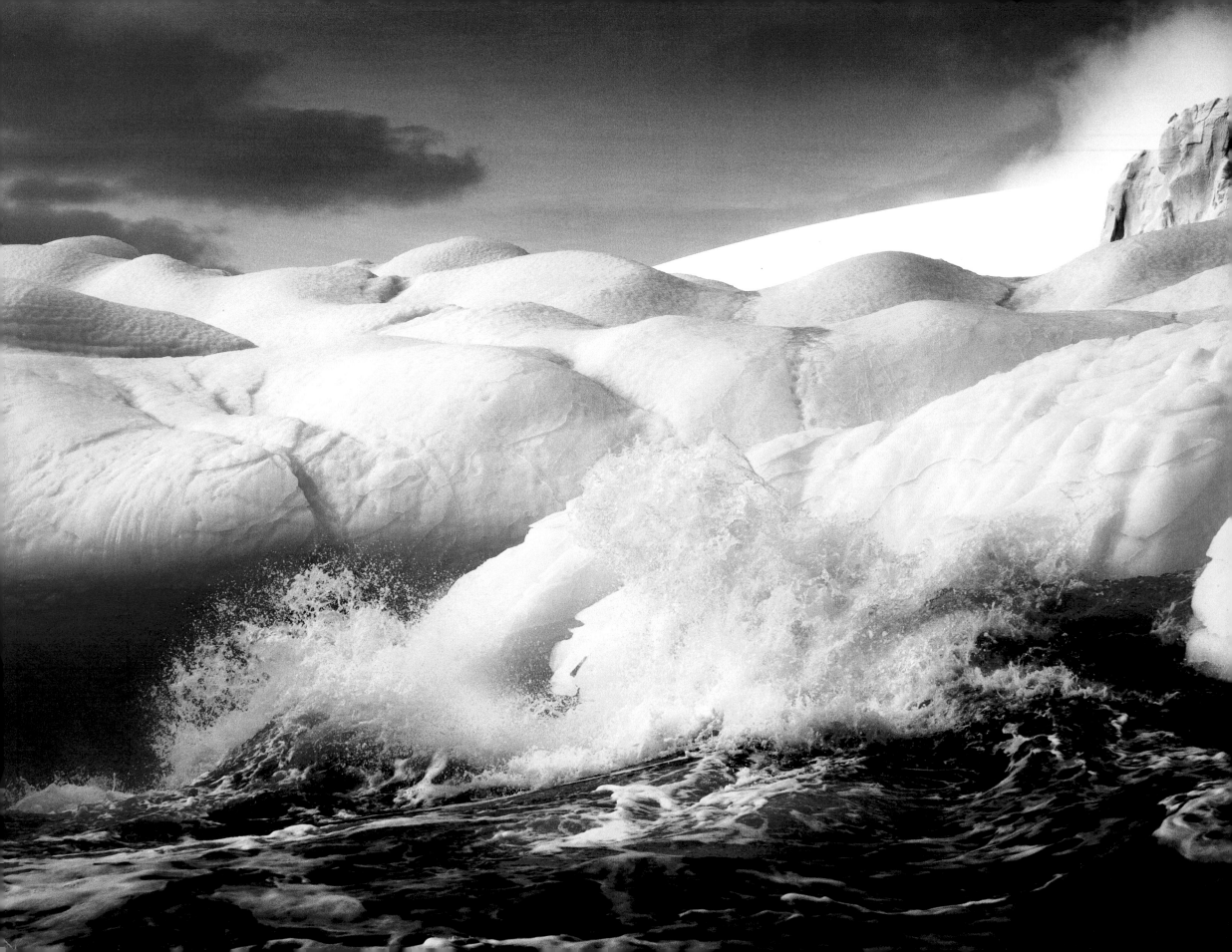

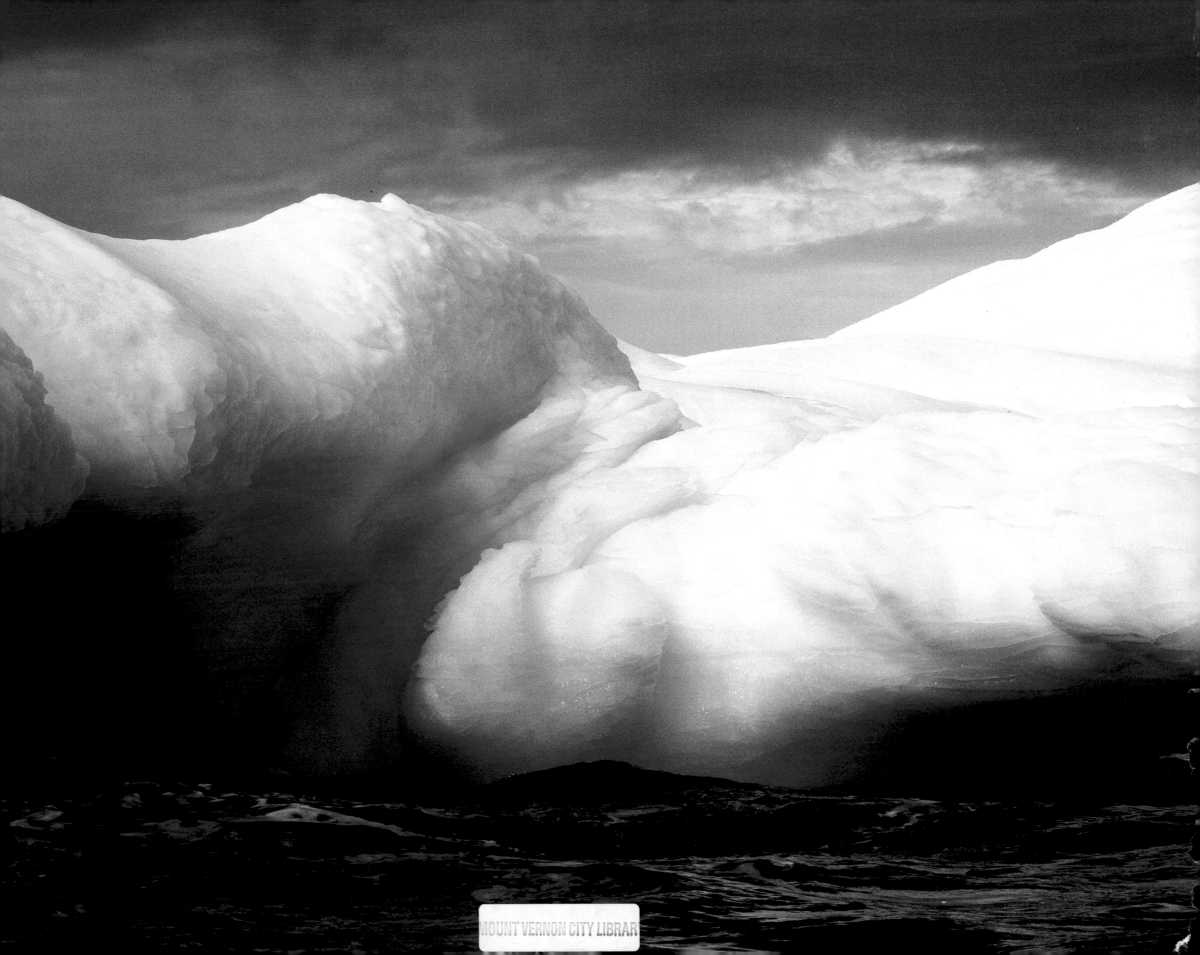

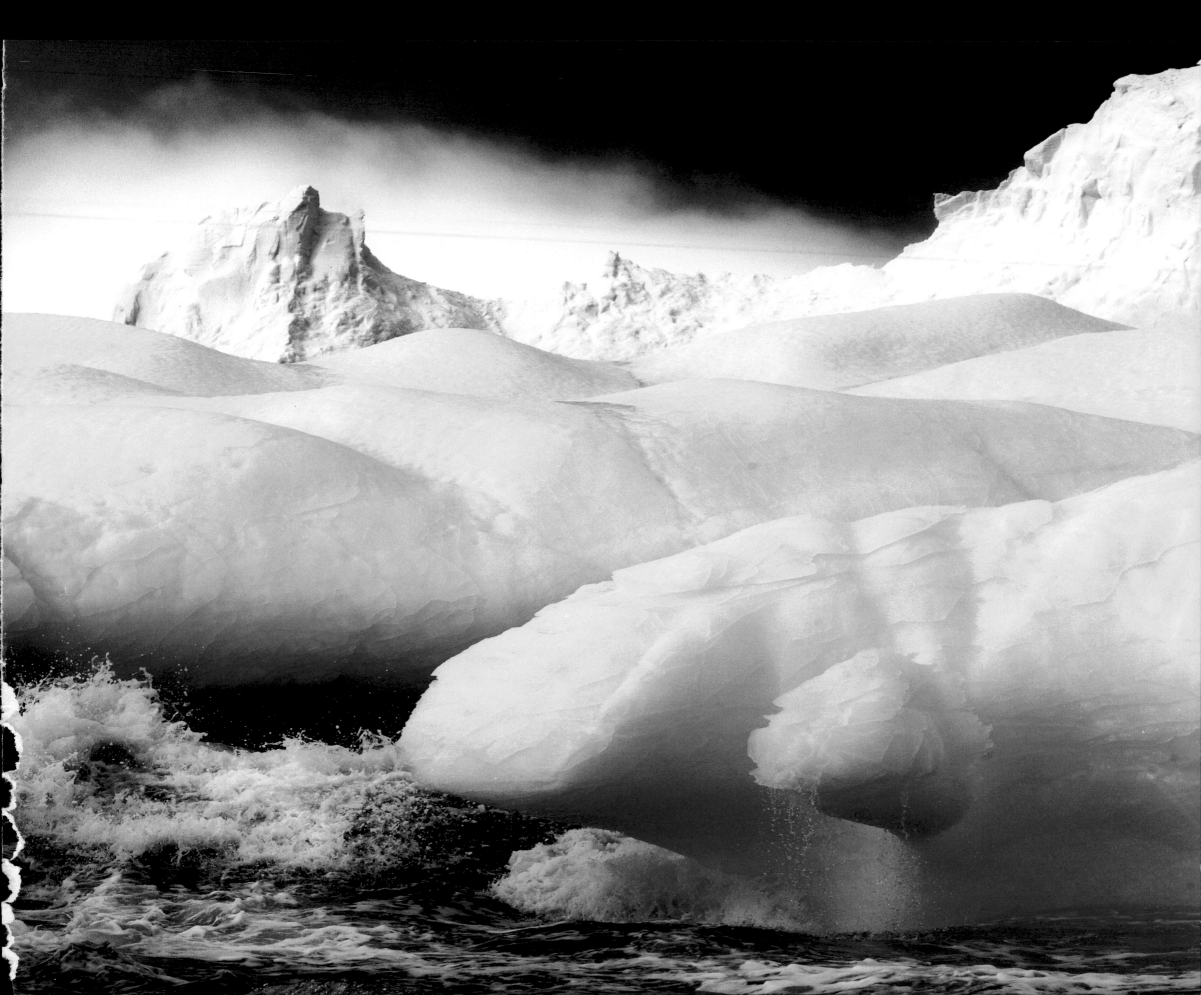

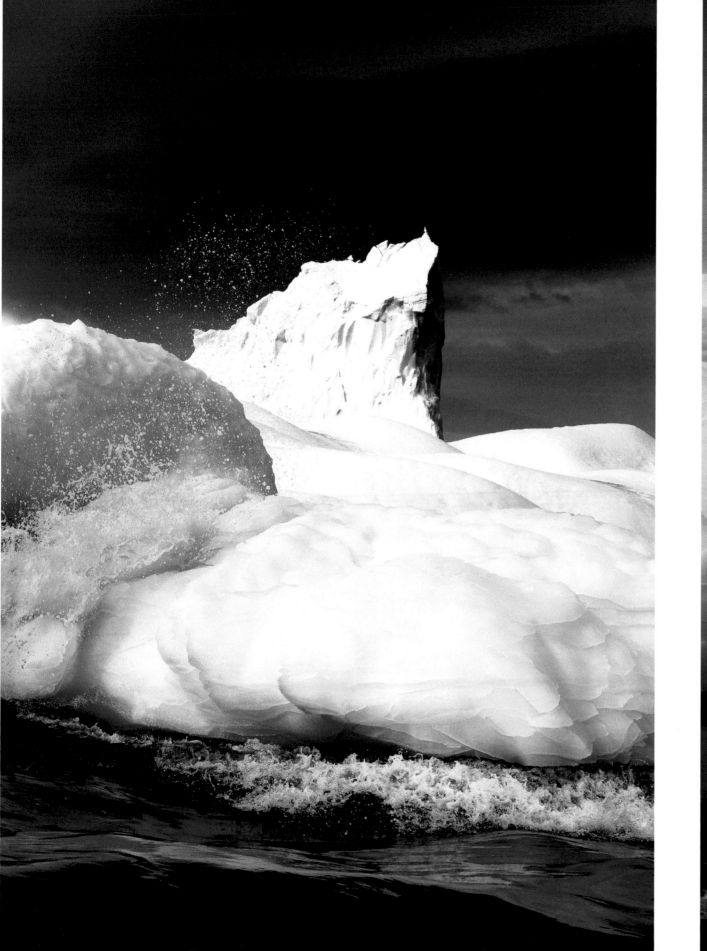
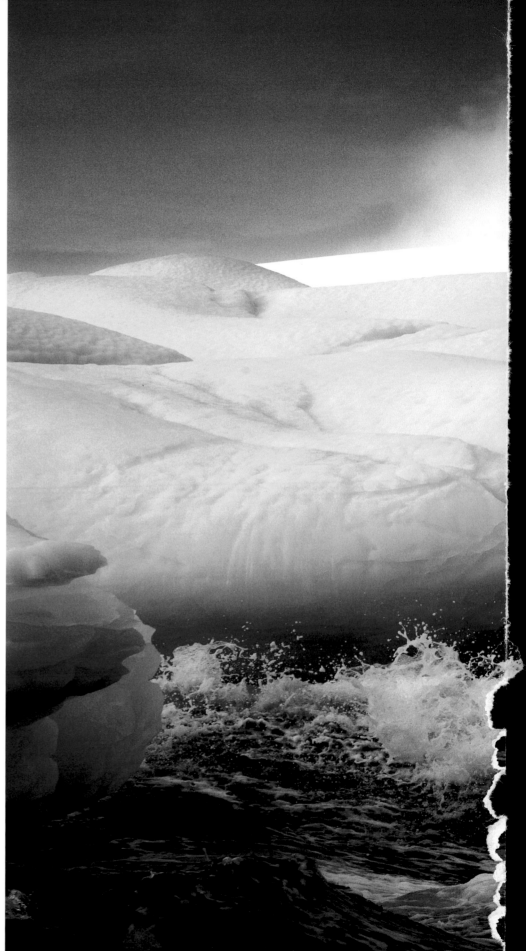

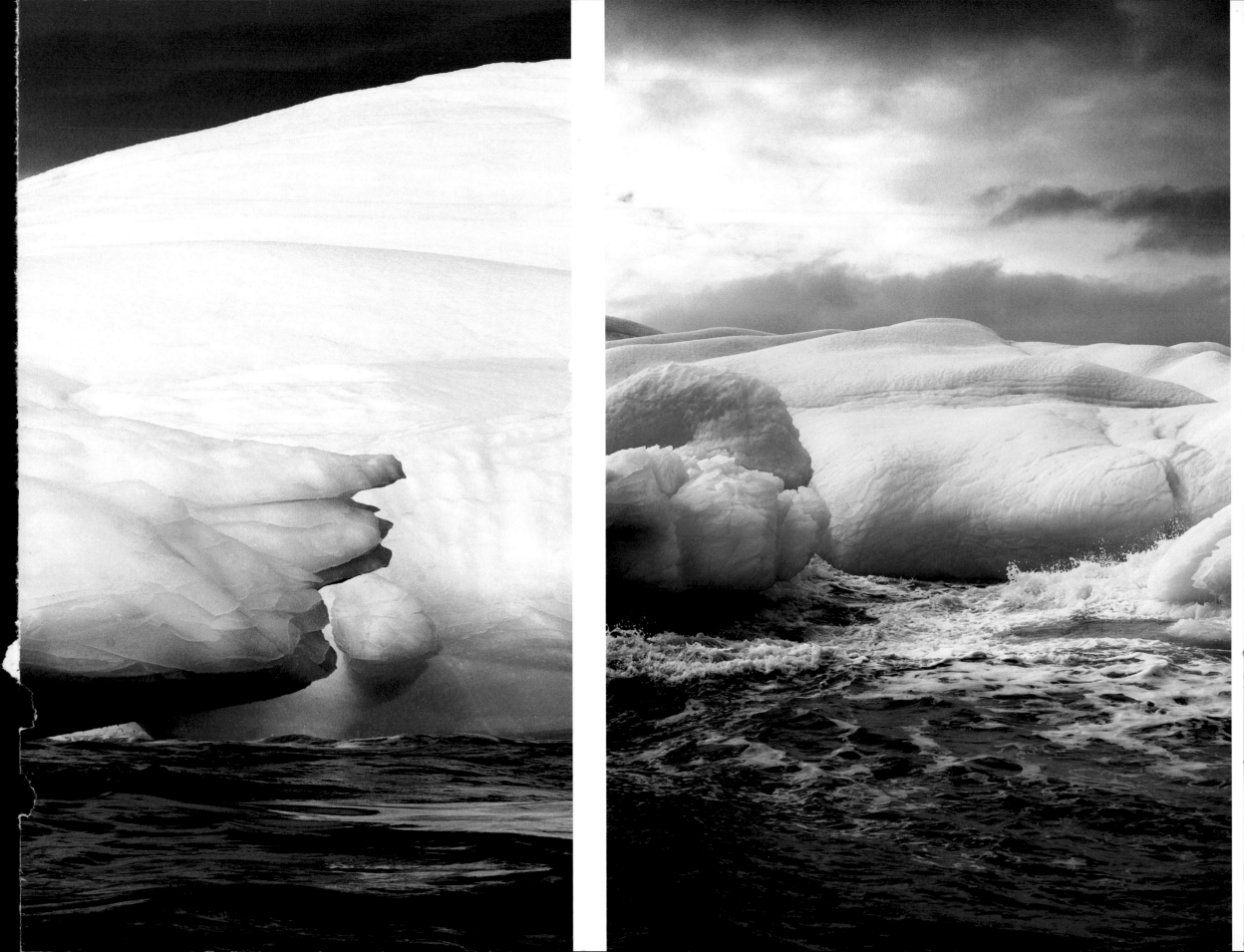

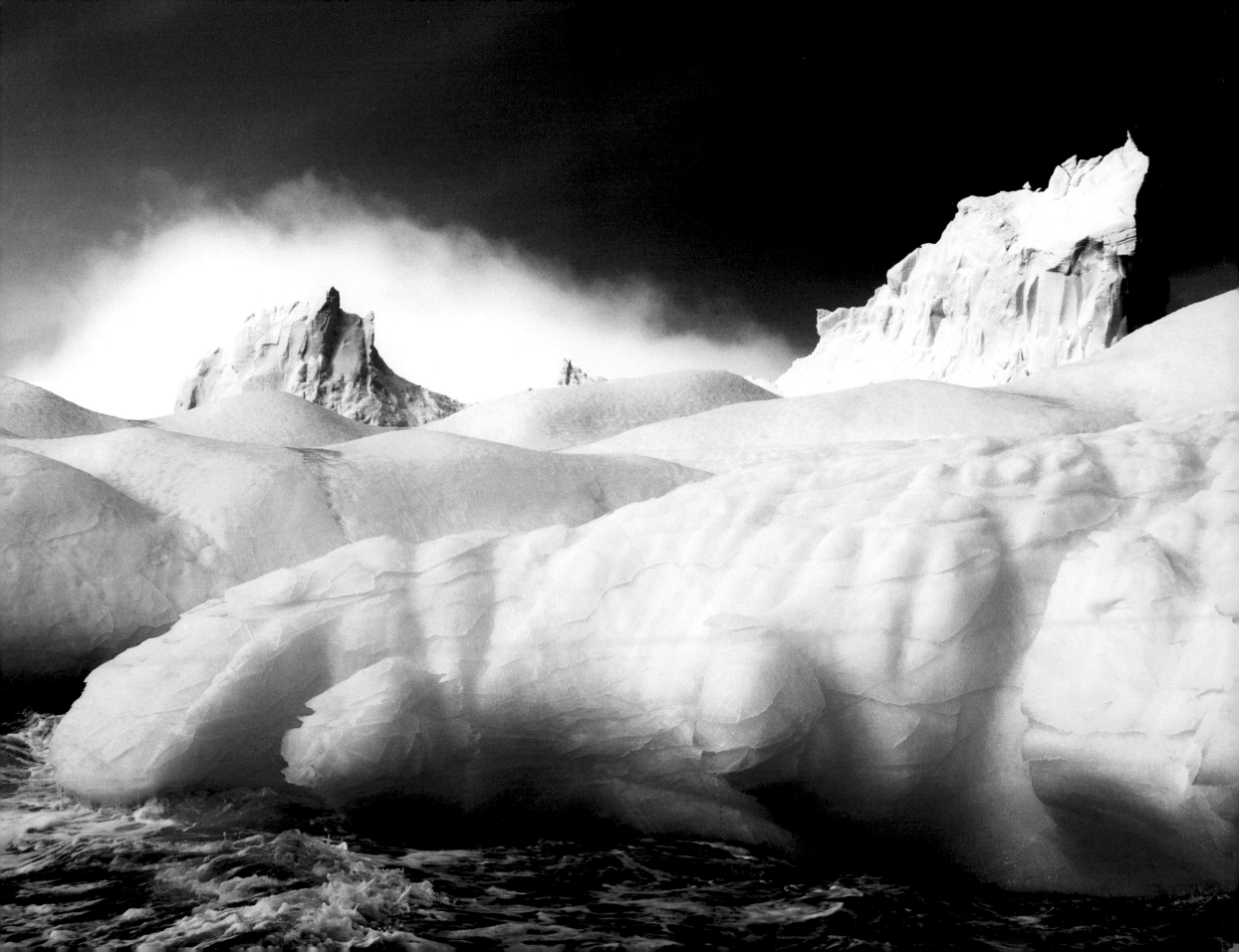

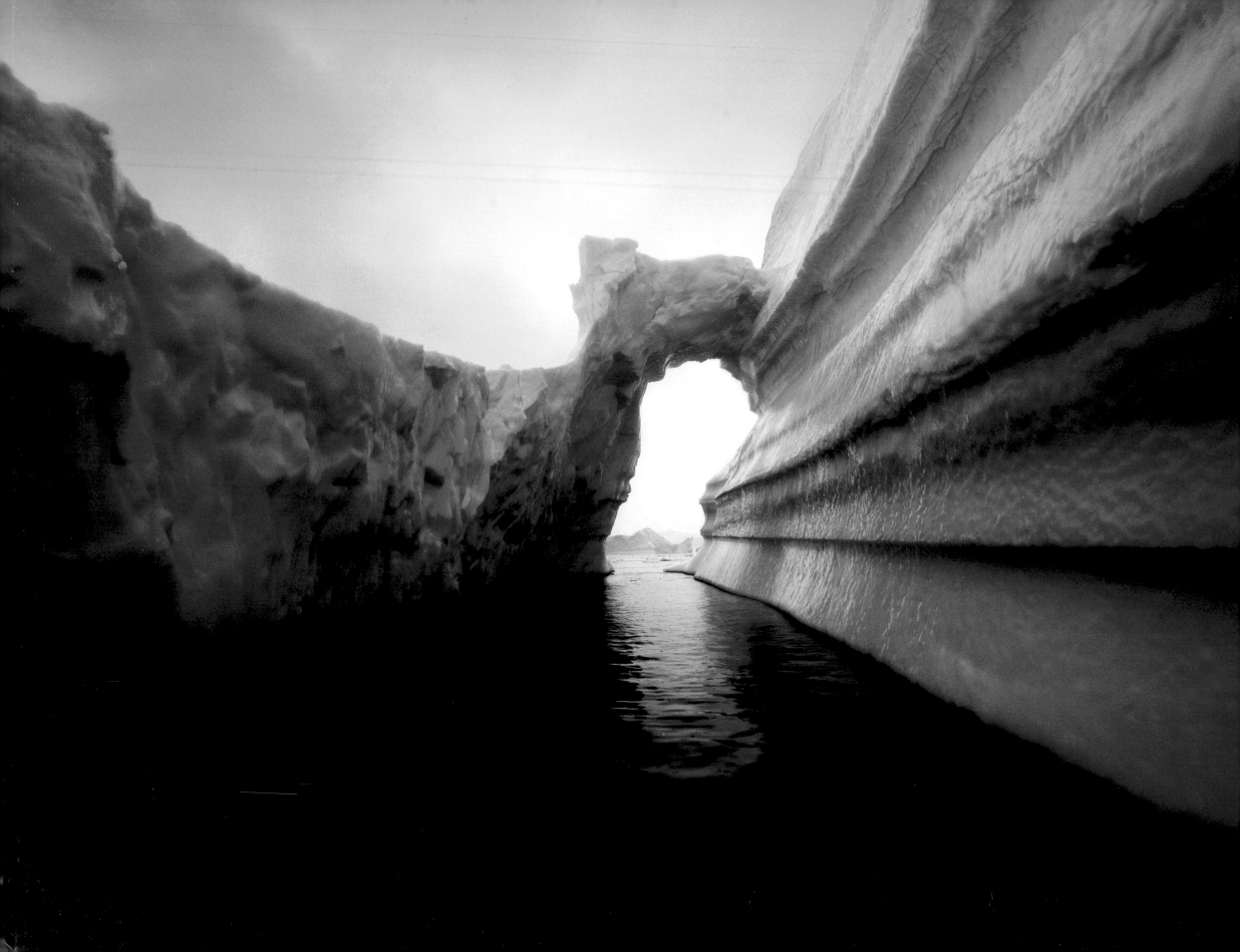

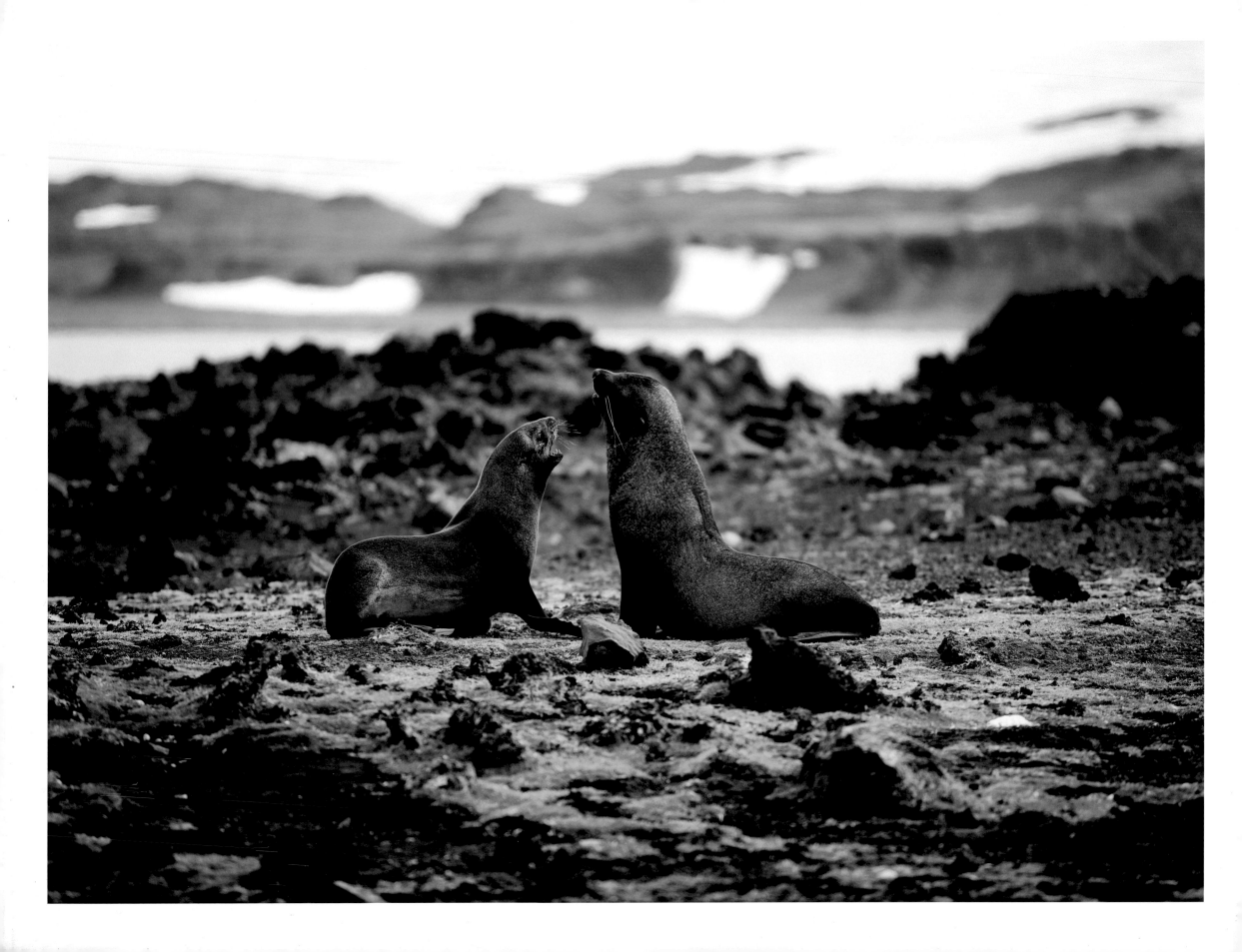

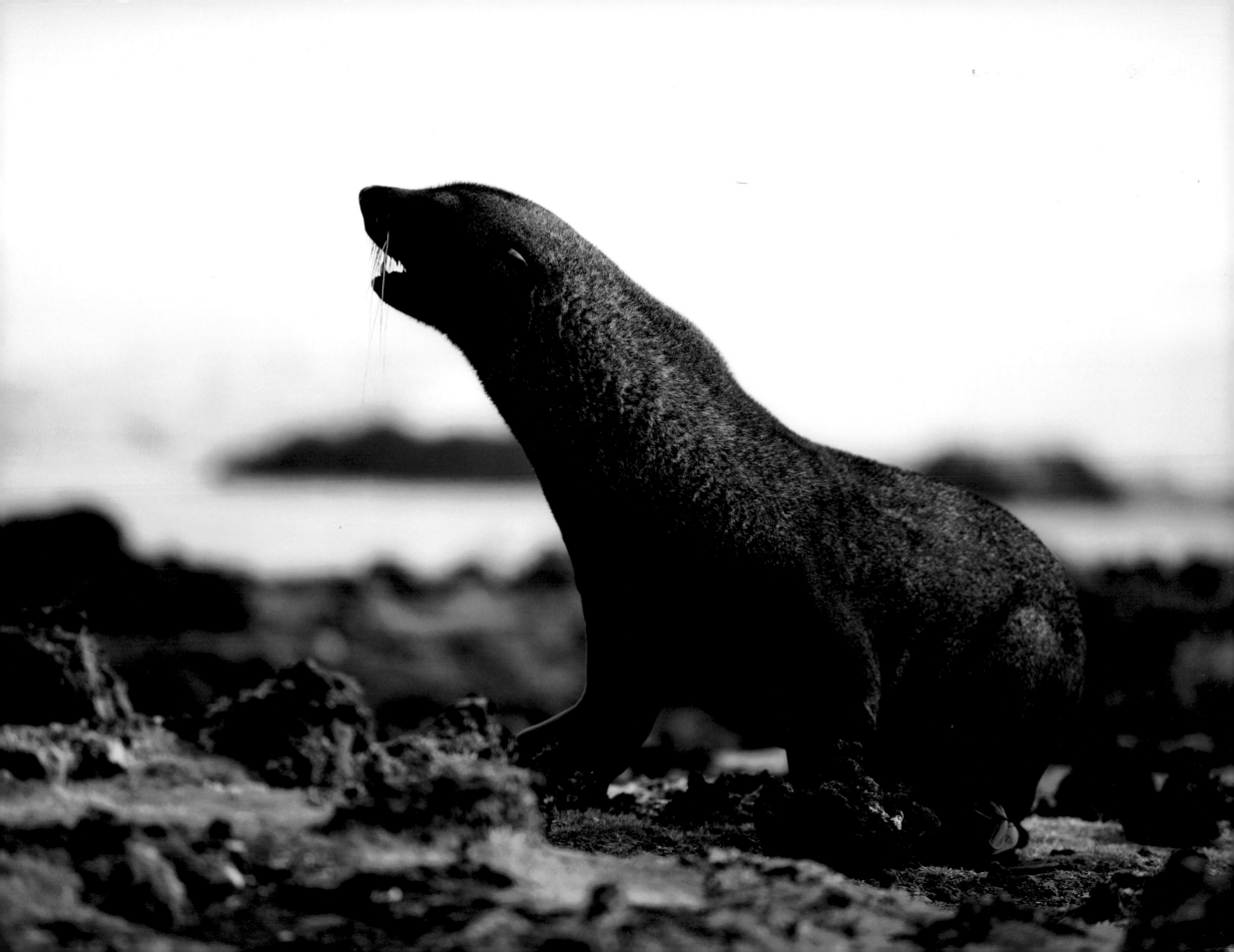

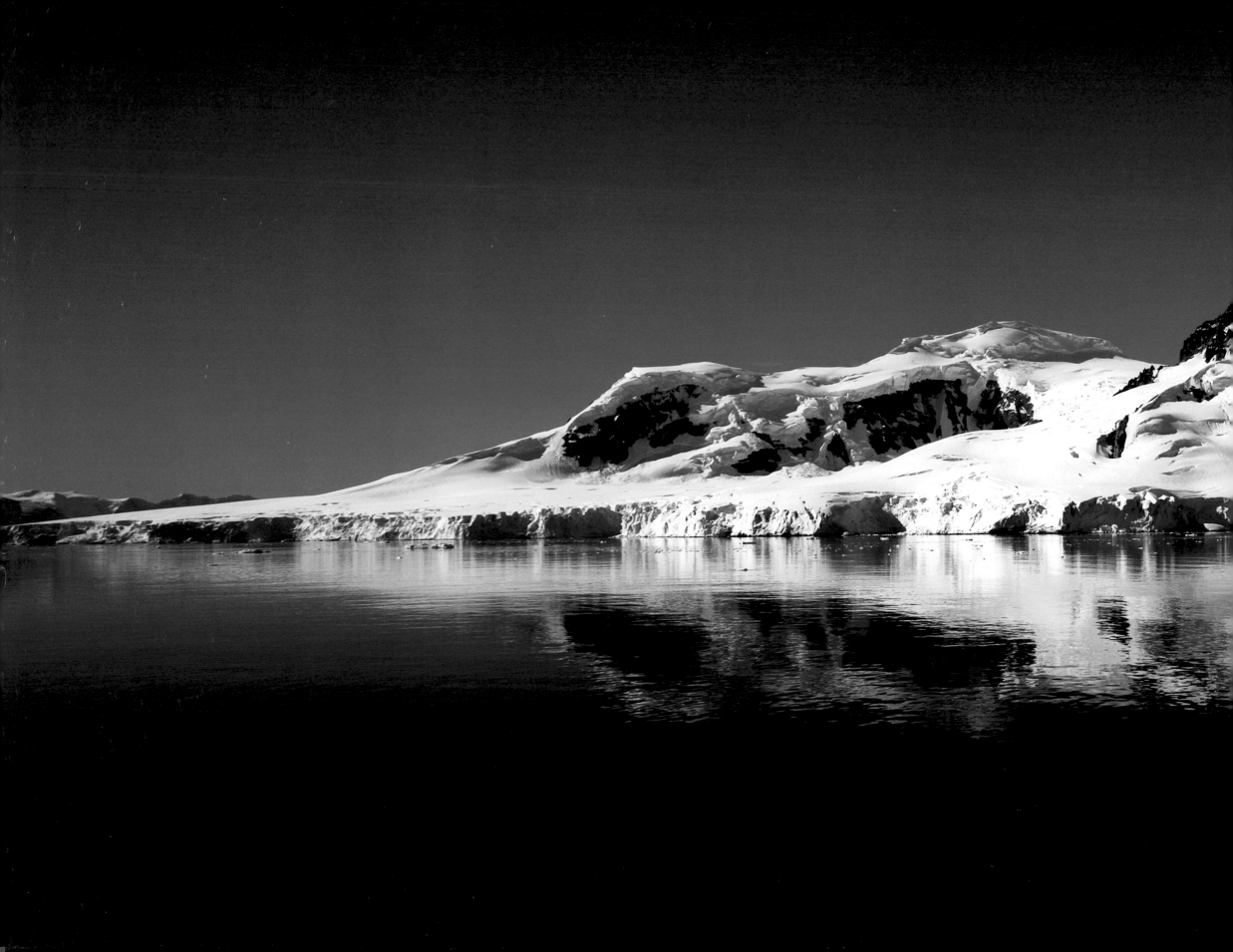

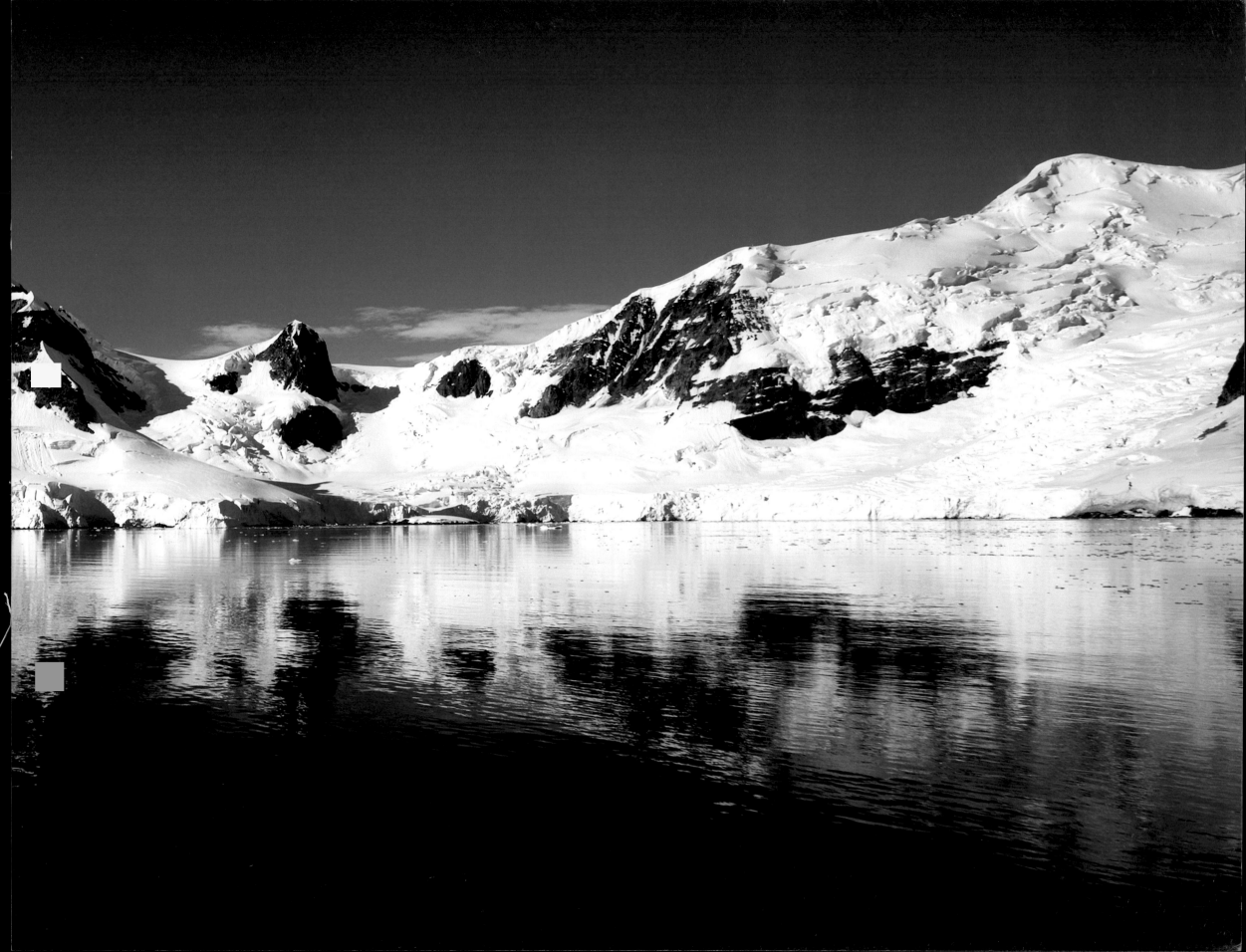

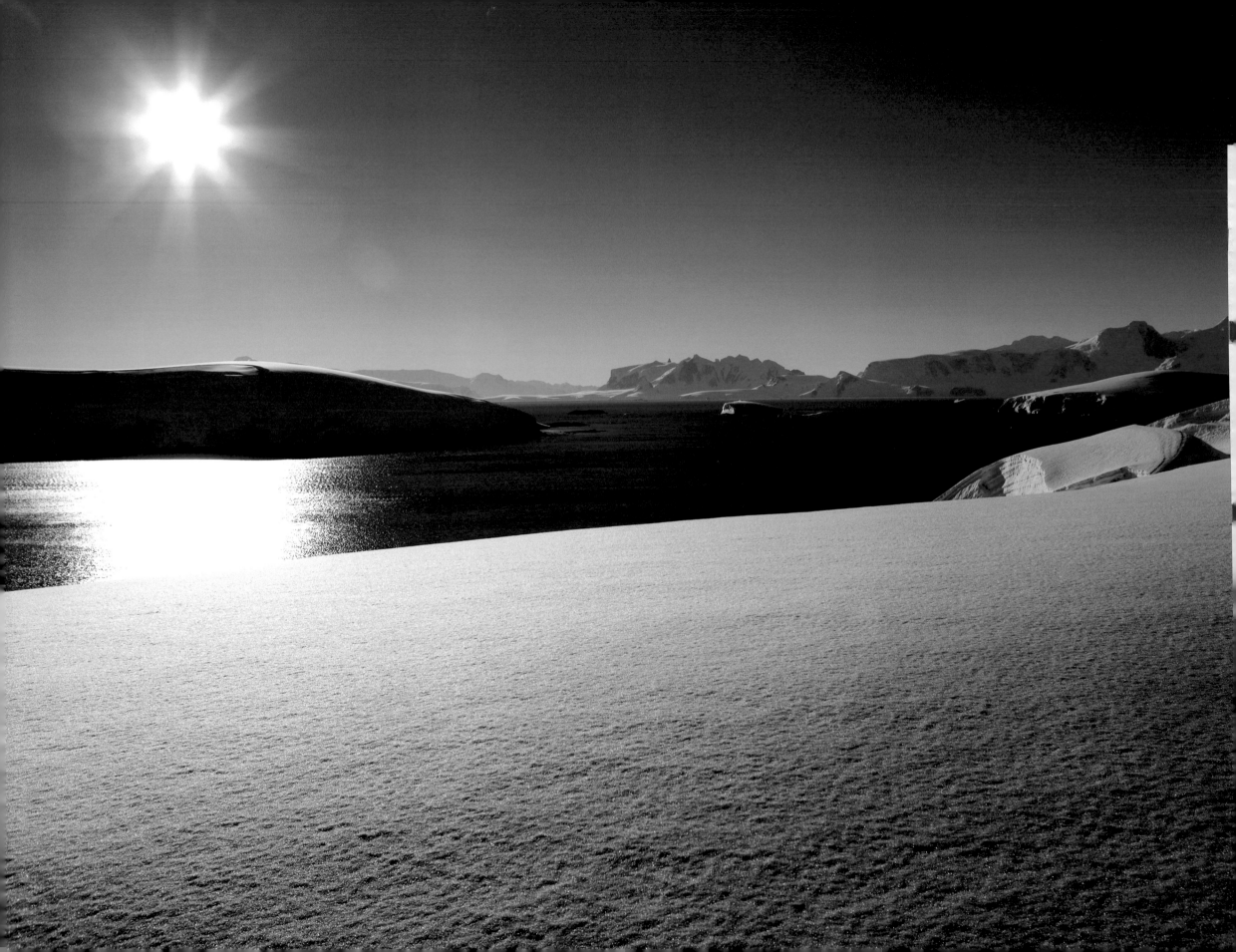

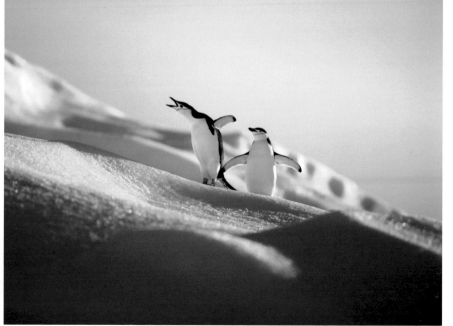

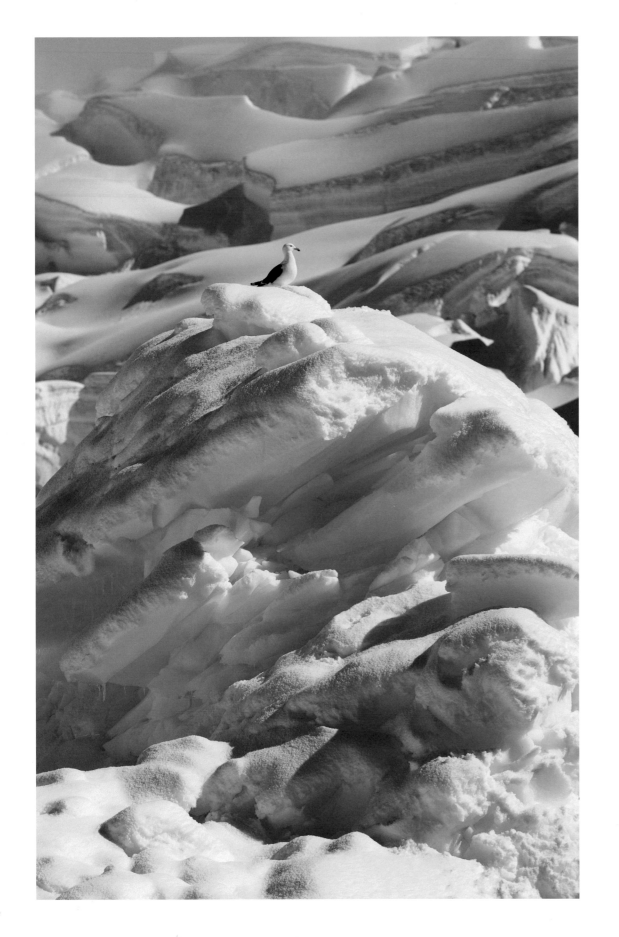

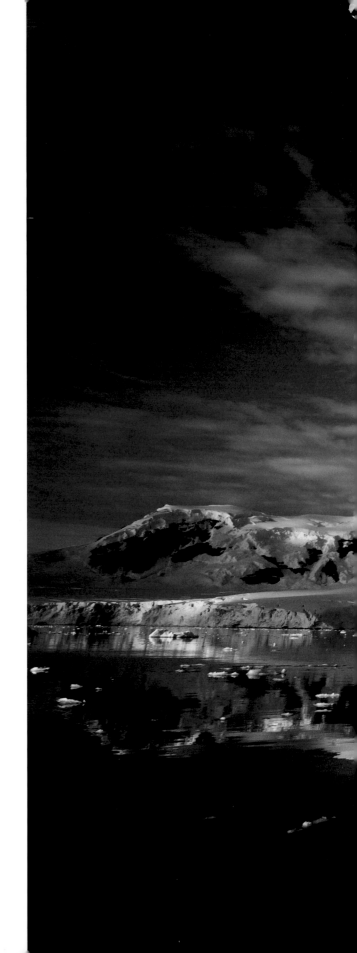

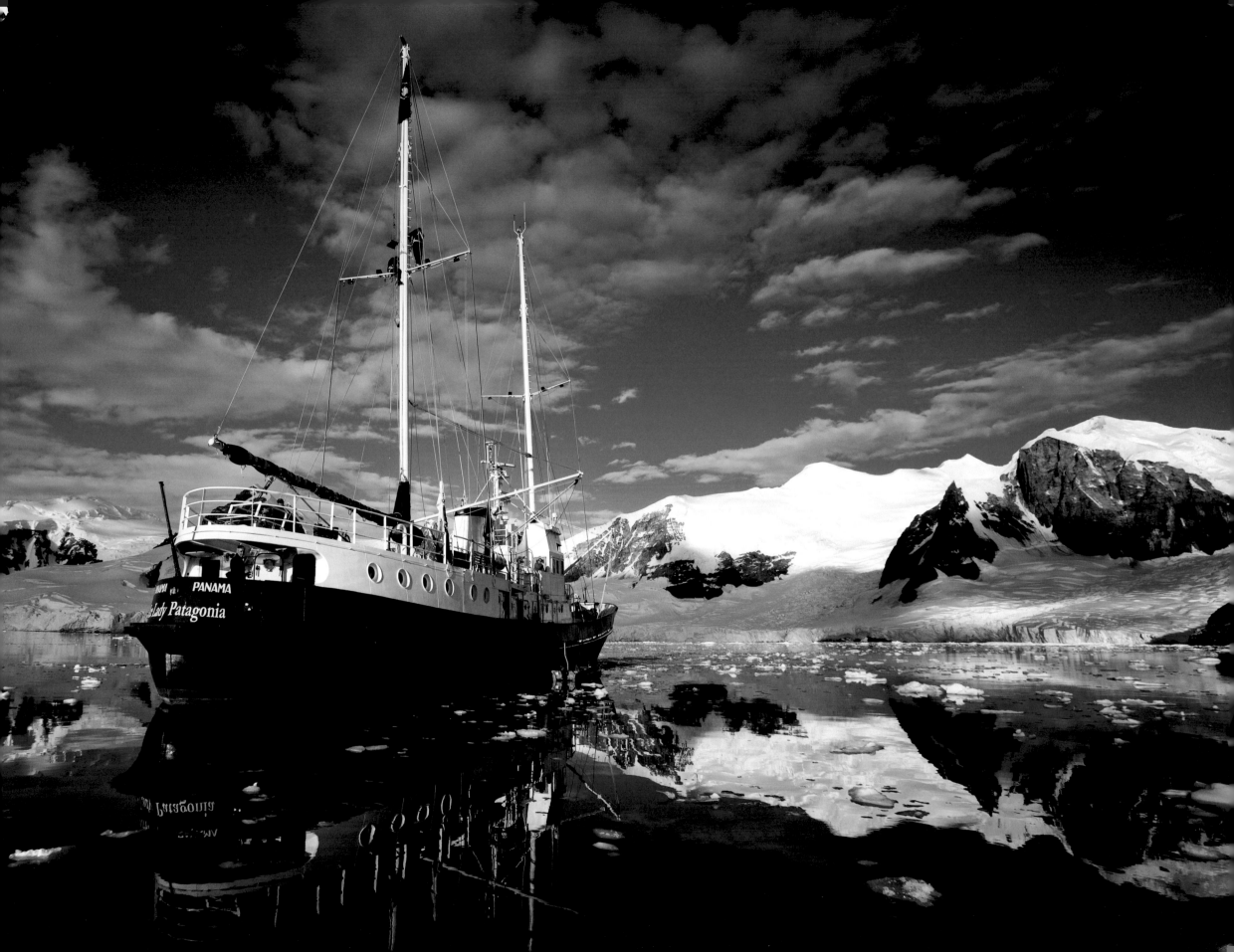

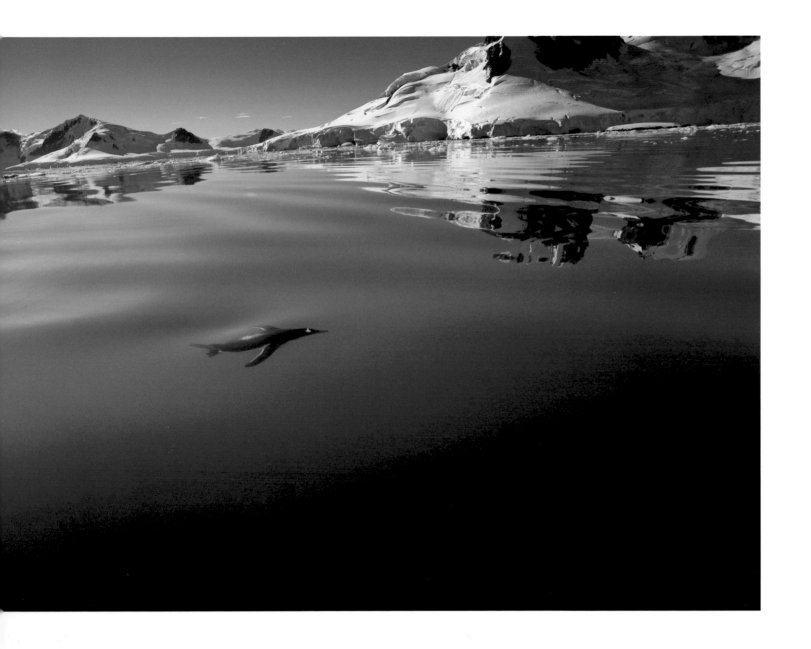
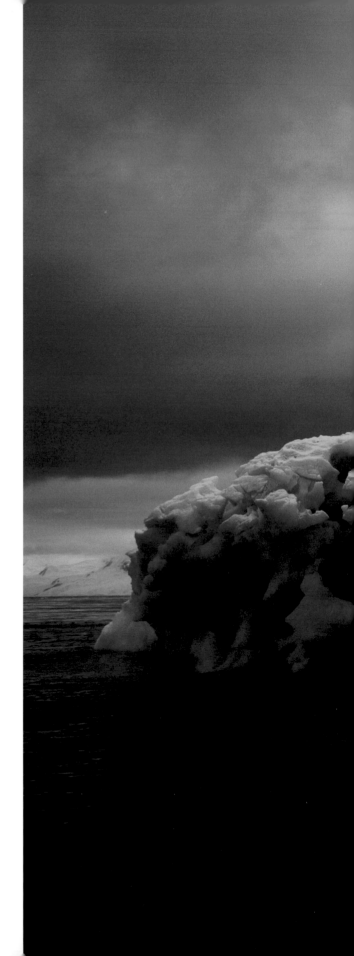

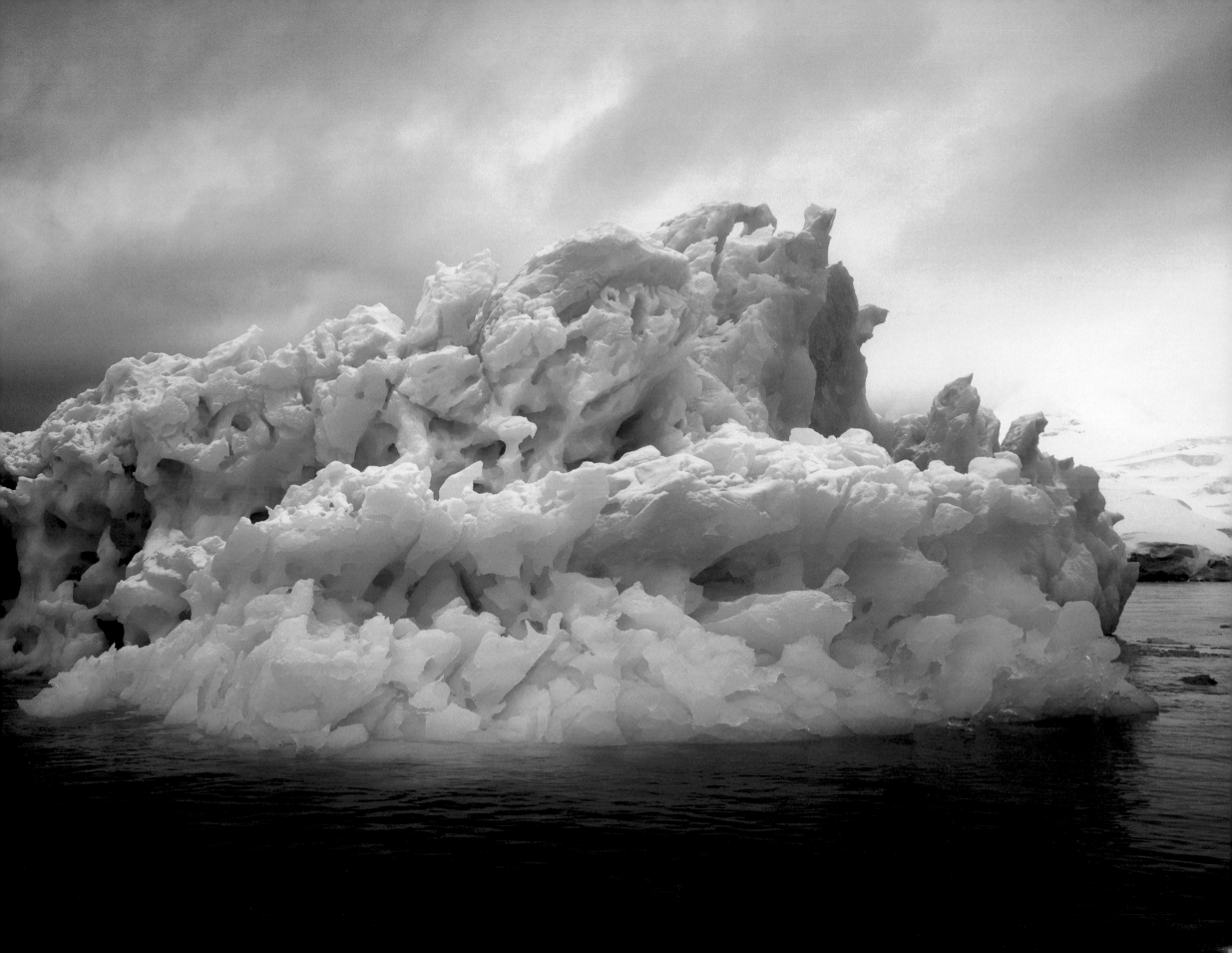

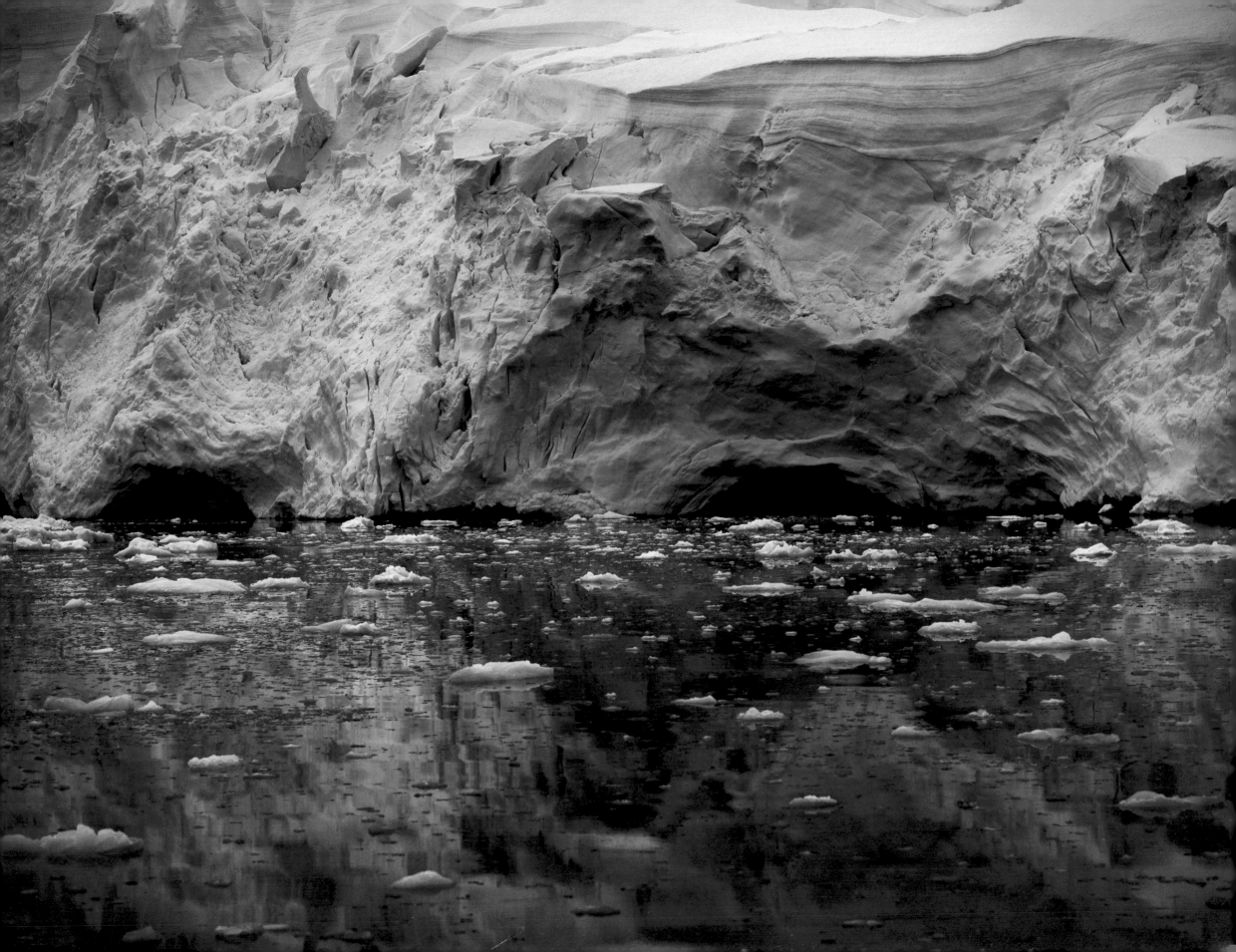

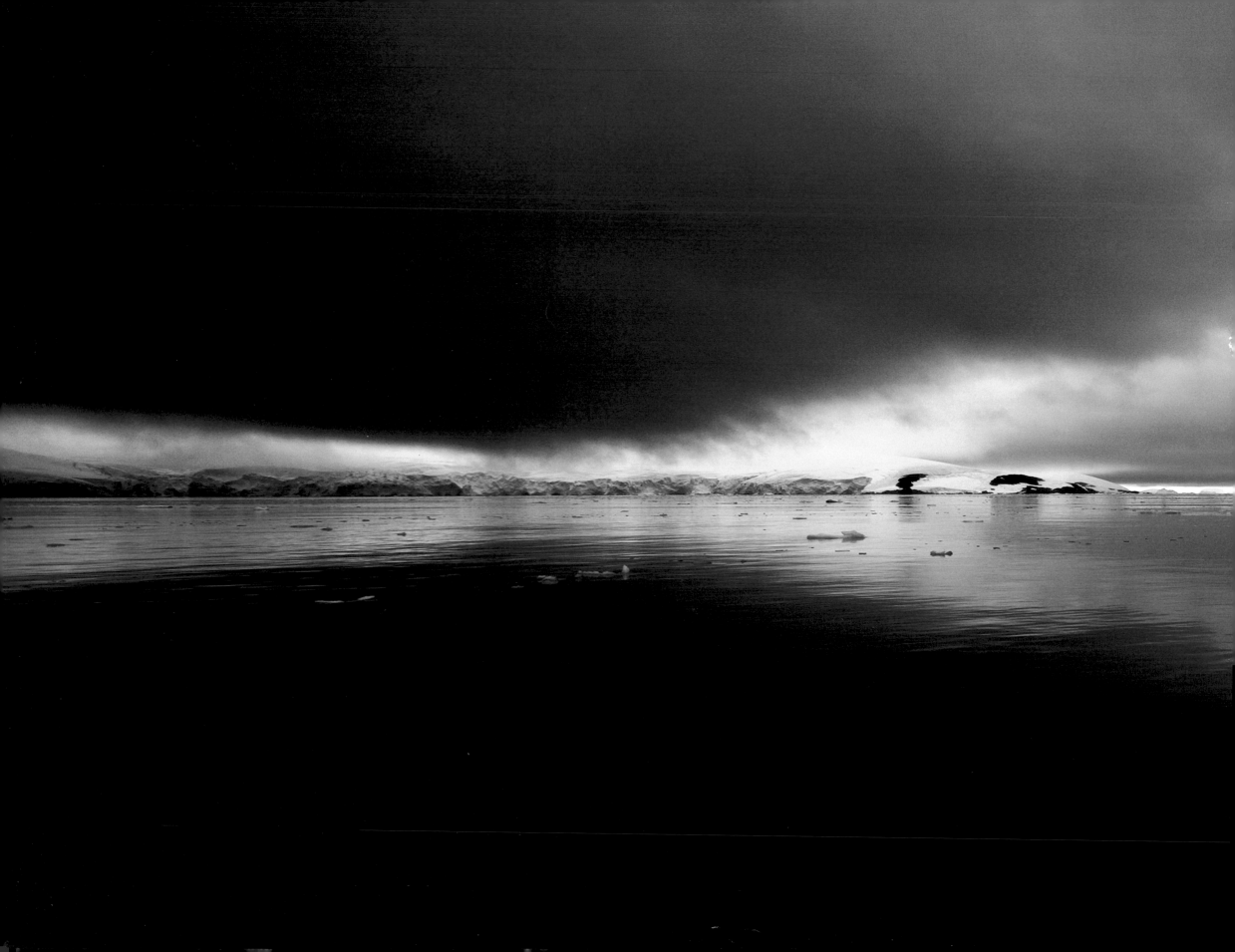

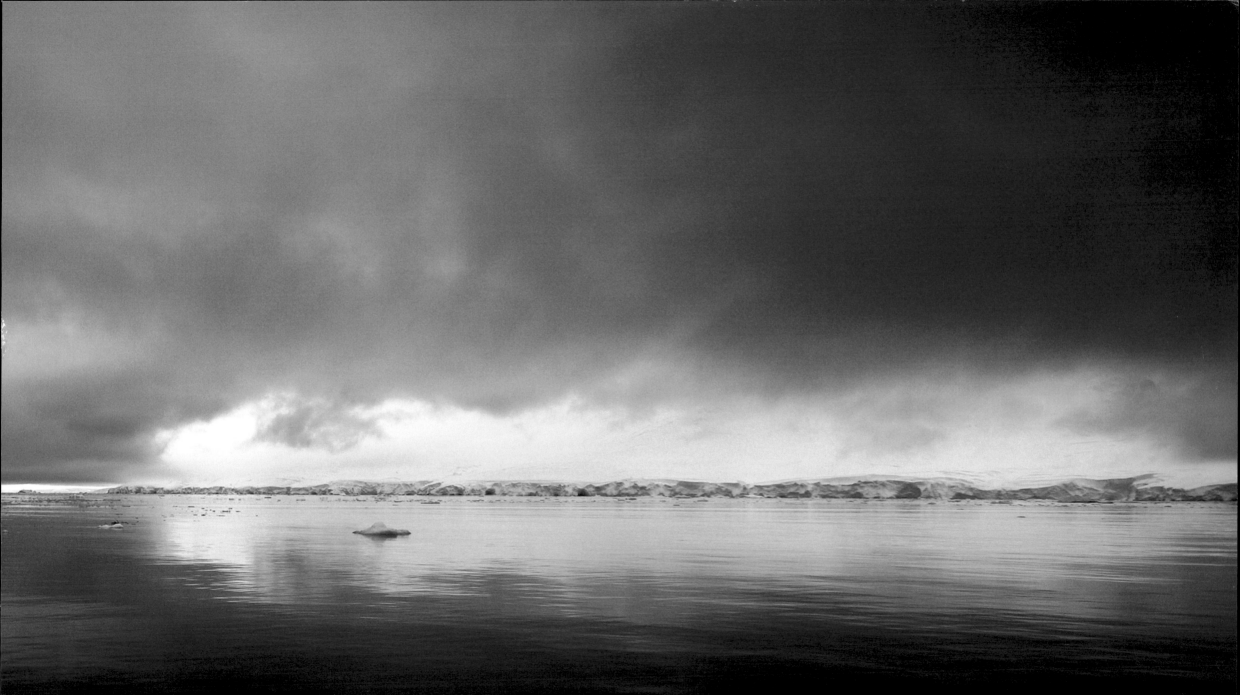

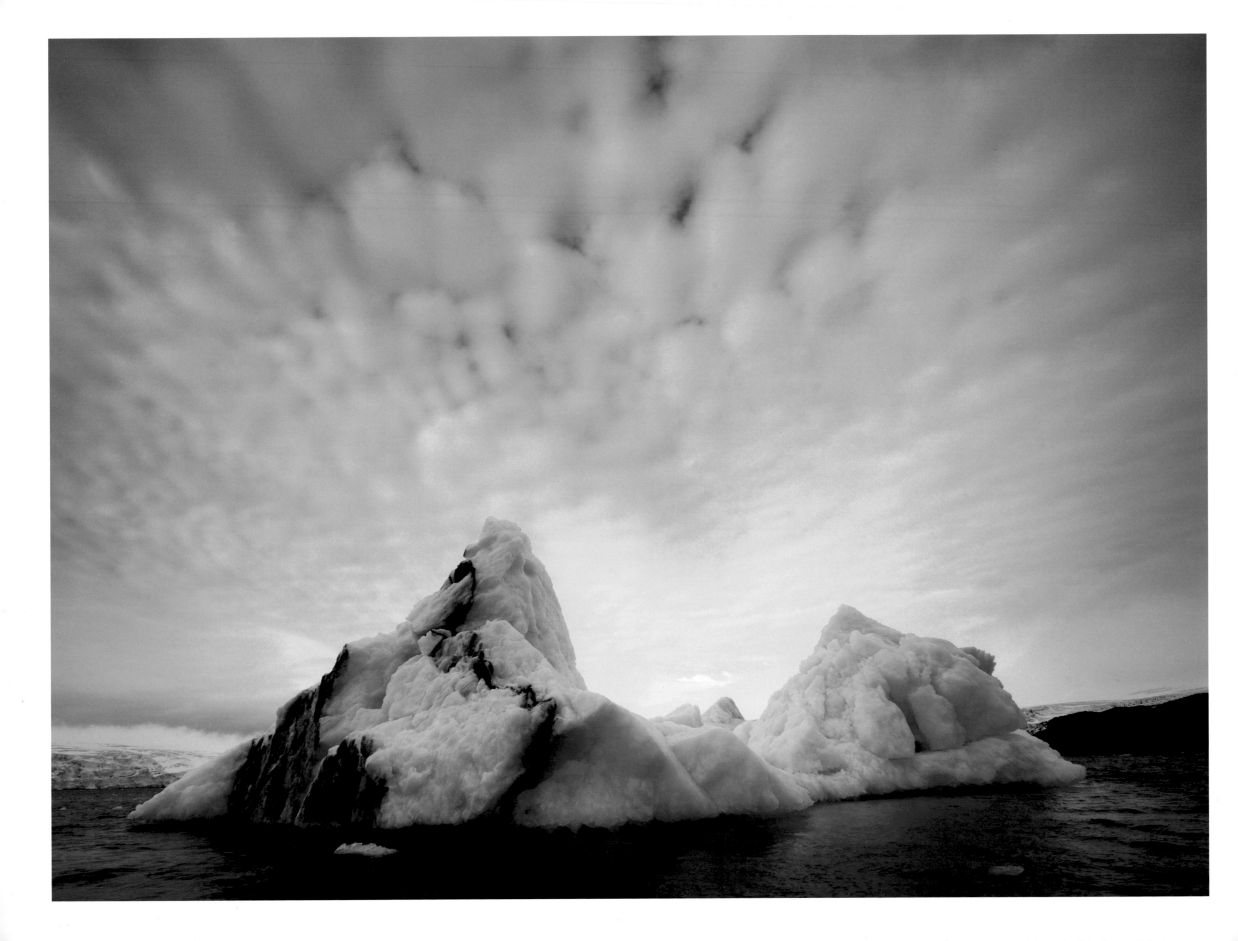

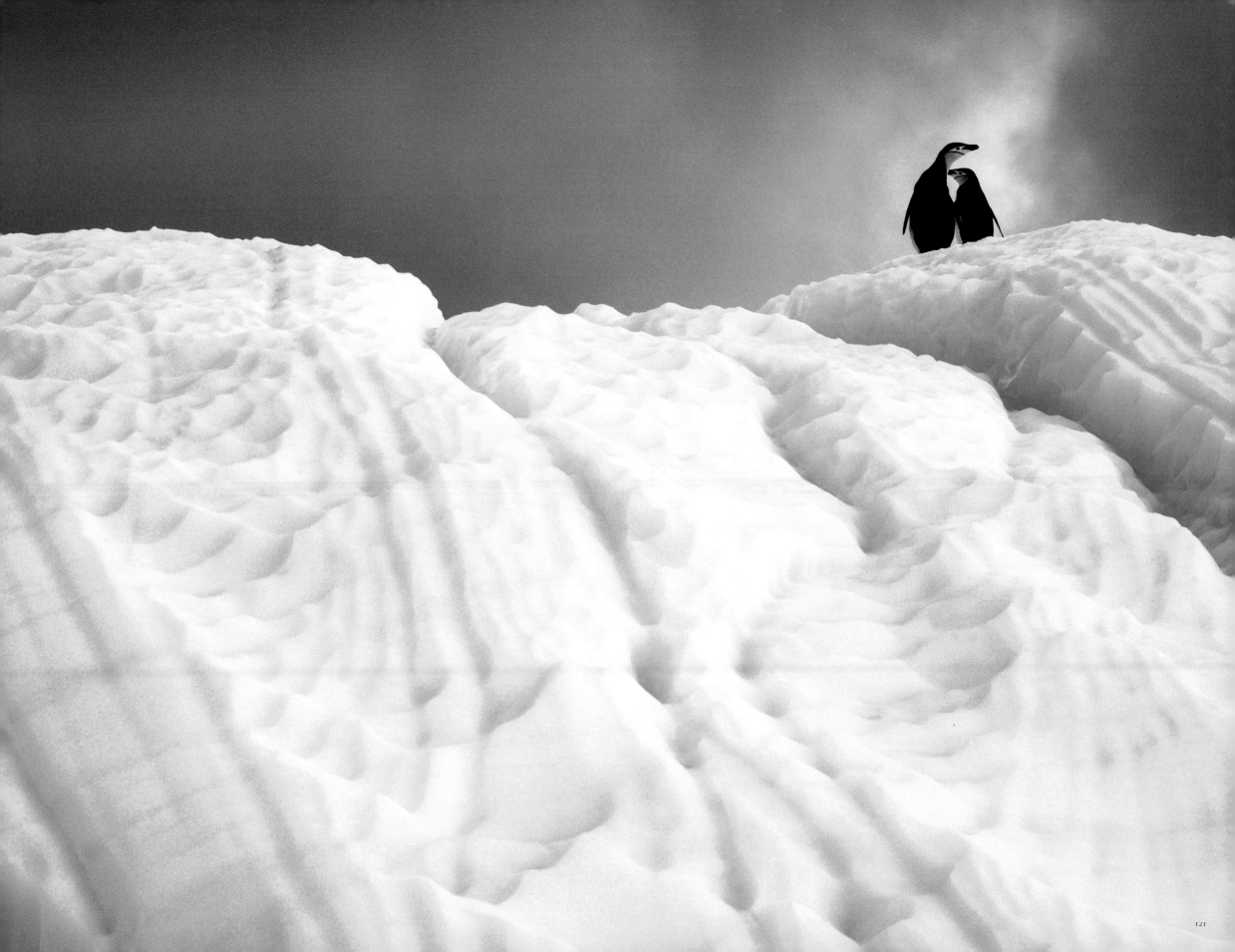

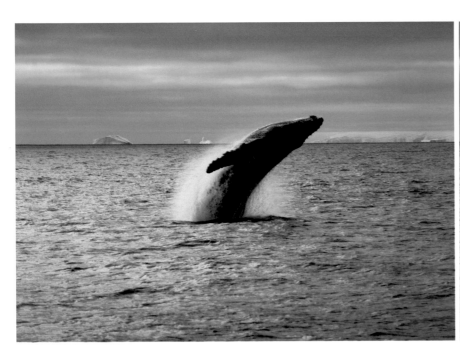
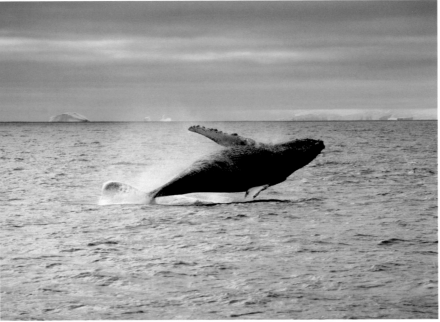

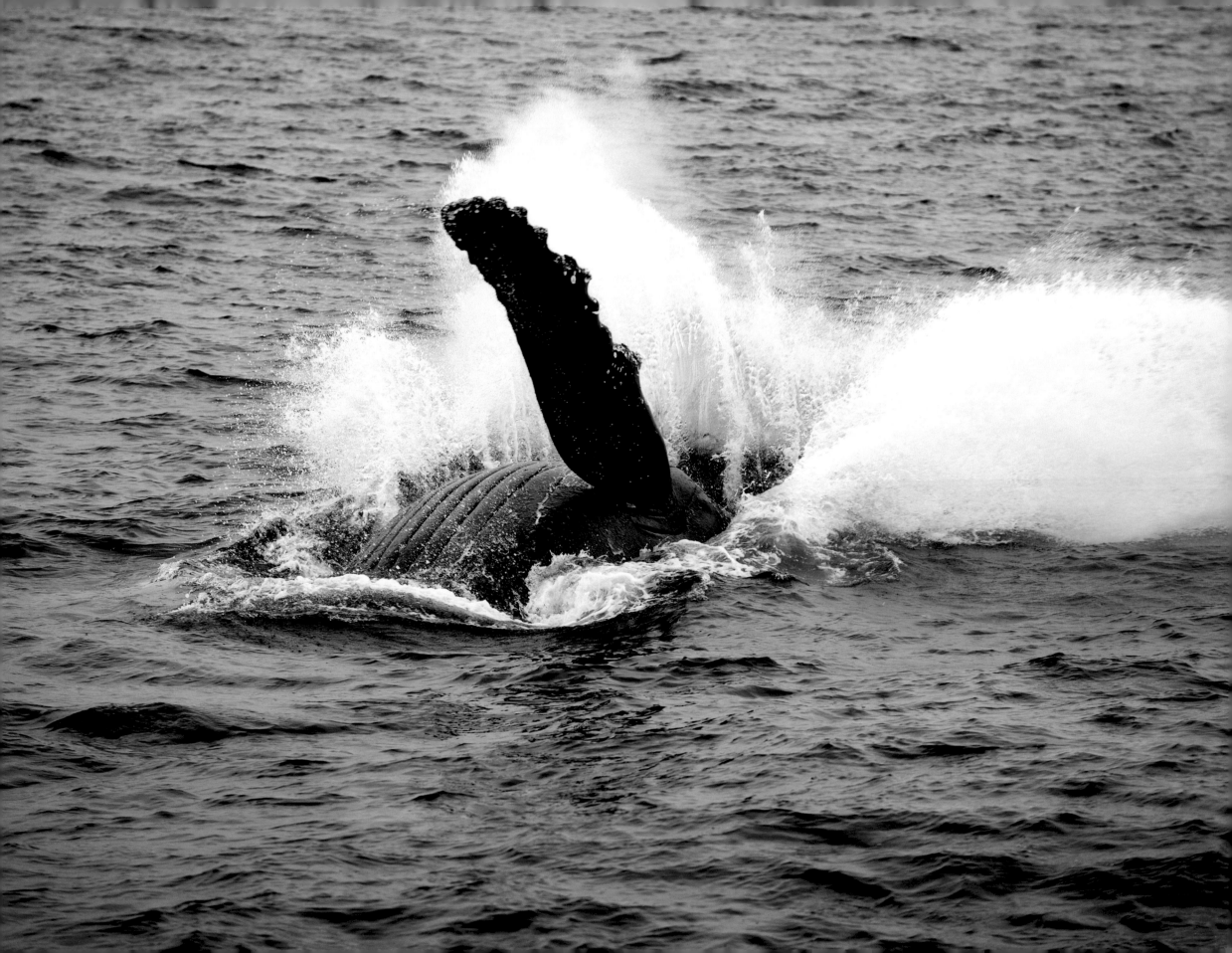

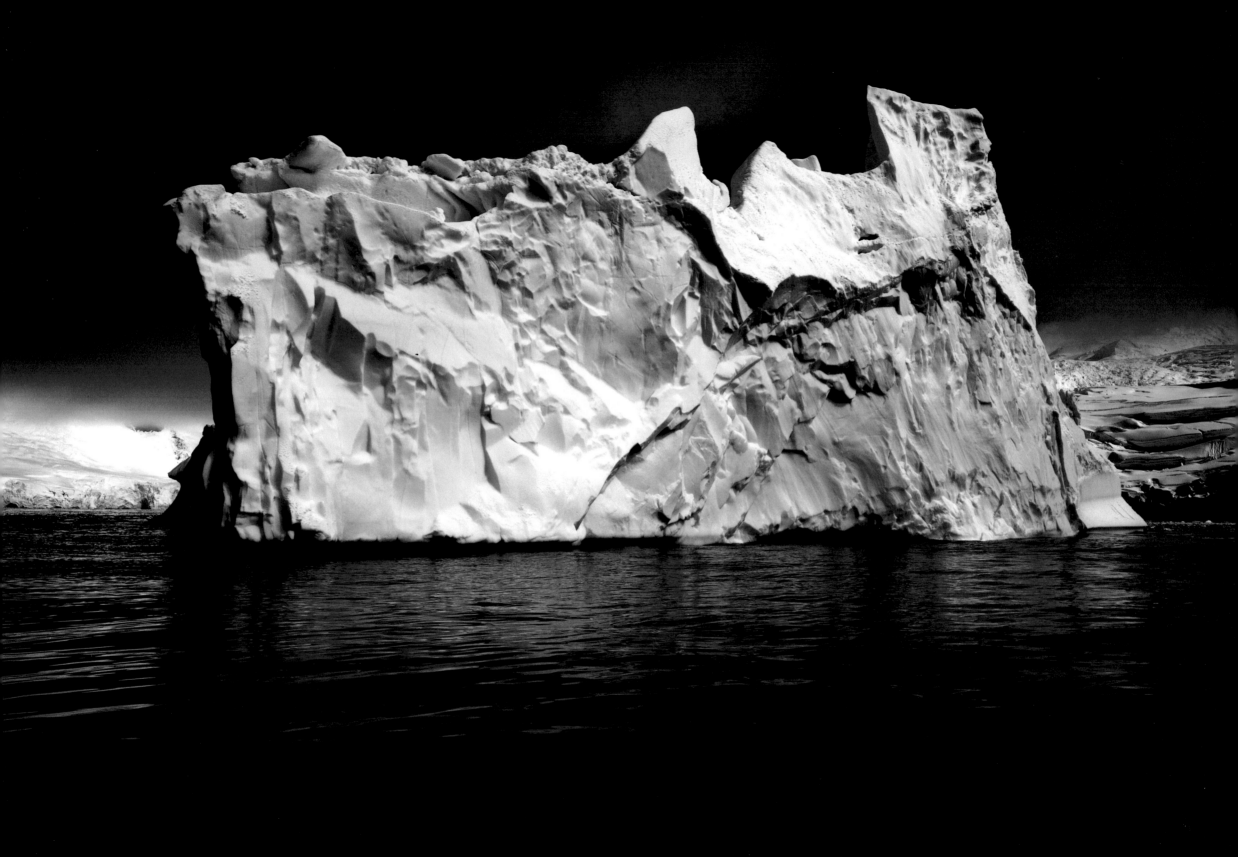

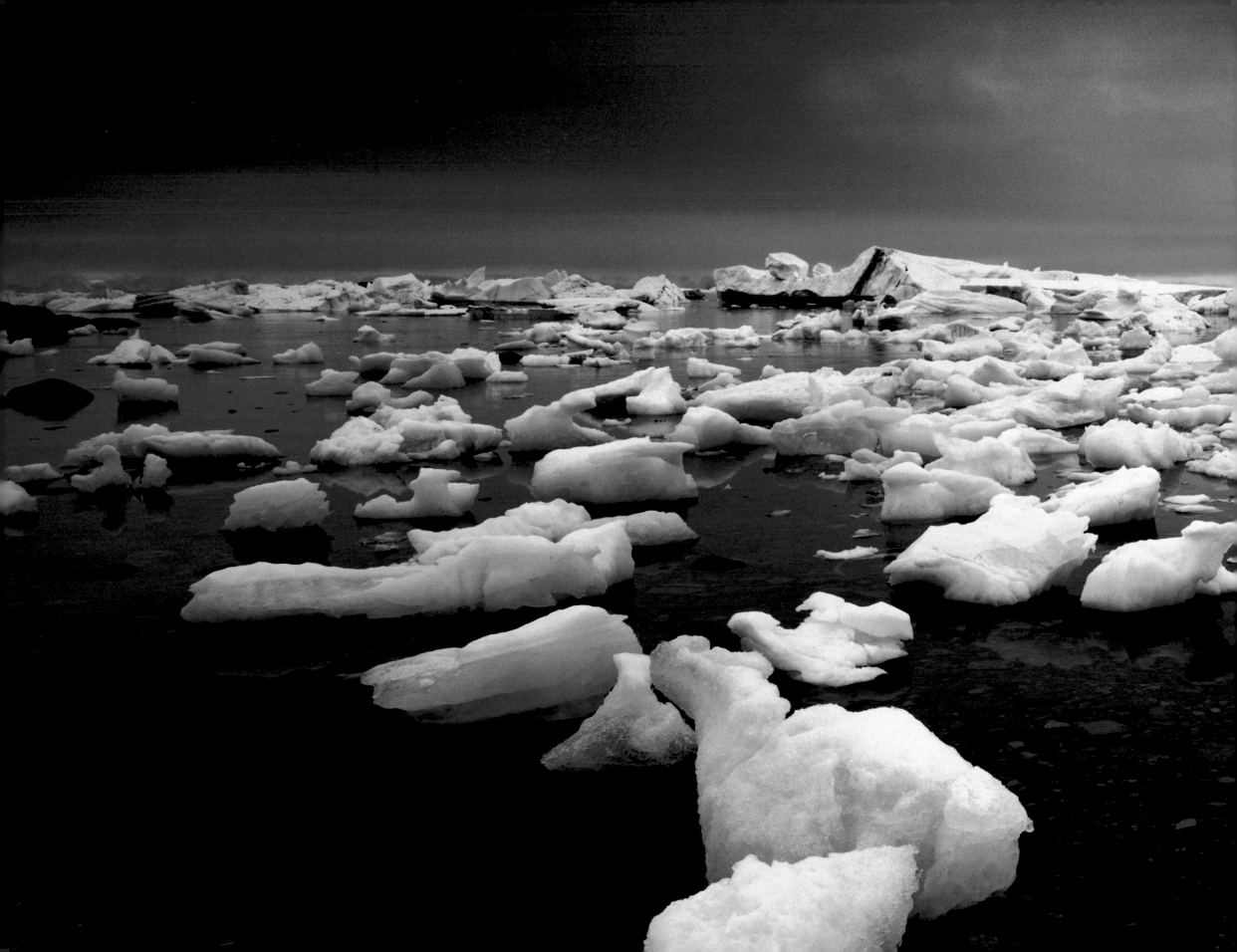

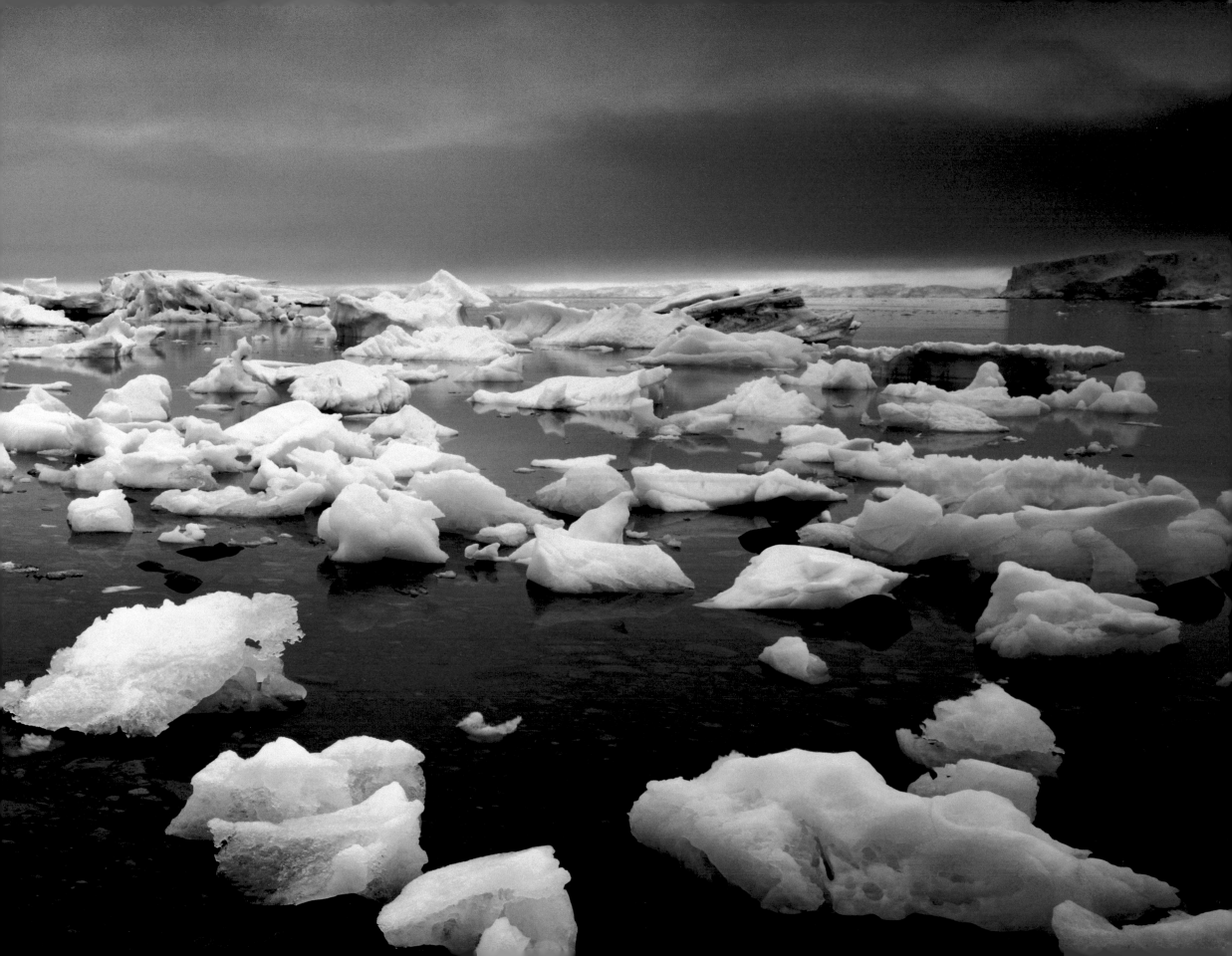

ZAC GOLDSMITH
Editor of The Ecologist

I became editor of *The Ecologist* magazine ten years ago, when I was in my early twenties. At the time, only the most dramatic environmental stories made it into the newspapers. To a lot of people, our articles were alarmist, even mad. And our solutions to environmental problems were considered off-the-scale radical.

But all that has changed, and it has done so amazingly quickly. Today we are approaching a consensus not only on the facts of climate change, but on the urgent need to do everything we can to reverse it. Whereas only dissident scientists dared discuss the issue ten years ago, today the dissidents are those who deny global warming – and often their opinions are paid for by the major polluters. The insurance industry, international aid agencies and even the religious right are joining the call for action. In government, too, politicians now have the courage to pursue an agenda that wouldn't have been possible only a few years ago. Most important, ordinary people are beginning to make changes in their daily lives.

While the media have played a role in this reversal, the real reason for the change is that problems that seemed abstract a few years ago are becoming all the more real. A neighbor of mine, for example, plants trees for a living. He's had to adjust his financial year by a month to accommodate unseasonable shifts in weather patterns. As climatic records are broken in region after region around the world, as glaciers retreat, as the scientific debate about the existence of climate change gives way to debate about how rapidly it's happening, it has become depressingly clear that this issue dwarfs all others.

Climate change may be the biggest threat we've ever faced, but it's also a grand opportunity. Despite some of the horror stories from global-warming detractors, dealing with climate change isn't going to force us all into the caves – quite the opposite. Many of the solutions are policies we should be pursuing irrespective of climate change: Investing in new energy technologies, reducing our dependence on oil and supporting local food producers carry benefits that extend far beyond the environment. We will all profit from a shift to a leaner, cleaner, more efficient, less wasteful economy.

There's no downside to taking climate change seriously. But if we do nothing, and the scientists are right, the consequences are unthinkable. What is there to consider?

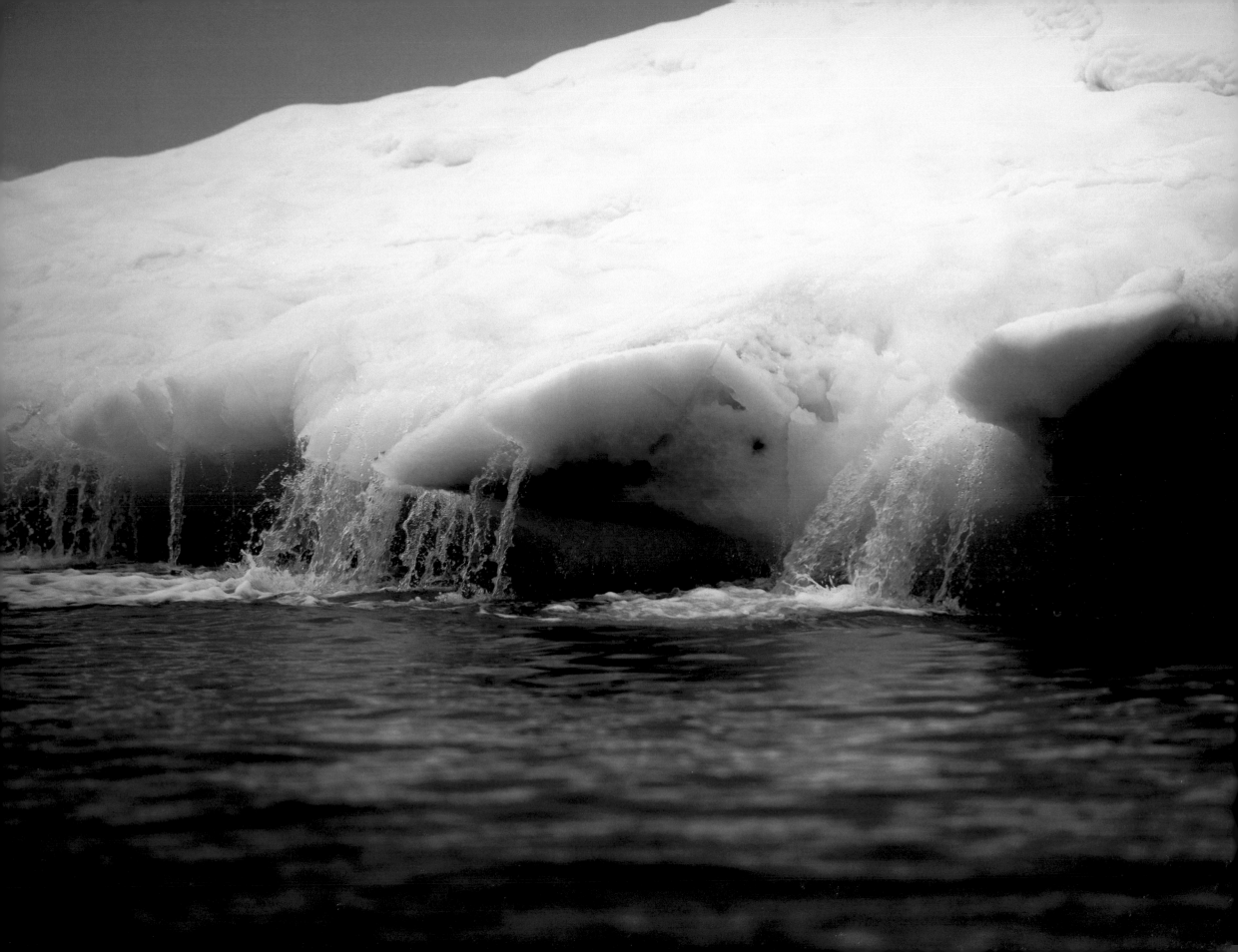

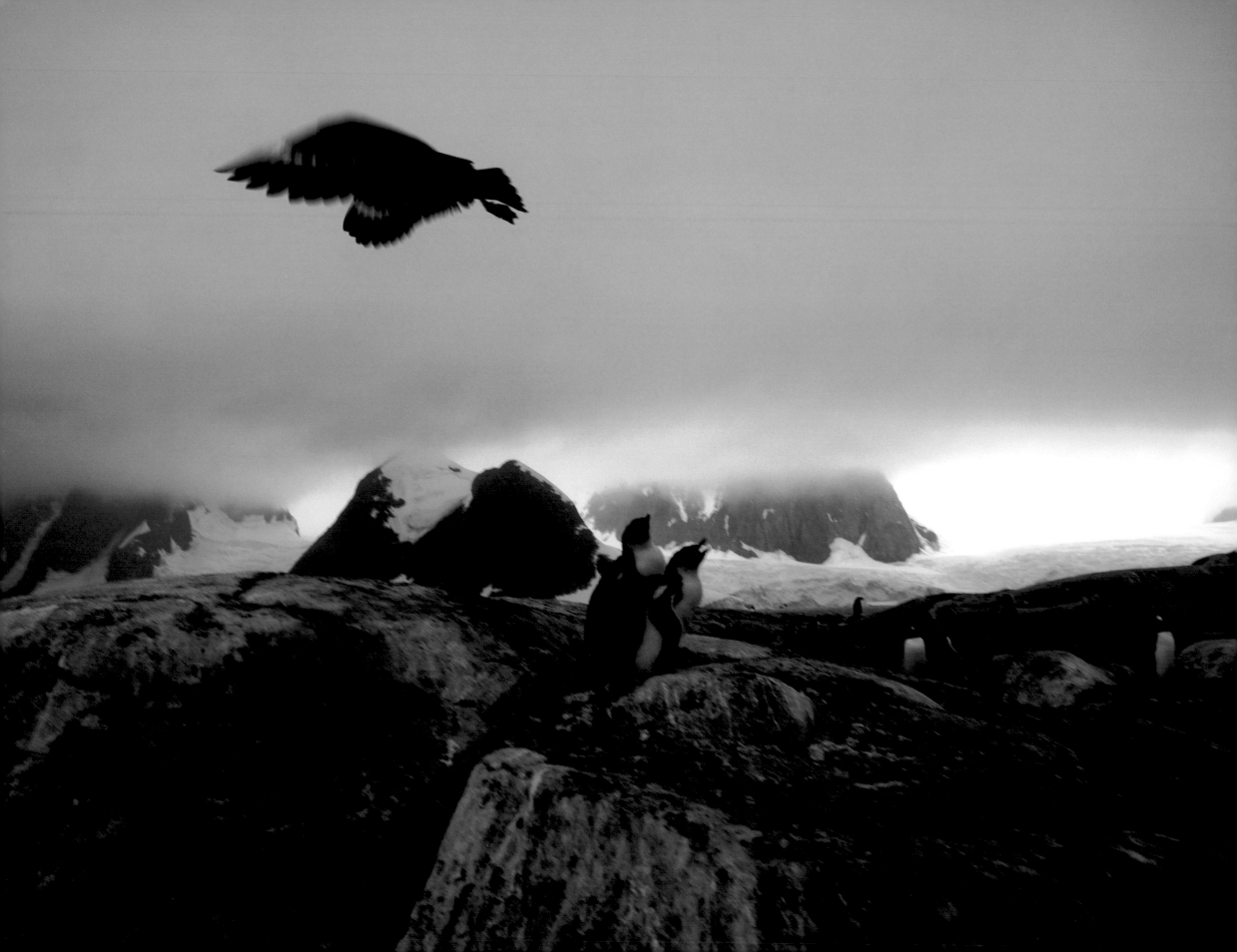

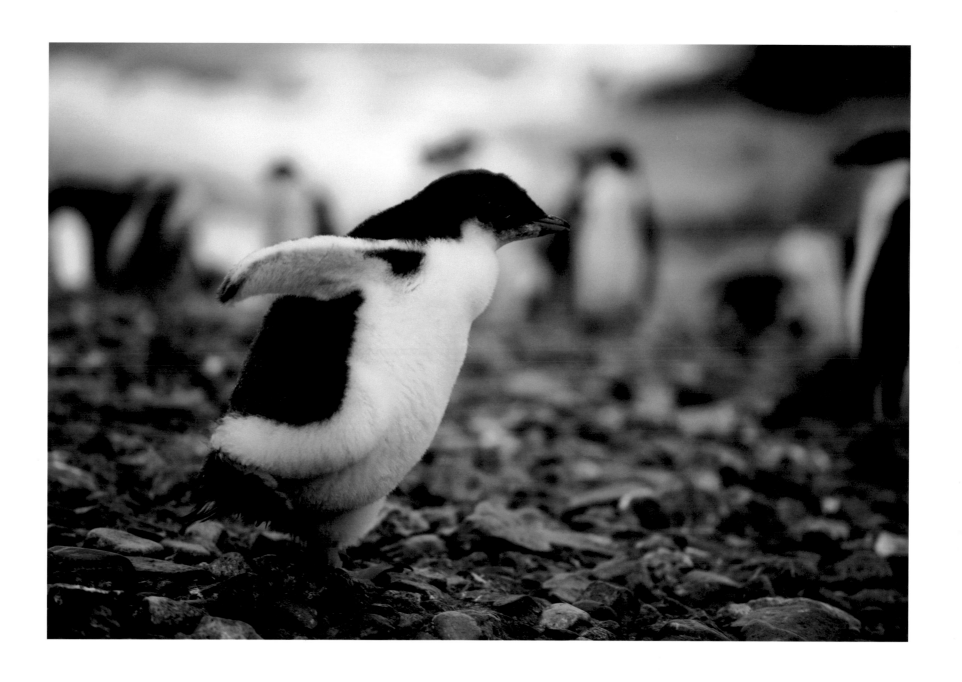

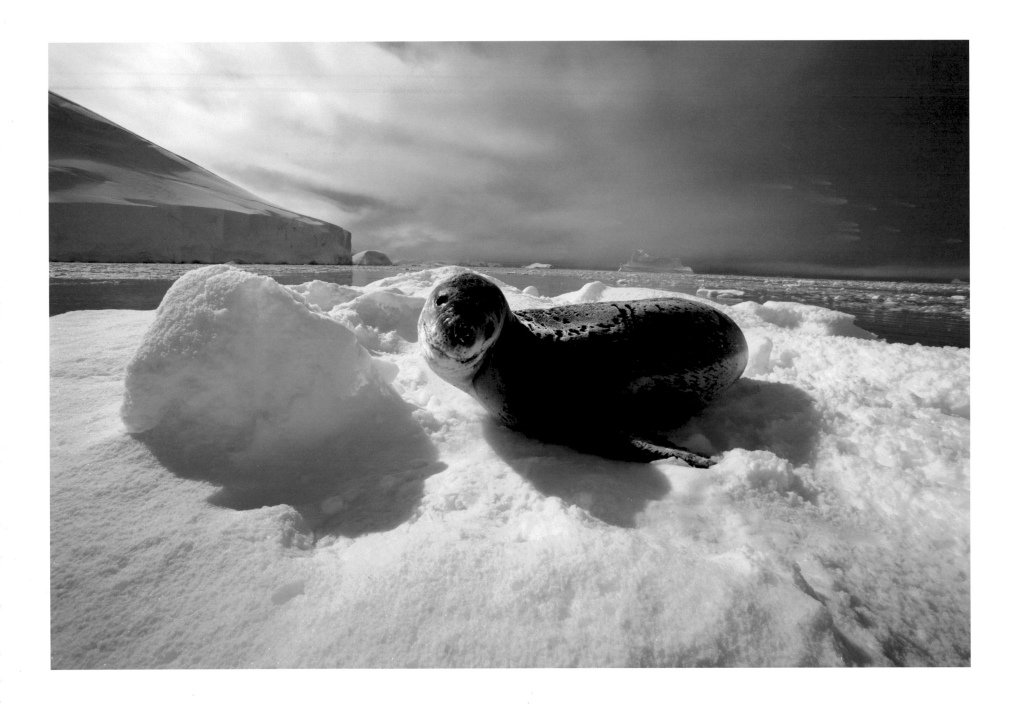

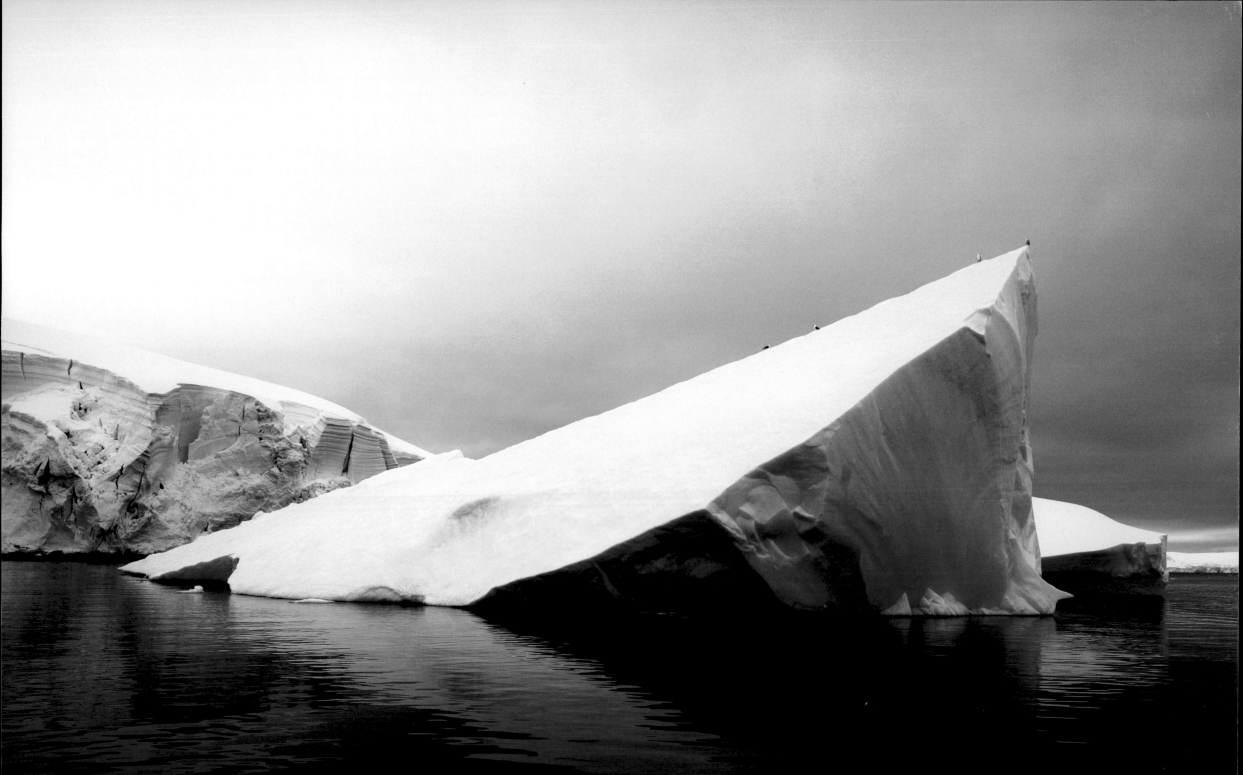

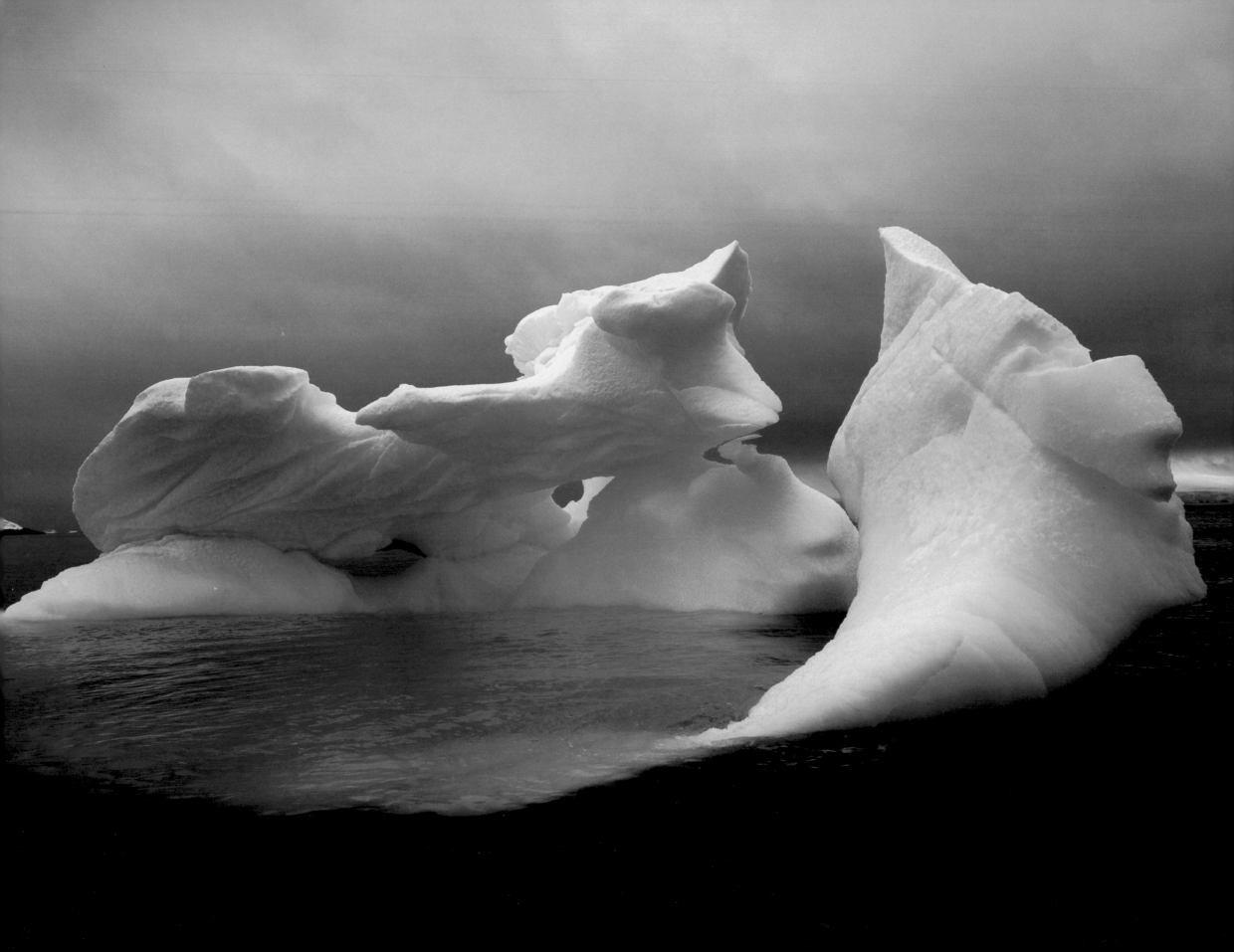

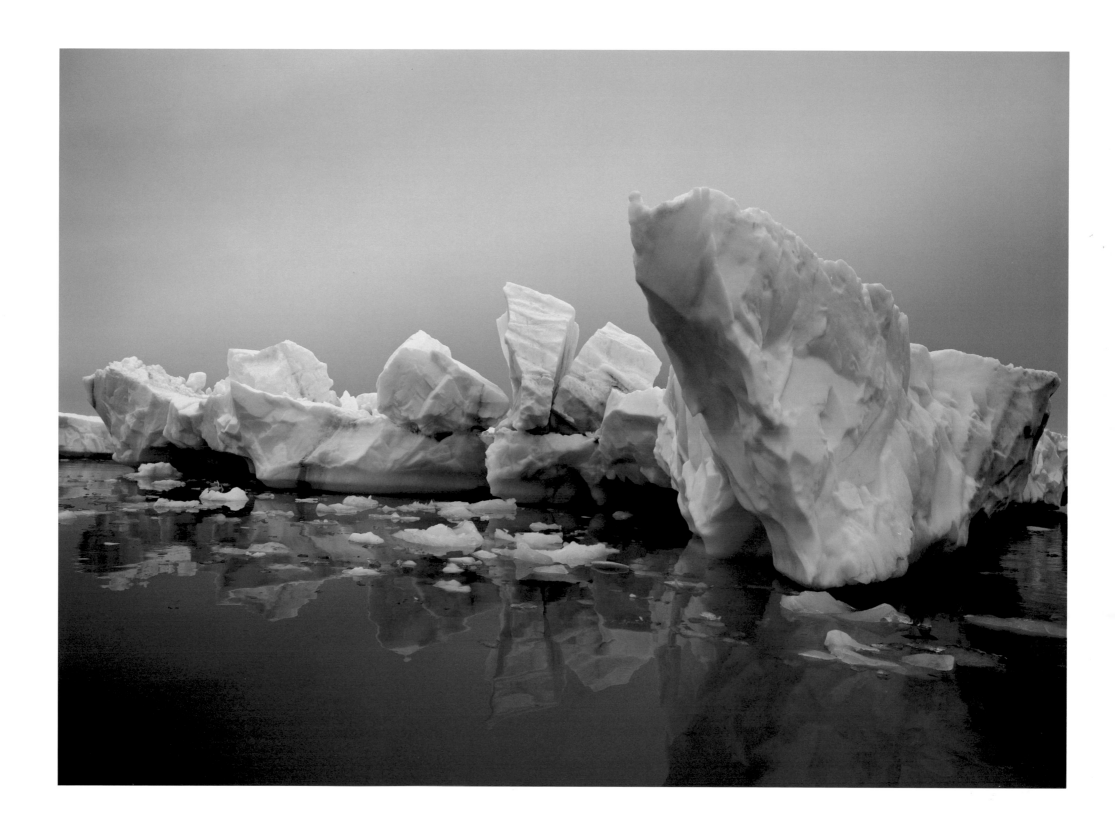

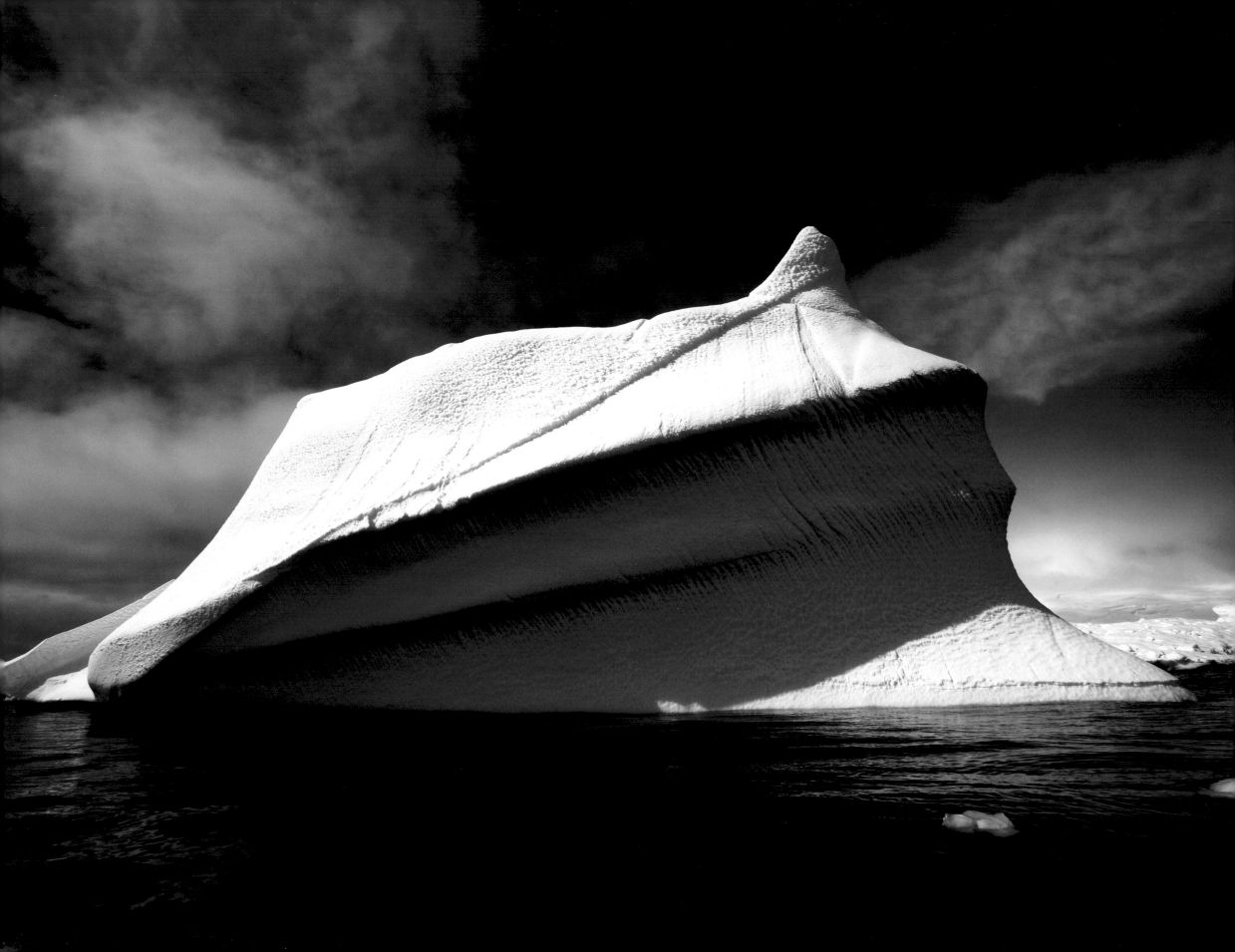

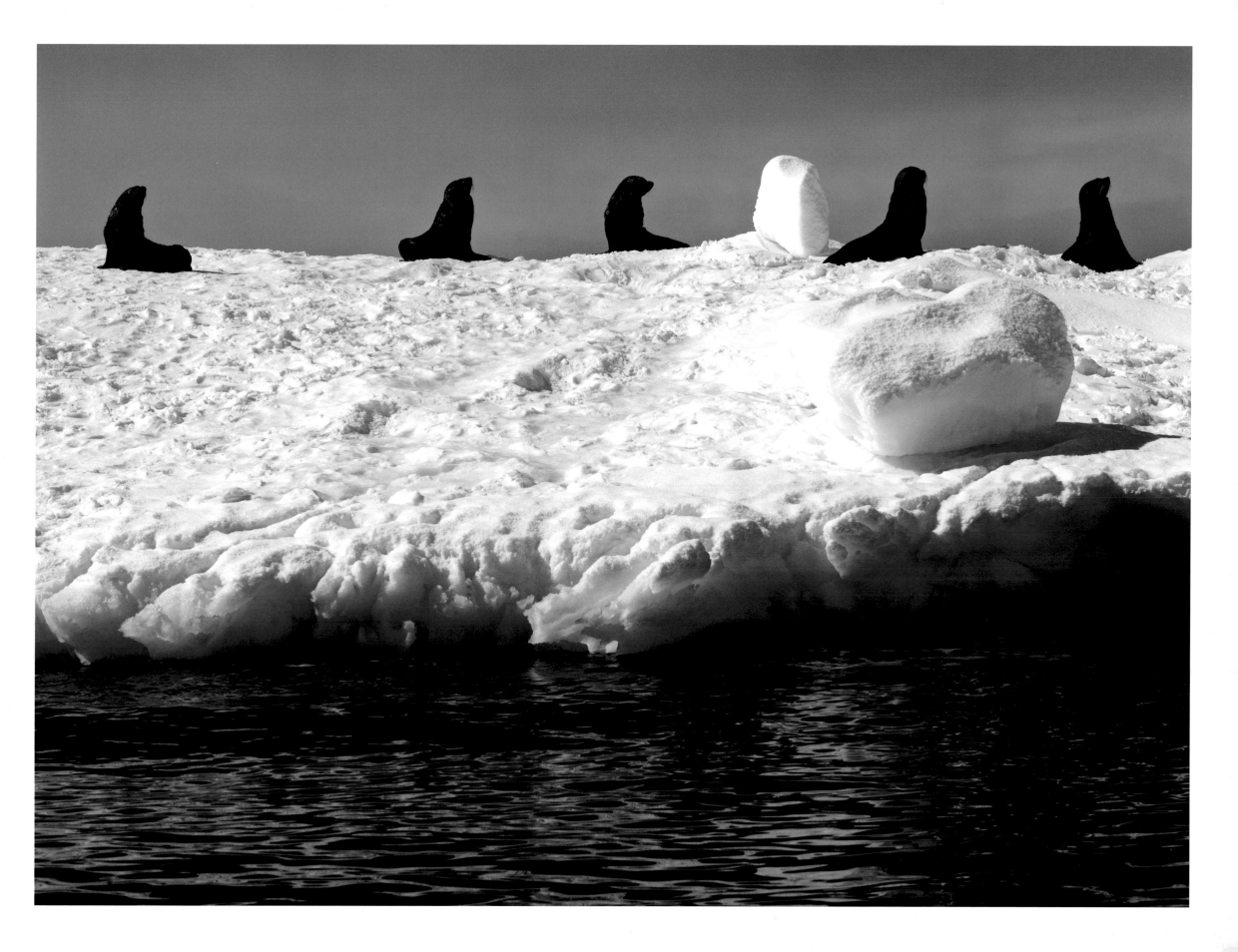

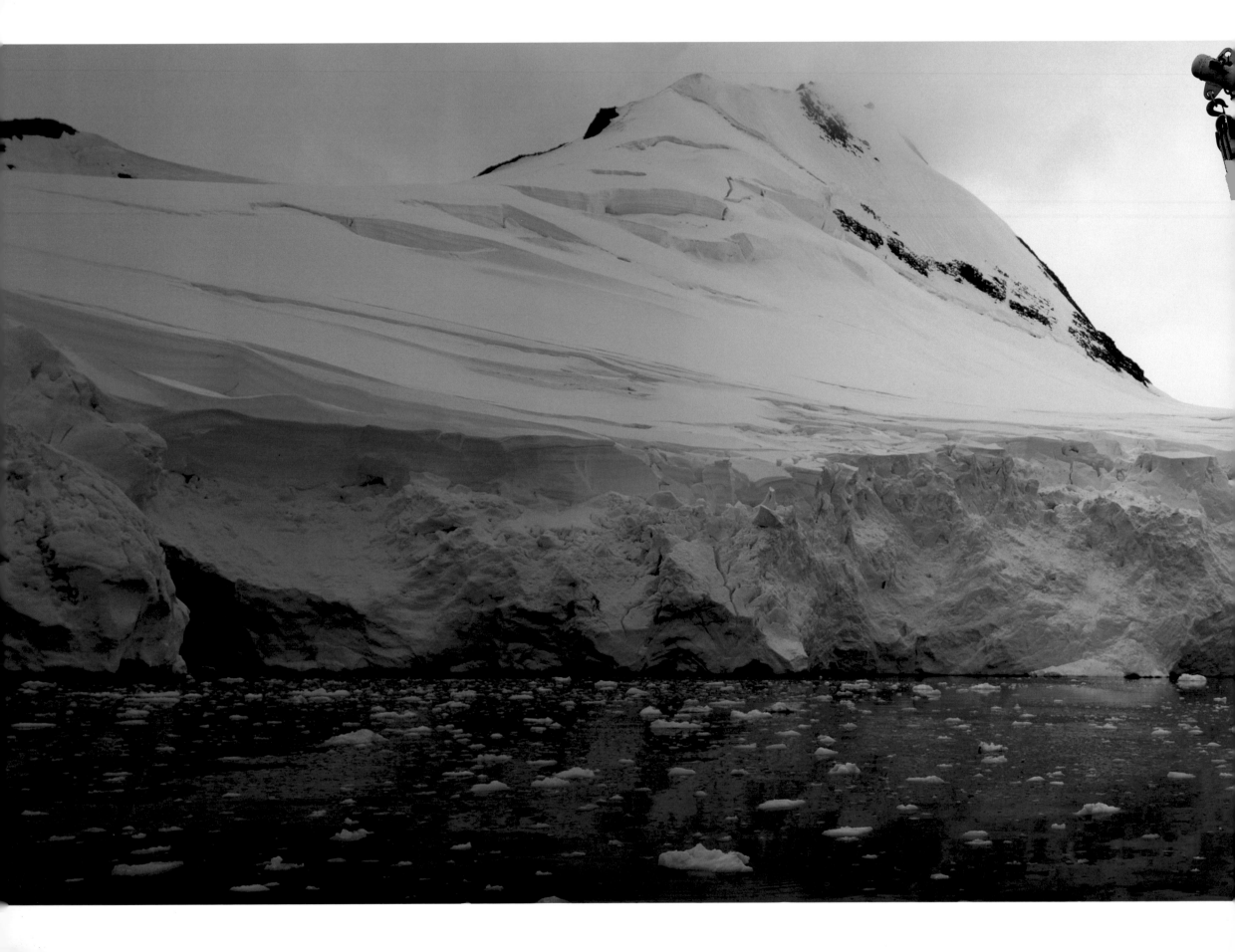

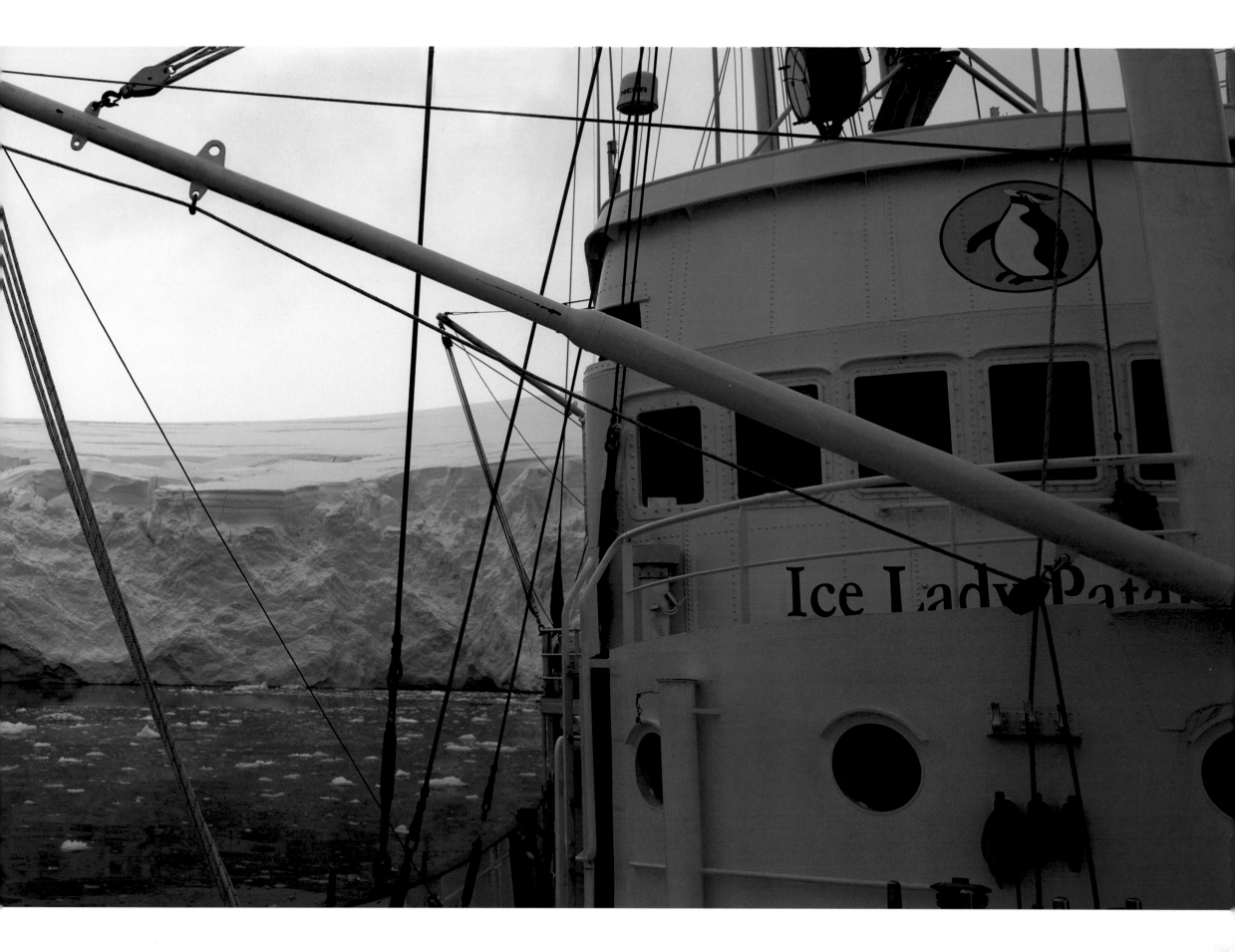

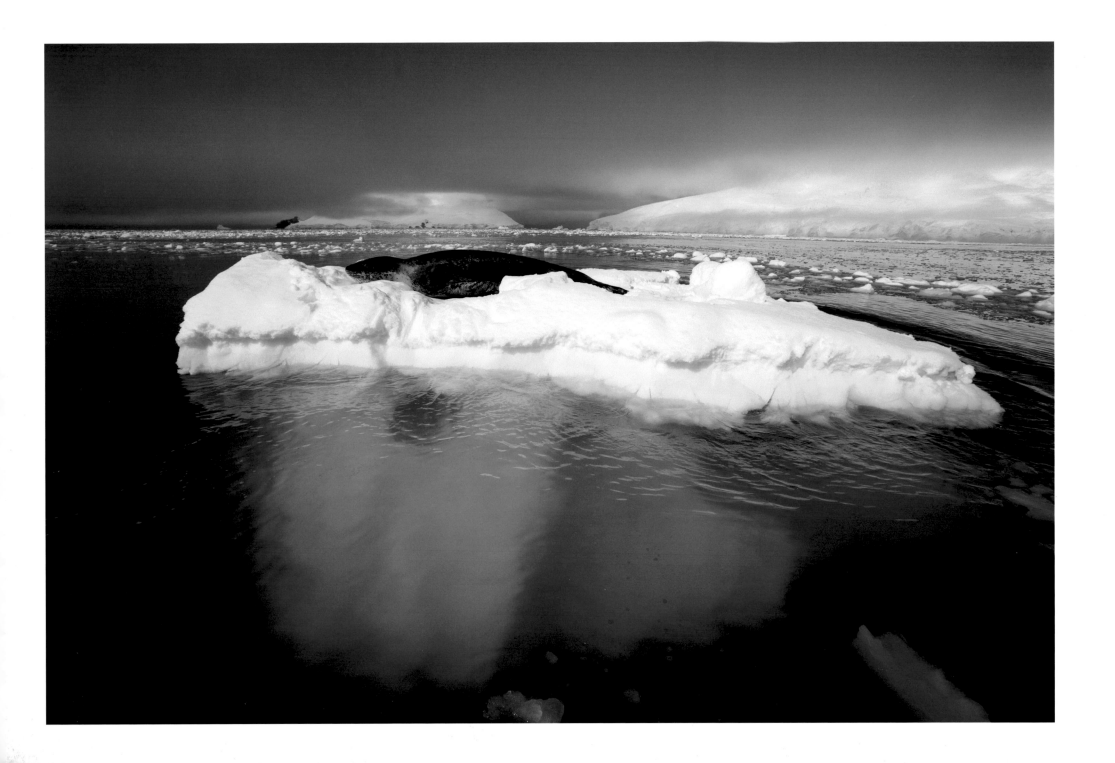

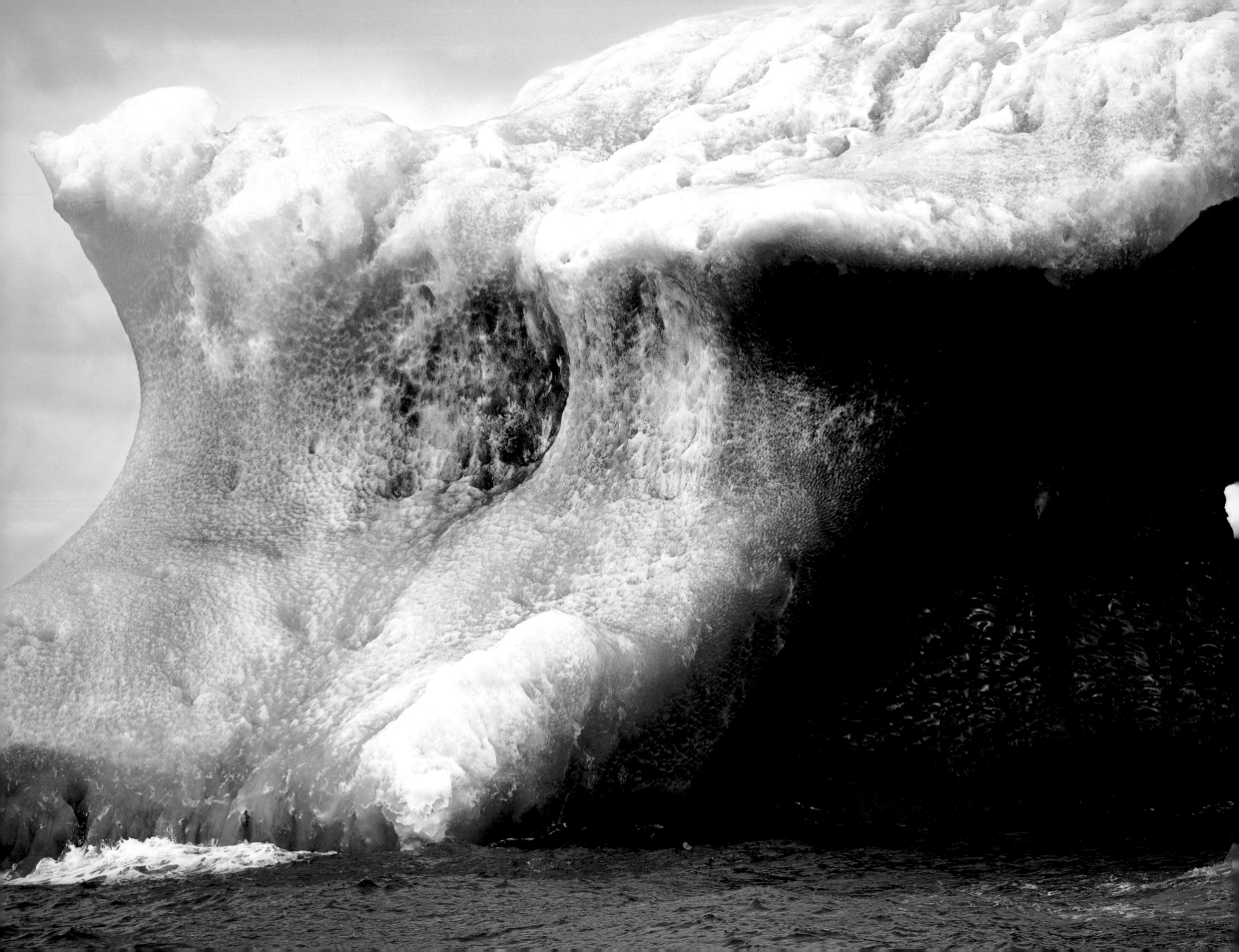

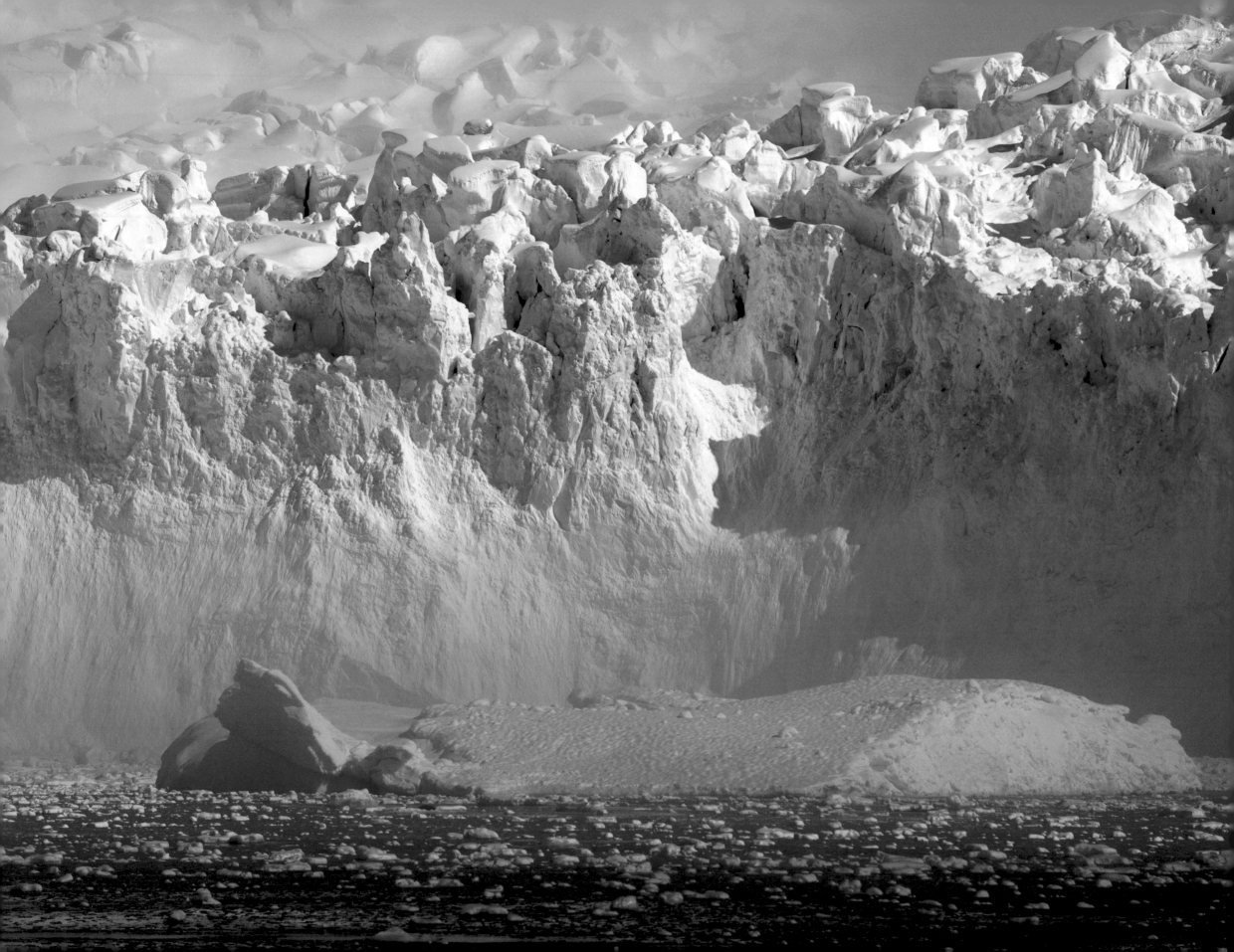

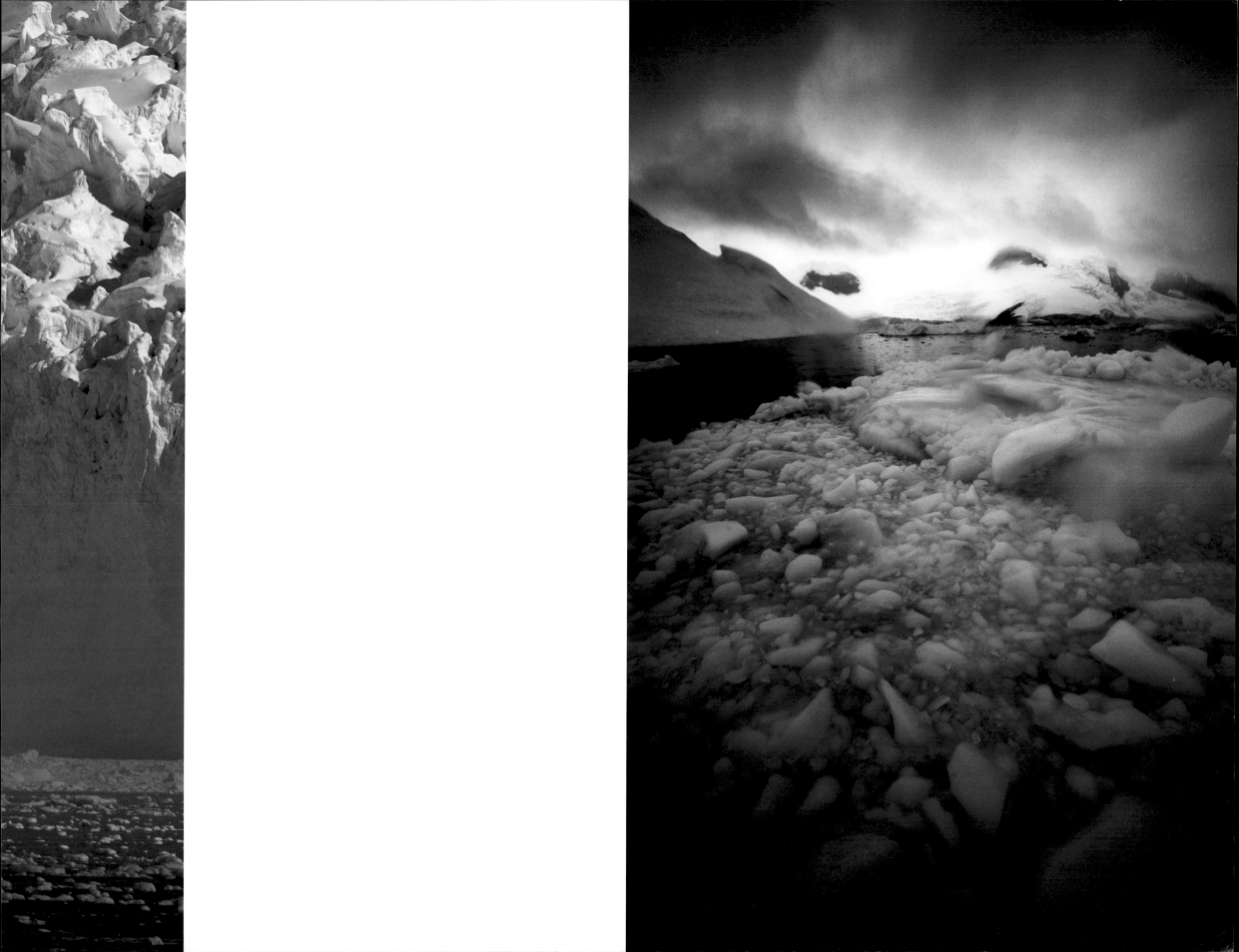

DAVID
DE ROTHSCHILD
Polar Adventurer

The extraordinary experience of spending more than eighty days in Antarctica left me with an insight that will stay with me for the rest of my life. My revelation took root when I stood at the bottom of one of the world's largest glaciers, Axel Heiberg in the Trans-Antarctic Mountains. It grew over the course of the next three months, during which I felt like nothing more than a speck of dust on the endless horizon of what is arguably Earth's most majestic and environmentally significant continent. It was in Antarctica that I truly began to grasp the scale and complexity of the consequences of climate change. While the planet's fragility was highlighted, the vulnerability of humankind was staring me in the face.

Melting sea ice, lethal storms, floods, disappearing glaciers, forest fires, fatal heat waves – these are the costs of living beyond our ecological limits. Climate records show that the six warmest years in the past century-and-a-half have all occurred since 1998. This warming is destroying our planet's most fragile ecosystems, including the polar regions. If we continue with business as usual, global temperatures could increase by up to 5°C. And if that happens, no matter how we slice it, things will become very uncomfortable.

If we look back in history we see that the warning signs have always been there, from Jean-Baptiste Fourier's coining the greenhouse analogy in 1827 to Roger Revelle's prescient statement in the mid-fifties that humanity was conducting a "large-scale geophysical experiment." But we didn't look and we didn't listen.

However, whether it was the environmental emergencies unfolding in front of our very eyes, or the increasingly alarming reports from the scientific community, or the unprecedented media attention, 2006 must go down as the year that we began to read the signs, the year that environmentalism became mainstream. As the political writer Thomas Friedman quite aptly phrased it, "Green is the new red, white, and blue."

We are newly greened, and newly awakened to the nature of global warming. We know that human activities have caused it, and that human activities can begin to reverse it. The problem is clearly defined, and within our power to solve.

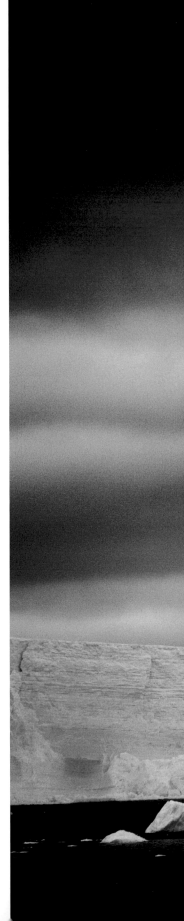

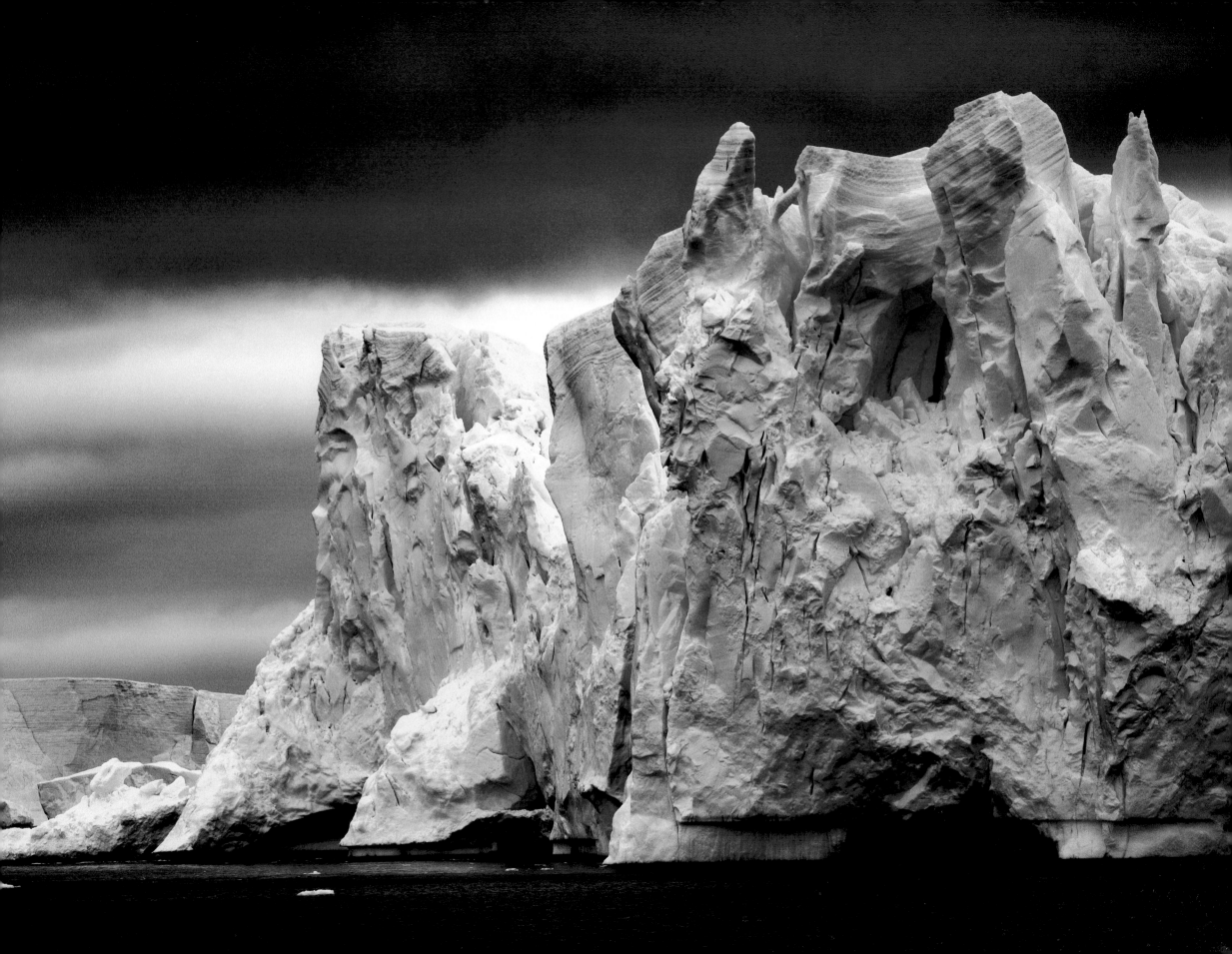

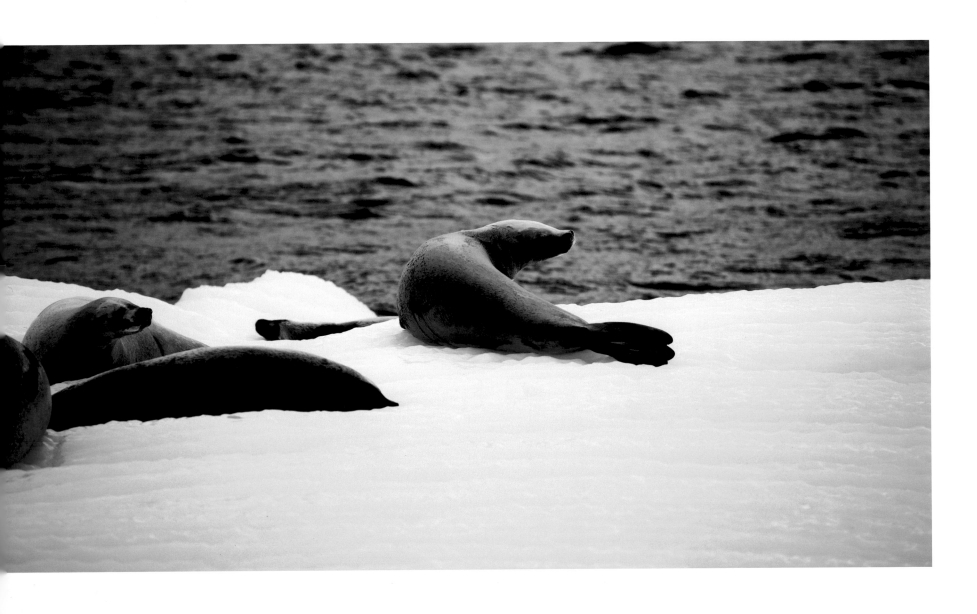

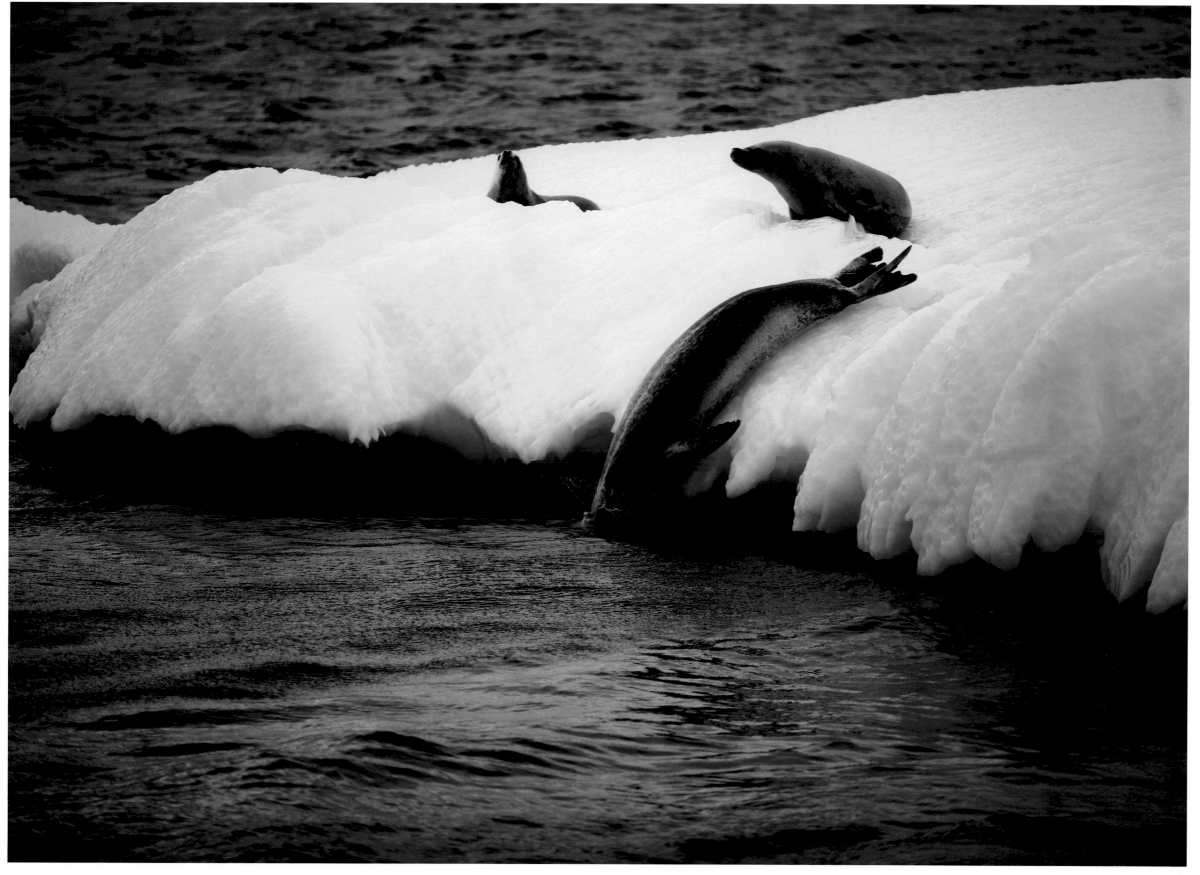

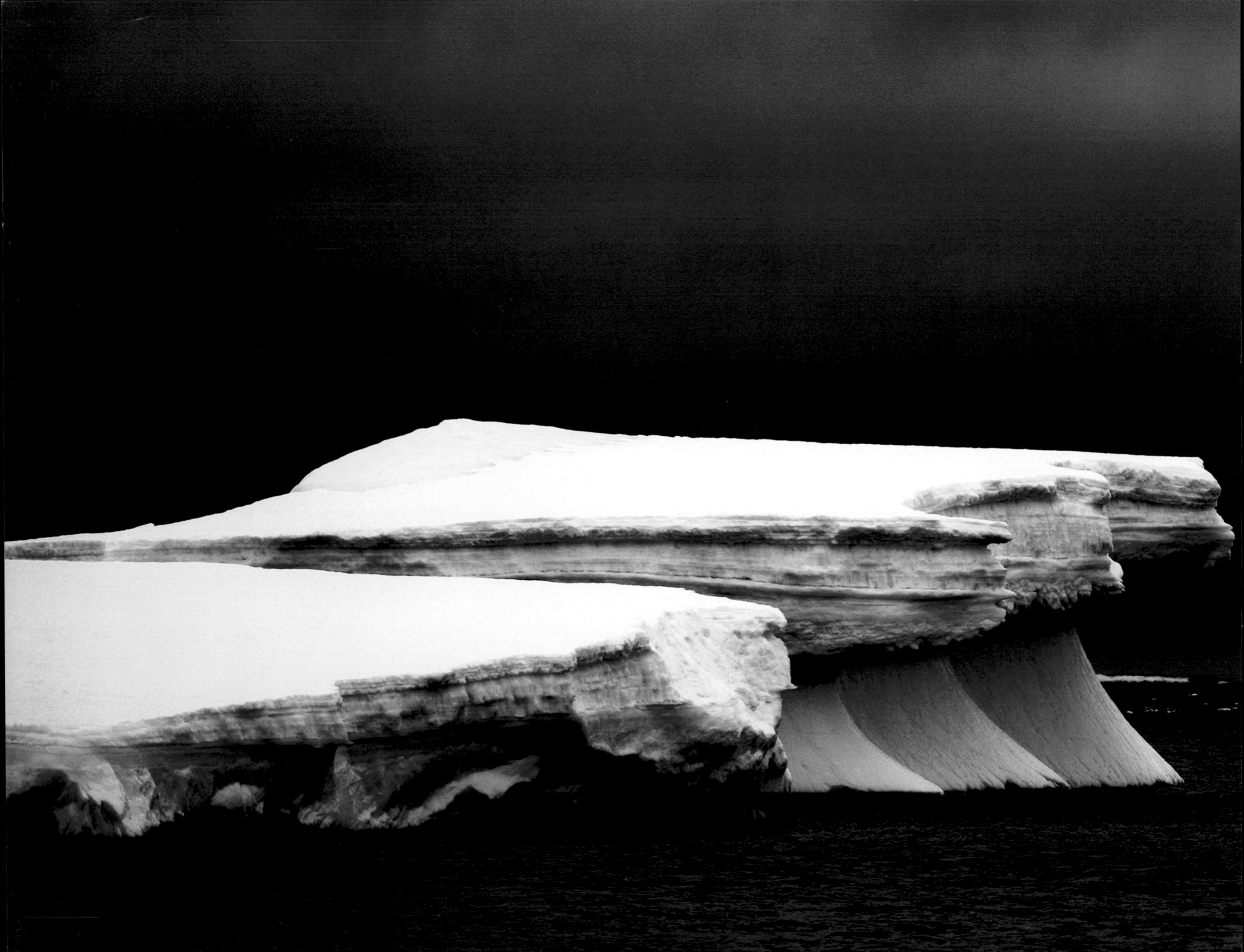

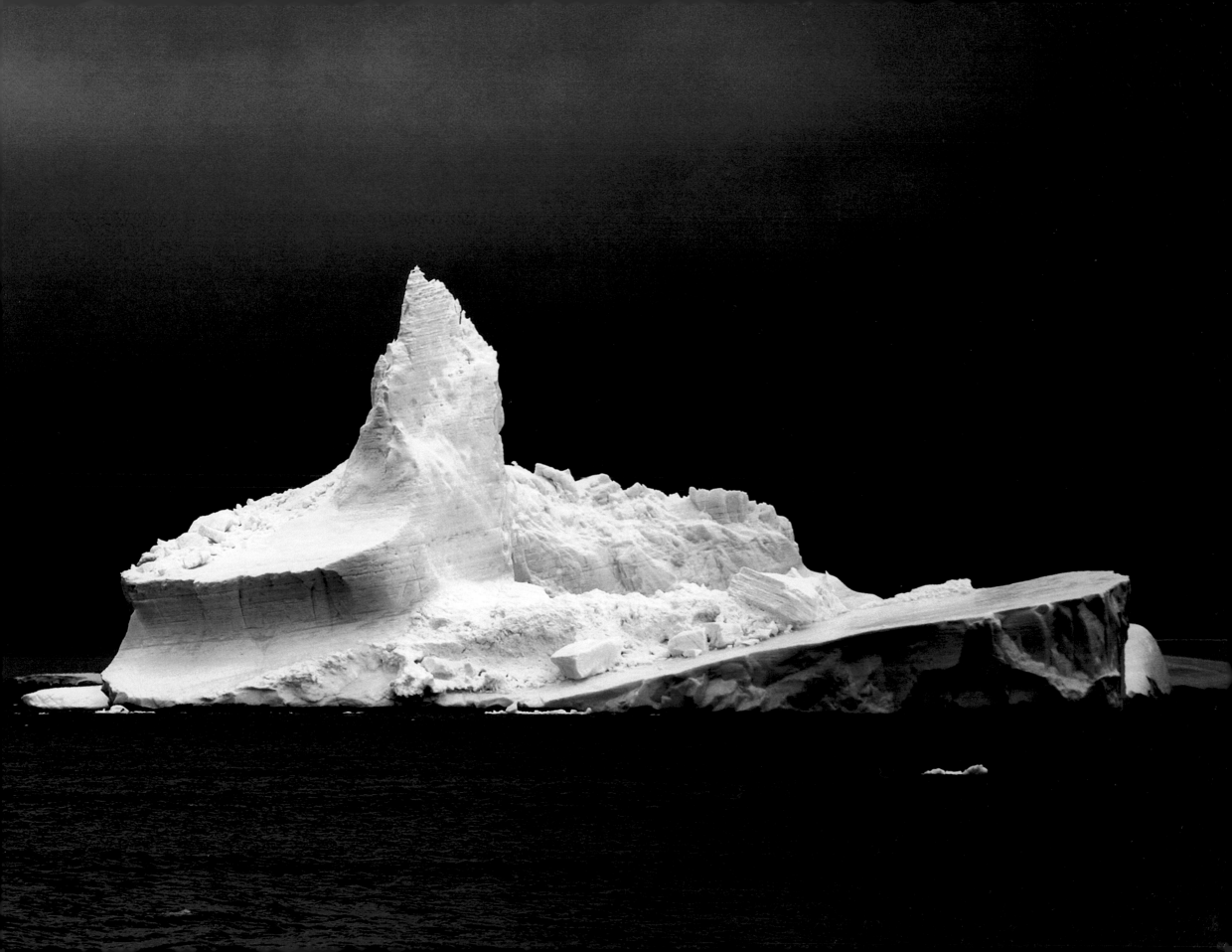

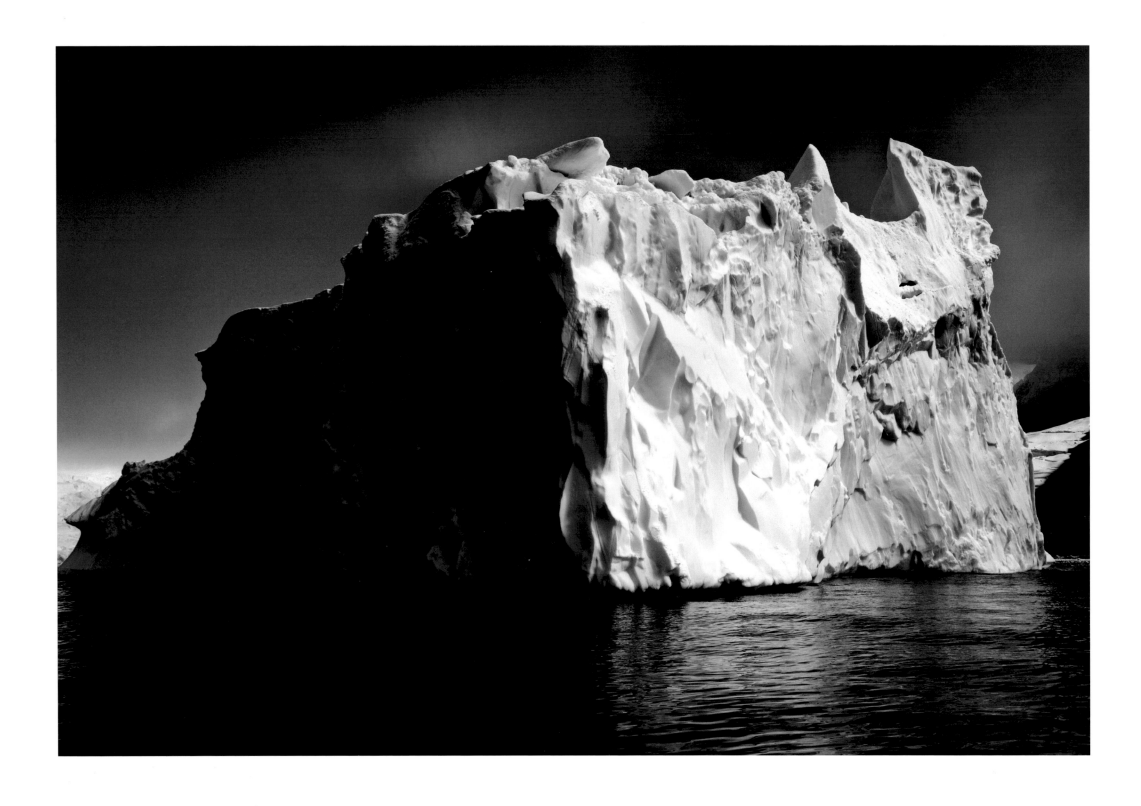

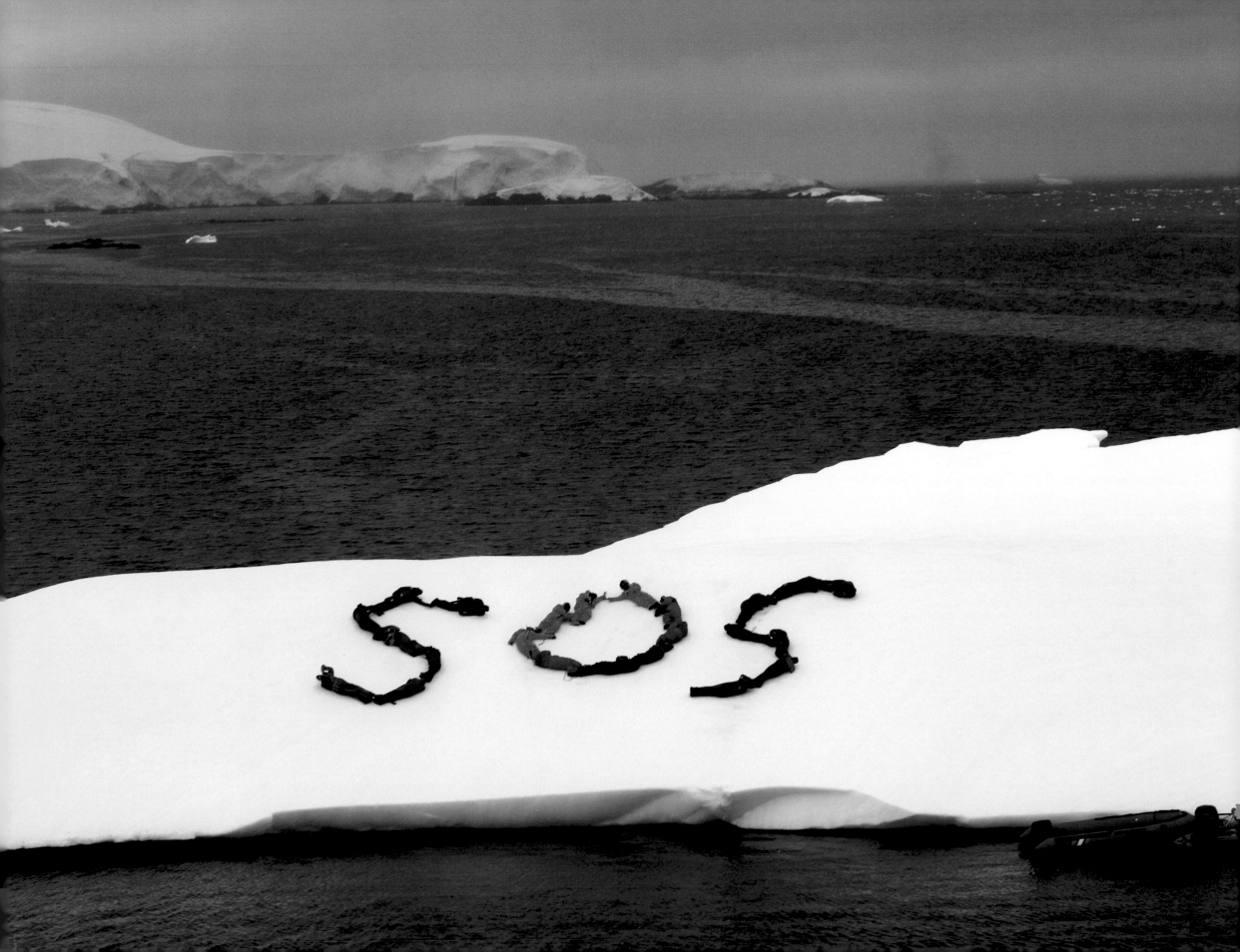

THE MAKING OF THE SOS IMAGE

A conversation between Sebastian Copeland and John Quigley

Sebastian Copeland: I just wanted to talk a little bit about how we found ourselves in Antarctica and the incredible experience we had creating the SOS image. How did you first come to hear about it?

John Quigley: Matt Petersen had gotten word from Green Cross Argentina that there was an expedition to Antarctica. And that there was an idea, I think it was Bertrand's [Charrier, vice president, Green Cross International], to do something similar to what we had done in the Artic, with Artic Wisdom the previous year. That began a process of thinking about how this could work in Antarctica when there is no native population; aerial art images naturally require people to create the messaging. So there was a whole series of ideas about using researchers – well, first of all, learning that there is actually quite a large population that lives in Antarctica, and all the research bases have thousand of people, at least in the summer months. And then with all the cruise ships that come; here is another group of people that could potentially be utilized. And so it was just a research process to see if it was even feasible.

SC: Yes, I remember when it was just this idea, and Matt talked to me about getting involved. And it was the same thing: where do we find people over there and this idea of trying to coordinate with cruise liners, which from thousand of miles away sounded like a reasonable proposition. But to approach and coordinate with these guys... I remember being in Ushuaia with you and going: "Here is a cruise liner, let's go talk to them!"

JQ: Yeah, and there is nothing like just showing up and going "Oh by the way, we need your cruise ship."

SC: "And see that little boat over there? Okay, that's us. We'll be in Antarctica, too. And we'd like to use your ship that's the size of a city block. But you know, we're environmentalists and we would like to use all of your tourists and lay them on an iceberg. Oh, and by the way, we don't have insurance!"

JQ: Right, right –

SC: – And lay them on an iceberg. To spell a ... that is what we were discussing: what the image was originally going to be.

JQ: Right. Well, there were a variety of ideas but at the time *March of the Penguins* was a big deal. So, we were going to create a screaming penguin.

SC: Yes the screaming penguin! The Munch. You had suggested a penguin, then I thought, what about a screaming penguin? Essentially, it was a nice idea but again a nice idea that works in Los Angeles...

JQ: I remember when we did a few sketches. We tried to combine Munch with a penguin–

SC: Conceptually it was certainly a nice idea. It addressed our core message. And with a hundred and fifty or two hundred

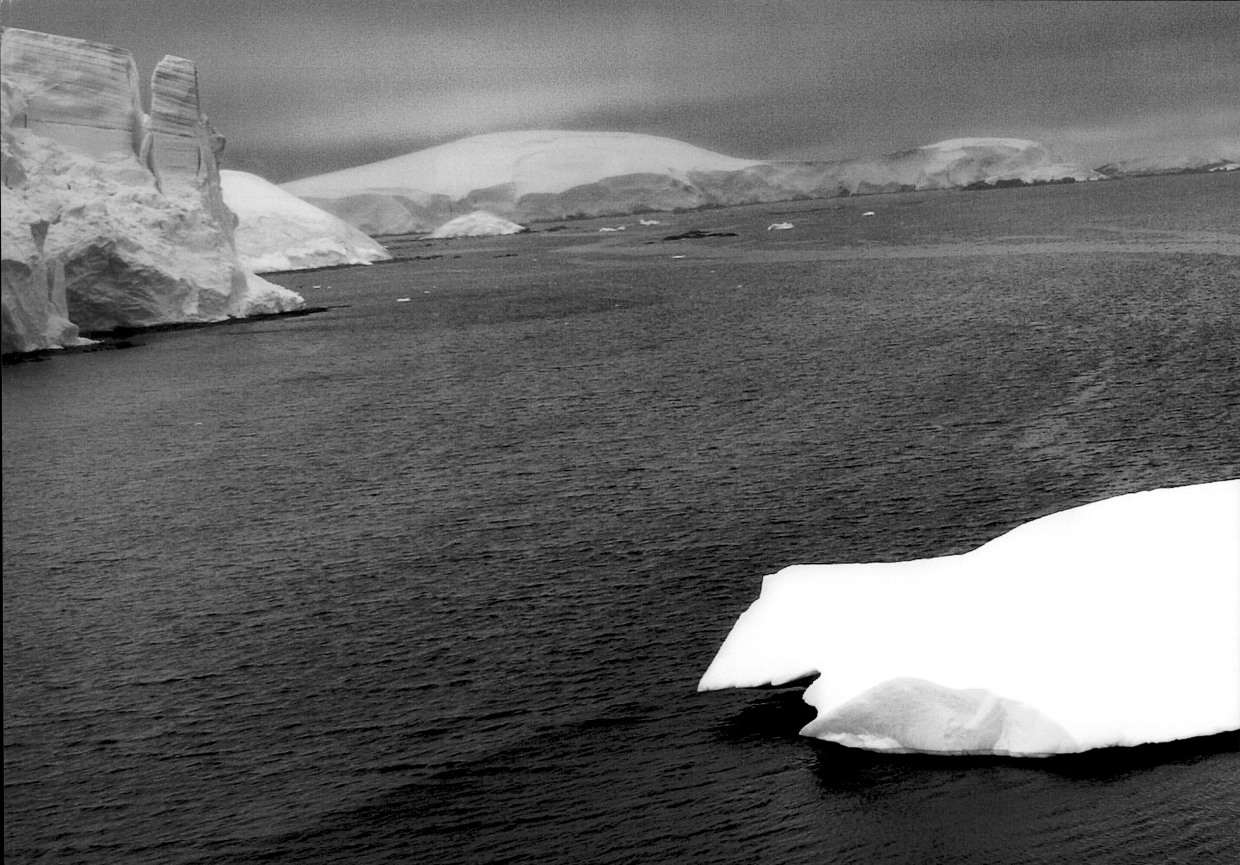

people on a cruise liner it sounded – if not exactly reasonable – like something we could execute. But then came the attempt to coordinate the ships, didn't it?

JQ: Well, there were issues: One was the challenge with the Antarctica rules about never having more than one hundred people in one location at any given time. Which obviously we respect as those rules are there to protect the land. But this type of work is usually measured by size of scale and scope; the larger the number of people, the better. So already, we had to think in different terms. Then we learned that if we did it at a research station, we could involve more numbers because that area was already inhabited. But that was one of the few things that didn't exactly work as planned!

SC: The other issue, of course, was that of an aerial image. Air support is intrinsic to the concept.

JQ: But we had a helicopter. It was on an Argentina icebreaker, which unfortunately –

SC: Unfortunately, got stuck in the ice!

JQ: Yeah, when we got word that the icebreaker got stuck and there would be no helicopter that was a pretty serious blow.

SC: No question! And so, after trying to communicate with these cruise liners, contending with the weather and coordinating our location with their ships to get all their people on an iceberg, which we had to first locate, which therefore made it very difficult to give them a point of location...

JQ: We were going to do it on a landscape, on a glacier, whatever.

SC: But then there was the issue of getting people together on a glacier, with the crevasses.

JQ: Yeah right, safety issues –

SC: As well as trying to determine if a nearby hill would give me the bird's eye view of the missing chopper!

JQ: And just the sheer distances in Antarctica and trying to coordinate with these ships. It wasn't really happening.

SC: Yeah. So eventually, we came to the conclusion to the great relief of our shipmates, who were getting slightly impatient with our goings on –

JQ: Mutiny was near –

SC: Mutiny, indeed! So we decided to damn the torpedoes and forge ahead with just our ship and our thirty shipmates. We would somehow improvise a location to be determined and forget the helicopter altogether, which the Brazilians may or may not be able to provide. And hopefully find an iceberg that could accommodate our thirty members in the shape of a screaming penguin somewhere in Antarctica!

JQ: Exactly, exactly. After Marisa didn't show up and we had waited for a few days and then the helicopter didn't show up. The crew of the boat was our only option. It was either that or turn back. So we set off to find an iceberg, which had to have certain qualities: it had to be a good canvas; it had to be in calm waters – it was very dangerous to mount an iceberg that can flip, and they are continually in motion; and there had to be a point on the iceberg where we could land a zodiac and climb on. And I remember we had our first debate crossing from King George Island to the peninsula. We found a beautiful iceberg but the seas where kind of rough and we were traveling at quite a quick pace. It was decided that it was a little too dangerous.

SC: And we had a constant knot in our stomachs as every time we approached an iceberg that it might be the one. So we'd get nervously excited as we were approached from a distance only to realize that, no, that's not going to be the one. And let's not forget that icebergs are ice by definition; they're incredibly

slippery and if the surface wasn't just about flat then it would be very difficult to implement. But then we found ourselves in the Gerlache Strait. And you and I went on a zodiac mission. Our crew was stationed somewhere else and we had a day to basically find our iceberg and we went off.

JQ: Also the patience of the boat was running thin. We knew we had to do it soon.

SC: We were facing a second potential mutiny.

JQ: Because most of these folks were not there, at least originally, to send this message. They had another agenda.

SC: But you managed to talk Guillermo, one of the owners of the boat, into doing it, and I think you made a good sales pitch. Because getting him on board was key as he made this his own personal mission.

JQ: Yeah, yeah absolutely. It was an interesting mix because you and I, working as a team, worked different angles at different moments to keep the momentum going. But our scouting mission was fascinating; we were deep in the Gerlache Strait. It was one of those ugly weather days where it was freezing rain. The kind of rain that you don't normally have in Antarctica, according to the gentleman from the British station down there. And we searched and searched for the right iceberg. And we found it eventually.

SC: We found a great iceberg! We were so excited when we

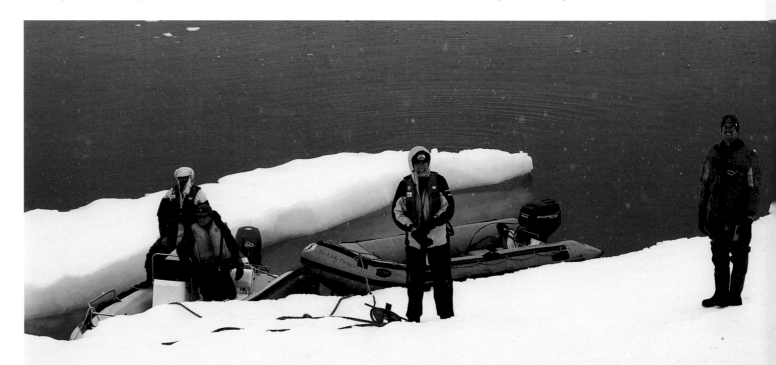

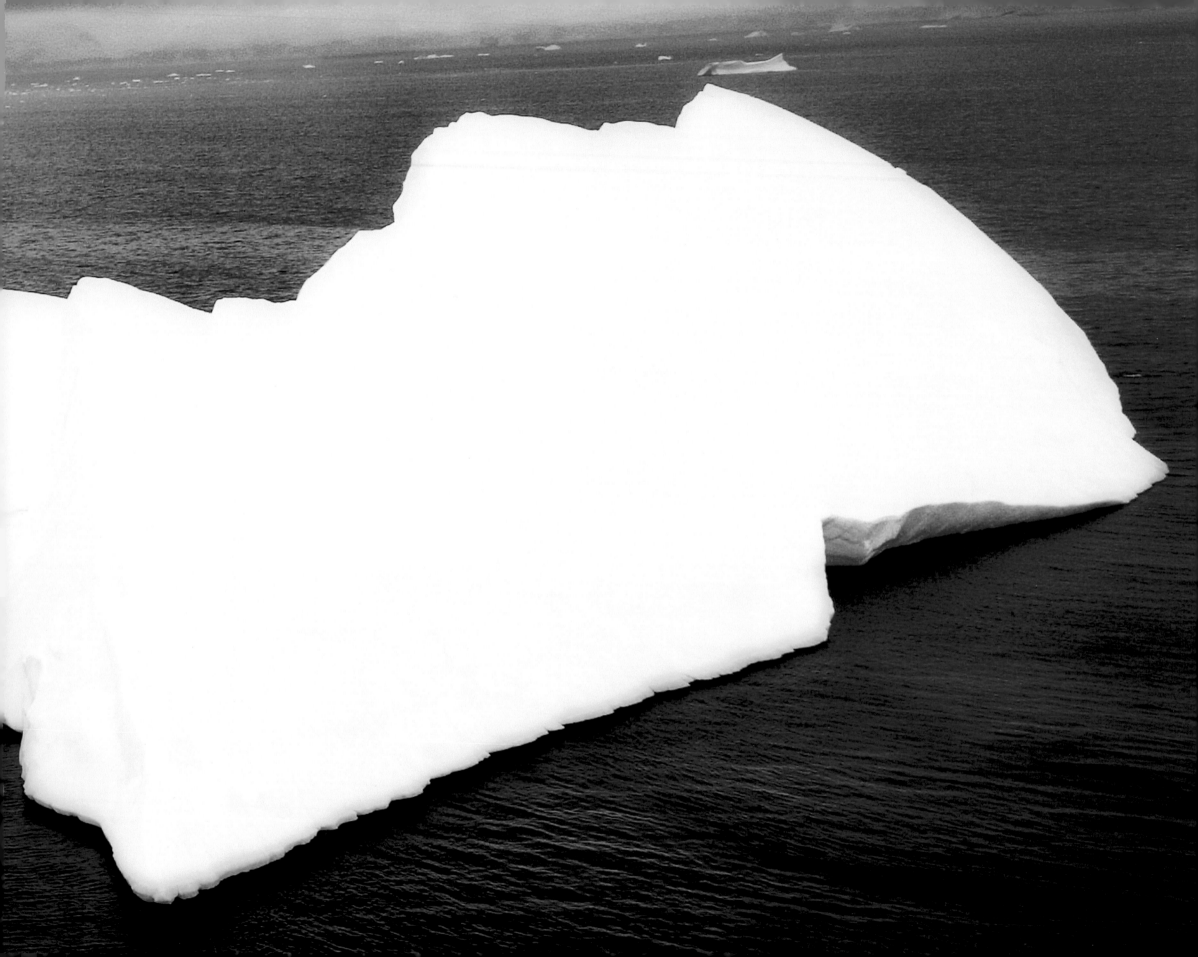

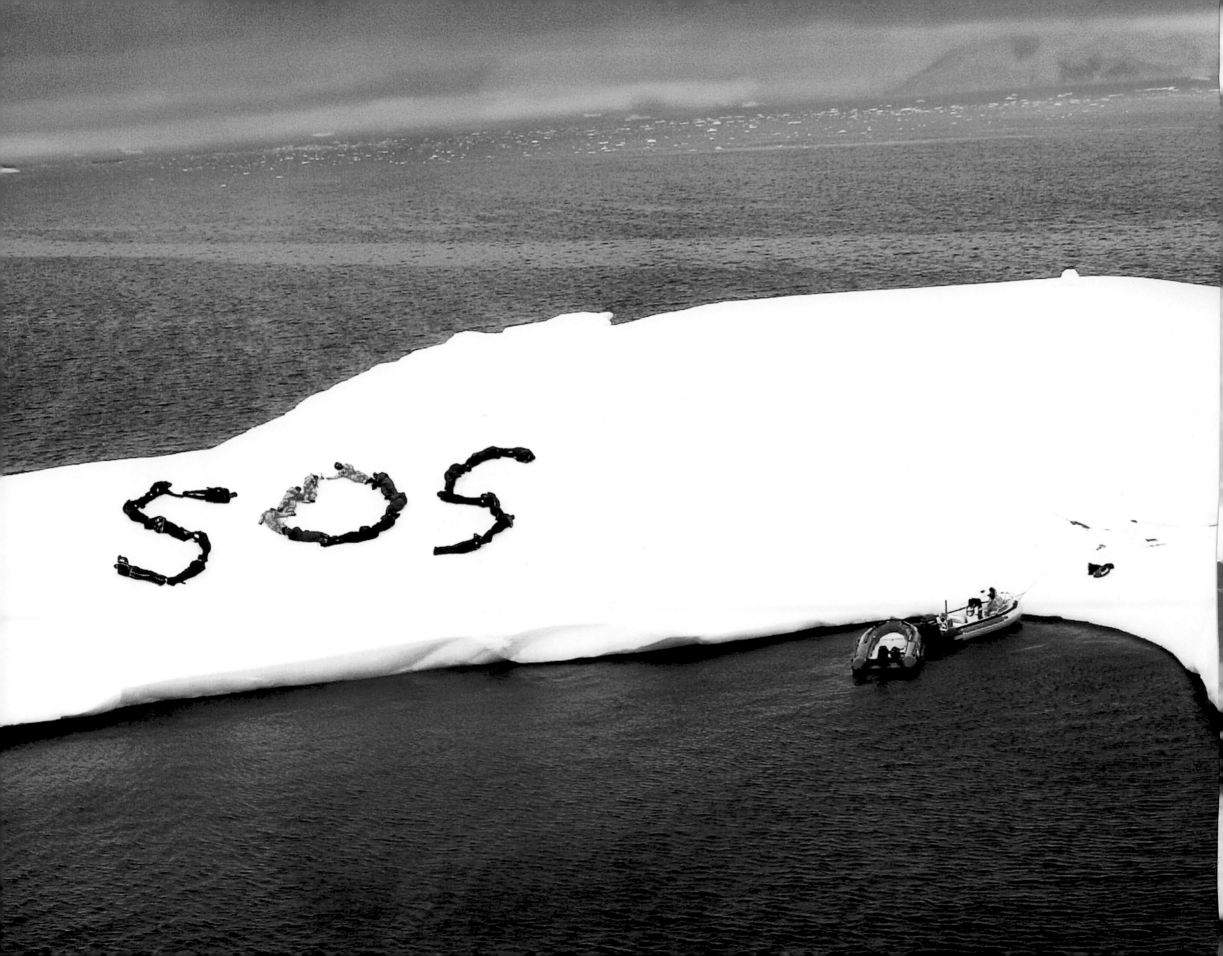

actually approached it. I remember it was completely inaccessible from our approach, but as we came around it there was a perfect landing with a perfect environment to bring a zodiac to it. In fact there were five sleeping seals on it I think, who were none too pleased with our interruption.

JQ: And there was debate about that and then we realized that there was no serious harm –

SC: There wasn't. We figured they spent a lot of time climbing on and off icebergs! But we were very excited because we had found our iceberg.

JQ: It was the morning when we went out. And I remember we were doing the depth soundings because we were going to shoot from the ship, because the new plan was for you to be on the mast of the ship.

SC: That's right.

JQ: And we had to be able to maneuver the ship into the strait, which was quite shallow at that point where we found this iceberg. Then we were on the way back to the ship, we came across this whale and we had the epic photo-athon with this whale.

SC: I think Kodak built a new factory on account of the film that was shot on that whale. So close, we could throw a quarter at it!

JQ: It seemed like hours on this whale, but it was beautiful. I mean, it was a beautiful moment. We finally got back to the ship; the call went out that the photo was going to be taken that afternoon. So we rallied on our zodiac after lunch and went back, but then –

SC: Lo and behold – this was hours later – we approach from a quarter of a mile out and go, "It's over there!" But when we got to it, it actually looked like another one might be the one – a quarter of a mile out in the other direction! And after doing this I think once or twice, we factored that the Gerlache Strait of course had a current and what was there ten hours prior, essentially, was gone! It was time for us to look for a brand new iceberg. But we had the ship in tow and everybody was getting suited up and ready to climb on an iceberg at this point. There was some pressure!

JQ: Exactly. And then as we were coming back out of the strait away from the cove we saw this other iceberg, but from our angle it looked unapproachable and we decided, I don't remember exactly how, I think it was you who said, "Well, let's just check around the other side." And that's when we pulled around and it ended up that it had a perfect canvas; it had a perfect landing point –

SC: It had a slight angle. It wasn't exactly flat.

JQ: It had two angles, one of which I thought originally was going to be the canvas. But the angle that was flatter was up on top of it, but we realized that from the angle of the ship it just wouldn't be extreme enough to read. And so that's where we decided to use the slope, the relatively steep slope that fell off right into the water.

SC: Yes, because now, short of the helicopter, we had to shoot from one of the masts, which were sixty feet in height. So we didn't have a direct view down onto the ice itself but nevertheless that iceberg was actually fantastic! We were really excited.

JQ: It was perfect. I remember that the challenge was that the crew actually showed up early as I was beginning to lay out the penguin. We had talked so much about the penguin that a lot about what these guys had bought into was that they were going to create a penguin.

SC: Yes.

JQ: It became shorthand for the image: "When are we going to do the penguin?" So I'm trying to lay out this penguin and suddenly they all show up on the ice in their survival suits and I'm not even close to laying out this penguin, so then I tried to free-hand the penguin. And I remember – and this is one of the great things about Sebastian that I can always count on him being absolutely blunt – and I remember that morning I said, "Look, if it is not reading you tell me immediately and we'll just go to the SOS."

SC: And I liked the SOS. I had suggested that early on because the message was very clear. Especially on an iceberg. I loved the penguin idea but I was nervous about the readability. SOS was a concept that was easily identifiable. I felt your magic is to create things that I wouldn't necessarily see because that is your specialty. But from a production standpoint, I'm looking at this thinking: we have twenty-five people and we're creating a penguin? But these guys show up, I proceed to climb to the top of the mast, and I'm sitting there with my camera wrapped in a plastic bag. It's raining at this point as well and freezing with windchill factor. Whatever the wind was at surface level, it's probably twice that sixty feet up. And the boat is extremely close to the iceberg at that point. And I'm thinking, "Wow, this is amazing, the boat can almost touch the iceberg." Really, they can maneuver this thing so well and they are moving very, very slowly in the direction of the iceberg while you are setting up the picture.

JQ: Yes, and I hear someone say, "They're going to stop, right?" And I'm like, "Huh?"

SC: That's what I was thinking!

JQ: And I see him looking over my shoulder so I slowly turn. It was like one of those moments in those old cartoons where there is a giant shadow looming over someone. And I turn and the prow of the ship is headed straight for me, and I'm doing these calculations in my brain: OK, speed of ship probably too fast, you know the distance from iceberg, way too close. I'm assessing the iceberg for its durability to receive impact and right as I'm thinking about that the ship just literally pulls a titanic into the iceberg thirty feet away from me. A chunk of about ten by forty feet collapses in a giant spray. Now the slope above me where the people are in the SOS is a pretty extreme slope – we had to rig up a rope with ice screws so that some of the people wouldn't slip off because their survival suits were so slippery, they couldn't even stick to the ice without the rope. So all of the sudden the whole iceberg is rocking.

SC: Shaking.

JQ: Yeah, and my first thought is, "Is it going to split in two and flip over? Is it going to shatter into little pieces?" I'm doing the calculations and everyone had on survival suits but most of them hadn't bothered to zip up their throat, their cuffs and stuff. So if we had gone in, if the iceberg had shattered, we probably would have lost at least five people. Because we'd only had five minutes, virtually everyone who would have been responsible for a rescue was on the ice with us and it was just one of those moments where, you know I always joke when I'm doing these things, when things get tense I always say, "Hey, relax everybody, it's not like anyone is going to die from this!"

SC: It was a pretty substantial iceberg. We forget that nine-tenths of an iceberg is below water. It was probably about two to three hundred feet in length. After this excitement and our attempt at creating the penguin, there came a point where the crew was getting quite impatient. I'm sitting up there in the freezing rain, and I'm wet from head to toe at that point, trying to cover the camera. And I'm looking down thinking we've been at it for probably about an hour.

JQ: It was about an hour from the time they arrived on the iceberg. And Sebastian was checking in from time to time on the radio, and then he's like: "It doesn't read!"

SC: Let's bag it and go to the SOS! And luckily you were very quick. This was probably a lot simpler for you to execute than what you normally do. So you did the SOS in relatively short order. Which was good because we were starting to face a potential third mutiny, if I recall.

JQ: Mutiny number three.

SC: The ones that you positioned first had been horizontal on the ice for about forty-five minutes by then. Emergency suit or not, they were definitely on the rocks!

JQ: And we have this situation where there were two types of survival suits and the orange ones were so slippery they had no traction on the ice.

SC: It was just thick plastic.

JQ: It was tough for anyone to hold their position. It was physically draining to just dig their muscles and bones into the ice even with the rope. Going into the SOS came at the right moment. And it's funny because it is the least number of people that I've worked with in one image. And when I look at it, it is kind of ridiculous – it's like a three-year-old child drew something on an iceberg, you know. And yet, I have real affection for it because I know there were two teenagers on that ice. And I think there were thirteen countries represented on the ice, and every generation. And the bottom line is that everyone risked their lives to be there.

SC: Yes, and then comes the moment when finally everybody is in position and I've been hugging this freezing mast for an hour and a half, and I am hoping that the camera will fire, and not short-circuit, but I can't check without exposing it to more rain. And I look down and think: This is good. We've got it. It's time to shoot it. I had the lens cap on and I'm taking the camera off the plastic bag. I knew that I had three, maybe five frames before the lenses would get wet. I had a second window, which was to remove the skylight filter which would then give me a dry lens again, and potentially another five frames before it, too, got wet. And for all of that, I was probably done shooting inside of three minutes. We had to do the pictures really quickly. I guess the accomplishment was to find ourselves in the middle of the Gerlache Strait on an iceberg, with this motley crew of people tied to ice screws to realize this environmental picture at really the bottom of the earth!

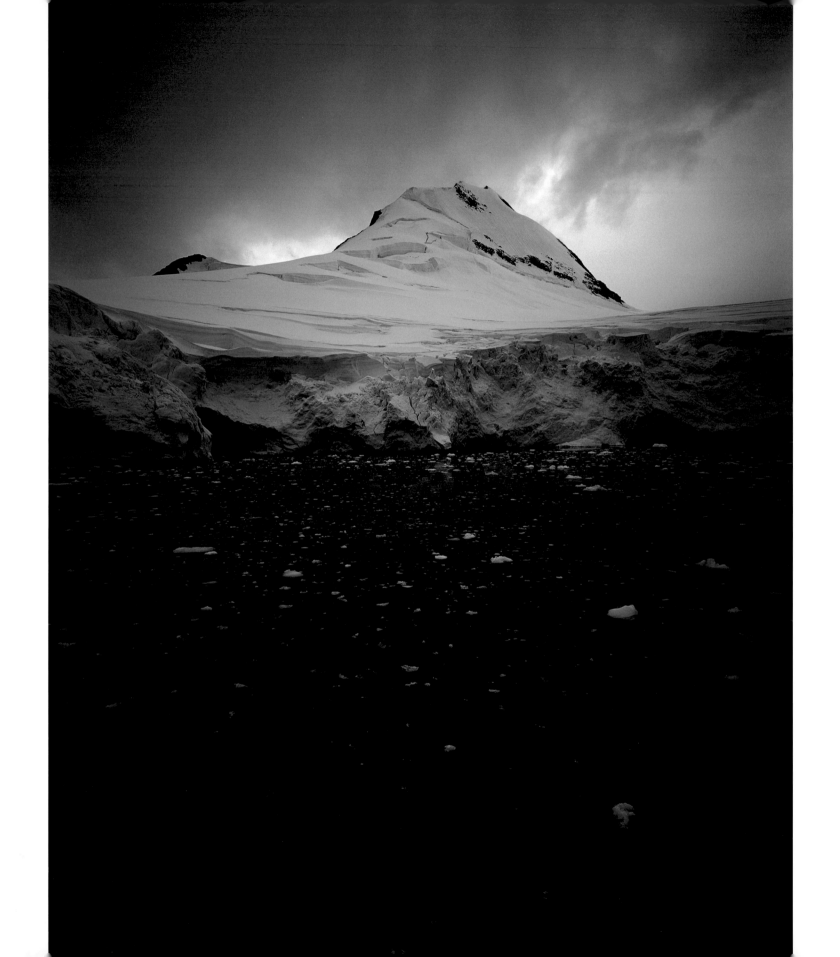

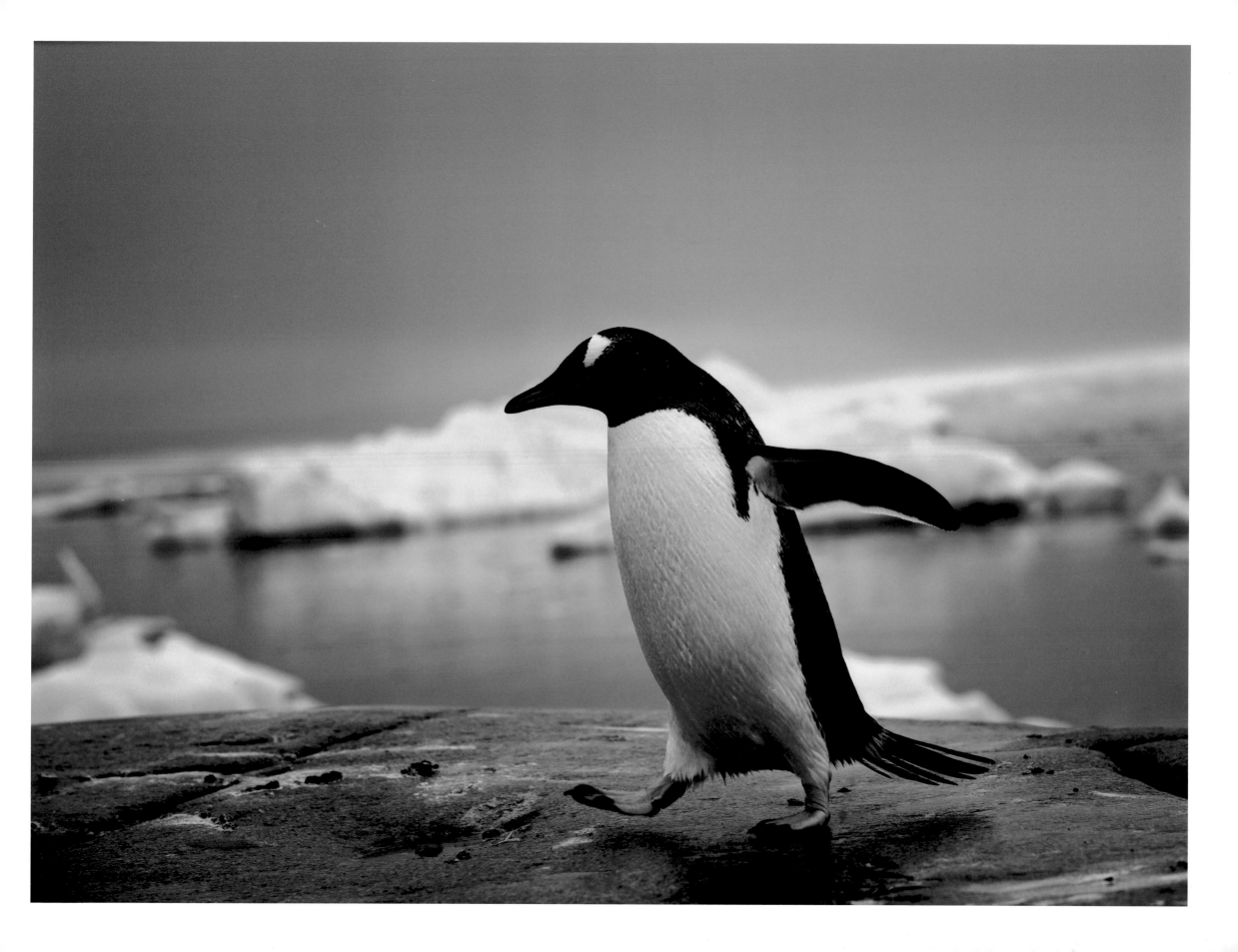

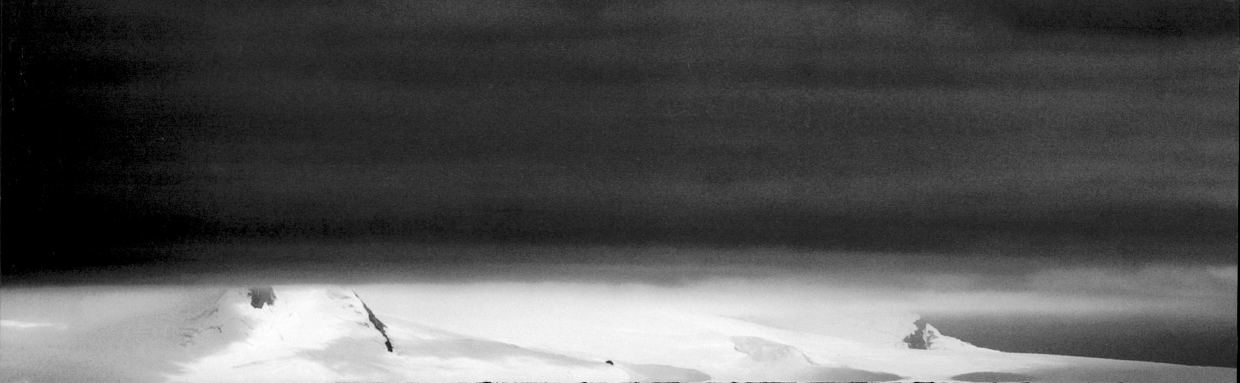

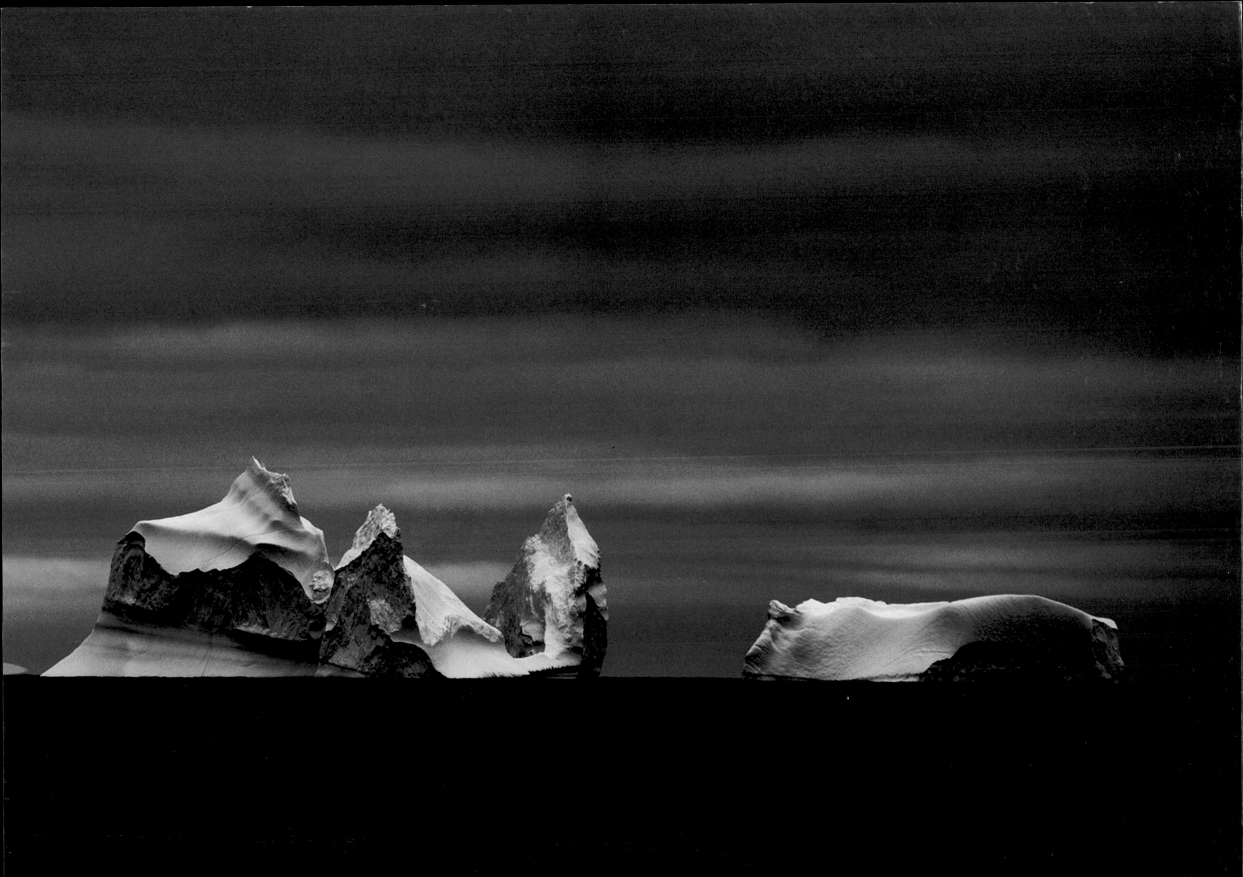

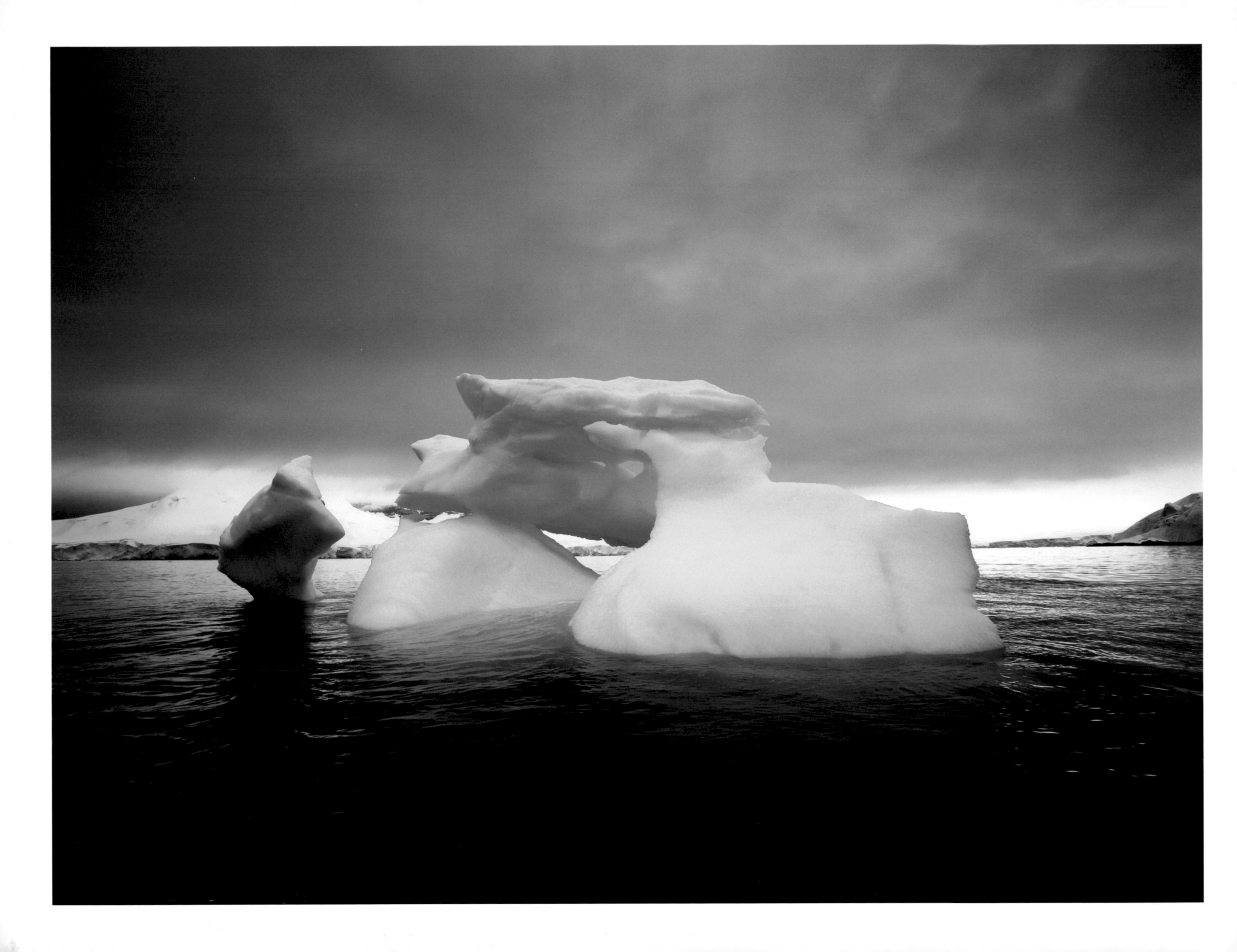

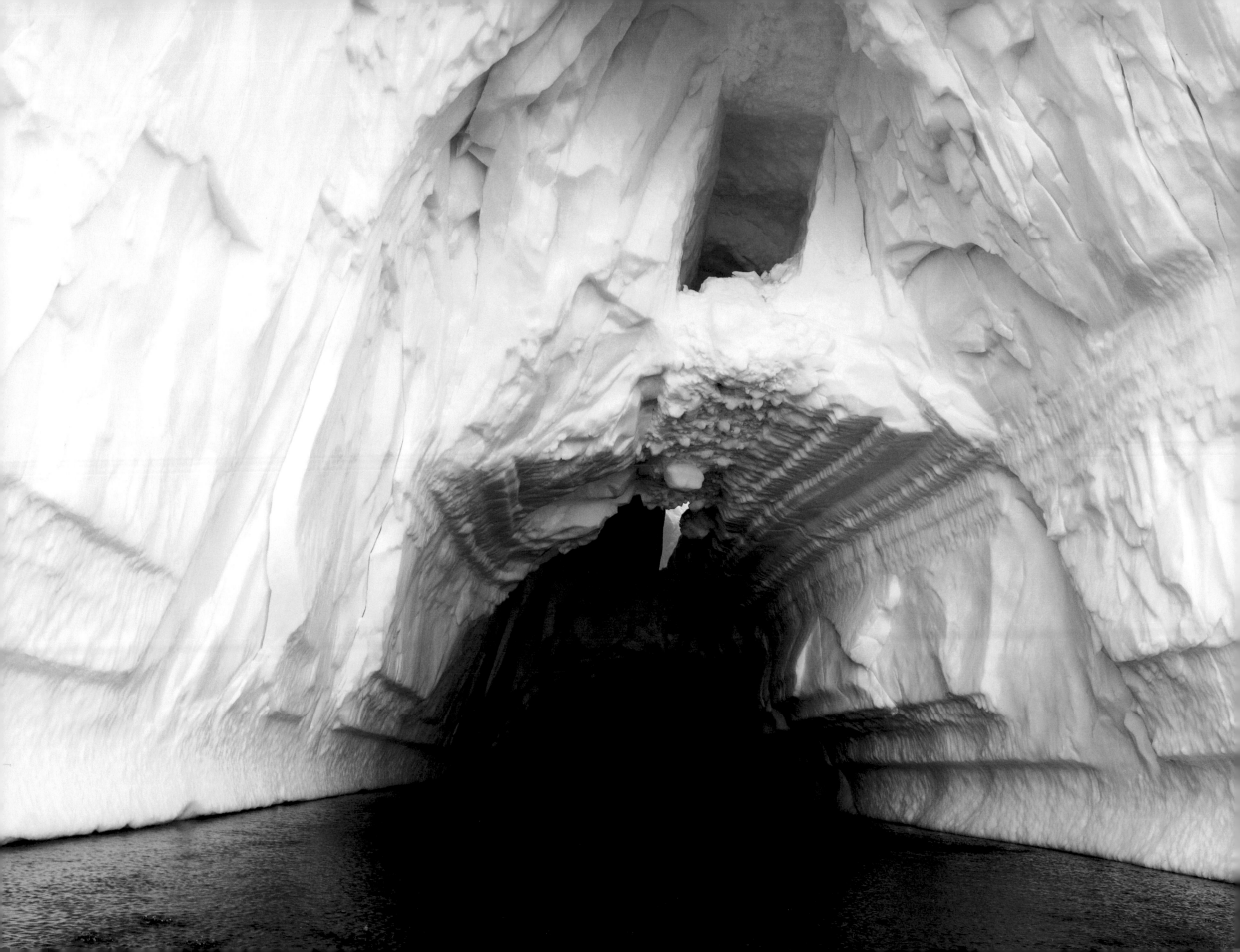

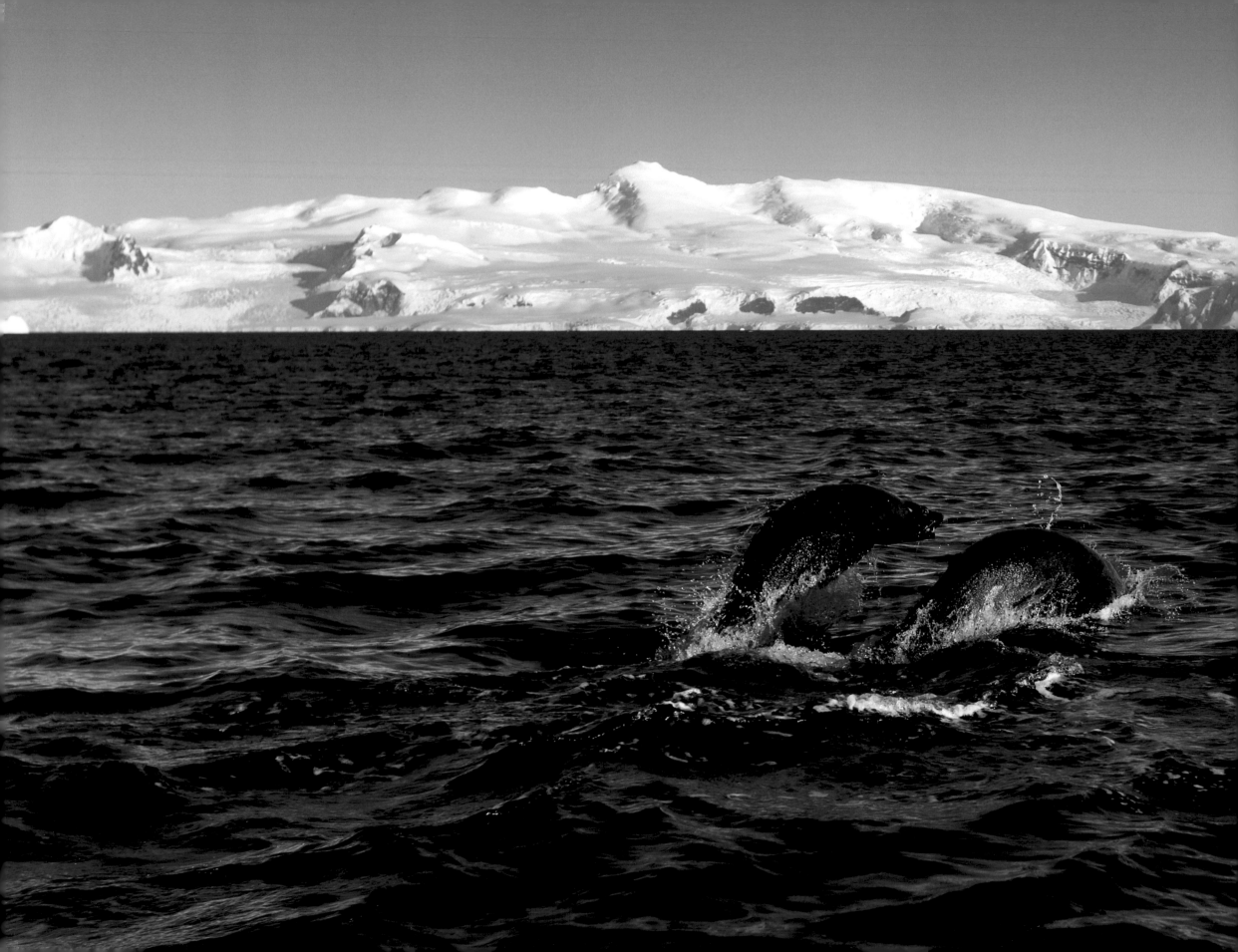

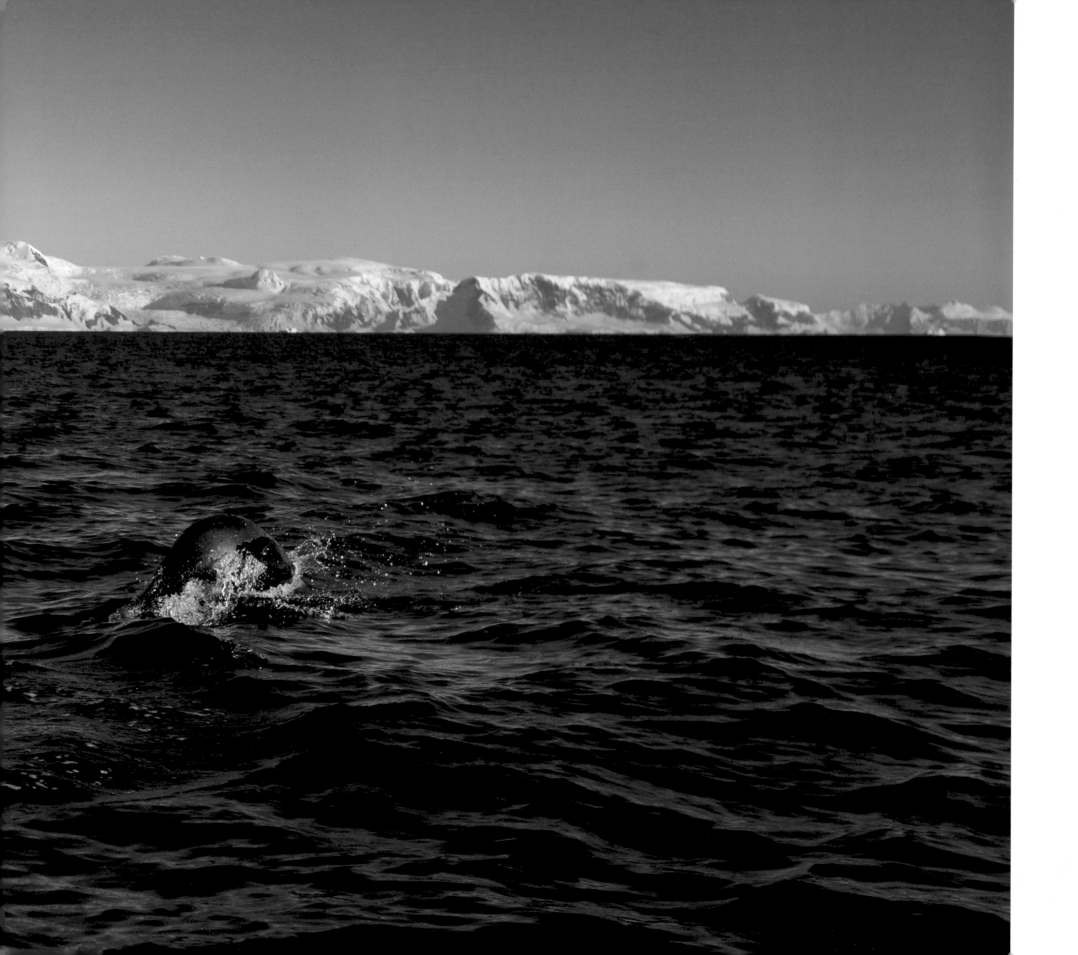

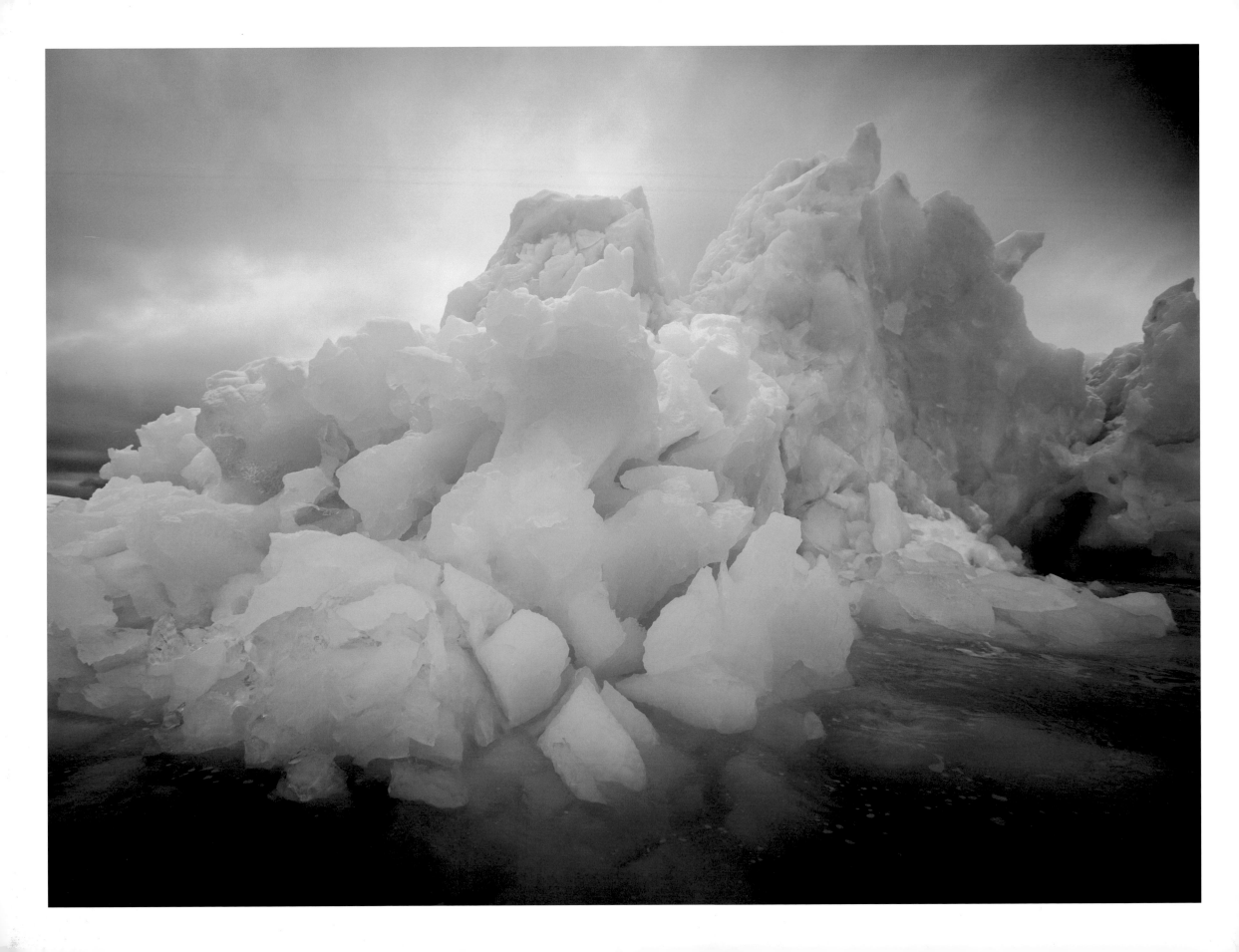

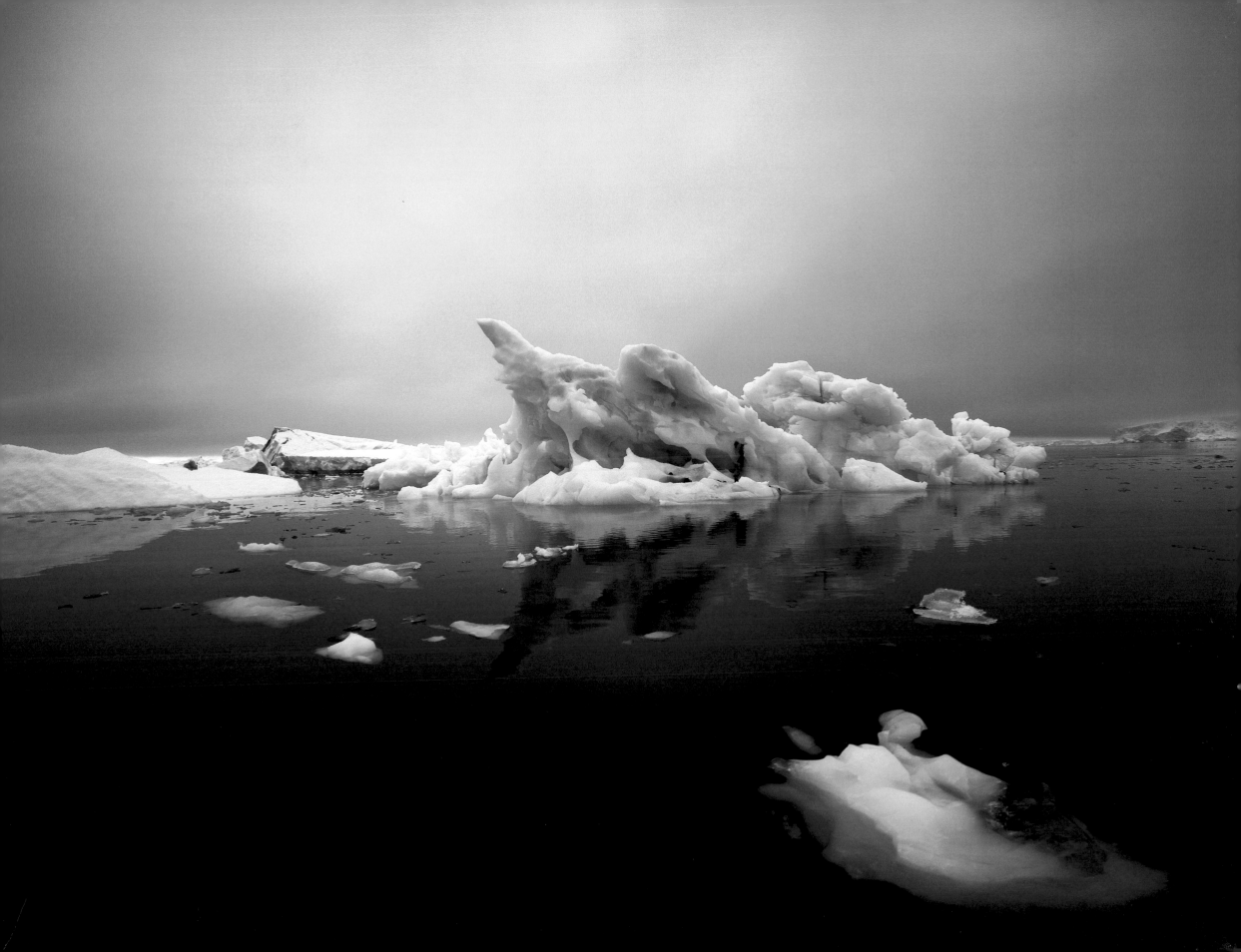

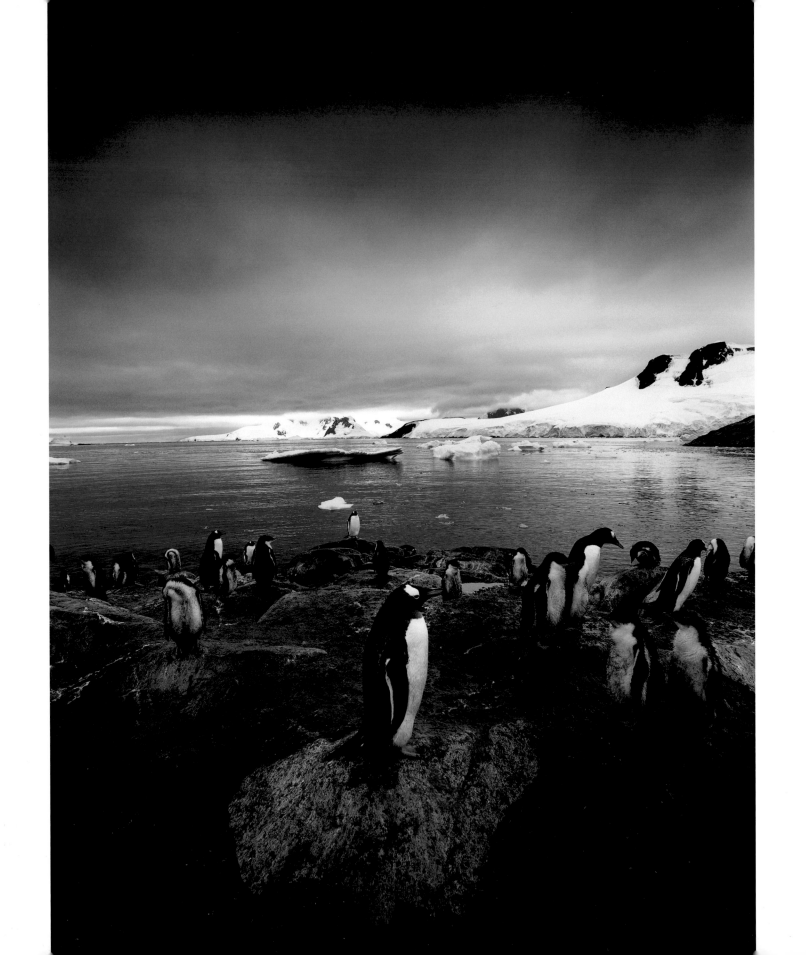

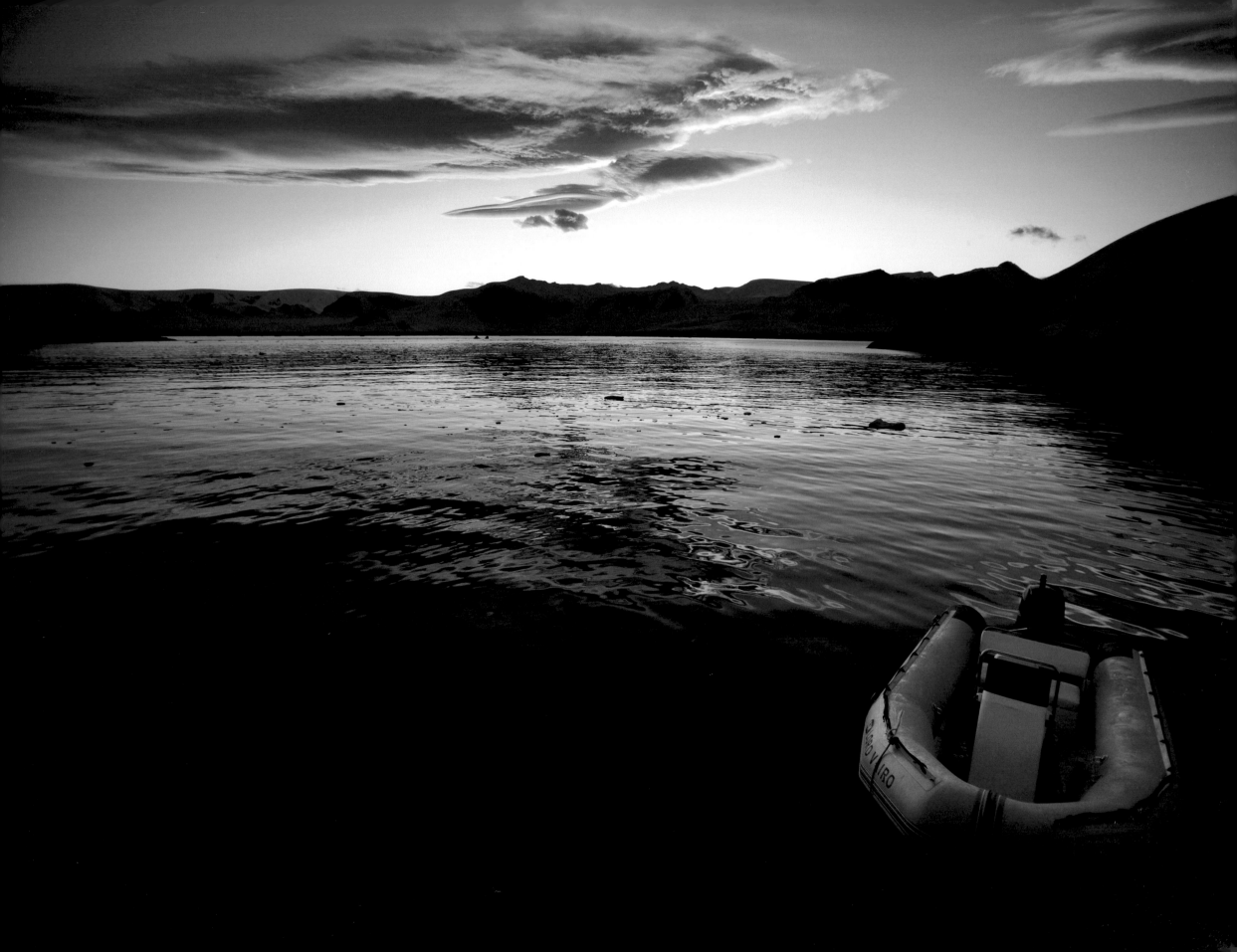

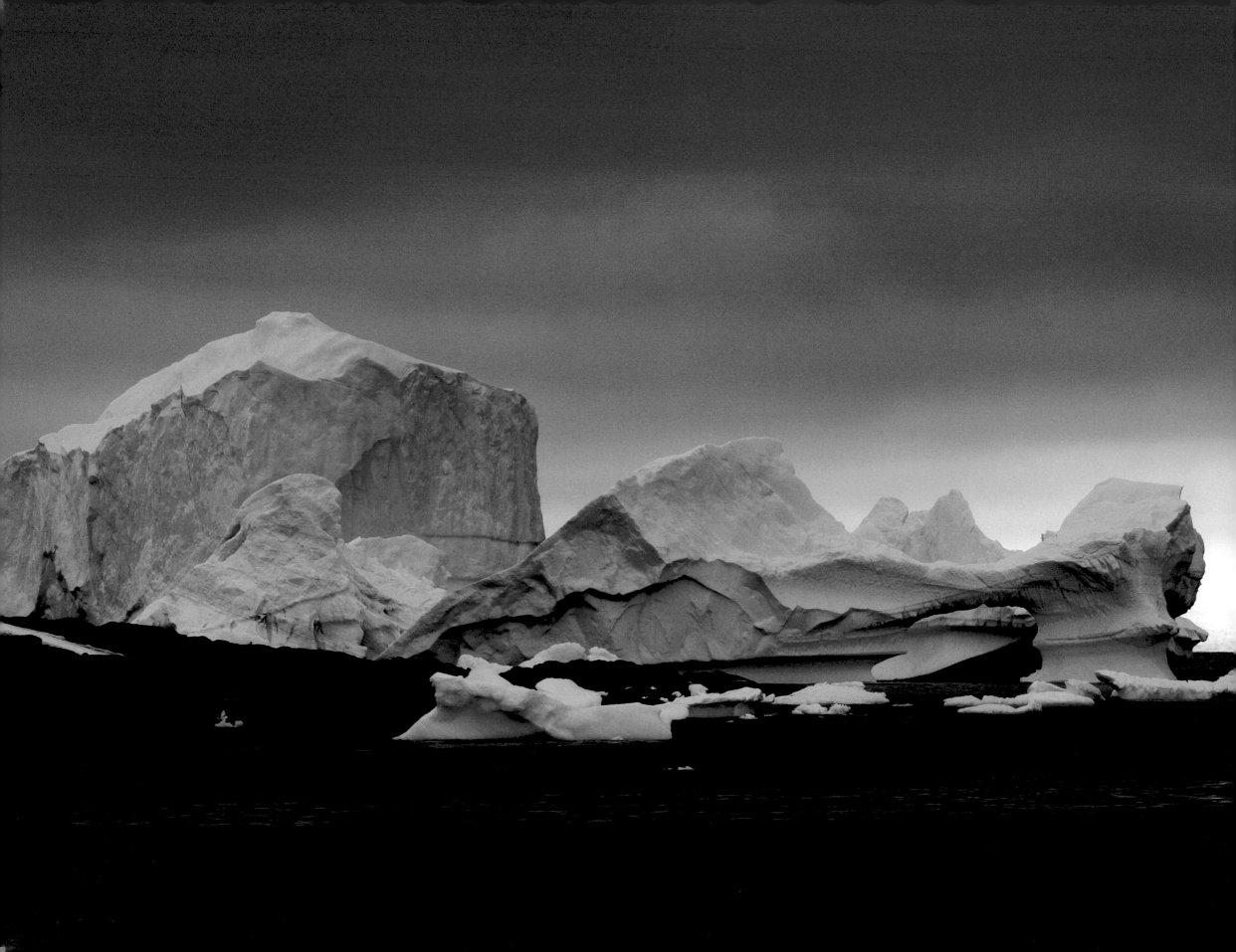

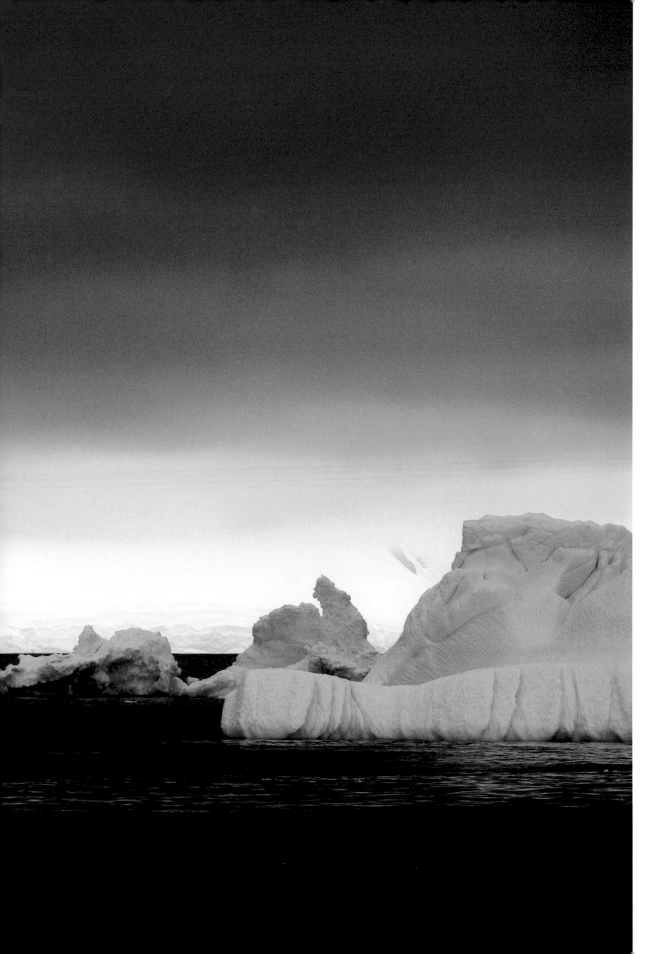

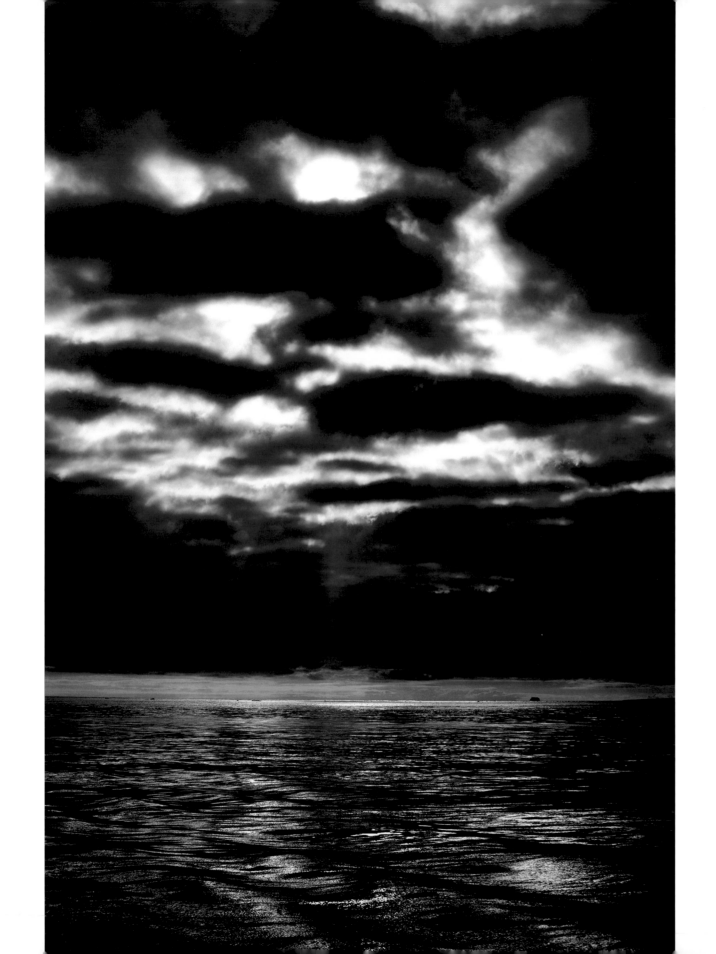

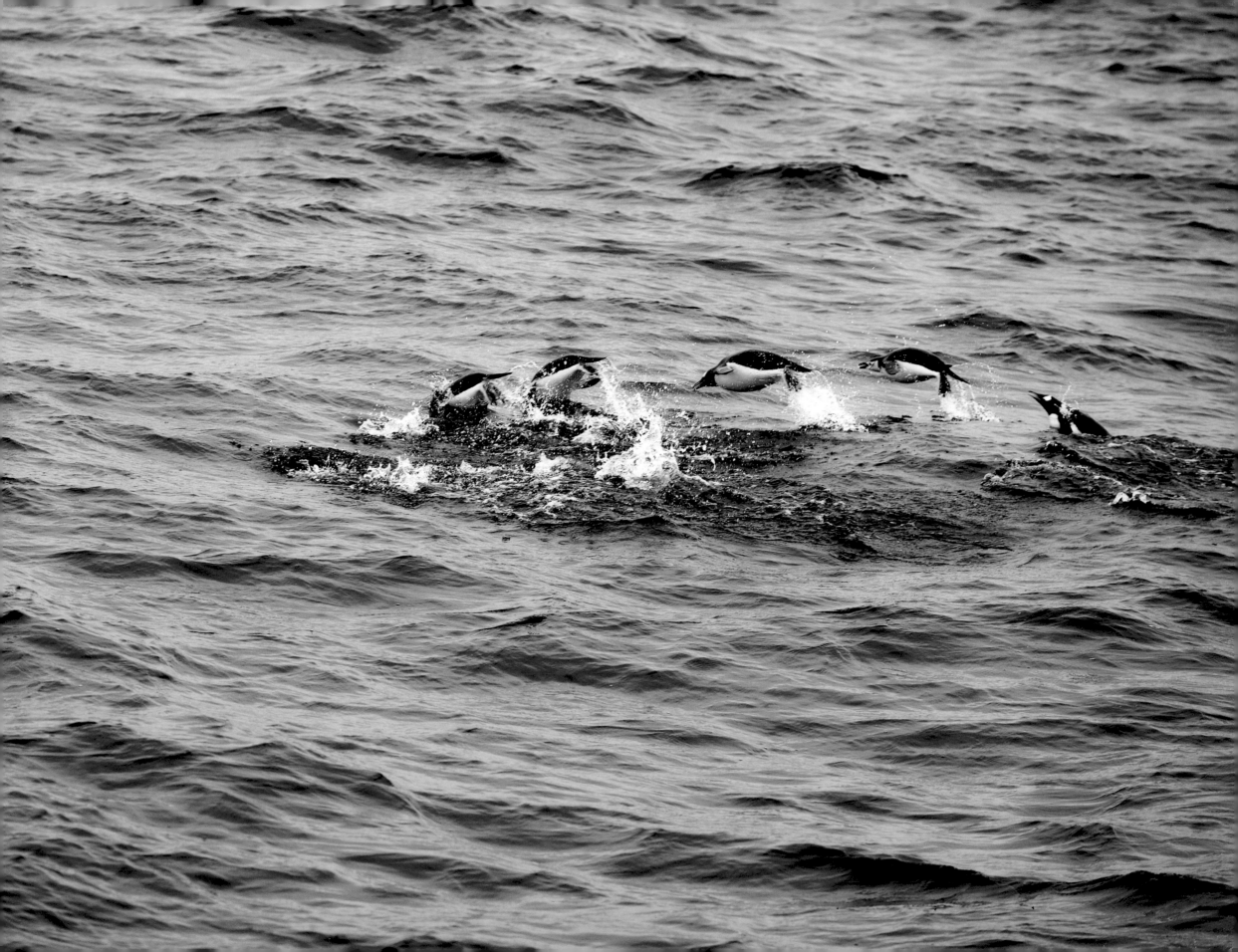

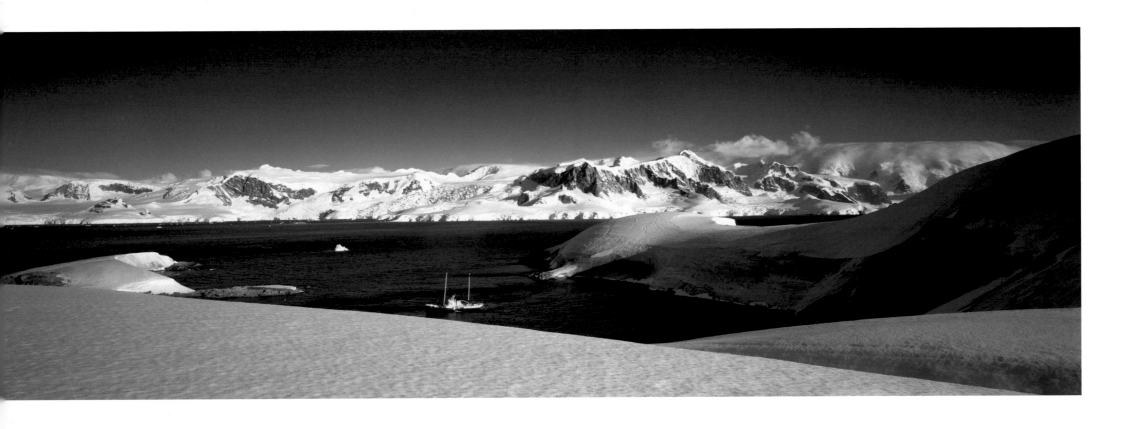

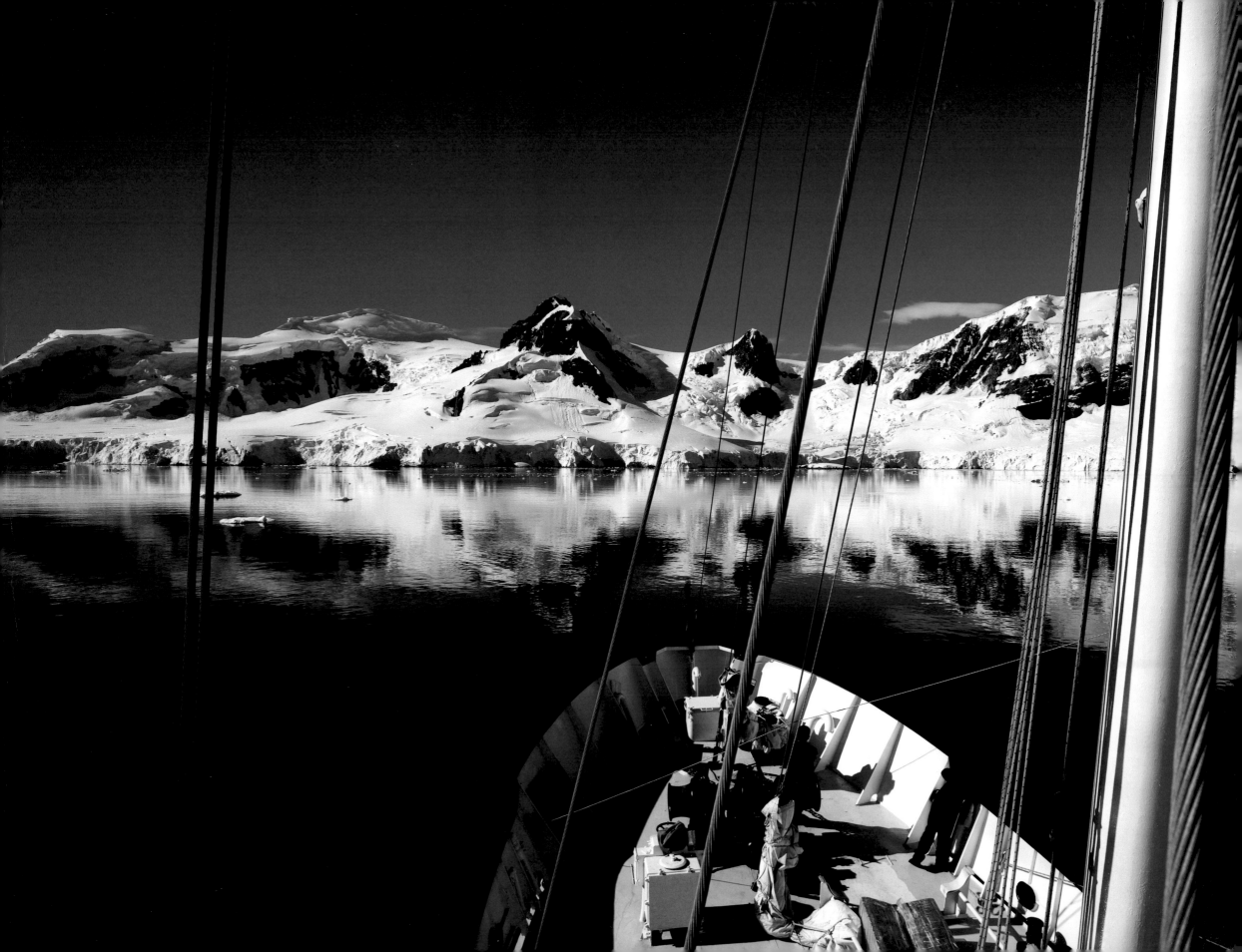

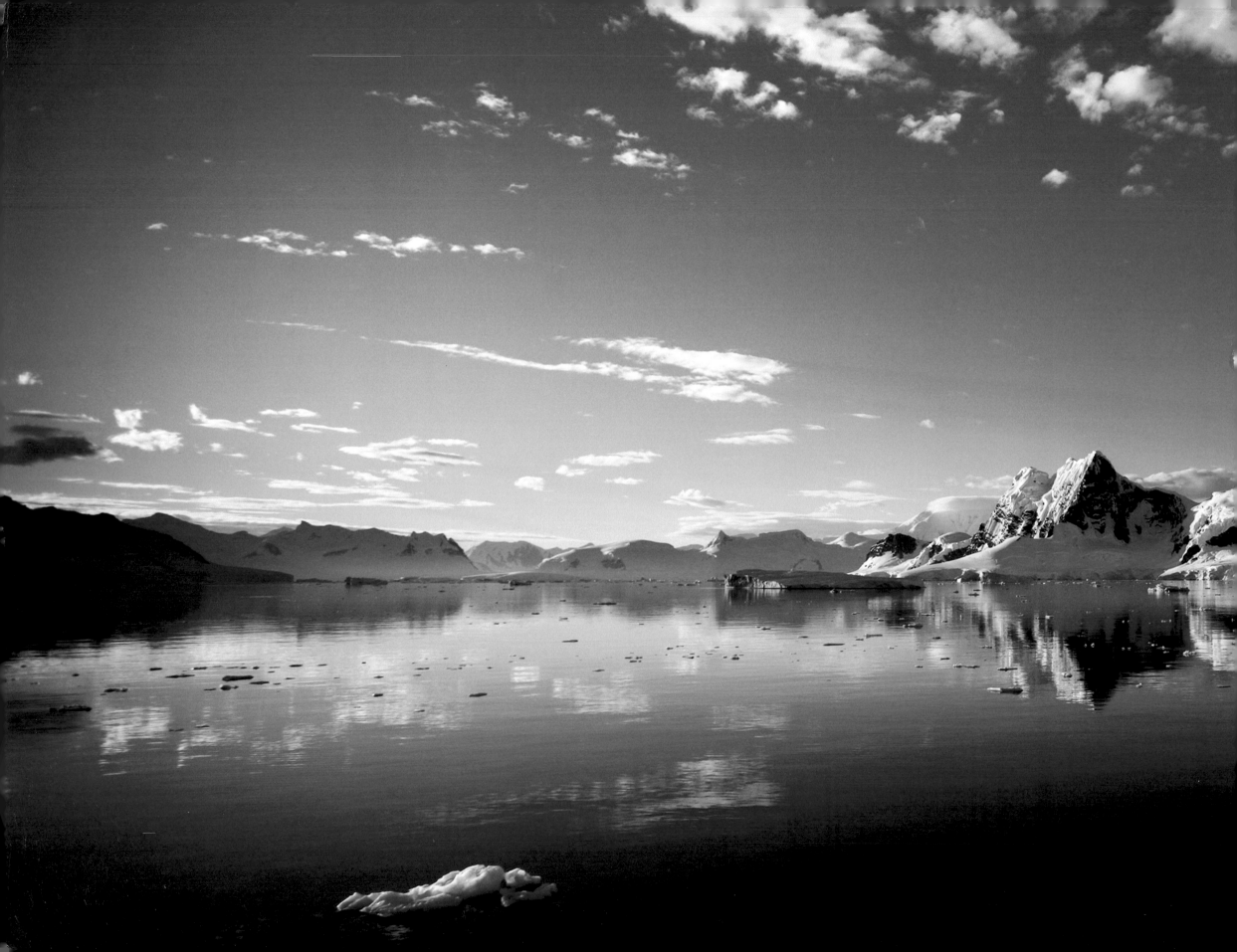

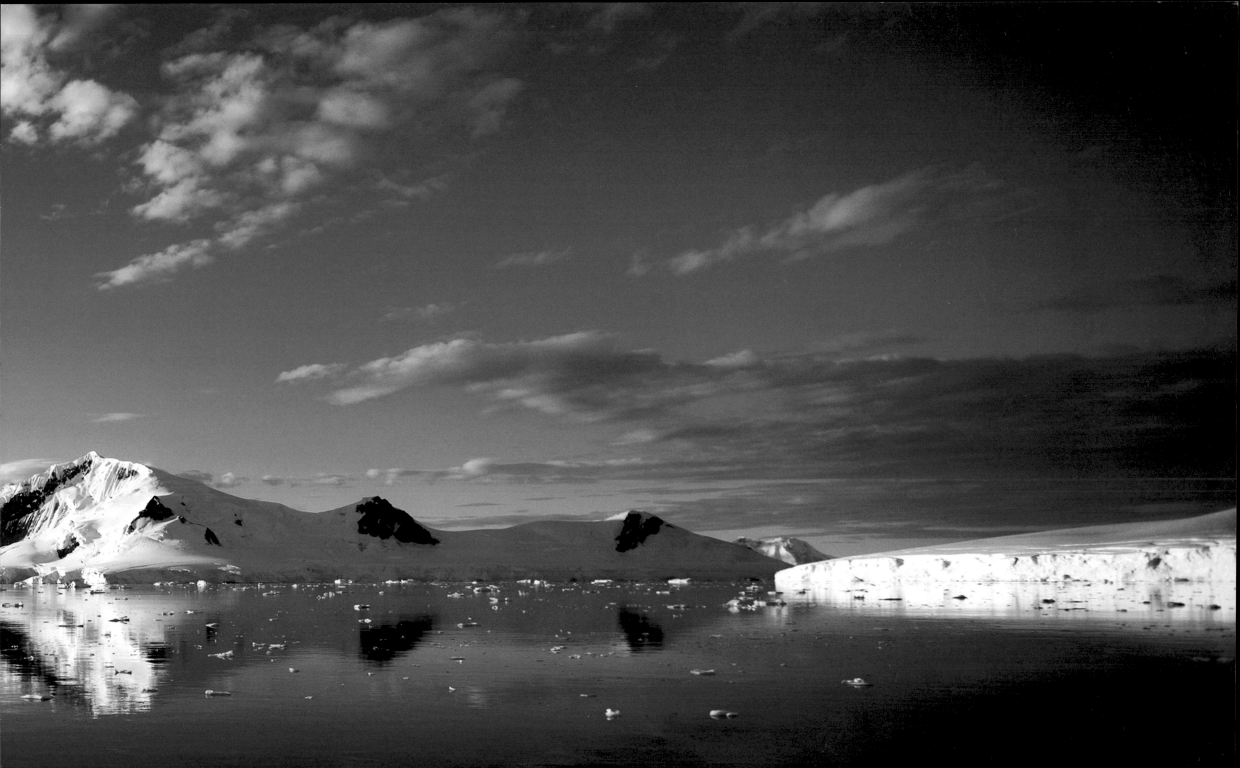

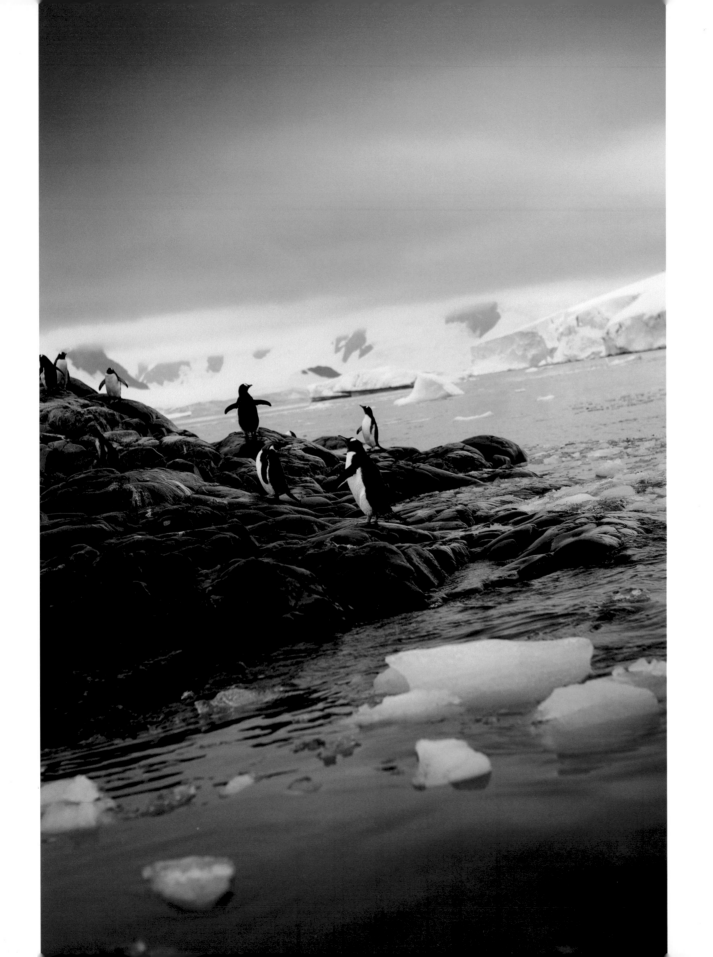

THE HUMAN FACE OF GLOBAL WARMING

By Matt Petersen

Antarctica seems distant, a zone beyond human reach. It is the one region of our planet that lacks an indigenous human population. Although the continent's mystery may have been partially unwrapped by such films as *Happy Feet* and *March of the Penguins*, one issue threatens to bring the Antarctic to everyone's door in a far more ominous light: that issue, of course, is global warming.

As this book illustrates, the accelerated – and accelerating – heating at the earth's poles is melting the world's ice shelves at an alarming rate, causing global sea levels to rise, increasing erosion, storm surges and flooding in coastal areas around the world. A peer-reviewed scientific study recently reported that 634 million people in more than 180 countries live in threatened coastal areas worldwide, defined as those lying at less than thirty-three feet above sea level.

While the world's most vulnerable areas are in Asia, with poorer nations at the most immediate risk, the threat of rising seawaters affects the entire globe. In America alone, nearly 150 million people live near the coasts, where rapid development has overwhelmed wetlands and other natural protections against tidal storm surge. Cities like Miami, Houston and New Orleans – and even parts of New York and Los Angeles – could end up routinely flooded as global warming increases. Indeed, the Intergovernmental Panel on Climate Change warns that by 2090, megafloods that would normally hit North America once every hundred years "could occur as frequently as every three to four years."

The long-term effects of climate change may seem abstract, but Sebastian Copeland and I saw the human face of global warming in the eyes of the Inuit people who live near the Arctic Circle when we traveled to Iqaluit. Global warming is impacting the region - and the lives of the Inuit - two to three times faster than the rest of the world.

To help get some sense of humanity's future, Global Green USA and Green Cross Argentina sponsored our Antarctic expedition onboard the Ice Lady (the travelers included program fellow Finn Longinotto, board member Sebastian Copeland along with John Quigley of Spectral Q). Our journey led to the creation of the human SOS image.

What is this SOS from Antarctica telling us? Most urgently, the world's poor citizens in low-lying flood areas will suffer the most. Indeed, the specter of "climate refugees" or "ocean exiles" displaced by rising sea levels is not some doomsday scenario from the future. It is already here.

In 2005 the Papua New Guinean government authorized the total, mandatory evacuation of the Carteret Islands in the South Pacific, which have progressively become uninhabitable, and which scientists estimate will be completely submerged by 2015. Ironically, these islanders could hardly have a smaller "carbon footprint," considering they have no cars, no stores and no electricity.

Similarly, another South Pacific island nation – Tuvalu – is disappearing as the surrounding sea levels have steadily risen over the past ten years. High tides in Tuvalu already bring seawater to doorsteps, and some islanders are forced to grow their crops in tins because the soil has become so salty. As Antarctica continues to melt, more and more low-lying communities face this dire prospect of being literally wiped off the world map.

So, how do we heed the SOS that Antarctica is sending? If we succeed in building the political will to solve global warming, will we include those in our communities who will be affected most but who are the most disenfranchised? Or will we leave them behind, attempting to "offset" our way into the future through diminishing the guilt of our most affluent?

The mass media have improved their coverage of global warming, yet still often feature the few scientific skeptics, thereby bolstering the misperception that "the jury is still out" on climate change and forestalling direct action. Meanwhile, our leaders in Congress are finally proclaiming it is time to act, but are still largely paralyzed by the auto and oil industries. Yet the solutions proposed so far do not even achieve the reductions in greenhouse gas emissions as prescribed in the Kyoto Protocol. More and more, businesses, local governments and others have joined the environmentalists' call for action. But this has not been enough.

In order to take the issue of global warming further out of the "green ghetto" where it was stuck for so long, we must build a broader coalition to act in the United States - not just the green-blue coalitions of environmentalists and labor, but a truly rainbow spectrum of individuals, organizations and community interests. We need the PTAs of the country to join arms with the poverty advocates in our towns, the community development organizations to join with teachers and health care workers to join with civil rights organizations. By engaging those constituencies - along with a small but growing number of businesses and over four hundred mayors who are committing to and taking action - we have a chance to engage America in a way that has not happened to date.

A truly grassroots movement could show how solving global warming not only protects our communities but also enriches and benefits our neighborhoods. By empowering schools, affordable housing, nonprofit hospitals and other community advocates to reduce their energy use, we can create a model that empowers everyone to take action and make a difference in their own lives.

This is the approach taken by Global Green USA: to advance green affordable housing and communities by creating policies and projects that lower energy bills for low-income families while supporting municipal green building. We imagine communities across this country embracing energy-efficient, affordable housing and schools becoming solar power plants for their surrounding neighborhoods in summer months when classrooms are empty. And when green schools are in session, we are increasing students' test scores while lowering energy costs for budget-strapped school districts.

These local climate solutions alone will not solve global warming. But they do represent real steps and solutions that may compel Congress to not just meet the Kyoto protocol but to beat it as merely a first step.

It is up to each of us to engage with the crisis of global warming by identifying as citizens rather than just "consumers." Doing so requires us to take our cues from outside the ad-driven commercial media, which, after all, have a vested interest in tempting us to ignore the world's problems and escape into selfish materialism. We have a moral and civic duty - if not to ourselves, then to our children and grandchildren - to recognize and enact our power as a polity, a community of citizens with shared ideals, working for the common good.

By looking today to the condition of Antarctica, we can measure not just how our communities' poorest and most at-risk will fare in the near future, but whether the shared fate of our species is progressing toward ultimate calamity and destruction, or toward a sustainable and secure future.

Matt Petersen
President and CEO
Global Green USA

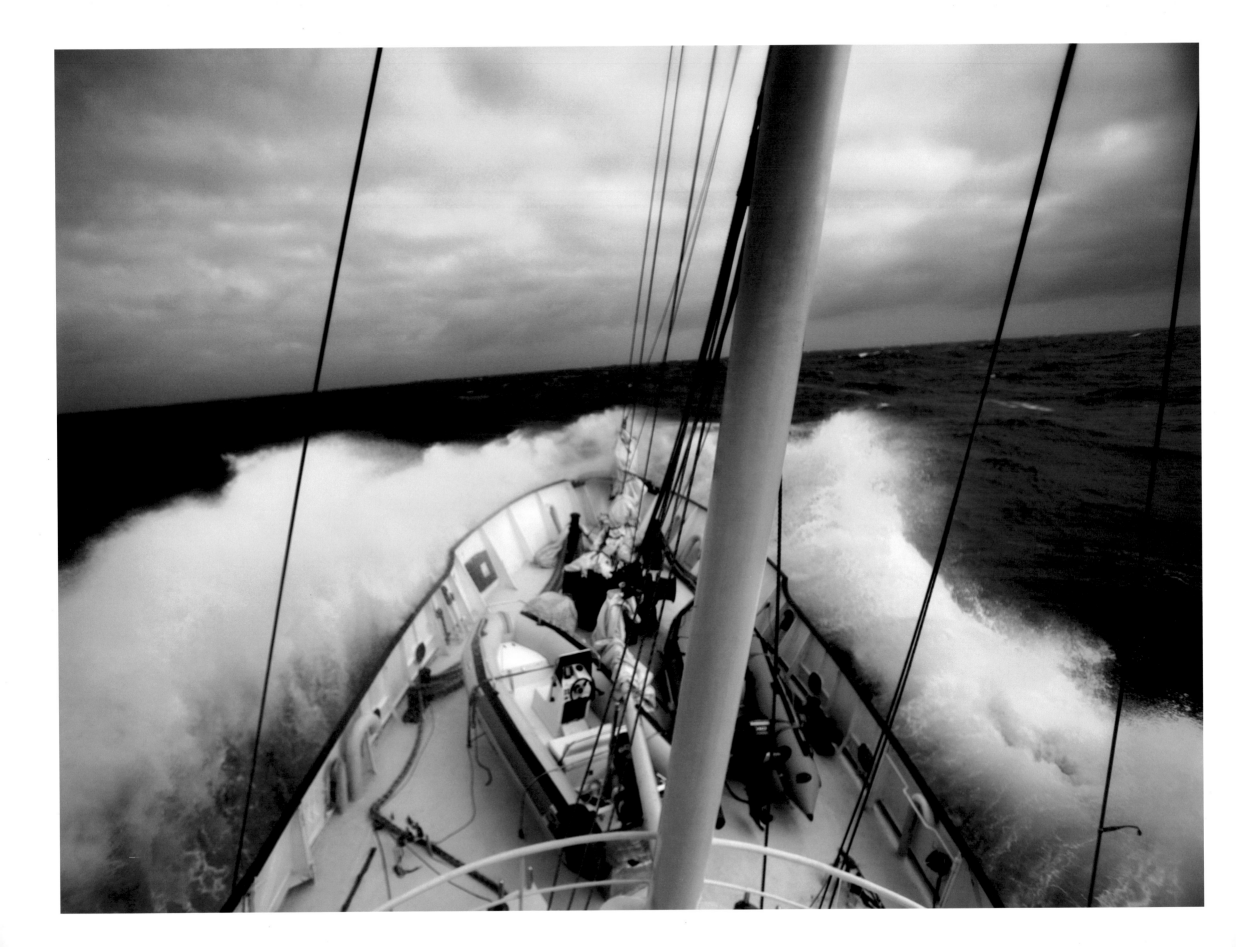

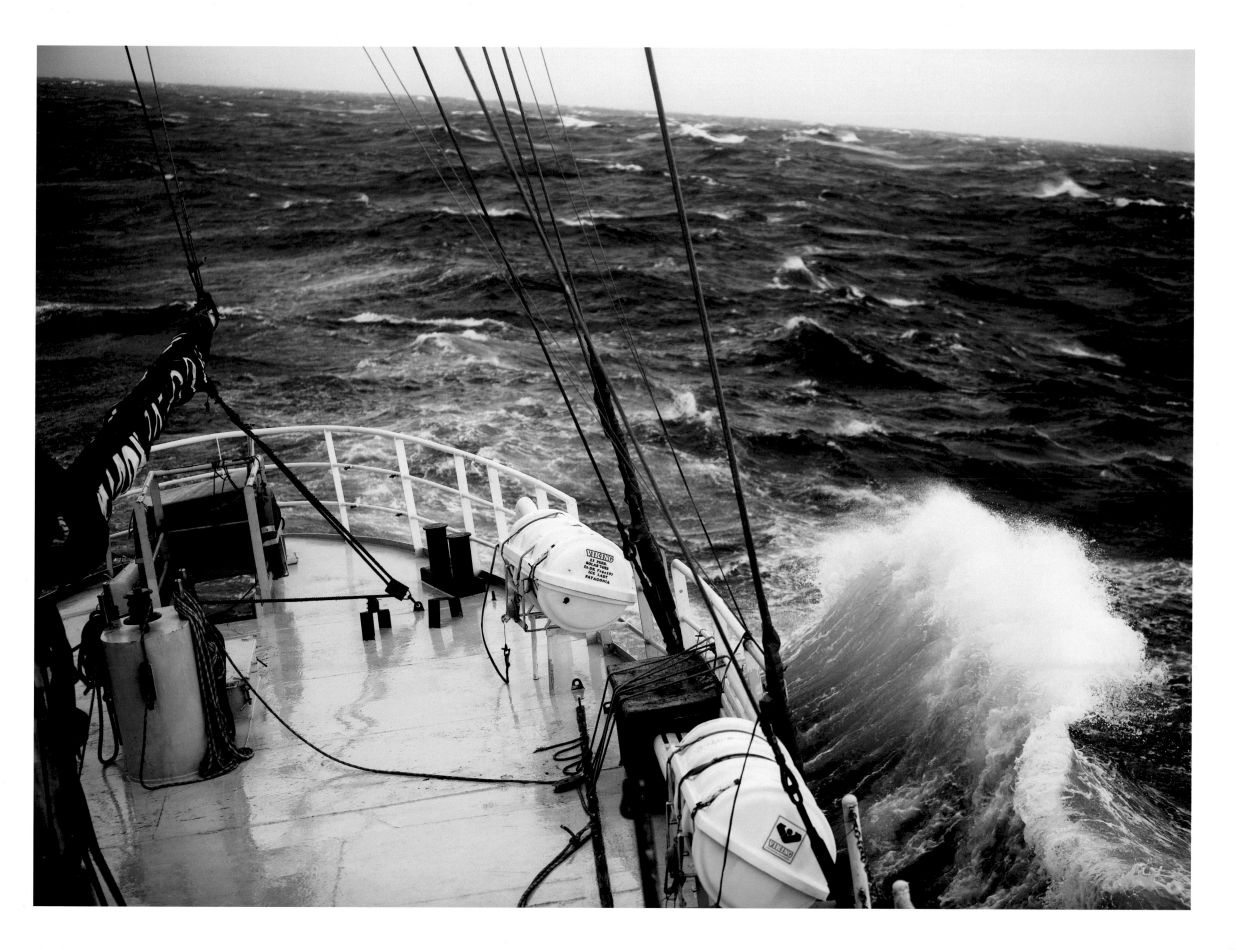

"Anything else you're interested in is not going to happen if you can't breathe the air and drink the water. Don't sit this one out. Do something. You are by accident of fate alive at an absolutely critical moment in the history of our planet."

— *Carl Sagan*

ADVENTURES IN THE GREEN TRADE

Sebastian Copeland's Journal Excerpts

April 20 to 24, 2005
Arctic Warning: A Press Conference in Defense of the Inuit

It didn't take much convincing to get me involved in the Arctic Wisdom initiative. Quigley had called me at the behest of my friend Lynda Stewart, who does volunteer work with the NRDC. John was planning to create an aerial image using five hundred or so kids to spell out a message of warning on the sea ice. I had met him a couple of years back when he campaigned to save an ancient tree named "Old Glory" just outside of L.A. Developers there had concluded that putting a road right through where the oak had lived for four hundred years would best suit their planning needs. John had valiantly camped inside the tree for ten weeks. In vain, as it turned out. Although the tree was eventually moved, at great expense in taxpayer dollars, it had little chance of survival.

Lynda had thought to get me involved with the Arctic initiative as an ambassador to Global Green and to help get the project both press and momentum. I liked it right away: the Inuit, the aboriginal people from the Arctic, faced the extraordinary threat of extinction from rising global temperatures. With them, a human face could finally be placed on the adverse effects of greenhouse gas emissions.

A hunting tribe by tradition, the Inuit have literally gone from the ice age to the space age in less than fifty years. Hunting, to them, is still very much a way of life. But with the sea ice receding and thawing persistently earlier in the season, their tradition and survival face real jeopardy. The clarity of the issue had universal appeal: the polar bears, for instance, would disappear there over the next eighty years; rising temperatures meant melting ice caps; endangered ecosystems; accelerated release of trapped greenhouse gases from the thawing tundra; slowing down of the Gulf Stream resulting in disruptive weather patterns, global receding of vast coast lines and disappearance of small island nations.... all this because of industrialization. The Inuit were the early indicators: the canary in the coal mine of the global economy.

For us [Global Green USA], I thought, the fit was right. NRDC was supporting the effort and this would give us the opportunity to work together which had been one of my objectives for some time – bringing environmental NGOs together to consolidate resources on common goals. But everyone in the office was pretty stretched out: the last couple of months had seen us organize three major fundraising and press efforts, while this initiative would come a week after our main fundraiser for the year, the Millennium Awards attended by President Gorbachev. In truth,

Matt was not overly enthusiastic with taking on another project, especially as our fundraising projections for the Millennium were low.

But to me, we were on a roll. And I was determined to capitalize on our momentum. Besides, the tangible plight of the Inuit had the empathic potential that often is lacking in a field dominated with statistics and computer models. I committed without much thought to providing celebrity attendance and air transportation. The celebrities would create media bait for a press conference in the Arctic, which would then entice participation from elected officials. Getting there, of course, is a tad off the beaten path, and the trip would necessitate what can be the trickiest of donations: a plane. In light of the many ridiculously wealthy people that were within one or two degrees of separation, this did not seem too ambitious at the time. The usual round of calls, however, proved unsuccessful. But through a friend, and within a week, I secured a wealthy benefactor. Or so I thought.

Our donor was a wealthy French-Moroccan who had made a fortune in the fashion industry and owned two planes: a G5 and a Boeing 727. He had no precedence with green charities, but was reportedly unmoved by the size of the commitment. In itself, this wasn't all that incongruous: it isn't unusual for wealthy individuals to generously donate this type of service without the blink of an eye. Sometimes it is just to swagger their egos, eager to buy their position into Hollywood or Washington by flaunting the bling. This donor was just like that. My friend shared with me that the man had spontaneously lent his plane to celebs for New York party trips. To me, and simplistically perhaps, this had more relevance than attendance at parties. To secure this plane, of course, I had to confirm celebrity attendance, which we would mix with elected officials and relevant press.

I had met Salma a few months earlier with Orlando. We had been to her house and spent an evening at dinner with Ryan Gosling at his restaurant on Robertson, drinking, dancing and playing cards. By then, the Academy Awards were approaching and we were embarking for the third time on our "Red Carpet/Green Cars" effort, offering chauffeured hybrid vehicles to celebrities as an alternative to gas-guzzling limos. It was also the time of our pre-Oscar party that I had started with Matt three years prior. Salma participated in the Oscar drive and graced us with her presence at the party, which that year generated the most press for us and established the event as a staple of Oscar week.

When I rang Salma to solicit her participation in Arctic Wisdom, she got it immediately. At first, I was cautious of her spontaneous response, especially

as she was filming in Tennessee on those dates, and would require production to shuffle her schedule to allow her the four days to the ice. But she brought with her the passion, energy and commitment that I have learned to recognize and admire as staples of her personality. She confirmed shortly thereafter. There was no time to waste. With her on board, getting press and politicians would be easy. We had six weeks to put it together. Two senators – from both sides of the aisle – expressed interest in joining our delegation. *The Washington Post*, CNBC and other major outlets confirmed attendance. Additionally, other environmental NGOs were responding to our solicitation, making this a real coalition.

I still had not met our plane donor. I was told by his people it would not be necessary, but I insisted as I needed to clearly outline the nature of this initiative, in person, and the premium placed on this generous donation. Iqaluit, our destination, is very remote and this initiative, in the end, depended on that plane. We met at the Beverly Hills Hotel, where the man lived with his family while their mansion was being remodeled.

I could not tell whether his disarmingly friendly manner was straight up compassionate or the generic mask of honey-coated grease. His son, dressed in basketball fatigues replete with a diamond encrusted heavy necklace and watch, joined the meeting. In his twenties, he addressed his father affectionately and incessantly as "my love" and threatened to join our delegation to the ice, which I'll admit, terrified me! Meanwhile, I explained everything, adding that by virtue of our 501 C3 status, I would ensure that he would receive a tax credit for his gift. Our friends at Future Forest would offset the carbon output of the plane. Everything was set.

Securing additional talent was met with the usual ups and downs. An A-lister committed but turned out to personally be driving a pimped-up hummer – a deal breaker when advocating CO_2 emission issues! The press – rightly so – loves to punch holes through what they perceive as opportunistic or hypocritical, which in the end, hurts everybody.

Salma offered to help and in no time convinced Jake Gyllenhal, fresh off *The Day After Tomorrow*, to join our group. The date was approaching, with all the pieces falling into place. About ten days before leaving, Washington called to get the tail number of our plane. It is standard protocol to conduct due diligence and ensure that the vessel carrying elected officials does not belong to a drug cartel or other colorful benefactors. After multiple requests for that information, and fielding calls from the senators' aides until I had the answer, I eventually got a call from our donor's secretary. Unceremoniously, she informed me that her boss now needed that plane, she was really sorry, and, no, he would not be available to speak. This was

late on a Friday afternoon. We were leaving in two business days! Much of the crew had already left for Iqaluit to set up the event. I had personally guaranteed attendance by media, celebrities and politicians. The next seventy-two hours were spent sweating bullets, exhausting every single possible lead, wondering with Matt whether to still fish or cut bait. We looked again into the possibility of commercial flights but these required three connections, including a sleep over in Canada: a deal breaker for this type of effort. This environmental adventure had suddenly turned into a complete quagmire; my credibility was seriously jeopardized. All would question Global Green's reputation: the NGOs we had enlisted; the celebs; the politicians; the press; and, most of all, the Inuit who once again would feel let down by empty promises. All fingers pointed at me. With one recanted promise, my credibility was shot. I was beginning to wonder whether I might find a hole big enough to crawl into. By the time we decided to charter a plane, we could not even find one for less than $100,000, and I had personally guaranteed the plane's fee.

After much negotiation, we managed to cut the cost in half. I would work on a raise, after the fact, to help shoulder that cost. By then, the senators had pulled out. But Eric Garcetti, president of the Los Angeles City Council, and California Assemblyman Joe Nation would eventually join Salma, Jake, Matt and myself. We all met on a private runway. After boarding the plane, I sank into my seat and let out a deep sigh of relief. The plane quickly lifted off, bearing into the night as we headed towards the world's northernmost airport, at the edge of the Canadian Arctic.

After a morning press conference in Iqaluit, during which Salma impressed everyone with her eloquence and compassion, and Jake displayed a keen, inquisitive mind, we were off to the sea ice. John had already assembled the one thousand kids and elders in a configuration that spelled the words "Arctic Warning" with an Inuit symbol meaning "Listen." The sky was overcast, but it did not snow as had been forecast. It felt like a big party, and I was impressed with how John and his team managed to swiftly position so many people and keep them put for the two hours or so needed to complete the image. The kids and all present there gave our celebrity friends a warm welcome that defied the chilly temperatures. Eventually, the helicopter was hovering overhead, and in a snap, the crowd was free to disperse. Mission accomplished.

The following day was spent on the sea ice with dogsleds and skiddoos. The temperatures had been especially chilly that morning, peaking below minus sixty factoring in wind chill. It occurred to me that a year ago at this time I had felt under my feet for the first time the fine, red sands of the Sahara. The sea ice is in fact a desert, vast and barren. Naturally, shooting in this environment is vastly different. And I faced the limitations of my excessive zeal and inexperience: the bulky clothes, the bitter cold and the exposure all prove to test the most basic methodology. Removing gloves – necessary to load film – proved testy, as the blood quickly thickens, staging the onset of a deep, throbbing pain. Light readings, framing, focusing; all become challenging steps in capturing a shot. It took the shutter on my large-format camera to freeze before I realized that this environment is best suited to 35mm digital... I cannot help but to think of Frank Hurley, the photographer on Shackleton's famed Endurance voyage, who shot with an 8x10 camera during that fateful survival feat. I am further humbled by the scope of his accomplishment.

1. From left to right: California Assemblyman Joe Nation, Sebastian Copeland, Salma Hayek, Matt Petersen, President of Los Angeles City Council Eric Garcetti and Jake Gyllenhal. Arctic sea ice, April 2005
2. Arctic sea ice, April 2005
3. Salma and Jake, Arctic sea ice, April 2005
4. Salma and Jake, with Inuit children and elders, Iqaluit, April 22, 2005
5. Salma and sled dogs. Arctic sea ice, April 2005
6. Arctic Wisdom aerial image of one thousand children and Inuit elders in Iqaluit, Nunavut, April 22, 2005. Photo by David Crane for John Quigley/Spectral Q
7. Salma and the elite Canadian Army Corps, Iqaluit, April 2005

On the ice I ran into David de Rothschild. He was training for a forthcoming trip to the North Pole. I love life's random moments!

Our faces were both covered for the cold and neither of us realized for ten minutes of conversation that we knew each other. We talked about London, Zac Goldsmith and other people we knew in common before he asked if I knew Orlando Bloom's cousin [Orlando is in fact my cousin]!

I had met David at a DeBeers sponsored dinner party in London where we had poured shots down each other's throat and we were off our heads in an otherwise stuffy diamond party. It was nice to see him here.

Arctic Wisdom helped put a face to global warming and got coverage in *The Washington Post*, CNBC and a wide variety of media. Salma was big news up there, and her engagement in the Great North was the beginning of a long-lasting relationship with Global Green.

It was also the precursor to my first Antarctica trip, the following year, as we endeavored to duplicate to the South the effort that we had accomplished in the Great North. That adventure would have profound personal resonance and would ultimately lead to the creation of this book.

25-JAN-2006 Antarctica Trip

I don't suppose there is anything wrong with feeling some measure of anxiety before leaving on a big trip. But as I think about it, I am typically unperturbed by trips right up to departure. Not this time. This one is different. Three weeks on a science research icebreaker, shipping out of Tierra del Fuego to land in Antarctica, four days later....That's not your casual getaway. It promises to be the experience of a lifetime and definitely an adventure. While things have been hectic since I got back from Europe three weeks ago, I have been mentally preparing. Slowing down my process and doubling up on the preparation has helped to quiet the internal trepidation, fueled by doubt and a thousand unanswered questions. Right up to the point when I realized that I was, in fact, anxious.

The idea for the trip originated with Bertrand Charrier of Green Cross International and Marisa Arienza of Green Cross Argentina, and it is co-sponsored by Global Green USA. It aims at continuing last year's Arctic effort, namely: to raise awareness on global warming, and impact the media with an iconic image sugarcoated with celebrity attendance. Quigley, again, would work with us on producing the aerial image which, this time, I would photograph as well as enlist a celebrity to participate in the adventure of a lifetime: to the land of penguins, endless magic hour and twenty-four-hour daylight.

But the last part would prove more challenging than ever. Getting a three-week commitment from a celebrity I knew would be tough. And I was well aware that if Orlando could not come the odds were against us. After running through a long list of A-list talent, I came back empty handed. By then I had committed to the trip but not without an awkward sense of unease: would the effort really pay off if I did not deliver what amounts to media bait, and was my presence there really necessary? In truth, soliciting talent can get me stuck between a rock and a hard place. Neither brown-noser nor true friend, I navigate the politics of ethos, egos and desensitized values amidst a false perception by those who want

– who need – to believe that having access means anything. Because access, to them, feels one step closer to catching some of that magic dust. I become a purveyor of hope and promises, which in itself, represents nothing unless I deliver. And this time, I did not. As the departure date loomed, I concluded that creating the image alone had enough value to stand on its own two feet, with or without celebrity.

After my experience shooting in the Arctic, I decide in a last-minute rush to purchase a high-end digital camera. It arrives *in extremis* the night before departure! I will read the manual during the flight down. We are greeted in Buenos Aires by the Green Cross team, and engage in a series of meetings to plan the execution of the image in Antarctica. On the strength of the movie *March of the Penguins*, John had suggested doing a penguin, which evolved to a screaming penguin to emulate Edvard Munch's famous painting. I suggest adding an S.O.S to drive the point: a screaming penguin, sending a message of help to the world. Sounds good on paper, and John will sketch different approaches. We will rely on the Argentine navy to provide the helicopter, and utilize scientists at the Argentine base of Jubani, as well as coordinate with a cruise ship of tourists to engage their participation in the image. All this to be executed on a glacier. We will release the image from the ice, with a sophisticated portable satellite transmitter. Marisa will fly in to the base station in an LC-130 from the air force (those oversized cargo planes) along with a choir of children to give the first-ever concert on the ice. An ambitious agenda....

We rush to the airport, for the additional three-and-a-half-hour flight south to Ushuaia, Patagonia. As we approach, a break in the sky reveals Tierra del Fuego: thousands of islands broken up to form the southernmost tip of South America. Legend has it that the aborigines kept fires going everywhere they went to keep warm, including on their boat, thus the name "The Land of Fire." We drive down to the harbor and get our first look at The Ice Lady Patagonia, our home for the next three weeks. A 144-foot icebreaker, the Ice Lady was decommissioned from the Finnish coast guards, where it specialized in de-mining missions during the cold war in the North Atlantic. The accommodations are Spartan, the onus definitely placed on function over comfort. The ship was acquired by an Argentine group (the Asociacion De Exploracion Cientifica Austral) run by two brothers, Jorge and Guillermo May, for scientific exploration and privately run missions. Our sleeping quarters are tight: seven feet by six feet four – the size of a walk-in closet. And sleeps three! John, Carter (who came down to assist in the creation of the image) and I will share the space. Reality sinks in – welcome to the navy! Outside, the rain is intermittent and, though it is summer here, the air is crisp. The shower isn't working. Trying to get comfortable on my two-inch mattress, I switch off the light and realize that thirty-six hours have passed since I left Los Angeles, and I haven't slept. Another eighteen days to go on this boat... and eighteen nights in this cot!

27-JAN-2006 Ushuaia, Patagonia

Slept really well. We have pasta in the galley for breakfast, but no shower still. I walk into town searching for towels – not included with the bed! – with a couple of crazy Argentines who will be with us on the

trip. Ushuaia is a quaint town, framed by mountains and waterways. It serves the Patagonian tourist industry, centered on hiking and camping. And of course, as the southernmost town in the world it is the foremost port of call for Antarctica. Finn, a Global Green staffer who came with us to coordinate, translate and contribute a daily blog, informs us that there is a storm brewing on the Drake, but that we will be lifting anchor after sundown. We approach two cruise ships moored behind us to ask staff for their cooperation with the image. The coordinators listen patiently to our unusual request: would the tourists on board supply their time to provide additional bodies on the ice? Tourism is very regulated in Antarctica – no more than 100 people can make landfall in one location at any given time. The reception from the ship staff is lukewarm. We are invited to communicate from down there and attempt to coordinate our effort if our two ships are within proximity. I catch an incredulous look on one of the coordinators, which leaves me skeptical: let's not hold our breath! The Ice Lady feels like summer camp for grown men. There is only one female on ship: Jorge's fourteen-year-old daughter! The atmosphere is relaxed, and we progressively get acquainted with our shipmates – thirty in total. By nightfall, the Ice Lady pulls out. On deck, there are cameras everywhere. The evening is cool, but very still, and the city lights slowly vanish into the night. I get the sense that somehow, after this trip, things will be different.

There is something penetrating about smelly feet in a closet-sized room: it isn't just nauseating, it repudiates all self respect, and no one shines. I feel forced to instill some rules when it comes to odors... We are all trying to adjust to the tight space for three, with virtually no storage space. We will sail all night down the Beagle Channel, which leads to the Drake. I was told once that crossing the Drake comes in one of three ways: lucky and moderately calm, which is quite rare; so bad, you think you will die; so bad, you wish you were dead!

We speculate how and when might we get sick. Finally, a shower. It's 4 AM: lights out.

28-JAN-2006 Beagle Channel

The drone of the engines and ocean sway make for deep sleep. Finn barges in the room at 9 AM warning of breakfast timeline. I feel fourteen again. I am groggy from the cumulative lack of sleep. The boat is anchored in a bay protected from the strong winds that are whipping the Drake. We wait here for a better weather window. Outside it is rainy but, in the wind shadow of the island, quite still. The coastline is reminiscent of British Columbia with overgrowth and thin beaches. Everyone is summoned for a meeting in the mess reviewing safety protocols. Scuba diving is on the agenda for the afternoon in seven-degree waters. I talk them into letting me dive as well, but the dry suits lesson won't heed much purpose: the wind picks up and my group won't get to dive today – the boat sways too much. I look forward to diving in the ice. Afternoon turns anticlimactic, as did this rainy day, waiting for the wind, waiting for the dive....Word gets out after dinner that we will make a run for it tonight. We are instructed to tie everything down as we will get rough seas! Outside the wind is howling. It will take sixty hours to make the crossing. We leave tonight, at midnight...

29-JAN-2006 Crossing the Drake

Slept until early afternoon. Woke up a few times to the sound of coughing in the bathroom. The seas are rough as we are experiencing forty-five-knot winds. The boat's ice-breaking round hull — with no keel — makes it throw in all directions. I caught myself a few times from rolling off my cot. The ship's quarters are eerily deserted, but for the bridge. Most spend the day in bed, some on deck emptying their stomach to the sea. Standing or walking requires serious sea legs, and no small amount of acrobatics. A bad step, a fall, and bones will shatter. I guess that is where the channel got its name: the Drake Shake! By chance, the ceaseless roll does not bother me. I'll admit to wearing a patch — why chance it? But in truth, I find the rolls almost soothing. Even though it is virtually impossible to read or focus on anything productive. Any attempt to write is like running a thread through a needle inside the wash cycle!

I am hindered by the language barrier: my Spanish is just good enough to get me in trouble, but not enough to carry any type of substantial conversation. It is humbling. I spend most of the afternoon and evening on the bridge, watching the hull relentlessly climb up the twenty-foot faces, only to explode down into walls of spray as it belly flops into the cold, dark blue seas of the channel. I have volunteered for driving duties and am assigned the six to nine watch — mornings and nights. The wind drops to twenty knots, and by midnight, it feels as though the worst is behind us.

In two days we should reach Antarctica.

30-JAN-2006 The Drake

Slept in late today, again. There is no mistaking it: the tiny room, the engine's monotonous drone and the constant roll of the hull as it cuts its way through the swell. It is very womb-like.

Wind has diminished considerably, and we raise the many sails the Ice Lady carries. No sight of land now for almost two days. The temperature is dropping, and we cross the Antarctic Convergence where the current surrounding

1. The Ice Lady's eating quarters
2. The bridge of The Ice Lady
3. Brazilian base station at Admiralty Bay, Antarctica, January 2006
4. Port Lockroy, February 2007
5. Carlos Vairo and Orlando Bloom, Paradise Bay, Antarctica, 2007
6. Cousins, Deception Island, Antarctica, February 2007
7. The bridge of The Ice Lady
8. Arriving in Antarctica, January 2006, Livingston Island, South Shetland Islands
9. Jorge May, January 2006
10. Crossing the Drake in rough seas. The ship rolled to 53 degrees. February 2006
11. Dive master "Pinino," Deception Island, Antarctica, February 2007
12. The Ice Lady ship hands, Antarctica
13. Heading for landfall, Antarctica, 2006
14. Orlando and Carlos, Port Leith, Antarctica 2007
15. Ushuaia, the southernmost city in the world, January 2006
16. Departing for Antarctica, Ushuaia, January 2006
17. John in our sleeping quarters on The Ice Lady, January 2006

Antarctica replaces that of the sub-Antarctic. The ocean temperature drops from around 6.5C to 1.1C within a few minutes. We are anxious to see something — anything! I keep a watch on the bridge, get giddy with John and Carter, read my new camera's manual cover to cover. Tomorrow we will see land.

31-JAN-2006 Livingston Island, South Shetlands

With only four hours of sleep, I get out of bed with anticipation. About a mile out, breaking the monotony of the horizon: the first iceberg! It is very exciting, and taking heed from our Japanese brother's time honored tradition, everyone on ship breaks out cameras and starts shooting those icy monoliths, about a mile out! This is followed, in short order, by a few penguins, and then a flock of Cape petrels who circle the ship, curious and welcoming.

In the distance, an island vertically rises to near 5,000 feet, its peak shrouded in clouds. This undeniably feels like another world, borne of King Kong-like novels. We have reached the South Shetland Islands. It takes a moment of mental adjustment to rationalize that what seems from afar to be a multitude of white yachts turns out, with little surprise, to be so many icebergs! We eventually drop anchor in Livingston Bay. People pile up inside two zodiacs — one will make landfall, the other will explore a nearby iceberg. I am about to crowd into one, when Jorge grabs hold of my arm, and gives me a confident frown-and-pout-of-the-lips combination, while slowly shaking his head up and down. "Wait with me," he says. "They will send the Zodiac back from land, and we will be more comfortable." Not one to turn down this attractive offer, I wait with the captain. From a photography standpoint, this will turn out to be a grave miscalculation. It turns out we wouldn't get out that day: a group of Spanish researchers gave us the mouth for not having a permit to anchor there and for disturbing their research of indigenous birds. What I had thought would guarantee me a great little VIP tour with Jorge turned into two hours of waiting on deck in cold gear and life jacket, discussing politics and, inspired by the gloriously still conditions, taking the same average picture of the distant shore over and over.

Meanwhile, the Zodiac comes back with what turns out to be the most amazing shots of a chinstrap colony on an iceberg, bathed in a surreal light. I am gutted to have missed it. I try to be philosophical, but it is tough to let go. I am told that it is rare, at this time of the year, to see penguins on icebergs. In this period of their breeding cycle; they mostly stay land-bound to steer clear of predatory seals in the open water. I am blown away by the quality of the light captured from enthusiastic but amateur photographers: the unique transparent luminescence, with a heavy dark cloud cover and dramatically still waters, makes for stunning images. This missed opportunity will live, for me, as the shot that got away....We lift anchor and sail by a low floe, where a leopard seal plops himself into the water. On the ice next to him, a pool of blood: the remnant of a full meal of penguin. The leopard seal is carnivorous, and the only Antarctic animal dangerous to humans. Outside of the Orca, it is the top dog on the food chain. Recently a research diver lost an arm to these fearsome creatures! A female diver was pulled down by one, never to be seen again.

I take my turn at the wheel on the bridge, shoot some magnificent endless sunset shots, and try to let go of the day's missed opportunity. I am

anxious to get off the boat and close to my subject. I will get my shot at it.

I will be up at 6 AM for my watch. It is now 3 AM, while outside, the night never got completely dark.

01-FEB-2006 Admiralty Bay, King George Island

Wake up at Penguin Island. I finally get out on a Zodiac with Jorge, in what will turn out to be a relatively tame exercise of going round an island, in frigid conditions, and not stopping for the colony of penguins....We eventually make landfall by Antarctic fur seals and its playful progeny. Most of the land is stripped of ice or snow, but the weather is very cold. The boat lifts anchor and sails by an emerald iceberg. Those are very rare, I am told, and get their color from having rolled: the green comes from the algae and plankton trapped in the ice. We are headed for Admiralty Bay for protection from a coming storm and sixty-mile-an-hour winds. A large glacier dominates the small bay, towered by precipitating volcanic slopes, mostly void of snow at this time of the year. The ambient temps are hovering around zero centigrade, ten degrees less with windshield factor. A Brazilian base controls that bay, and we are off to make contact.

The rocky volcanic beach is parched with whale bones, and moss estimated to be some six hundred years old. I photograph my first penguins — five of them — though the scenic environment is not especially arresting. The weather is terribly overcast and the light flat. I will come to long, again, for the missed opportunity of yesterday's penguins on an iceberg! Antarctica, at its best, is so beautiful that it is essentially a point-and-shoot environment. The challenge is to be positioned at the right time, and in the right conditions, to maneuver the constricting politics of shooting from a largely moving vessel. The Brazilians offer us coffee and a tour of their base. Finn, John and I are beginning to formulate a plan for the image; the Brazilians may play a key role, as one of their ships pull into the bay carrying two helicopters.

Not much to shoot at here though, admittedly, the color spectrum down here vibrates at a frequency that is unique and difficult to describe. Even in today's flat light, hues of grays and browns separate explosively. I am getting tired of shooting everything from the boat: I need dimension and foreground to add depth to what is otherwise an arrestingly unique and lunar environment. Shooting digital has a very fast learning curve. So fast in fact, that the camera does most of the thinking for you. The down side is that it's easy to get lazy and less systematic about depressing the shutter. And shoot ridiculous amounts of images — there is no additional cost. I am downloading heaps of files, mostly repetitive, and many uninteresting.

02-FEB-2006 Admiralty Bay

This morning saw a powdering of snow, and the temps are a tad chillier. The light, again, is decidedly flat. Like much of what happens on this ship, we hurry out of bed upon warning from Finn that we can now go talk to the Brazilians, but then wait a good hour until somebody announces that we will eat lunch before getting anywhere. Things on the image front — the reason that brought us here — are looking up: we could get the picture done

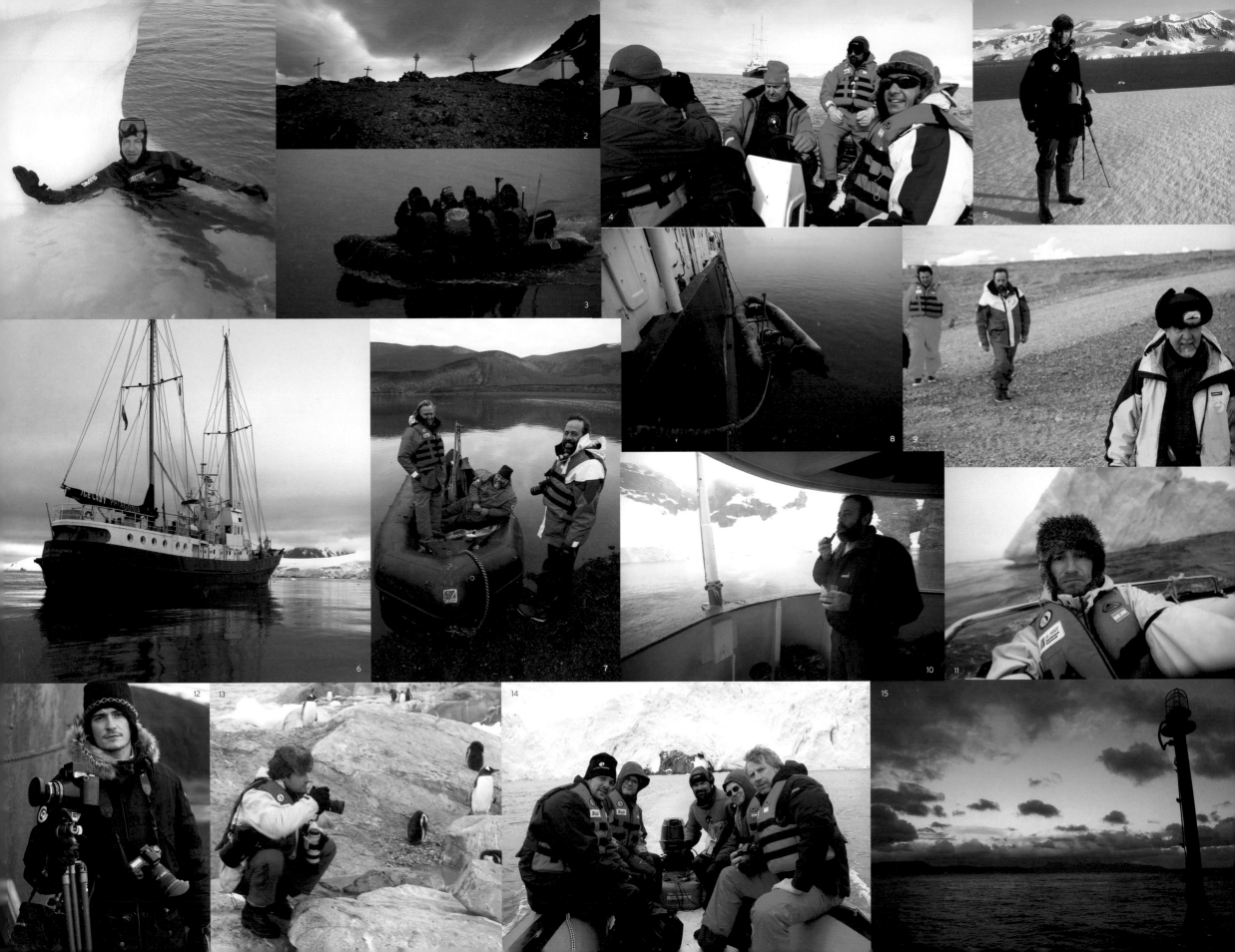

today. The Brazilians have a ship carrying a helicopter, and there is talk that they would let us use it. We are starting to conceive a plan, the most concrete so far, but it gets killed when we learn that the Brazilians don't want to inherit that responsibility – which is reasonable. After hanging in their camps for almost three hours, we come back empty handed. A brief jaunt to another shore, for what will turn out to be a rushed and mediocre shooting opportunity. We lift anchor and sail for a short while, namely through a section of water parched with ice blocks: beautiful.

There is good weather announced for tomorrow, which will hopefully bring this magic land of ice to fulfill its luminescent promise.

03-FEB-2006 Ezcurra Inlet

Woke up to another day of flat light and gray skies. Still, there is a unique quality about the air here. The lack of dust or moisture, with no familiar comparative landmarks, makes distances difficult to approximate. The narrow spectrum of monochromatic hues and tones are explosively and individually defined. We are anchored in the mostly restricted Ezcurra Inlet, a cove surrounded by towering volcanic peaks and glaciers. There are virtually no beaches in this complex system of fjords and channels, as the geology above ground is mirrored under water; just vertiginous slopes plunging into the water.

I go diving in the afternoon, which is incredible! The preparation was by far the most unnerving, as the dry suits are terribly tight and constricting. The hood alone squeezes one's face to the extent that the small window left for eyes and lips makes them swell out of the rubber like a Michelin man. It is hard to breath, and I silently wonder how I will cope underwater as I can hardly breath above. Beyond the tank and the BC, I carry extra weights to compensate for the buoyancy of the dry suit, and the whole getup is very cumbersome. But as I hit the water, all that weight goes away: a valve allows air to be inflated into the suit, regulating temperature and facilitating breathing, and pretty soon, I forget how restricted I was on the surface. The visibility is nil and there was a killer whale sighting in the bay this morning! Would be something to come face to face with one of those with six feet of visibility! No leopard seals either, which is just as well given the glimpse I caught the other day! We are looking for a sunken ship, and drop down to 35 meters, but find nothing, not even a

1. Diving at Nekko Bay, Antarctica, February 2006
2. The cemetery of the Brazilian base station at Admiralty Bay, January 2006
3. Making landfall on the Gerlache Strait, February 2007
4. JP, Jorge, Marianno and Mohamed, King George Island, January 2006
5. A glacier above Port Foyn, February 2007
6. The Ice Lady on a quiet evening in the Andword Inlet, February 2006
7. Jorge, Pinino and Carlos, Deception Island, February 2007
8. A snowy day at Deception Island, February 2007
9. Guillermo May, King George Island, Antarctica, January 2006
10. Carlos at Nekko Bay, February 2006
11. The Errera Inlet, February 2006
12. A high-priced camera caddy! Family has its privileges. Deception Island, February 2007
13. Port Lockroy, February 2006
14. John, Finn and crew, Nansen Island, January 2006
15. Return to civilization – Terra Del Fuego visible in the distance, February 2006

single fish. Water here is about minus 1.5 degrees Celsius. Swimming up is surreal as we push aside huge blocks of ice, making surface swimming rather impractical. Surprisingly, however, water temperature is hardly a factor, as the dry suit works like a dream. Inside of it, I am dressed normally. Except for the hands, I have not been bothered by the cold as I had anticipated. I climb into the zodiac with a grin from ear to ear that won't go away.

Tomorrow we lift anchor at 5 AM to make out for the Argentine base of Jubani and determine whether we can create the image there. After that, we will head south for what I am told packs the real beauty of Antarctica...

04-FEB-2006 Jubani Argentine Station, South Shetlands

An early rise today yields a long overdue experience with morning light. Admittedly, getting up at seven – again with only four hours of sleep – is too late for early light around here. By three-thirty, when I shut down, it was already light out. But the morning is calm and the frigid water without a ripple. We are rushed to shore, and told the Ice Lady will leave at noon sharp. If we are to produce this image here, it will have to happen before then. Jubani is set in a bay surrounded by the perennial glaciers. Not especially visually arresting, the area where the station is located is ominously uncovered by ice. Marine mammals and birds are the primary subjects of the research conducted here, but the base commander shares with us that they have seen more rain than snow in recent years. Large areas are decidedly depleted of ice in the summer months, which is unnerving. John and I quickly come to the decision that we will take our chances and bet on a better context as we head south, relying solely on the resources and body count here on the boat. No helicopter, no Argentine base personnel to up the numbers, no meeting up with the representatives of Green Cross Argentina who were meant to have arrived four days ago (but whose Hercules airplane could not leave Buenos Aires due to poor weather prospects). The original plan had involved flying in a choir of children for the first-ever concert in Antarctica. But that plan has changed so many times that I believe at this point only five kids are allegedly coming down! Who they will play to, and the relevance of this event is anybody's guess. Either way, unfortunately we will be gone by the time they get here, if ever.

Our stop in Jubani allows me the first opportunity to walk around, alone. In reference to the aesthetic of the place, I should perhaps clarify that the setting is stunning, in its fresh and pure natural beauty. It is by comparing it to the other vistas of this extraordinary land that it does not particularly stack up. But walking around, breathing pure fresh Antarctic air, on solid ground, is a nice change. The ozone-depleted atmosphere makes sunscreen mandatory. Skuas are large brown birds, about the size of an eagle. In Antarctica, they must figure pretty high up on the food chain, because they charge me with no fear, dive bombing their hooked and ominous beaks to within inches of my head any time I unknowingly come too close to their progeny.

The unsettling "Waiting for Godot" nature of creating this environmental image notwithstanding, I contemplate how complete I feel on this trip. I wish Kristine could share with me the inspiring beauty that surrounds me, and the gracious company of the Argentines hosting us. Jorge and Guillermo May, both heir to a plastic factory business in Buenos Aires, impress me

with their generous dispositions. While the carrot had clearly been the no-show celebrity attendance, not once do I feel unwelcome. Ingratiating myself to them was not hard: in spite of the language barrier and our intrusion in their group, by now, I feel well integrated into this motley crew of adventure seekers. I am blessed, even while my shooting experience still leaves a lot to be desired. It feels like we have reached the halfway point of our journey and the rest should be the cream. Back on the boat, we are headed for open ocean sailing again, smoking cigars and drinking great wine with Mohamed, a French-educated Egyptian Banker of forty-four, and Jorge, a sophisticated retired Navy officer. We banter and crack jokes off the stern, bathed in invigorating sun and wind. I have become the de facto technical photography advisor. Nights are spent reviewing and critiquing the day's sessions, and movie screenings. Tonight, appropriately enough, is *The Life Aquatic* with Bill Murray! The boat's engines are churning under the night sky. Tomorrow is my day to wash dishes and serve meals! Hands on deck at 8 o'clock sharp in the galley!

05-FEB-2006 Port Foyn, North Nansen Island

A whale breaches the surface a hundred yards from the ship. We stop to witness a twenty-minute aerial spectacle! Like clockwork, it takes 27 to 30 seconds after the tail appears, and the whale assumes its dive mode, for it to reach enough depth to generate the upward speed required to hurl its body into the air. The trick is to guess where it will break the surface to accurately point the lens. I get some good shots only to realize that in my excitement, I forgot to adjust the shutter to 1/2000th second or more to "freeze" the water and motion. I shot at 1/500th second which won't be as sharp. I am frustrated at myself. We search for a workable location for the environmental image – my reason for being here – and Guillermo is on the job. We suss out an iceberg, isolated out in the ocean, but no good: the seas are too rough, making it dangerous to scale.

We pull into a magnificent cove named Port Foyn, at North Nansen Island in the Gerlache Strait. The area was a busy whaling station at the turn of the century, and the place was named after the infamous Sven Foyn, inventor of the explosive harpoon in 1868, who helped pave the way to a disseminating campaign by the whaling industry. Up to twenty-two harpoon guns used to outfit these killing vessels. At its peak, the slaughtering of blue whales reached over 29,000 in one season (1931)! In spite of the IWC's ban on blue whale hunting, their numbers have never recovered. Today, they figure around 12,000 globally. Steel moors, driven into rocks, lay exposed, as well as large piles of wooden oil barrels, preserved by the ice, an eerie reminder of those times' intense whaling activity. We moor off the bow of a Norwegian whaling vessel, the Governoren, which lays half sunken where it has been for almost a century. Built in 1891 by Palmers Shipbuilding & Iron Company of Newcastle, and purchased in 1912 by a Norwegian whaling company, the ship caught fire in 1915 and the captain decided to beach it rather than lose it. A rock pierced its hull and the wreck partially sank as it reached shore. Seven of us pile into a Zodiac to explore the surrounding area. It is a challenging shooting experience not being able to wander alone or control the direction of the boat for the best possible angle. Very

antonymous to traditional landscape photography. I end up over shooting – it's digital…. While I miss the individual meditative communion with nature, this is one of the most unique and beautiful journeys I have experienced. We make landfall on a small island and I must inadvertently have gotten too close to a skua chick. An adult dive bombs me repeatedly as I walk away. I turn around and the bird clocks me in the eye with its wing leaving me with what will turn out to be a black eye! Ballsy birds!

Too many images, starting to realize the amount of work ahead, editing….

tomorrow we create the image; and dive the wreck!

06-FEB-2006 Gerlache Strait

Very little sleep downloading and backing up all those digital files! John, Carter and I take a zodiac out early in the AM to scout our image. The day is overcast with intermittent rain and there is wind. The crew, who has agreed to participate after lunch, could lose interest if we wait any longer, thereby jeopardizing our mission. We must shoot today. After a long and wet scout with the zodiac, and many frustrated near misses, we finally find a floe that will work. Excitement is in the air! On our way back, we encounter a whale who gently swims around the inflatable, occasionally surfacing within ten feet of the boat, slowly shaking its tail and treating us to a dance for over an hour. The magnificent landscape emanates a vibrant light even with this cloudy, rainy sky. We make landfall on an island and find piles of whale oil wooden barrels where they have stood for almost one hundred years, preserved in ice. Today, due to warmer summers and longer thawing cycles, they lay exposed to decay and the elements. The Ice Lady will transport some back to Ushuaia. I question the take, but I am told that they will be displayed in the Antarctica Museum. No dive for us, as we took too long following the whale. The divers explored the wreck and brought back china from the galley and harpoons from the deck. Buccaneers!

After lunch, we motivate our crew and set off to our location. People get into their orange emergency suits. To our dismay, the iceberg from the morning's scout has disappeared! Located in the Gerlache Strait and framed by dramatic glaciers pouring into the ocean, the wind and current have drifted this massive block of ice away and out of sight! I am afraid we will lose the crew if we do not accomplish this now – patience is running thin, and a mutiny is afoot! We scramble to find another workable floe. With the Ice Lady in tow, our little zodiac wanders, this way and that, desperate for an adequate location.

The iceberg has to meet a specific set of criteria to be workable. For one, it must be scalable; stable – that is, not susceptible to rolling while we're on it; and relatively flat to provide an adequate canvas for the image: the ice, by definition, is incredibly slippery. Those parameters will turn out to be challenging, and for a moment, things are looking dire. Depth is also a consideration for the Ice Lady, as I will shoot from the top of one of the masts and need the ship near the floe. We approach a large block of ice with prohibitively high walls. Instinctively, I suggest circumnavigating it and by chance, the berg reveals a perfect approach and a relatively flat surface. We found our spot!

It starts to rain again. Long and hard. I climb up the mast sixty feet in the air and wait there for an hour and a half while John arranges people on the ice in the shape of a penguin. The wind up here is considerably stronger than on the surface, and it is quite cold. The Ice Lady, I notice, is moving slowly but noticeably close to the ice. For a moment, I marvel at the incredible maneuvering control of our captain, until it becomes clear that we are about to collide! I scream down and brace myself, and in an instant the bow of the ship impacts the floe, collapsing a ten-by-forty-foot section into the ocean! By luck, the floe is very sturdy, and we avoid the worst….With no one hurt, we resume the work. From my vantage point, however, the penguin shape does not read, let alone the scream. Some are getting cold and tired. I radio John and suggest going to plan B: a simple SOS. The message, to me, is clearer and to the point. John wastes no time and efficiently repositions our crew. For some, whose emergency suits offer zero traction, the slight angle of the ice makes it hard not to slide. Pitons are driven into the ice to anchor them. With the SOS in place, I radio the ship to get into position as the wind and current makes it impossible to stay in place. I am soaked. I pull the camera from the plastic bag that protected it from the rain. I remove the lens cover and rapidly shoot until rain hits the lens – perhaps five frames. I remove the skylight filter, which affords me another few frames. Within minutes, we have the shot. Everyone is excited. Thank God! The image is iconic. Mission accomplished. Life is good. Officially on holiday now, and can relax! I am tired. And very cold.

07-FEB-2006 Gerlache Strait, Neumayer Strait

The ship lifts anchor at 4 AM and sails south into the day. This makes for a deep, relaxing slumber, to the rhythm of the swell and the sound of the engine. Nice to catch up on some sleep. I wake up around 11 AM to another cloudy day. Our sophisticated portable satellite transmitter is apparently not sophisticated enough to beat the steep angle that our position imposes this far south. So we are told by the technician who traveled with us from Buenos Aires for what turns out to be a paid vacation! We are not able to deliver the image in the time parameters announced to the press. The ship enters the Neumayer Strait, framed by precipitous mountain ranges on both sides. It's a shame that the light is so flat, as this is truly the stuff of adventure illustrations. We finally reach a penguin colony, and I fight my way onto the zodiac headed for shore: I will get my penguin shots! Unfortunately, this will hardly make up for that first day which I still angst about, all too aware of the extraordinary opportunity that I missed. John and Carter both have loaded those images on rotation as their laptops' screensavers, a cruel and constant reminder! The rookery is void of ice, but replete with the bird's krill dropping, which reeks of a urinal. It's hard to be down on the scenic context, but comparatively, this hardly measures up to much of what we have seen. The session is further shortened by Jorge, who activates the ship's horn, anxious to leave. No great contribution to the photographic annals of Antarctica will be made this day… I find solace in making a first edit of my images thus far: there is no question that this place is a photographer's Shangri-la.

08-FEB-2006 Nekko Bay, corner of the Andword Inlet

Another gray day, as I wipe the moisture off the porthole next to my cot. I jump into my clothes and we head over to the British station of Port Lockroy, in hopes of finding an internet connection to load the SOS image. It is pouring rain – naturally, this is England after all – and my hopes for an internet hookup and a proper cuppa are quickly thwarted by the unceremonious scolding we get from the formal representative who meets us as we pull the zodiac to shore. We are here at the same time as a tourist cruise liner, and we have not booked our visit as is customary. I respect that – besides, it feels like home! The station is modestly manned by three officials and set in the midst of yet another penguin rookery. I sacrificed a dive under icebergs for this visit, and instead got soaked, steeped in penguin poop and scolded like a child! This hardly makes for a civilized window, let alone a Kodak moment. They do, however, carry a small gift shop (contextually incongruous), and a postal service – British mail, of course! Kristine will get a legitimate Antarctica card.

We lift anchor, and head for yet another penguin rookery, at a Chilean base, this time. While it is still drizzling, the vista surrounding us is nothing short of stunning. It is unnerving how much rain this place is getting and the mild temperatures we are experiencing. Hardly good for the ice, which here again, is replaced by the mud-like penguin droppings. But this stark and harsh environment bustles with animal life, with mothers feeding their chicks and skuas hovering overhead, ominously preying on unattended babies. I finally get some good shots and leave shore elated. Nothing would prepare me for the bay in which we anchor for the night. With heavy clouds looming above and a bright band of light on the horizon, monolith-like icebergs float by us, reflected in the stillness of the frigid waters and framed by the surrounding mountain range on all sides. Words pale in the face of this arresting spectacle of nature. And so, true to form, I grab my camera and indulge in this visual orgy, late into the evening. Thank God for digital! Mohamed and I end our evening sitting up on deck, bundled up, our headphones hooked into ipods, listening to jazz and middle eastern music, drinking whiskey and smoking cigars, bathed in the remaining light reflecting off the mirror-like stillness of the water… this is perfection. What a life! What privilege. This is perfection!

09-FEB-2006 Nekko Bay

It's hard to find too much wrong with the light of Antarctica, what with the transparency of the air and the explosive palette of subtle hues, which have come to define this place in my eyes. Still, waking up to another drizzly day makes me realize how special we got it on our first day here. Every night I mourn the missed opportunity of shooting those chinstrap penguins propped on a smooth, flat iceberg, floating in mirror-smooth waters, framed by monolith chiseled blocks of ice and the low-angle sun cutting through the dark gray clouds with razor-sharp definition! I know how senseless it is to hang on, particularly in light of the trip's extraordinary variety, but yesterday's perfect pitch was the punctuation that announced the beginning of the end of our journey. How I wish to have added those shots to my collection…. There is light rain again today, and the mild temperatures have precipitated large calvings from the bay's surrounding ice shelves. The waves generated by one of those considerably rocked the boat.

I go diving again today, exploring the surrounding depths of an iceberg. There is something truly surreal about swimming around the bottom of a giant block of ice in sub-zero degree water. The light glows blue and purple into the cracks, and for a moment there, I feel like a penguin!

Over night, a giant iceberg has floated near our ship. About the size of a city block and shaped like a cathedral, it inspires the same piety as a hallowed place of worship. The texture of its contour shaped by cracks or raindrops alternately would make it feel manufactured were it not over ten stories high! By now, it is pouring hard, and raindrops pluck the silver surface of the ice-littered water. My camera is soaked, and worse yet, it is impossible to prevent raindrops from hitting the lens. The equipment is being put through its paces. As the zodiac glides me through this world of sea and ice, rain whipping my face while I fill my lungs with the fresh air, I smile and shoot away. It will be tough to re-enter the urban reality that looms ahead.

A gentoo penguin, alone on a small floating piece of ice, observes us curiously as we glide by. Man as an island: I will get my penguin on an iceberg after all!

10-FEB-2006 Andword Bay and the Errera Inlet

After our trip to the Arctic last year, Lynda had talked to me about continuing our effort to raise awareness of the human face of global warming by focusing on Tuvalu, the small south Pacific island nation that will see its landmass disappear to rising ocean levels. This translated into a campaign that John is undertaking consisting of photographing, in as many countries as possible, people displaying a banner that reads: "We are all Tuvalu." Given that this group has representatives of thirteen nations, I kick off the campaign by shooting the first image here in Antarctica. I will shoot with my Linhof panoramic and am done setting the shot up when Carter, unbeknownst to me, takes the initiative to unnecessarily set my Canon digital – which has mostly been my work horse down here – on a tripod. At full height. In twenty knots of wind... Since I will figure in the image (a representative of both England and France) it is only after stepping into the shot that I notice my unattended camera propped up like a sail about to take off. Sure enough, as if in slow motion, the tripod begins to tip over. I lunge into the air, but no amount of rugby training would allow me to prevent it from bouncing on the rocks, cracking the filter, and it seems, the zoom as well! I am livid. The camera gets banged up as well, and I ponder the ironic luck that after almost three weeks of serious abuse on the equipment, it will take the last day to damage it! It is the 24–70mm that gets it – uninsured. Carter, very kindly, assumes responsibility.

Carlos Vairo, the director of the Antarctica Museum in Ushuaia, and I brave the intermittent rain again, determined to find our penguins on an iceberg! He too, missed that first day's opportunity, and is as determined as I am. Nearby, a leopard seal displays for us its fearsome jaws, and – a cruel answer to my prayers – two penguins on an iceberg! Not a colony, but I did ask all week for penguins on an iceberg! We also discover extraordinarily shaped ice. The intermittent fog and rain reveal stunning vistas. Photographs will hardly do them justice. Behind the Errera Inlet is the open ocean and the Drake, where a taste of the swell reminds us of what's to come: while exploring the contour of an ice floe, a rogue wave seriously challenges the zodiac's

tipping point, in what felt like a close call. I reflect in silence how fragile we are and on what often feels, in Antarctica, like a false sense of security. In these frigid waters, most humans would die inside four minutes. We are soaked, again, as is the gear...

Our last dinner in Antarctica is followed by an award ceremony on the ship, honoring, and dishonoring, the outstanding members of our troop. While I feared receiving the Worst "Slave" Award (named for the day each week we all get our turn at washing dishes and serving the rest of the group), Mohamed walks away with the honor! Instead, I am handed an Antarctica diploma, evidencing my foray below sixty degrees latitude. On it, a moniker in association with my name amuses me. I wonder whether my Argentine friends actually intended its double entendre: "Hollywood Penguin"! Whatever anxiety prevailed before our initial crossing is back on this, our last day in Antarctica. We are anchored in a protected bay, in the eye of a storm. On the other side of a thin strip of land the Drake is churning. We cross tomorrow. Of the three ways to get it, the last was wishing you were dead...

11-FEB-2006 Drake Channel, Day 1

Back from my ten to midnight watch at the wheel, the sea is still throwing pretty good. The ship is cutting through fifteen-foot swells, coming in all directions. The Drake Channel, notorious for its famed Cape Horn, is where the depth of the Atlantic meets the continental shelf. Depths in excess of two thousand meters suddenly rise to a couple of hundred meters, resulting in generally fierce sailing conditions. We have had winds of around thirty knots all day, which came down to twenty in the evening. But strangely (with this much wind) a thick fog has engulfed the ship, while the barometer has plunged precipitously all afternoon. We have crossed the Antarctic Convergence. The consensus is that by tomorrow, we should catch up to the storm that we had tried to avoid. Hold on to your seats, this could be sport!... Meanwhile, most of the group has stayed in bed, hibernating. The constant roll and pitch of the ship does not bother me; I'll admit that I like it!

12-FEB-2006 Drake Channel, Day 2

This morning saw some rough seas. Deep in sleep, I was practically thrown out of bed; I narrowly caught myself from crashing down onto my camera cases. After a brief period of moderate seas and a slight climb of the barometer, I thought that the worst might be behind us. In fact, over my evening watch, the barometer plummets again. Now, early into the AM, in pitch darkness, the ocean is viciously throwing in all directions. I believe the swell to be well over twenty-five feet. It is dangerous to stand, and I got thrown to the ground in the galley as I attempted to fill a glass of water. I am lucky not to have broken a rib. I fell heavily and will walk away with a nice bruise on the shoulder. By the time I reached the bridge, most of the glass's content rested on my face! We are about twenty hours from land; we should see Horn during my first watch. Around here the ocean isn't angry: it is fierce and relentless. Not for the faint of heart.... Awake, I have some difficulty not getting thrown off my cot. I doubt I will get much sleep tonight.

13-FEB-2006 The Drake

Crossing the channel when the Drake is in a fury will live in memory as one of the most awesome display of Nature's power. It is deeply humbling to see this 144-foot heavy ship, designed to break ice, being tossed around like a cork in a fountain. The storm indeed intensified. And as predicted, I had no sleep: my cot is one of very few positioned parallel to the hull, and its safety belt was torn. Designed without a keel, the Ice Lady Patagonia rolls violently, sometimes beyond fifty degrees! I was less concerned with getting rest as I was avoiding a flight to the ground, four feet below. My first morning watch had seen the barometer drop to the last notch on the wheel, which simply reads: "Storm." By "Storm," as I have learned, the Drake means "batten down the hatches, and hang on very tight"!

With winds gusting to sixty miles per hour, in thirty-foot seas, this is truly dangerous sport. Standing, I was thrown twice when the ship violently rolled without warning. What stopped my flight were the wooden-paneled walls of the mess making direct contact with my head, inches from the brass portholes! It was lucky that the paneling is thin and flexible, as it happened so fast that there was simply nothing I could do! Standing in there, at the stern of the boat, when it is throwing as it did, is outright scary, and I am amazed not to have broken bones. Around five o'clock, the winds start to calm down. In an hour we should sail past Cape Horn, and the last section of our five-hundred-mile crossing.

This much motion plays on one's nerves, and I'll admit it: sad though I am to leave the ship, I am ready for this crossing to be over! By 8 PM, the first islands of Tierra del Fuego appear in the distance. We should make Ushuaia by morning. Tomorrow, the best of this extraordinary voyage will live with me in memory. A token of my experience, the photographs I bring back, I know, won't do justice to this other world: Where connecting with the land is profound and spiritual. Where the challenges inherent to reaching this distant landscape reinforce the privilege of my experience. At times fierce or deadly calm, I am awed by the power of its extremes. Antarctica feels like a world that existed long before we did. But its rate of change reflects our own. One gets the sense that this fragile system carries in its balance the fate of the world. I will leave here with a reaffirmed belief that to protect it is to save ourselves. And the distinct feeling that I will be back.

PERSONAL CLIMATE ACTION

The increased warming at the earth's poles represents the figurative and literal "tip of the iceberg" when we contemplate the likely effects of accelerating global warming. Not the least of these effects is the rise in sea levels that stems directly from melting glaciers, ice shelves and ice caps. But if present-day Arctic and Antarctic regions are "climate canaries" in the global coal mine, responding to the SOS can seem like a daunting prospect for a mere individual to undertake.

Indeed, the Intergovernmental Panel on Climate Change estimates that humanity must reduce carbon emissions by about 70 percent to stabilize the climate – hardly a trivial reduction, especially considering our narrow window of opportunity. But while it is clear that significant and immediate local, regional, national and international policy shifts away from oil and coal – and toward clean, renewable energy – are critical if we are to meet the IPCC's goal before passing some irreversible tipping point of runaway global warming, there are also plenty of important choices we can make as individuals to minimize our environmental footprint and to educate and inspire those around us.

SIMPLE WAYS YOU CAN HELP FIGHT GLOBAL WARMING

1. LIGHT UP Each replacement of an incandescent bulb with a compact fluorescent bulb in your home keeps 100 pounds of CO_2 out of the atmosphere per year and saves you at least $30 in electric bills over the bulb's lifespan.

2. RECYCLE Recycling half of the aluminum, glass, plastic and paper you use reduces 2,400 pounds of CO_2 annually.

3. TURN IT DOWN, TURN IT UP Minimizing your heater and air conditioner use reduces climate change and your electricity bill. Turning your heater down three degrees in the winter and up by three degrees in the summer saves 1,050 pounds of CO_2 annually.

4. DRIVE LESS Five miles less driving per week (bike, carpool, walk) eliminates 900 pounds of CO_2 per year. Public transportation (bus, train) uses about half the fuel consumed by cars, trucks and light SUVs, according to the American Public Transportation Association.

5. DRIVE SMART If you can, drive hybrids or cars that get more than thirty miles per gallon. Inflate your tires, too. For every three pounds below recommended pressure, fuel economy goes down by about 1 percent.

6. WASH COLD Washing one load of laundry per week in cold instead of warm water saves 250 pounds of CO_2 from entering the atmosphere per year.

7. UNPLUG IT When not using appliances, unplug them. Turn off power strips when leaving the house and sleeping. This keeps CO_2 from being expended and saves around $10 per month on your utility bill.

8. EAT SMART Eating meat-free meals every other day eliminates 487 pounds of CO_2 from the atmosphere per year. Eating locally avoids the high transportation energy costs of getting food to your plate. Eating local food once a week saves a whopping 5,000 pounds of CO_2 from entering the atmosphere annually.

9. USE SUNLIGHT Utilizing sunlight instead of electricity-generated light when applicable saves CO_2 and has been shown to increase productivity. Replacing old windows with double-pane windows reduces heat loss and cuts down heating bills.

10. SHOWER Taking showers instead of baths eliminates 1,000 pounds of CO_2 per year. Also, decreasing the length and temperature of your shower will decrease the amount of carbon needed to heat the water.

11. PLANT LOW-WATER LANDSCAPES Grass guzzles water. Instead, replace your lawns with native plants and plants that suit your climate. Group plants together for productive growth with less water.

12. ELIMINATE JUNK Your annoying junk mail kills trees. Services like greendimes.org and 41pounds.org will remove you from junk mail listings and promise to eliminate 80 to 95 percent of unsolicited mailings.

13. SUPPORT ENVIRONMENTAL ORGANIZATIONS Your financial support and volunteer work with environmental nonprofits such as Global Green USA helps finance advocacy campaigns and environmental programs to steer policy making towards a sustainable future. Good for you and your children.

COMMUNITY ADVOCACY

SUPPORT SOLAR AND WIND

Ask your utility company to give customers a way to buy electricity from alternative, renewable energy sources

or ask your local officials to consider Community Choice Aggregation, which allows local control over

energy policy and increases the use of renewable energy.

JOIN THE CLIMATE PROTECTION AGREEMENT

So far, more than 300 mayors, representing more than 50 million Americans, have signed the U.S. Mayors Climate

Protection Agreement. Tell your mayor to agree to meet or beat the Kyoto Protocol targets in your community.

PROMOTE GREEN BUILDING

Local governments can mandate green building practices for residences, schools and businesses. A green building

ordinance promotes a whole-building approach by regulating sustainable site development, water savings,

energy efficiency, materials selection and indoor air quality.

SUPPORT PEACE

Write U.S. and foreign policymakers on the importance of support for nonproliferation,

arms control and demilitarization worldwide.

Biographies

WILL STEGER A polar explorer, educator, photographer, writer and lecturer, Will Steger is also a passionate advocate for the preservation of Antarctica.

Steger's historic accomplishments at the planet's extremes include the first confirmed dogsled journey to the North Pole without re-supply; a 1,600-mile south-north traverse of Greenland; the International Trans-Antarctica Expedition; and the International Arctic Project, the first and only dogsled traverse of the Arctic Ocean from Russia to Ellesmere Island, Canada. In 1995 Steger joined the company of Amelia Earhart, Robert Peary, Roald Amundsen and Jacques Cousteau when he was awarded the National Geographic Society's John Oliver La Gorce Medal for "accomplishments in geographic exploration, in the sciences, and for public service to advance international understanding."

Steger has put his unique experiences and observations at the service of his community, both national and local. He has twice testified before Congress on polar and environmental issues. In 1991 he founded the Global Center of Environmental Education at Hamline University in St. Paul, Minnesota, and two years later he established the World School for Adventure Learning at the University of St. Thomas, also in St. Paul. Steger is the author of four books: *Over the Top of the World*, *Crossing Antarctica*, *North to the Pole* and *Saving the Earth*.

STEPHEN SCHNEIDER One of the world's leading experts in the causes and effects of climate change, Dr. Stephen H. Schneider is a professor of environmental studies and biological sciences at Stanford University. Schneider focuses on climate-change science, assessment of ecological and economic impacts of climate change and identification of viable climate policies and technological solutions. He has consulted with federal agencies and/or White House staff in the Nixon, Carter, Reagan, Clinton and Bush administrations.

In 1992 Schneider was honored with a MacArthur Fellowship for his ability to integrate and interpret the results of global climate research through public lectures, classroom teaching, environmental-assessment committees, the media, congressional testimony, and collaboration with colleagues. He was elected to the National Academy of Sciences in 2002.

Schneider is founder and editor of the interdisciplinary journal *Climate Change*, editor-in-chief of the *Encyclopedia of Climate and Weather*, and author of *The Genesis Strategy: Climate and Global Survival; Global Warming: Are We Entering the Greenhouse Century?* and *Laboratory Earth: The Planetary Gamble We can't Afford to Lose*. In addition, he has authored or co-authored more than 400 scientific papers, proceedings, legislative testimonies and book chapters.

JOHN QUIGLEY The founder of Spectral Q Aerial Art (www.spectralQ.com), John Quigley has created seventy-five human images involving nearly 100,000 people around the globe. In February 2006, Quigley teamed up with Sebastian Copeland and representatives from more than a dozen countries to create Human SOS on an iceberg off the Antarctic Peninsula. The image was chosen as one of *Stern Magazine*'s 2006 photos of the year.

Quigley is also a producer, director, educator and environmental and social activist. He was a key organizer for the Earth Day 1990 and 2000 events in Los Angeles, and continues to serve as the city's Earth Day executive director.

Quigley launched the Adopt-a-Beach program in San Francisco schools, and was a creative consultant in the development of the "Green Power Hero" school-assembly program for the Los Angeles Department of Water and Power.

Quigley has produced a series of outdoor shows, including "Awakening" at the U.N. Change Convention in Buenos Aires in 1998; "Wild Ballona" in Los Angeles in 1999; and "Awakening: Solaria" at the Earth Summit in Johannesburg in 2002. His multimedia spectacles involve a unique combination of large-scale video projections and the vertical dance troupe Project Bandaloop.

ZAC GOLDSMITH has been the director and editor of *The Ecologist* magazine for eight years. In 2005 he was appointed Deputy Chairman of the Conservative Party's Quality of Life Policy group, which will deliver its recommendations on a wide range of policy issues in July 2007.

When not working for *The Ecologist* or the Conservative Party, Goldsmith raises funds for groups around the world that deal with issues ranging from agriculture and energy to climate change and trade. He has supported campaigns to reduce the use of pesticides, which have contributed to the banning of 320 pesticide ingredients across the European Union.

Goldsmith, who was awarded a 2003 Beacon Prize for Young Philanthropist, spent a year doing environmental work in the Himalayas and now runs an organic farm in Devon.

DAVID DE ROTHSCHILD is the founder of Sculpt the Future, a nonprofit organization whose goal is to raise environmental awareness through education. Along with other projects on several continents, Sculpt the Future is working to designate the South Pole a World Heritage Site.

De Rothschild's commitment to the environment has taken him to some of the world's most remote places. In 2006 he spent more than 100 days traversing the Arctic Ocean from Russia to Canada, after which he became one of only forty-two people (and, at 28, the youngest British person) ever to reach both geographical poles. Prior to the Arctic expedition, de Rothschild was already a member of the fourteen-person club of those who had traversed Antarctica.

Following his other passion, health, de Rothschild earned an advanced diploma in natural medicine, and in 2002 he began laying the groundwork for a naturopathic/ecological-education centre and certified organic farm in New Zealand.

De Rothschild is a 2007 National Geographic Emerging Explorer and a member of the World Economic Forum's Young Global Leaders network.

MATT PETERSEN is the CEO of Global Green USA, the U.S. affiliate of Green Cross International. *Global Green* focuses its resources on halting climate change, eliminating weapons of mass destruction and providing safe drinking water for the 2.4 billion people who lack access to clean water. Petersen has led Global Green since 1994, building and guiding its innovative programs and initiatives. He serves on the Managing Committee of Green Cross International and is coordinator of GCI's Energy and Resource Efficiency Program. He has run local, state and federal political campaigns and has served as the executive director of Americans for a Safe Future.

Petersen is a member of the Council on Foreign Relations and the Pacific Council on International Policy. He serves on the advisory board of the Environmental Media Association, the board of the Institute for Market Transformation to Sustainability and the City of Santa Monica Environmental Task Force.

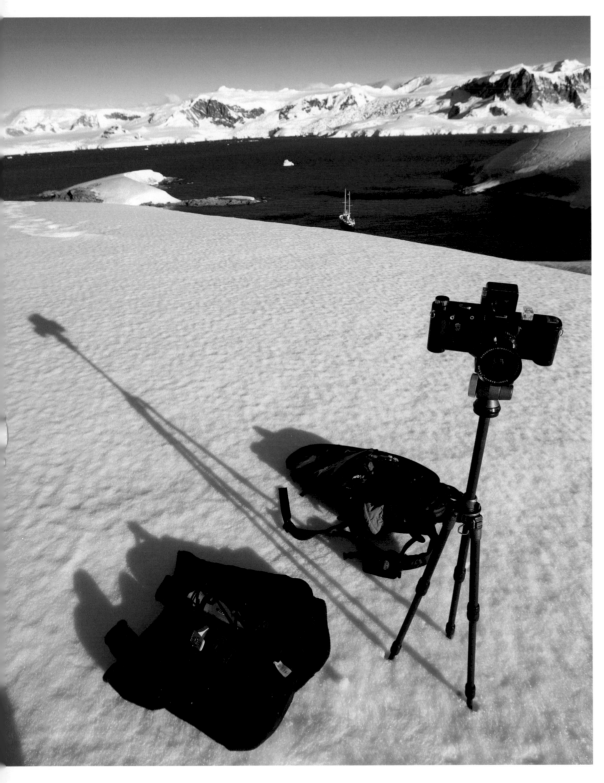

TECHNICAL SPECS

A quick word on technical specs and equipment. Most of the images in this book were shot digitally with the Canon 5D and 1Ds Mark II. For those bodies I used three zooms: 16-35mm 2.8; 24-70mm 2.8; and 70-200mm 2.8. The Canons performed admirably well even when subjected to demanding conditions. Aside from the cold, they were often soaked from the rain, snow or saltwater spray. I can't say enough about their durability. I used Lexar cards and Lacie Rugged portable hard drives for storage.

About 10 percent of the book was shot on film. I used a Linhof panoramic large format (6X17) with a Schneider 90mm Super-Angulon 5.6. And a Mamiya 7 medium format (6X7) with 43mm 4.5; 80mm 4.0; and 150mm 4.5. I shot mainly Fuji chrome Provia 100F; but also some Kodak negatives 160 NC and Plus-X 125 black and white.

I still prefer shooting film. But after bringing film cameras to the Arctic, I quickly learned that the polar regions are best suited for 35mm digital. Aside from the shutter on my Schneider freezing over from sub-zero temperatures, the convenience of not having to load film in extreme cold or wet conditions, alone, is worth the price of admission! 4GB compact flash cards will carry over 200 shots, thereby removing at least one set of variables. That is especially relevant when working from boats, as the Peninsula dictates. To shoot landscape from a moving vessel is antonymous to that discipline: with no time to carefully compose a shot and reflect on the approach, you're forced to shoot first and ask questions later! 35mm means faster lenses, auto focus and greater depth of field. All important assets when in quasi-constant motion. It also allowed me to shoot a lot, never sure whether the next position would better the last. I have great respect for the photographers who have done all their work in Antarctica on film, and large format (beginning, of course, with Frank Hurley, Shackleton's photographer on the Endurance voyage!). It is laborious, exacting and costly.

A final word on the treatment of the images. I had originally thought to shoot a lot more black and white. Antarctica's limited color spectrum is so rich in saturation, however, that I was compelled to use more color than initially planned. I shot almost exclusively without filtration, and if so, on very rare occasions, with a polarizer. I have done minor work in Photoshop, mainly curves to address the soft contrast issue of the Canon sensors, and some burning and dodging. But the colors you see in this book are just about faithfully represented. I have often said that Antarctica is a point-and-shoot environment: the pictures take themselves. I am grateful for the privilege I experienced just to be there, and the access afforded me by the captain and crew of *The Ice Lady*.

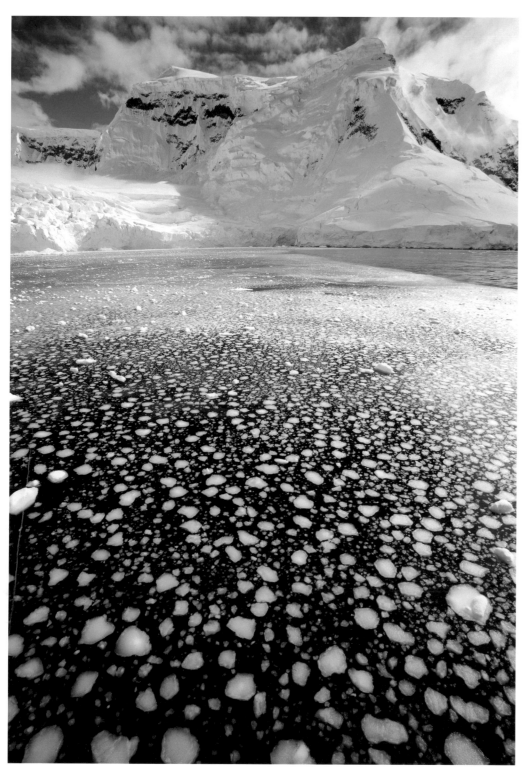

ACKNOWLEDGMENTS

Over the years, and through my work with Global Green USA, I have poured through volumes of environmental data. As well, I have had the privilege to talk directly with experts, climatologists and environmental scientists and explorers. The insight I have gained, I owe to their knowledge and research.

I would like to thank my friends and fellow peaceful warriors Matt and Leila Petersen for their support and friendship throughout this journey; President Gorbachev for his inspiring global leadership; Leonardo for shining light where it matters; my friends Zac Goldsmith, David de Rothschild, Stephen Schneider and Will Steger who generously contributed text and lent their expertise and personal insight; John Quigley, my "brother in arm" and a true partner both in the Arctic and Antarctica; Salma Hayek for her grace, passion and commitment; Arianna Huffington, Sheila Watt-Cloutier, and Sting for their endorsement of this project; my editor Lisa Fitzpatrick for her tireless patience and guidance; my publisher Raoul Goff for his faith in me and the purpose of the mission; and everyone at Palace Press who worked so hard to make this book everything I hoped it would be; Jorge and Guillermo May and *Asociacion de Exploracion Cientifica Austral* for their hospitality on The Ice Lady Patagonia; Carlos Vairo for getting out with me on no sleep for sunrise shots! Marisa Arienza of Green Cross Argentina whose vision was the genesis of this project; Finn Longinotto; Bertrand Charrier and Alexander Likhotal from Green Cross International for their early and continued support; Joy Cernac and Max Wolf for compiling the personal action list; for the DVD elements I owe a debt of gratitude to Mike Brady, Luke and Liz Thornton of Believe Media for their loyal and unconditional help; Dean Miyahira, John Howard and Deanne Mehling of Chrome for their great support in editing *Solissimo*; Taichi Erskine and Chris Gernon for jumping on board in spite of an overloaded schedule to edit *Eskimo*; Brady Hammes for cutting the profile on me, and Harold Hinde for directing it; Brian Knappenberger for editing *in extremis* the Quigley interview piece; David Heisler for jumping without hesitation into the fray of assisting me with image treatment when I could not finish alone; Bonny Taylor at The Icon; Quinton Alsbury for his gifted web support; Michele Colonna and Napapijri for their endorsement of my adventures; David Butterfield for his generous support and contagious smile; my friend Greg Gorman for his patient guidance and generous resources; John Omvik and Michelle Pitts at Lexar Media for their kind support; my brother-in-law Didier Lockwood for his superb musical talent and gifting me with *Solissimo*; Damien Rice for giving me use of the superb *Eskimo* track; Jacqueline Moorby for her selfless dedication and the many nights she spent working to give this book's design... longevity; my late paternal grandfather whose example of altruism has taught me that the greatest gift to the self is to help others; my late maternal grandfather for the adventurous spirit he infused in his grandchildren; Kristine Hardig for her patience and sacrifice during the many months of absence this project required; my father who has taught me that art without discipline is like a mission without purpose; my mother whose endless support and tireless belief in me has given me the greatest gift of all: self expression.

COLOPHON

EARTH AWARE

Earth Aware Editions
17 Paul Drive
San Rafael, CA 94903
www.earthawareeditions.com
415.526.1370

Library of Congress Cataloging-in-Publication Data available.

ISBN-13: 978-1-933784-19-9

ROOTS of PEACE REPLANTED PAPER

Palace Press International, in association with Roots of Peace, will plant two trees for each
tree used in the manufacturing of this book. Roots of Peace is an internationally renowned
humanitarian organization dedicated to eradicating landmines worldwide and converting
war-torn lands into productive farms and wildlife habitats. Together, we will plant 2 million
fruit and nut trees in Afghanistan and provide farmers there with the skills and support
necessary for sustainable land use.

10 9 8 7 6 5 4 3 2 1

Printed in China by Palace Press International

This book was made possible in part thanks to a generous contribution
from the Zangrillo family and the compassionate Developers of Loreto Bay.

www.antarcticabook.com

Publisher & Creative Director: Raoul Goff
Executive Director: Peter Beren
Acquiring Editor: Lisa Fitzpatrick
Art Director: Iain R. Morris
Managing Editor: Jennifer Gennari
Press Supervisor: Noah Potkin
Editorial Assistant: Sonia Vallabh

Project Art Director & Designer: Jacqueline C. Moorby

VIDEO COMPILATIONS
Sebastian Copeland: A Photographer's Eye in Antarctica
Directed by Harold Linde
Filmed by Sebastian Copeland
Edited by Brady Hammes
Music by Sigur Rós: *Glosoli* from the album *TAKK...* ℗ 2005 Geffen Records

Sending a Message to the World: The Making of the SOS
Director & Editor: Brian Knappenberger
Music by Sigur Rós: *Glosoli* from the album *TAKK...* ℗ 2005 Geffen Records
and by Didier Lockwood: *Solissimo*, an original musical composition created for
Antarctica: The Global Warning © 2007 Didier Lockwood

Eskimo
Executive Producer: Mike Brady
Filmed & Directed by Sebastian Copeland
Edited by Chris Gernon & Taichi Erskine
Music by Damien Rice: *Eskimo* from the album *O* ℗ & © 2003 Damien Rice, Under license to
Vector Recordings, LLC/Warner Bros. Records Inc. & 14th Floor Records. By arrangement with
Warner Music Group Film & TV Licensing and Warner Strategic Marketing UK. Administered by
Warner/Chappell Music Publishing Ltd.

Solissimo
Executive Producer: Deanne Mehling
Edited by Dean Miyahira
Assistant Editor: Jon Howard
Music by Didier Lockwood: *Solissimo*, an original musical composition created for
Antarctica: The Global Warning © 2007 Didier Lockwood

DVD post production, Executive Producer: Mike Brady, Liz and Luke Thornton (Believe Media)
DVD mastering by Michael Wanger